Video Demystified

A Handbook
for the
Digital Engineer

by Keith Jack

Library of Congress Cataloging-in-Publication Data
Jack, Keith, 1955–
 Video demystified: a handbook for the digital engineer / by Keith Jack.
 p. cm.
 Includes bibliographical references and index.
 ISBN 1-878707-09-4: $29.95
 1. Digital television. 2. Microcomputers. 3. Video recordings–Data processing. I. Title.
TK6678.J33 1993
621.388–dc20 93.14705
 CIP

Printed in the United States of America
10 9 8 7 6 5 4

Cover design: Brian McMurdo, Ventana Studio, Valley Center, CA
Cover photograph: Kevin Halle Photography
Developmental editing: Carol Lewis, HighText Publications
Production services: Lynn Edwards, Bookmark, San Diego, CA

ISBN: 1-878707-09-4
Library of Congress catalog number: 93-14705

HighText is a trademark of HighText Publications, Inc.

125 N. Acacia Ave., Suite 110
Solana Beach, CA 92075

Foreword

Video on computers is a hot topic. Articles about multimedia, video compression, digital high-definition television, and related subjects are rampant in the technical literature. Multimedia in particular seems to have captured everyone's imagination, and inclusion of video is perhaps the most important piece of the multimedia puzzle.

However, until quite recently, video and computers had very little to do with each other. They were from separate worlds—digital and analog—each with its own vastly different history, standards, and problems. As anyone who has tried to incorporate video on a computer can tell you, these worlds are often at odds with one another.

The digital designer attempting to work with video would of course prefer that video look just like any other kind of computer image data. This, however, is decidedly not the case, and many digital engineers are relatively unfamiliar with broadcast and recording standards. It is often difficult to find published material on the ins and outs of video signals, as our own engineers discovered when they began work several years ago on Brooktree's line of video encoder/decoder chips. They had to pull together information from scattered sources and often had difficulty locating the exact information they needed.

Clearly there is a need for better communication, and this book is Brooktree's response. Keith Jack is a Brooktree digital engineer who has delved deeper than most into the video/computer problem. He has become our own de facto video expert, and we think he has done an excellent job of assembling a vast amount of practical information for others trying to incorporate video on a computer. He covers the basics of all the major standards, including broadcasting standards (both analog and digital), data compression techniques, and solutions to many of the common problems encountered by designers. Our engineers began to use this book as a reference before it was even finished (and complained that it wasn't available a couple of years earlier)! We hope you find it just as useful.

James A. Bixby
President, CEO, Chairman of the Board
Brooktree Corporation

Acknowledgments

The development of an extensive work such as this requires a great deal of research and the cooperation and assistance of many individuals. It's impossible to list everyone who contributed, but I would like to acknowledge all those at Brooktree Corporation who provided technical assistance and advice, as well as moral support.

Contents

Chapter 6 • *NTSC/PAL Digital Decoding* *197*

Chapter 7 • *Digital Composite Video* *257*

Chapter 8 • *4:2:2 Digital Component Video* *282*

Introduction

A popular buzzword in the computer/workstation world is "convergence"—the intersection of various technologies that, until very recently, were unrelated (see Figure 1.1). Video is a key element in the convergence phenomenon. Whether you call it multimedia, "PCTV", desktop video, digital video, or some other term, one thing is for certain: we are now entering an era of digital video communications that will permeate both homes and businesses. Although technical hurdles still remain, most agree that the potential for this technology has few limits.

Implementing video on computers is not without its problems, and digital engineers working on these problems often have had little previous exposure to or knowledge of video. This book is intended as a guide for those engineers charged with the task of understanding and implementing video features into next-generation computer graphics and imaging equipment. It concentrates both on system issues, such as getting video into and out of a computer environment, and video issues, such as video standards and new processing technologies.

Emphasis is placed on the unique requirements of the computer environment. The book can be used by the system design engineers of personal computers and workstations who need or want to learn video, VLSI design engineers who want to build video products, or anyone who wants to evaluate or simply know more about such systems.

It is assumed that the reader has a working knowledge of the design of computer graphics and imaging systems; a glossary of video terms has been included for the user's reference. If you encounter an unfamiliar term, it will likely be defined in the glossary.

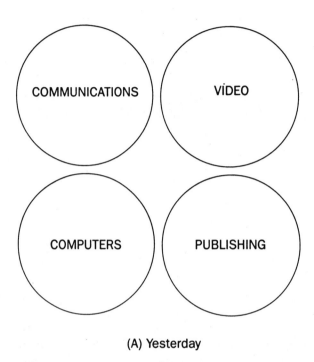

(A) Yesterday

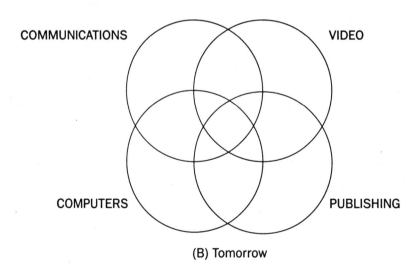

(B) Tomorrow

Figure 1.1. Technology Overlap of the Communications, Video, Computer, and Publishing Markets.

Some of the better-known applications for merging video and personal computers/workstations are listed below. At this point, everyone is still waiting for the broad-based application that will make video-in-a-computer a "must have" for users, similar to the spreadsheet and word processor.

Each of these applications requires real-time video decompression and possibly real-time compression. Some applications can use software compression and/or decompression, while others will require dedicated hardware for that function.

- *Video help windows*. Rather than the conventional text-only on-line help available from within applications, video help windows contain digitized audio and video, allowing moving images to be displayed. A user can see what to do, and see what the expected results will be, before actually committing to execute a command.

- *Video notes within a document*. Video and audio can now be transferred within a file to another user. A "video note" can be included to clarify a point or just to say "Hi!" to your co-worker.

- *Video teleconferencing*. Video teleconferencing over a computer network or telephone lines allows users to interact more personally and be able to use visual aids to make a point more clearly. This application requires that a small video camera, and probably speakers, be mounted within or near the CRT display enclosure.

- *CD-ROM and network servers*. Digitized and compressed images may be stored on CD-ROM or on a network server, and later may be retrieved by any user and modified for inclusion within a presentation or document. With compression, it is possible to play back a compressed video over the network. However, performance is dependent on the number of users and network bandwidth. It's usually acceptable to do a non–real-time download of the compressed video, and perform the decompression locally for viewing. CD-ROMs containing digital audio and video clips—similar to "clip art" files in desktop publishing—are now available. They include various forms of music and images for inclusion in presentations. Once the CD-ROM is purchased, the owner has the rights to use its contents whenever needed.

- *Video viewing*. This application allows one or more channels of television to be viewed, each with its own window. Users such as stock brokers would use this application to monitor business news while simultaneously using the computer to perform transactions and analysis. No compression or decompression is really required, just the ability to display live video in a window.

- *Video editing*. Some users need the ability to edit video on-line, essentially replacing multiple tape decks, mixers, special-effects boxes, etc. This application requires up to three video windows, depending on the level of editing sophistication, and very high video quality.

- *Video tutorials/interactive teaching*. Interactive video allows the user to learn at his or her own pace. Video tutorials allow on-line explanations, optionally in an interactive mode, of almost any topic from grammar to jet engines.

An example of the impact of merging video and computers can be seen by taking a look at the video editing environment, as shown in Figures 1.2–1.5. The analog solution, shown in Figure 1.2, has been to provide two video sources to an editing controller, which performs mixing, special effects, text overlays, etc. The output of the edit controller is stored using another video tape recorder. Note that the two video sources must be genlocked together. (Genlocking means getting the video signals to line up correctly—refer to Chapter 5 for more information on this topic.)

As personal computers and workstations develop the ability to generate video, they can be used to provide one of the video sources, as shown in Figure 1.3. Note that the video output of the computer must be able to be genlocked to the other video source. If not, a time base corrector for each video input source (which includes genlock capability) is required.

Advances in software development now allow editing and special effects to be performed within the computer, eliminating the need for a dedicated editing controller, as shown in Figure 1.4. Only one video source is required if the computer provides the other video source. If both video sources are external to the computer, they must be genlocked together.

The ideal video editing environment is shown in Figure 1.5. In this case, any external video source is individually digitized by the computer and JPEG compressed in real-time, storing the results to disk. Any number of video sources may be supported, since they are processed one at a time and need not be genlocked together. Editing is done by JPEG decompressing only the fields of each video source required for the edit, performing the processing, JPEG compressing the results, and storing it back to the disk. JPEG compression and decompression is preferable over MPEG in editing applications, since JPEG allows each field or frame to be individually accessed during the compression or decompression operation. The final result may be JPEG decompressed and output to a video tape recorder and also MPEG compressed for storage or transmission. (Note: JPEG and MPEG compression/decompression standards are covered in Chapter 10.)

As a side note, for video editing solutions to be sold into the studio market, in many cases they will also have to be able to handle digital composite video, digital component video, several analog YUV video formats, and analog Y/C video (S-video), in addition to analog composite video.

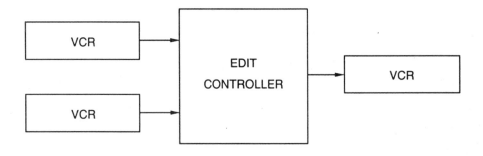

Figure 1.2. Analog Video Editing.

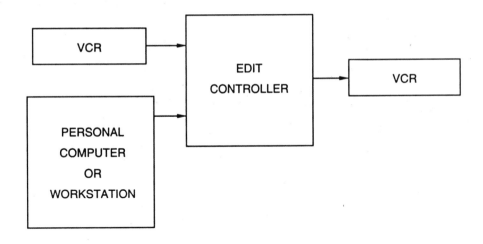

Figure 1.3. Video Editing with a Computer Providing a Video Source.

The remainder of the book is organized as follows:

Chapter 2 discusses various *architectures for incorporating video* into a computer system, along with the advantages and disadvantages of each. Also reviewed is why scaling, interlaced–noninterlaced conversion and field rate conversion are required.

Chapter 3 reviews the common *color spaces*, how they are mathematically related, and when a specific color space is used. Color spaces reviewed include RGB, YUV, YIQ, YCrCb, YDrDb, HSI, and CMYK. Considerations for converting from a non-RGB to a RGB

color space and gamma correction are discussed. A review of commercially available VLSI solutions for color space conversion is also presented.

Chapter 4 is an *overview of analog video* signals, serving as a refresher course. The NTSC, PAL and SECAM composite analog video signal formats are reviewed. In addition, SuperNTSC™ (a trademark of Faroudja Labs) and the SMPTE high-definition production standard are discussed.

Chapter 5 discusses using digital techniques for the *encoding of NTSC and PAL* color video signals. Also reviewed are various video

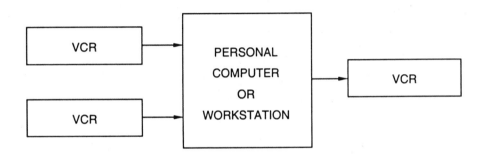

Figure 1.4. Video Editing Using the Computer.

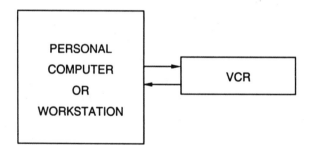

Figure 1.5. Ideal Video Editing Setup.

test signals the encoder may easily generate, timecoding, and "clean encoding" options. A review of commercially available VLSI digital encoders is also presented.

Chapter 6 discusses using digital techniques for the *decoding of NTSC and PAL* color video signals. Also reviewed are various luminance/chrominance separation techniques and their trade-offs. A review of commercially available VLSI digital decoders is also presented.

Chapter 7 reviews the background development and applications for *composite digital video*, sometimes incorrectly referred to as D2 or D3 (which are really tape formats). This chapter reviews the digital encoding and decoding process, digital filtering considerations for bandwidth-limiting the video signals, video timing, handling of ancillary data (such as digital audio), and the parallel/serial output interface and timing. It also discusses why supporting a 10-bit environment is desirable, and considerations for interfacing to a standard imaging/graphics system. A review of commercially available VLSI solutions for digital composite video is also presented.

Chapter 8 discusses *4:2:2 digital component video*, sometimes incorrectly referred to

as D1 (which is really a tape format), providing background information on how the sample rates for digitizing the analog video signals were chosen and the international efforts behind it. It also reviews the encoding and decoding process, digital filtering considerations for bandwidth-limiting the video signals, video timing, handling of ancillary data (such as digital audio, line numbering, etc.), and the parallel/serial output interface and timing. It also discusses the 4:4:4 format, and why supporting a 10-bit environment is desirable. The 4:4:4:4 (4 × 4) digital component video standard is covered. A review of commercially available VLSI solutions for digital component video is also presented.

Chapter 9 covers several *video processing* requirements such as real-time scaling, interlaced–noninterlaced conversion, field rate conversion (i.e., 72 Hz to 60 Hz) to match video rates and graphics display requirements, alpha mixing, and chroma keying.

Chapter 10 discusses *video compression and decompression*, covering topics including the JPEG and MPEG standards and video teleconferencing.

Video and the Computer Environment

In the early days of personal computers, televisions were used as the fundamental display device. It would have been relatively easy at that time to mix graphics and video within the computer. Many years later, here we are at the point (once again) of wanting to merge graphics and video. Unfortunately, however, the task is now much more difficult!

As personal computers became more sophisticated, and workstations entered the marketplace, higher resolution displays were developed. Now, 1280 × 1024 noninterlaced displays have become common, with 1600 × 1280 and higher resolutions now upon us. Refresh rates have increased up to 80 Hz noninterlaced or higher.

However, in the video world, most analog video sources use an *interlaced* display format; each frame is scanned out as two fields that are separated temporally and offset spatially in the vertical direction. Although there are some variations, NTSC (the North American and Japanese video standard in common use) color composite video signals have a refresh rate of 60 Hz interlaced (actually 59.94 Hz), while PAL and SECAM (used in Europe and elsewhere) color composite video signals have a refresh rate of 50 Hz interlaced.

Digital component video and digital composite video were developed as alternate methods of transmitting and storing video digitally to preserve as much video quality as possible. The basic video timing parameters, however, remain much the same as their analog counterparts. Recently, video and still image compression techniques have become feasible, allowing the digital storage of video and still images within the computer or on CD-ROM. Figure 2.1 illustrates one possible system-level block diagram showing many of the audio and video input and output capabilities now available to a system designer.

To incorporate video into a personal computer or workstation environment now requires several processing steps, with trade-offs on video quality, cost, and functionality. With the development of the graphical user interface (GUI), users expect video to be treated as any other source—displayed in a window that can be any size and positioned anywhere on the display. In most cases some type of video scaling is required. On the output side, any

portion of the display could be selected to be output to video, so scaling on this side is also required. Computer users want their displays to be noninterlaced to reduce fatigue due to refresh flicker, requiring interlaced-to-noninterlaced conversion (deinterlacing) on the video input side and noninterlaced-to-interlaced conversion on the video output side. The refresh rate difference between NTSC/PAL/SECAM video (50 or 60 Hz interlaced) and the computer display (60–80 Hz noninterlaced) must also be considered.

This chapter reviews some of the common architectures and problems for video input and output. (Of course, there are as many possible architectures as there are designers!)

9

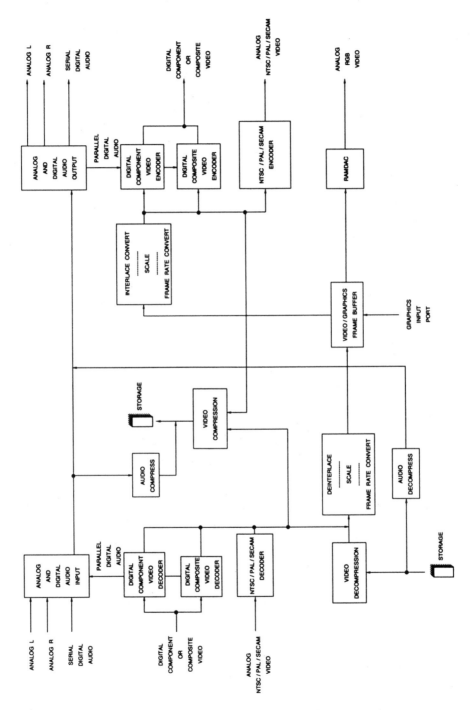

**Figure 2.1. Example of Video/Graphics Computer Architecture
Illustrating Several Possible Video Input and Output Formats.**

Displaying Real-Time Video

There are several possible ways to display live video in the computer environment, each with its own trade-offs regarding functionality, quality, and cost. The video source for each of these example architectures could be a NTSC, PAL, or SECAM decoder (decoding video from a video tape recorder, laserdisk player, or camera), a MPEG or JPEG decoder (decompressing real-time video from a CD-ROM or disk drive), a teleconferencing decoder (decompressing teleconferencing video from a network), or a digital component video or digital composite video decoder (decoding digital video from a digital tape recorder). As work progresses on video compression and decompression solutions, there will undoubtedly be other future sources for digital video.

In many consumer NTSC/PAL decoders, additional circuitry is included to sharpen the image to make it more pleasing to view. How-ever, this processing reduces video compression ratios and should not be used if the video is to be compressed. In the computer environment, the ideal place for such video-viewing-enhancement circuitry is within the RAMDAC, which drives the computer display. MPEG, JPEG, and video teleconferencing decoders currently do not include circuitry to support brightness, contrast, hue, and saturation adjustments. If each video source does not have these user adjustments supported within the RAMDAC, there is no way to compensate for nonideal video sources.

Simple Graphics/Video Overlay

An example architecture for implementing simple overlaying of graphics onto video is shown in Figure 2.2. This implementation requires that the timing of the video and computer graphics data be the same; if the incoming video signal is 50 Hz or 60 Hz interlaced,

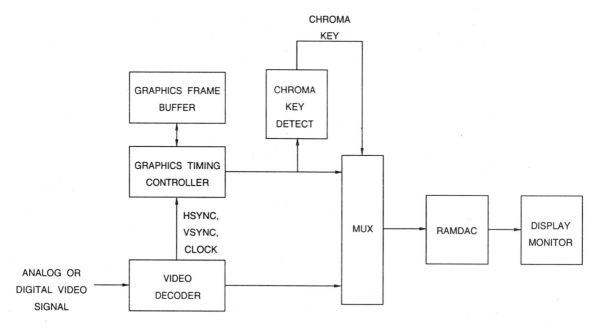

Figure 2.2. Example Architecture of Overlaying Graphics Onto Video (Digital Mixing).

the graphics controller must be able to operate at 50 Hz or 60 Hz interlaced. The display is also limited to a resolution of approximately 640 × 480 (NTSC) or 768 × 576 (PAL and SECAM); resolutions for other video formats will be different. Note that some newer computer display monitors may not support refresh rates this low. Timing synchronization may be done by recovering the video timing signals (HSYNC, VSYNC, and pixel clock) from the incoming video source, and using them to control the video timing generated by the graphics controller. Note that the graphics controller must have the ability to accept external video timing signals—many of the graphics controllers in low-end computer systems do not support this requirement.

A chroma key signal is used to switch between the video or graphics data. This signal is generated by detecting on a pixel-by-pixel basis a specific color (usually black) or pseudo-color index (usually the one for black) in the graphics frame buffer. While the specified chroma key is present, the incoming video is displayed; graphics information is displayed when the chroma key is not present. The RAMDAC processes the pixel data, performing gamma correction and generating analog RGB video signals to drive the computer display. If the computer system is using the pseudo-color pixel data format, the RAMDAC must also convert the pseudo-color indexes to 24-bit RGB digital data.

Software initially fills the graphics frame buffer with the reserved chroma key color. Subsequent writing to the frame buffer by the graphics processor or MPU changes the pixel values from the chroma key color to what was written. For pixels no longer containing the chroma key color, graphics data is now displayed, overlaid on top of the video data. This method works best with applications that allow a reserved color that will not be used by another application. A major benefit of this implementation is that no changes to the operating system are required.

Rather than reserving a color, an additional bit plane in the frame buffer may be used to generate the chroma key signal directly ("1" = display video, "0" = display graphics) on a pixel-by-pixel basis. Due to the additional bit plane, there may be software compatibility problems, which is why this is rarely done on low-end systems.

Note that the ability to adjust the gamma, brightness, contrast, hue, and saturation of the video independently of the graphics is required. Otherwise, any adjustments for video by the user will also affect the graphics.

Higher-end systems may use alpha mixing (discussed in Chapter 9) to merge the graphics and video information together. This requires the generation of an 8-bit alpha signal, either by the chroma key detection circuitry or from additional dedicated bit planes in the frame buffer. The multiplexer would be replaced with an alpha mixer, enabling soft switching between graphics and video. If the resulting mixed graphics and video signals are to be converted to NTSC/PAL/SECAM video signals, alpha mixing is very desirable for limiting the bandwidth of the resulting video signal.

A problem occurs if a pseudo-color graphics system is used. Either the true-color video data from the video decoder must be converted in real-time from true-color to pseudo-color (the color map must match that of the graphics system), or the pseudo-color graphics data must be converted to true-color before mixing with the video data, and a true-color RAMDAC used. Because of this, low-cost systems may mix the graphics and video data in the analog domain, as shown in Figure 2.3.

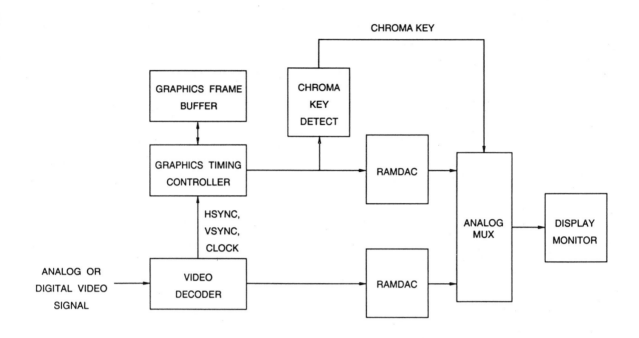

Figure 2.3. Example Architecture of Overlaying Graphics Onto Video (Analog Mixing).

Separate Graphics/Video Frame Buffers

This implementation (Figure 2.4) is more suitable to the standard computer environment, as the video is scaled to a window and displayed on a standard high-resolution monitor. The video frame buffer is typically the same size as the graphics frame buffer, and display data is output from both the video and graphics frame buffers synchronously at the same rate (i.e., 135 Mpixels per second for a 1280 × 1024 display). This architecture is suited to the current graphical user interfaces (GUI) many systems now use. Switching between the video or graphics data may be done by a chroma key or alpha signal, as discussed in the previous example, or by a window-priority encoder that defines where the video window is located on the display (video is displayed inside the window and graphics is displayed outside the window). This architecture has the advantage that the graphics and video frame buffers may be independently modified.

The video buffers must be large enough to hold the largest video window size, whether it is a small window or the entire display. If a high-resolution display is used, the user may want the option of scaling up the video to have a more reasonable size window or even to use the entire display. Note that scaling video up by more than two times is usually not desirable due to the introduction of artifacts—a result of starting with such a bandwidth-limited video signal.

As the video source is probably interlaced, and the graphics display is noninterlaced, the video source should be converted from an interlaced format (25- or 30-Hz frame rate) to a noninterlaced format (50- or 60-Hz frame rate).

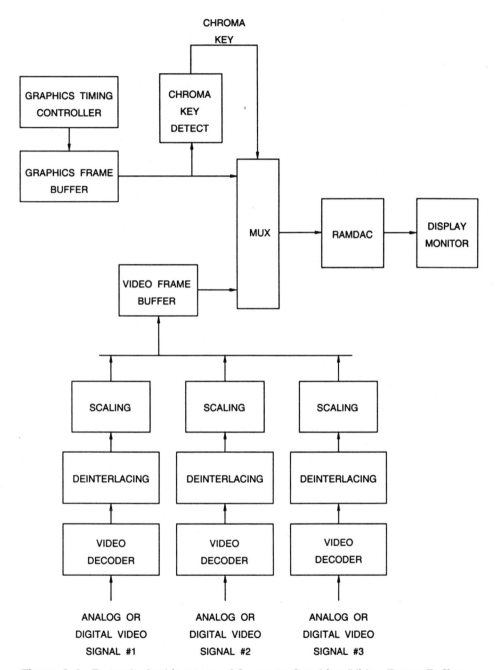

Figure 2.4. Example Architecture of Separate Graphics/Video Frame Buffers.

There are several ways of performing the deinterlacing. The designer must trade-off video quality versus cost of implementation. Today's GUI environment will also probably require scaling the video to an arbitrary-sized window; this also requires a trade-off of video quality versus cost.

The video frame buffer is usually double-buffered to implement simple frame-rate conversion and eliminate "tearing" of the video picture, since the frame rate of the video source is not synchronized to the graphics display. After deinterlacing, the video will have a frame rate of 60 Hz (NTSC) or 50 Hz (PAL and SECAM) versus the 70–80 Hz frame rate of the graphics system. Ideally, the video source would be frame-rate converted to generate a new frame rate that matches the computer display frame rate. In reality, frame-rate conversion is complex and expensive to implement, so most solutions simply store the video and redisplay the video frames at the computer display rate. The video frame must therefore be stored in a frame buffer to allow it to be displayed for multiple computer display frames.

Tearing occurs when a video picture is not from a single video frame, but rather is a portion of two separate frames. It is due to the updating of the video frame buffers not being synchronized to the graphics display. As a result, a video picture may not be from a single video frame, but rather a portion of two separate frames. Switching between the video frame buffers must be done during the display vertical retrace interval only after the video frame buffer that is to be used to drive the display has been completely updated with new video information.

Alpha mixing (discussed in Chapter 9) may be used in some high-end systems to merge the graphics and video information together. An 8-bit alpha signal is generated, either by the chroma key detection circuitry or from additional dedicated bit planes in the frame buffer. An alpha mixer replaces the multiplexer, permitting soft switching between graphics and video. If the resulting mixed graphics and video signals are to be converted to NTSC/PAL/SECAM video signals, alpha mixing is very desirable for limiting the bandwidth of the resulting video signal.

If a pseudo-color graphics system is used, the pseudo-color graphics data must be converted to true-color before mixing with the video data, and a true-color RAMDAC used. Alternately, the true-color video data may be converted in real-time from true-color to pseudo-color (the color map must match that of the graphics system), although this is rarely done since it is difficult to do and affects the video color quality.

Two problems with this architecture are the cost of additional memory to implement the video frame buffer and the increase in bandwidth into the video frame buffer required when more than one video source is used. Table 2.1 illustrates some bandwidth requirements of various video sources. Due to the overhead of accessing the video frame buffer memory (such as the possible requirement of read–modify–write accesses rather than simple write–only accesses) these bandwidth numbers may need to be increased by 1.5 times to 2 times in a real system. Additional bandwidth is required if the video source is scaled up; scaling the video source up to the full display size may require a bandwidth into the frame buffer of up to 300–400 Mbytes per second (assuming a 1280 × 1024 display resolution). Supporting more than one or two live video windows is difficult!

An "ideal" system would support multiple video streams by performing a "graceful degradation" in capabilities. For example, if the hardware can't support the number of full-featured video windows that the user wants, the

Format	Format Resolution		Bandwidth	
	Total Resolution	**Active Resolution**	**MBytes/sec (burst)**	**MBytes/sec (continuous)**
CCIR 601 (30 Frames per Second, 4:3 Aspect Ratio)				
QCIF	214×131	176×120	1.68	1.27
CIF	429×262	352×240	6.74	5.07
full resolution	858×525	720×485	27.0	20.95
CCIR 601 (25 Frames per Second, 4:3 Aspect Ratio)				
QCIF	216×156	176×144	1.69	1.27
CIF	432×312	352×288	6.74	5.07
full resolution	864×625	720×576	27.0	20.74
Square Pixel (30 Frames per Second, 1:1 Aspect Ratio)				
QCIF	195×131	160×120	1.53	1.15
CIF	390×262	320×240	6.13	4.61
full resolution	780×525	640×480	24.55	18.43
Square Pixel (25 Frames per Second, 1:1 Aspect Ratio)				
QCIF	236×156	192×144	1.84	1.38
CIF	472×312	384×288	7.36	5.53
full resolution	944×625	768×576	29.5	22.12

Table 2.1. Bandwidths of Various Video Signals. Continuous column indicates entire frame time is used to transmit active video. 16-bit 4:2:2 YCrCb format assumed. Multiply these numbers by 1.5 if 24-bit RGB data is used.

windows could be made smaller or of reduced video quality. Note that the ability to adjust the gamma, brightness, contrast, hue, and saturation of the video independently of the graphics is required—otherwise, any adjustments for video by the user will also affect the graphics.

A variation on this architecture that solves the bandwidth problem into the video frame buffer is possible by allowing each video input source to have its own video frame buffer. This approach, however, increases memory cost in direct proportion to the number of video sources to be supported.

Single Unified Frame Buffer

This implementation (Figure 2.5) is also suitable to the standard computer environment, as

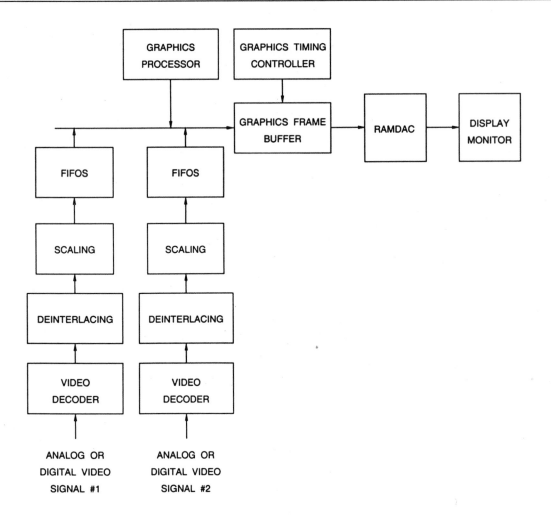

Figure 2.5. Example Architecture of a Unified Graphics/Video Frame Buffer.

the video is rendered into the graphics frame buffer. The video data is treated as any other data type that may be written into the frame buffer. Since video is usually true-color, a true-color graphics frame buffer is normally used. One advantage of this architecture is that the video is decoupled from the graphics/display subsystem. As a result, the display resolution may be changed, or multiple frame buffers and display monitors added, without affecting the video functionality. In addition, the amount of

frame-buffer memory remains constant, regardless of the number of video sources supported. A disadvantage is that once the video is mixed with another source (video or graphics), the original image is no longer available.

In this system, the decoded video source is deinterlaced and scaled as discussed in the previous example. Since access to the frame buffer is not guaranteed, FIFOs are used to temporarily store the video data until access to the frame buffer is possible. Anywhere from 16

pixels to an entire scan line of pixels are loaded into the FIFOs. When access to the frame buffer is available, the video data is read out of the FIFO at the maximum data rate the frame buffer can accept it. Note that, once written into the frame buffer, video and graphics data may not be differentiated, unless an additional bit plane is used to "tag" the video data. Each video source must have its own method of adjusting the gamma, brightness, contrast, hue, and saturation, so as not to affect the graphics data.

Bus arbitration is a major concern. Real-time video requires a high-bandwidth interface into the frame buffer, as shown in Table 2.1, while other processes also require access. A standard deinterlaced NTSC, PAL, or SECAM video source may require up to 50–100 Mbytes per second bandwidth into the frame buffer, due to bus latency or read–modify–write operations being required. Additional bandwidth is required if the video source is scaled up; scaling the video source up to the full display size may require a bandwidth into the frame buffer of up to 300–400 Mbytes per second (assuming a 1280 × 1024 display resolution). A potential problem is that the video source being displayed may occasionally become "jerky" as a result of not being able to update the frame buffer with video information, due to another process accessing the frame buffer for an extended period of time. In this instance, it is important that any audio data accompanying the video not be interrupted.

If the data in the frame buffer is also to be converted to NTSC, PAL, or SECAM video signals for recording onto a video tape recorder, the video and graphics data should be alpha-mixed (discussed in Chapter 9) to eliminate hard switching at the graphics and video boundaries. To perform alpha mixing, data must be read from the frame buffer, mixed

with the video data, and the result written back to the frame buffer. This technique can also be used to perform gradual fades and dissolves under software control.

Ideally, this system would be able to support multiple video streams by performing the "graceful degradation" discussed previously. For example, if the hardware can't support the number of video windows that the user wants, the windows could be made smaller or of reduced video quality to enable the display of the desired number of windows.

Virtual Frame Buffer

This implementation, shown in Figure 2.6, uses a large "segmented" memory. Each segment may be any size, and may contain graphics, video, or any other data type. All communications in and out of the memory occurs over a high-bandwidth bus. To display graphics and video, the graphics and video data is read out of the memory and loaded into the RAMDAC, where alpha mixing may also be performed.

The decoded video source is deinterlaced and scaled as previously discussed. Since access to the memory is not guaranteed, FIFOs are again used to store the video data until access to the memory is possible. When memory access is available, the video data is read out of the FIFO at the maximum data rate possible. Note that, once written into the memory, there *is* still a way of differentiating video and graphics data, since each has its own memory allocation. Alternately, as shown in Figure 2.7, the deinterlacing and scaling of video sources could occur at the front-end of the RAMDAC, with interlaced, full-resolution video stored in the memory. This has the advantage of substantially reducing the bus bandwidth requirements.

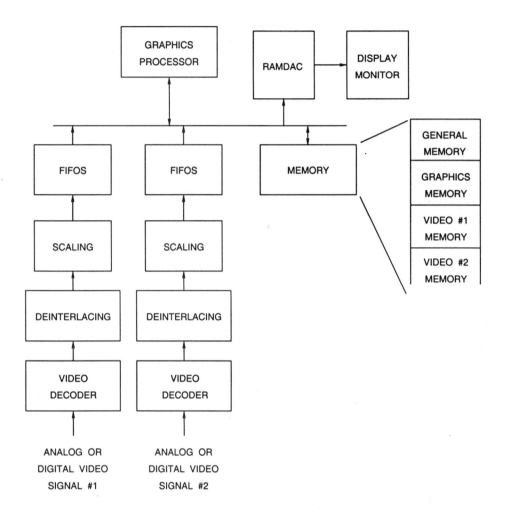

Figure 2.6. Example Architecture of a Virtual Graphics/Video Frame Buffer.

Again, if the data in the memory is to also be converted to NTSC, PAL, or SECAM video signals for recording onto a video tape recorder, the video and graphics data should be alpha-mixed at the encoder to eliminate hard switching at the graphics and video boundaries.

The major limitation to this approach is the bus bandwidth required to handle all of the sources. For a 1280 × 1024 display, just the RAMDAC requires a bus bandwidth of up to 400 MBytes per second for the true-color graphics and up to 30 Mbytes per second for each video window (assuming scaling of the video is done at the RAMDAC). Each video input source also requires up to 30 Mbytes per second to store the video (again assuming scaling of the video is done at the RAMDAC). Don't forget the bandwidth required for drawing graphics information into the memory!

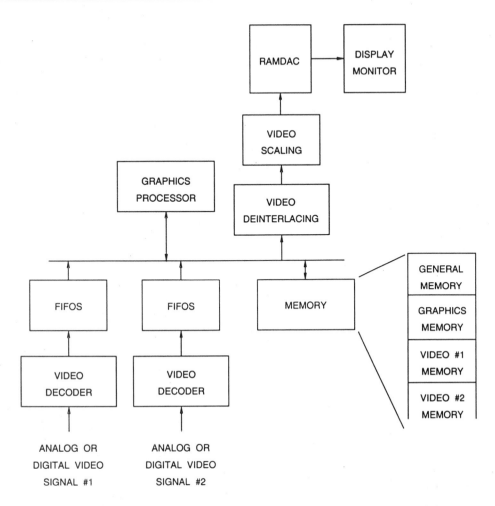

Figure 2.7. Alternate Example Architecture of a Virtual Graphics/Video Frame Buffer.

Fast Pixel Bus

This implementation, shown in Figure 2.8, uses a high-bandwidth bus to transfer graphics and video data to the RAMDAC. Separate graphics and video frame buffers are maintained, and all scaling, interlace conversion, and mixing is done within the RAMDAC.

The decoded video source may be deinterlaced and scaled before being transferred to the RAMDAC. However, doing the deinterlac-ing and scaling within the RAMDAC allows additional processing. These processing functions may include determining which overlays (if any) are associated with the video and optionally disabling the cursor from being encoded into the NTSC, PAL, or SECAM video signal. A constant bandwidth for a video source is also maintained if the processing is done within the RAMDAC, rather than having the bandwidth be dependent on the scaling factors involved.

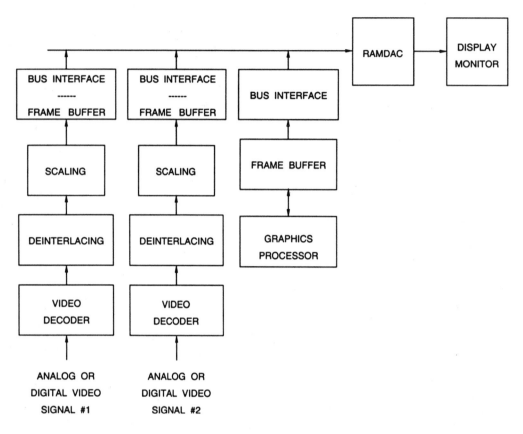

Figure 2.8. Example Architecture of a Graphics/Video System Using a Fast Pixel Bus.

The major limitation to this approach is the bus bandwidth required to handle all of the sources. For a 1280 × 1024 display, the RAMDAC requires a bus bandwidth of up to 400 Mbytes per second for the true-color graphics and up to 30 Mbytes per second for each video window (assuming video scaling is done at the RAMDAC). However, with this ap-proach, no bandwidth is required to store the video signals (since each input source has its own frame buffer), and the graphics processor uses its own dedicated port to the graphics frame buffer.

Generating Real-Time Video

Several possible implementations exist for generating "non-RGB" video in the computer environment, each with its own functionality, quality, and cost trade-offs. The video signals generated can be NTSC, PAL, or SECAM (for recording video onto a video tape recorder), a teleconferencing encoder (compressing teleconferencing video for transmission over a network), or a digital component video or digital composite video encoder (for recording digital video onto a digital tape recorder). The discus-

sions in this chapter focus on generating analog NTSC/PAL/SECAM composite color video.

Figure 2.9 illustrates adding a video encoder to the video/graphics system shown in Figure 2.2. This example assumes that the graphics timing controller and display are operating in an interlaced mode, with a display resolution of 640 × 480 (for generating NTSC video) or 768 × 576 (for generating PAL or SECAM video). Since the refresh rates and resolutions are what the video encoder requires, no scaling, interlace conversion (converting from noninterlaced to interlaced), or frame rate conversion is required. Some newer computer display monitors may not support refresh rates this low and, even if they do, the flicker of white and highly saturated colors is worsened by the lack of movement in areas containing computer graphics information.

Figure 2.10 and Figure 2.11 illustrate adding a video encoder to the video/graphics system shown in Figure 2.4 and Figure 2.5, respectively. Display resolutions may range from 640 × 480 to 1280 × 1024 or higher. If the computer display resolution is higher than the video resolution, the video data may be scaled down to the proper resolution or only a portion of the entire display screen may be output to the video encoder. Scaling should be done on noninterlaced data if possible to minimize artifacts.

Since computer display resolutions of 640 × 480 or higher are usually noninterlaced, conversion to interlaced data after scaling must typically be performed. Some newer computer

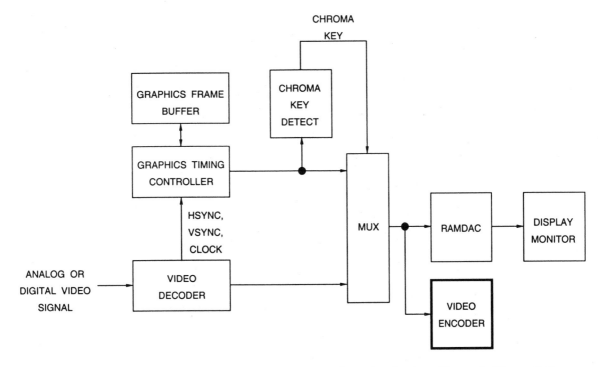

Figure 2.9. Adding a Video Encoder to the Video/Graphics System Shown in Figure 2.2.

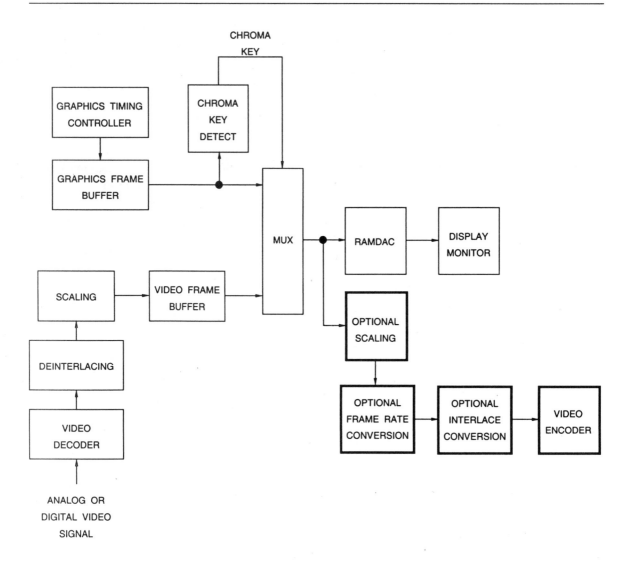

Figure 2.10. Adding a Video Encoder to the Video/Graphics System Shown in Figure 2.4.

display monitors may not support the low refresh rates used by interlaced video, and if they do, the flicker of white and highly saturated colors is worsened by the lack of movement in areas containing computer graphics information.

Computer display refresh rates higher than 50 or 60 Hz (i.e, 72 Hz) also require some type of frame-rate conversion to 50 or 60 Hz interlaced. Frame-rate conversion may be eliminated by using shadow video and graphics frame buffers. Containing the same information as the primary video and graphics frame buffers, these duplicate buffers employ a separate timing controller that allows data to be output at 60 Hz (NTSC) or

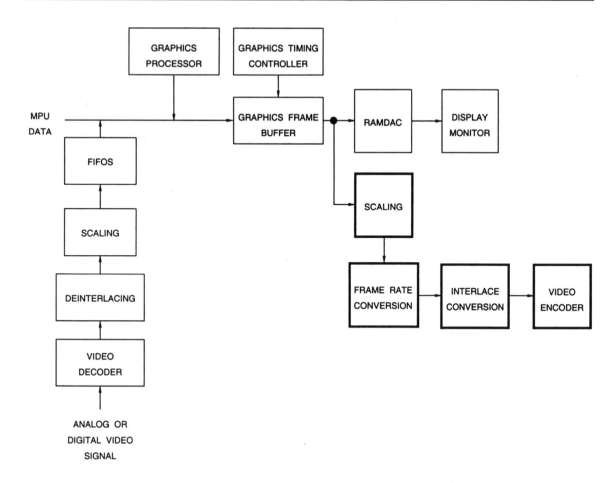

Figure 2.11. Adding a Video Encoder to the Video/Graphics System Shown in Figure 2.5.

50 Hz (PAL and SECAM), either interlaced or noninterlaced. Interlaced operation would eliminate the noninterlaced to interlaced conversion, but consideration of the graphics information is required (for example, no one-pixel-wide lines or small fonts) for acceptable video quality. Alternately, using triple-port frame buffers (allowing support of two independent serial output streams) will also eliminate frame-rate conversion. One serial output port drives the RAMDAC at the display refresh rate, and the other serial output port

drives the optional scaling and video encoder circuitry at the appropriate NTSC or PAL/SECAM refresh rates.

A problem arises if the RAMDAC incorporates various types of color processing, such as supporting multiple pixel formats on a pixel-by-pixel basis. For example, the RAMDAC may have the ability to input 8-bit pseudo-color, 16-bit RGB, or 24-bit RGB data on a pixel basis, or provide overlay support for cursors and menus. Either the circuitry performing the color processing inside the RAMDAC must be

duplicated somewhere in the video encoder path or the RAMDAC must output a digital RGB version of its analog outputs to drive the video encoder path.

Color Space Issues

Most personal computers and workstations use the RGB color space (either 15-, 16-, or 24-bit RGB) or 8-bit pseudo-color. Although newer video encoders and decoders support both RGB and YCrCb as color space options, the video processing required (such as interlace conversion and scaling) is usually much more efficient using the YCrCb color space. As some video quality is lost with each color space conversion (for example, converting from RGB to YCrCb), care should be taken to minimize the number of color space conversions used in the video encoding and decoding paths.

For example, along the video encoding path, the RGB data from the frame buffer should be converted to YCrCb before any scaling and interlace conversion operations (the input to the scaler should support RGB-to-YCrCb conversion). The input to the video encoder should then be configured to be the YCrCb color space.

Color spaces are discussed in detail in the next chapter. To facilitate the transfer of video data between VLSI devices that support multiple color spaces, a de facto standard has been developed, as shown in Table 2.2.

Aspect Ratio Issues

Most modern displays for personal computers and workstations use a 1:1 aspect ratio (square pixels). Most consumer video sources currently in use, including MPEG- and JPEG-compressed video sources, have a 4:3 pixel aspect ratio. Without taking these differences into account, computer-generated circles will become ellipses when processed by a video encoder. Similarly, circles as displayed on a television will appear as ellipses when displayed on the computer.

To compensate for the aspect ratio differences, newer NTSC/PAL/SECAM video encoders and decoders are able to operate at special pixel clock rates and horizontal resolutions. Square-pixel NTSC video encoders and decoders operate at 12.2727 MHz (640 active pixels per line), while square-pixel PAL and SECAM video encoders and decoders operate at 14.75 MHz (768 active pixels per line). NTSC/PAL/SECAM encoders and decoders are also available that operate at 13.5 MHz (720 active pixels per line), supporting the conventional 4:3 video aspect ratio.

When processing a video stream, it is important to know its aspect ratio. For example, if a NTSC decoder supports square pixels, and a MPEG encoder expects 4:3 pixels, scaling between the NTSC decoder and the MPEG encoder must take place. When the video is stored in memory for processing, if the aspect ratio is not what is expected, major processing errors will occur.

Audio Issues

Just as there are many issues involved in getting video into and out of a computer environment, there are just as many issues regarding the audio. As seen in Figure 2.1, some of the possible audio sources are analog audio from a microphone or video tape recorder, or digital audio from a digital component video decoder, digital composite video decoder, MPEG decoder, or digitized audio file on the disk or CD-ROM.

Just as there are many video standards, there are even more audio standards. The audio may be sampled at one of several rates (8

24-bit RGB (8, 8, 8)	16-bit RGB (5, 6, 5)	15-bit RGB (5, 5, 5)	24-bit 4:4:4 YCrCb	16-bit 4:2:2 YCrCb	12-bit 4:1:1 YCrCb
R7	–	–	Cr7	–	–
R6	–	–	Cr6	–	–
R5	–	–	Cr5	–	–
R4	–	–	Cr4	–	–
R3	–	–	Cr3	–	–
R2	–	–	Cr2	–	–
R1	–	–	Cr1	–	–
R0	–	–	Cr0	–	–
G7	R7	–	Y7	Y7	Y7
G6	R6	R7	Y6	Y6	Y6
G5	R5	R6	Y5	Y5	Y5
G4	R4	R5	Y4	Y4	Y4
G3	R3	R4	Y3	Y3	Y3
G2	G7	R3	Y2	Y2	Y2
G1	G6	G7	Y1	Y1	Y1
G0	G5	G6	Y0	Y0	Y0
B7	G4	G5	Cb7	Cb7, Cr7	Cb7, Cb5, Cb3, Cb1
B6	G3	G4	Cb6	Cb6, Cr6	Cb6, Cb4, Cb2, Cb0
B5	G2	G3	Cb5	Cb5, Cr5	Cr7, Cr5, Cr3, Cr1
B4	B7	B7	Cb4	Cb4, Cr4	Cr6, Cr4, Cr2, Cr0
B3	B6	B6	Cb3	Cb3, Cr3	–
B2	B5	B5	Cb2	Cb2, Cr2	–
B1	B4	B4	Cb1	Cb1, Cr1	–
B0	B3	B3	Cb0	Cb0, Cr0	–

Timing control signals:

standard:
horizontal sync (HSYNC*)
vertical sync (VSYNC*)
composite blank (BLANK*)

CCIR 601:
horizontal blanking (H)
vertical blanking (V)
even/odd field (F)

Table 2.2. Pixel Format Standards for Transferring Video Data in Various Color Spaces Over a 24-bit Bus.

kHz, 11.025 kHz, 22.05 kHz, 32 kHz, 44.1 kHz, or 48 kHz), be 8-bit, 12-bit, or 16-bit samples, mono or stereo, linear PCM (pulse code modulation) or ADPCM (adaptive differential pulse code modulation). Problems arise when mixing two or more digital audio signals that used different sampling rates or formats. Both audio streams must be converted to a common sample rate and format before digital mixing is done. With the CD, DAT, DCC, MD, and laserdisk machines now supporting digital audio as an option, having the ability to input and output digital audio is desirable. Although the bandwidths required for audio are much smaller than those for video (Table 2.3 illustrates the audio bandwidth requirements for various sample rates and resolutions), they must be taken into account along with the video bandwidths when determining the maximum system bandwidth required.

When generating audio for recording with computer-generated video, system-dependent sounds should not be recorded with the video. Two solutions are to turn off the system audio during recording or to generate separate system audio signals that drive the internal speakers within the computer. The CD/DAT serial interface should support both the digital and optical serial audio interfaces. Audio sample rates are 44.1 kHz for CD; DAT sample rates are 32 kHz, 44.1 kHz, or 48 kHz. A generic serial audio interface enabling interfacing to MIDI sound synthesizers and DSP processors should be supported. The sample rate converters provide resampling of the digital audio to a common sample rate so digital mixing can be done.

Sample Rate	Mono or Stereo	Resolution	Bandwidth (kbytes per second per audio channel
8.0 kHz	mono	8-bit μ-law PCM	8.0
	mono	8-bit A-law PCM	8.0
	mono	4-bit ADPCM	4.0
11.025 kHz	m/s	8-bit linear PCM	11.1
	m/s	4-bit ADPCM	5.6
22.05 kHz	m/s	8-bit linear PCM	22.1
	m/s	4-bit ADPCM	11.1
44.1 kHz	m/s	16-bit linear PCM	88.2
	m/s	4-bit ADPCM	22.1
48.0 kHz	m/s	16-bit linear PCM	96.0
	m/s	4-bit ADPCM	24.0

Table 2.3. Bandwidths of Common Audio Signal Formats.

Color Spaces

A color space is a mathematical representation of a set of colors. Three fundamental color models are RGB (used in color computer graphics and color television), YIQ, YUV, or YCrCb (used in broadcast and television systems), and CMYK (used in color printing). However, none of these color spaces are directly related to the intuitive notions of hue, saturation, and brightness. This has resulted in the development of other models, such as HSI and HSV, to simplify programming, processing, and end-user manipulation.

All of the color spaces in common use can be derived from the RGB information supplied by devices like cameras and scanners.

RGB Color Space

The red, green, and blue (RGB) color space is widely used throughout computer graphics and imaging. Red, green and blue are three primary additive colors (individual components are added together to form a desired color) and are represented by a three-dimensional, Cartesian coordinate system (Figure 3.1). The indicated diagonal of the cube, with equal amounts of each primary component, represents various gray levels. Table 3.1 contains the RGB values for 75% amplitude, 100% saturated color bars, the most commonly used test signal.

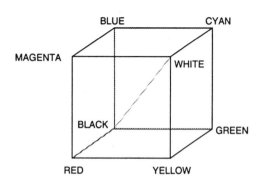

Figure 3.1. The RGB Color Cube.

	Nominal Range	White	Yellow	Cyan	Green	Magenta	Red	Blue	Black
R	0 to 255	191	191	0	0	191	191	0	0
G	0 to 255	191	191	191	191	0	0	0	0
B	0 to 255	191	0	191	0	191	0	191	0

Table 3.1. 75% Amplitude, 100% Saturated RGB Color Bars.

The RGB color space is the most prevalent choice for graphics frame buffers because color CRTs use red, green, and blue phosphors to create the desired color. Therefore, the choice of the RGB color space for a graphics frame buffer simplifies the architecture and design of the system. Also, a system that is designed using the RGB color space can take advantage of a large number of existing software routines, since this color space has been around for a number of years.

However, RGB is not very efficient when dealing with "real-world" images. All three RGB components need to be of equal bandwidth to generate any color within the RGB color cube. The result of this is a frame buffer that has the same pixel depth and display resolution for each RGB component. Also, processing an image in the RGB color space is not the most efficient method. For example, to modify the intensity or color of a given pixel, the three RGB values must be read from the frame buffer, the intensity or color calculated, the desired modifications performed, the new RGB values calculated and written back to the frame buffer. If the system had access to an image stored directly in the intensity and color format, some processing steps would be faster. For these and other reasons, many broadcast, video, and imaging standards use luminance and color difference video signals. These may exist as YUV, YIQ, YDrDb, or YCrCb color spaces. Although all are related, there are some differences.

YUV Color Space

The YUV color space is the basic color space used by the PAL (Phase Alternation Line), NTSC (National Television System Committee), and SECAM (Sequentiel Couleur Avec Mémoire or Sequential Color with Memory) composite color video standards. The black-and-white system used only intensity (Y) information; color information (U and V) was added in a such a way that a black-and-white receiver would still display a normal black-and-white picture. Color receivers decoded the additional color information to display a color picture.

The basic equations to convert between gamma-corrected RGB and YUV are:

$$Y = 0.299R' + 0.587G' + 0.114B'$$

$$U = -0.147R' - 0.289G' + 0.436B'$$
$$= 0.492 \,(B' - Y)$$

$$V = 0.615R' - 0.515G' - 0.100B'$$
$$= 0.877 \,(R' - Y)$$

R′ = Y + 1.140V

G′ = Y − 0.395U − 0.581V

B′ = Y + 2.032U

(The prime symbol indicates gamma-corrected RGB.)

In an 8-bit digital system, for RGB values with a range of 0 to 255, Y has a range of 0 to 255, U a range of 0 to ±112, and V a range of 0 to ±157. These equations are usually scaled to simplify the implementation in an actual NTSC or PAL digital encoder or decoder.

If the full range of (B′ − Y) and (R′ − Y) had been used, the modulated chrominance levels would have exceeded what the (then current) black-and-white television transmitters and receivers were capable of supporting. Experimentation determined that modulated subcarrier excursions of 33% of the luminance (Y) signal excursion could be permitted above white and below black. The scaling factors were then selected so that the maximum level of 75% amplitude, 100% saturation yellow and cyan color bars would be at the white level (100 IRE).

YIQ Color Space

The YIQ color space is derived from the YUV color space and is optionally used by the NTSC composite color video standard. (The "I" stands for "in-phase" and the "Q" for "quadrature," which are the modulation methods used to transmit the color information.) The basic equations to convert between gamma-corrected RGB and YIQ are:

Y = 0.299R′ + 0.587G′ + 0.114B′

$$I = 0.596R′ − 0.275G′ − 0.321B′$$
$$= V\cos 33° − U\sin 33°$$
$$= 0.736(R′ − Y) − 0.268(B′ − Y)$$

$$Q = 0.212R′ − 0.523G′ + 0.311B′$$
$$= V\sin 33° + U\cos 33°$$
$$= 0.478(R′ − Y) + 0.413(B′ − Y)$$

or, using matrix notation:

$$\begin{bmatrix} I \\ Q \end{bmatrix} = \begin{bmatrix} 0 & 1 \\ 1 & 0 \end{bmatrix} \begin{bmatrix} \cos(33) & \sin(33) \\ -\sin(33) & \cos(33) \end{bmatrix} \begin{bmatrix} U \\ V \end{bmatrix}$$

R′ = Y + 0.956I + 0.620Q

G′ = Y − 0.272I − 0.647Q

B′ = Y − 1.108I + 1.705Q

In an 8-bit digital system, for RGB values with an 8-bit range of 0 to 255, Y has a range of 0 to 255, I has a range of 0 to ±152, and Q has a range of 0 to ±134. I and Q are obtained by rotating the U and V axes 33°. These equations are usually scaled to simplify the implementation in an actual NTSC digital encoder or decoder.

YDrDb Color Space

The YDrDb color space is used by the SECAM composite color video standard. The black-and-white system used only intensity (Y) information; color information (Dr and Db) was added in a such a way that a black-and-white receiver would still display a normal black-and-white picture; color receivers decode the additional color information to display a color picture.

The basic equations to convert between gamma-corrected RGB and YDrDb are:

Y = 0.299R′ + 0.587G′ + 0.114B′

$$Db = 1.505(B′ − Y)$$
$$= −0.450R′ − 0.883G′ + 1.333B′$$

$$Dr = −1.902(R′ − Y)$$
$$= −1.333R′ + 1.116G′ + 0.217B′$$

$R' = Y - 0.526Dr$
$G' = Y - 0.129Db + 0.268Dr$
$B' = Y + 0.665Db$

In an 8-bit digital system, for RGB values with a range of 0 to 255, Y has a range of 0 to 255, and Dr and Db have a range of 0 to ± 340. These equations are usually scaled to simplify the implementation in an actual SECAM digital encoder or decoder.

YCrCb Color Space

The YCrCb color space was developed as part of Recommendation CCIR601 during the development of a world-wide digital component video standard (discussed in Chapter 8). YCrCb are scaled and offset versions of the YUV color space. Y is defined to have a nominal range of 16 to 235; Cr and Cb are defined to have a range of 16 to 240, with 128 equal to zero. There are several YCrCb sampling formats, such as 4:4:4, 4:2:2, and 4:1:1, which are also described.

The equations to convert between digital gamma-corrected RGB signals with a 16 to 235 nominal range and YCrCb are:

$Y = (77/256)R' + (150/256)G' + (29/256)B'$

$Cr = (131/256)R' - (110/256)G' - (21/256)B' + 128$

$Cb = -(44/256)R' - (87/256)G' + (131/256)B' + 128$

$R' = Y + 1.366(Cr - 128) - 0.002(Cb - 128)$

$G' = Y - 0.700(Cr - 128) - 0.334(Cb - 128)$

$B' = Y - 0.006(Cr - 128) + 1.732(Cb - 128)$

When performing YCrCb to RGB conversion, the resulting gamma-corrected RGB values have a nominal range of 16–235, with possible occasional excursions into the 0–15 and 236–255 values. This is due to Y and CrCb occasionally going outside the 16–235 and 16–240 ranges, respectively, due to video processing. Table 3.2 lists the YCrCb values for 75% amplitude, 100% saturated color bars.

Graphics Systems Considerations

If the gamma-corrected RGB data has a range of 0 to 255, as is commonly found in computer systems, the following equations may be more convenient to use:

	Nominal Range	White	Yellow	Cyan	Green	Magenta	Red	Blue	Black
Y	16 to 235	180	162	131	112	84	65	35	16
Cr	16 to 240 (128 = zero)	128	142	44	58	198	212	114	128
Cb	16 to 240 (128 = zero)	128	44	156	72	184	100	212	128

Table 3.2. 75% Amplitude, 100% Saturated YCrCb Color Bars.

$Y = 0.257R' + 0.504G' + 0.098B' + 16$

$Cr = 0.439R' - 0.368G' - 0.071B' + 128$

$Cb = -0.148R' - 0.291G' + 0.439B' + 128$

$R' = 1.164(Y - 16) + 1.596(Cr - 128)$

$G' = 1.164(Y - 16) - 0.813(Cr - 128) - 0.391(Cb - 128)$

$B' = 1.164(Y - 16) + 2.018(Cb - 128)$

Note that for the YCrCb-to-RGB equations, the RGB values must be saturated at the 0 and 255 levels due to occasional excursions outside the nominal YCrCb ranges.

4:4:4 YCrCb Format

Figure 3.2 illustrates the positioning of YCrCb samples or pixels for the 4:4:4 format. Essentially, each pixel has a Y, a Cr, and a Cb value. Each value is typically 8 bits (computer graphics and consumer video applications) or 10 bits (high-end video applications). Each sample or pixel therefore requires 24 bits (or 30 bits for high-end video applications).

4:2:2 YCrCb Format

Figure 3.3 illustrates the positioning of YCrCb samples or pixels for the 4:2:2 format. Essentially, for every two Y samples, there is one Cr and Cb value. Each value is typically 8 bits (computer graphics and consumer video applications) or 10 bits (high-end video applications). In a frame buffer, each pixel requires 16 bits (or 20 bits for high-end video applications), formatted as shown in Figure 3.4. During display, pixels with no Cr and Cb data interpolate new Cr and Cb data from the previous and next pixels that do.

4:1:1 YCrCb Format

There are two implementations for the 4:1:1 YCrCb format. The orthogonal approach (Figure 3.5) was used in early consumer video applications, and has been almost entirely replaced by the 4:2:2 format. Essentially, for every four Y samples, there is one Cr and Cb value. Each value is typically 6–8 bits. In a

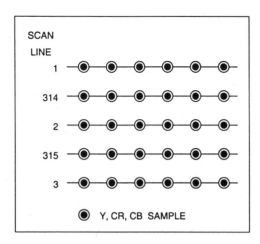

Figure 3.2. 4:4:4 Orthogonal Sampling. The position of sampling sites on the scan lines of an interlaced system.

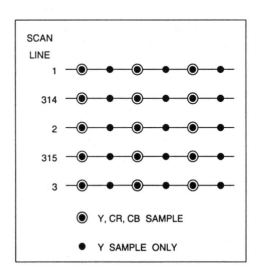

Figure 3.3. 4:2:2 Orthogonal Sampling. The position of sampling sites on the scan lines of an interlaced system.

PIXEL 0	PIXEL 1	PIXEL 2	PIXEL 3	PIXEL 4	PIXEL 5
Y7 - 0	Y7 - 1	Y7 - 2	Y7 - 3	Y7 - 4	Y7 - 5
Y6 - 0	Y6 - 1	Y6 - 2	Y6 - 3	Y6 - 4	Y6 - 5
Y5 - 0	Y5 - 1	Y5 - 2	Y5 - 3	Y5 - 4	Y5 - 5
Y4 - 0	Y4 - 1	Y4 - 2	Y4 - 3	Y4 - 4	Y4 - 5
Y3 - 0	Y3 - 1	Y3 - 2	Y3 - 3	Y3 - 4	Y3 - 5
Y2 - 0	Y2 - 1	Y2 - 2	Y2 - 3	Y2 - 4	Y2 - 5
Y1 - 0	Y1 - 1	Y1 - 2	Y1 - 3	Y1 - 4	Y1 - 5
Y0 - 0	Y0 - 1	Y0 - 2	Y0 - 3	Y0 - 4	Y0 - 5
CB7 - 0	CR7 - 0	CB7 - 2	CR7 - 2	CB7 - 4	CR7 - 4
CB6 - 0	CR6 - 0	CB6 - 2	CR6 - 2	CB6 - 4	CR6 - 4
CB5 - 0	CR5 - 0	CB5 - 2	CR5 - 2	CB5 - 4	CR5 - 4
CB4 - 0	CR4 - 0	CB4 - 2	CR4 - 2	CB4 - 4	CR4 - 4
CB3 - 0	CR3 - 0	CB3 - 2	CR3 - 2	CB3 - 4	CR3 - 4
CB2 - 0	CR2 - 0	CB2 - 2	CR2 - 2	CB2 - 4	CR2 - 4
CB1 - 0	CR1 - 0	CB1 - 2	CR1 - 2	CB1 - 4	CR1 - 4
CB0 - 0	CR0 - 0	CB0 - 2	CR0 - 2	CB0 - 4	CR0 - 4

16 BITS PER PIXEL

- 0 = PIXEL 0 DATA
- 1 = PIXEL 1 DATA
- 2 = PIXEL 2 DATA
- 3 = PIXEL 3 DATA
- 4 = PIXEL 4 DATA

Figure 3.4. 4:2:2 Frame Buffer Formatting.

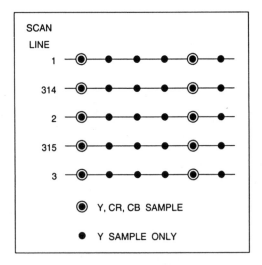

**Figure 3.5. 4:1:1 Orthogonal Sampling.
The position of sampling sites on the
scan lines of an interlaced system.**

frame buffer, each pixel requires up to 12 bits, formatted as shown in Figure 3.6. During display, pixels with no Cr and Cb data interpolate new Cr and Cb data from the previous and next pixels that do.

The video compression standards (such as H.261 and MPEG) use a slightly different 4:1:1 implementation, as shown in Figure 3.7. Although the Y samples conform to standard 4:1:1 sampling, the Cr and Cb samples are offset.

PhotoYCC Color Space

PhotoYCC (a trademark of Eastman Kodak Company) was developed by Kodak to encode Photo CD image data. The goal was to develop a display-device-independent color space. For maximum video display efficiency, the color space is based upon CCIR Recommendations 601 and 709.

The encoding process (RGB to PhotoYCC) assumes the illumination is CIE Standard Illuminant D_{65} and that the spectral sensitivities of the image capture system are proportional to the color-matching functions of the CCIR 709 reference primaries. The RGB values, unlike those for a computer graphics system, may be negative. The color gamut of PhotoYCC includes colors outside the CCIR 709 display phosphor limits.

RGB to PhotoYCC

Linear RGB data (normalized to have values of 0 to 1) is nonlinearly transformed to PhotoYCC as follows:

PIXEL 0	PIXEL 1	PIXEL 2	PIXEL 3	PIXEL 4	PIXEL 5	
Y7 - 0	Y7 - 1	Y7 - 2	Y7 - 3	Y7 - 4	Y7 - 5	
Y6 - 0	Y6 - 1	Y6 - 2	Y6 - 3	Y6 - 4	Y6 - 5	
Y5 - 0	Y5 - 1	Y5 - 2	Y5 - 3	Y5 - 4	Y5 - 5	
Y4 - 0	Y4 - 1	Y4 - 2	Y4 - 3	Y4 - 4	Y4 - 5	
Y3 - 0	Y3 - 1	Y3 - 2	Y3 - 3	Y3 - 4	Y3 - 5	
Y2 - 0	Y2 - 1	Y2 - 2	Y2 - 3	Y2 - 4	Y2 - 5	12 BITS
Y1 - 0	Y1 - 1	Y1 - 2	Y1 - 3	Y1 - 4	Y1 - 5	PER
Y0 - 0	Y0 - 1	Y0 - 2	Y0 - 3	Y0 - 4	Y0 - 5	PIXEL
CB7 - 0	CB5 - 0	CB3 - 0	CB1 - 0	CB7 - 4	CB5 - 4	
CB6 - 0	CB4 - 0	CB2 - 0	CB0 - 0	CB6 - 4	CB4 - 4	
CR7 - 0	CR5 - 0	CR3 - 0	CR1 - 0	CR7 - 4	CR5 - 4	
CR6 - 0	CR4 - 0	CR2 - 0	CR0 - 0	CR6 - 4	CR4 - 4	

- 0 = PIXEL 0 DATA
- 1 = PIXEL 1 DATA
- 2 = PIXEL 2 DATA
- 3 = PIXEL 3 DATA
- 4 = PIXEL 4 DATA

Figure 3.6. 4:1:1 Orthogonal Frame Buffer Formatting.

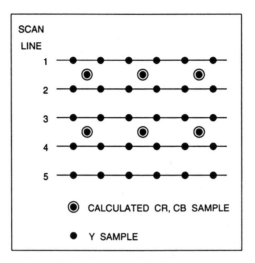

Figure 3.7. 4:1:1 Coded Picture Sampling. The position of sampling sites on the scan lines of a noninterlaced system.

for R, G, B \geq 0.018

$$R' = 1.099\ R^{0.45} - 0.099$$
$$G' = 1.099\ G^{0.45} - 0.099$$
$$B' = 1.099\ B^{0.45} - 0.099$$

for R, G, B \leq – 0.018

$$R' = -1.099\ |R|^{0.45} - 0.099$$
$$G' = -1.099\ |G|^{0.45} - 0.099$$
$$B' = -1.099\ |B|^{0.45} - 0.099$$

for – 0.018 < R, G, B < 0.018

$$R' = 4.5\ R$$
$$G' = 4.5\ G$$
$$B' = 4.5\ B$$

From R′, G′, and B′, a luminance (luma) and two chrominance signals (chroma1 and chroma2) are generated:

$$luma = 0.299R' + 0.587G' + 0.114B' = Y$$
$$chroma1 = -0.299R' - 0.587G' + 0.866B'$$
$$= B' - Y$$
$$chroma2 = 0.701R' - 0.587G' - 0.114B'$$
$$= R' - Y$$

These are quantized and limited to the 8-bit range of 0 to 255:

$$luma = (255 / 1.402)\ luma$$
$$chroma1 = (111.40\ chroma1) + 156$$
$$chroma2 = (135.64\ chroma2) + 137$$

As an example, a 20% gray value (R, G, and B = 0.2) would be recorded on the Photo CD disc using the following values:

$$luma = 79$$
$$chroma1 = 156$$
$$chroma2 = 137$$

PhotoYCC to RGB

Since PhotoYCC attempts to preserve the dynamic range of film, decoding PhotoYCC images requires the selection of a color space and range appropriate for the output device. Thus, the decoding equations are not always the exact inverse of the encoding equations. The equations presented below are suitable for

generating RGB values for driving a display, and assume a unity relationship between the luminance in the encoded image and the displayed image.

$L' = 1.3584$ (luma)
$C1 = 2.2179$ (chroma1 – 156)
$C2 = 1.8215$ (chroma2 – 137)

$R_{display} = L' + C2$
$G_{display} = L' - 0.194(C1) - 0.509(C2)$
$B_{display} = L' + C1$

The RGB values should be limited to a range of 0 to 255. The equations above assume the display uses phosphor chromaticities that are the same as the CCIR 709 reference primaries, and that the video signal luminance (V) and the display luminance (L) have the relationship:

for $0.0812 \leq V < 1.0$

$$L = ((V + 0.099) / 1.099)^{2.2}$$

for $0 \leq V < 0.0812$

$$L = V / 4.5$$

HSI, HLS, and HSV Color Spaces

The HSI (hue, saturation, intensity) and HSV (hue, saturation, value) color spaces were developed to be more "intuitive" in manipulating color and were designed to approximate the way humans perceive and interpret color. Hue describes pure color, such as pure red, pure yellow, pure blue, etc. Saturation describes to what degree a pure color is diluted with white (how deep or faded a color appears to be). Intensity or value is a color-neutral attribute that describes relative brightness (corresponding to the gray-scale version of the color). HLS (hue, lightness, saturation) is similar to HSI; the term lightness is used rather than intensity.

The difference between HSI and HSV is the computation of the brightness component (I or V), which determines the distribution and dynamic range of both the brightness (I or V) and saturation (S). The HSI color space is best for traditional image processing functions such as convolution, equalization, histograms, etc., which operate by manipulation of the brightness values since I is equally dependent on R, G, and B. The HSV color space is preferred for manipulation of hue and saturation (to shift colors or adjust the amount of color) since it yields a greater dynamic range of saturation.

Figure 3.8 illustrates the single hexcone HSV color model. The top of the hexcone corresponds to V = 1, or the maximum intensity colors. The point at the base of the hexcone is black and here V = 0. Complementary colors are 180° opposite one another as measured by H, the angle around the vertical axis (V), with red at 0°. The value of S is a ratio, ranging from 0 on the center line vertical axis (V) to 1 on the sides of the hexcone. Any value of S between 0 and 1 may be associated with the point V = 0. The point S = 0, V = 1 is white. Intermediate values of V for S = 0 are the grays. Note that when S = 0, the value of H is irrelevant. From an artist's viewpoint, any color with V = 1, S = 1 is a pure pigment (whose color is defined by H). Adding white corresponds to decreasing S (without changing V); adding black corresponds to decreasing V (without changing S). Tones are created by decreasing both S and V. Table 3.3 lists the 75% amplitude, 100% saturated HSV color bars.

Figure 3.9 illustrates the double hexcone HSI color model. The top of the hexcone corresponds to I = 1, or white. The point at the base of the hexcone is black and here I = 0. Complementary colors are 180° opposite one another as measured by H, the angle around the verti-

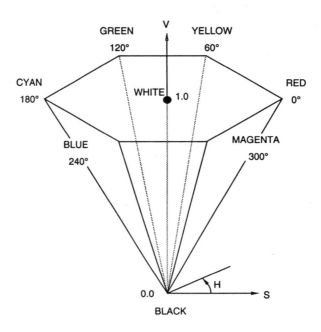

Figure 3.8. Single Hexcone HSV Color Model.

cal axis (I), with red at 0° (for consistency with the HSV model, we have changed from the Tektronix convention of blue at 0°). The value of S ranges from 0 on the vertical axis (I) to 1 on the surfaces of the hexcone. The grays all have S = 0, but maximum saturation of hues is at S = 1, I = 0.5. Table 3.4 lists the 75% amplitude, 100% saturated HSI color bars.

There are several ways of converting between HSI or HSV and RGB. Although based on the same principles, they are implemented slightly differently.

	Nominal Range	White	Yellow	Cyan	Green	Magenta	Red	Blue	Black
H	0° to 360°	x	60°	180°	120°	300°	0°	240°	x
S	0 to 1	0	1	1	1	1	1	1	0
V	0 to 1	0.75	0.75	0.75	0.75	0.75	0.75	0.75	0

Table 3.3. 75% Amplitude, 100% Saturated HSV Color Bars.

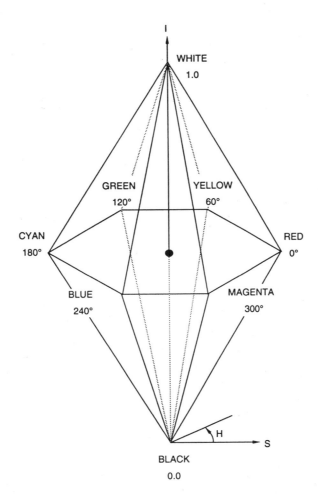

Figure 3.9. Double Hexcone HSI Color Model. For consistency with the HSV model, we have changed from the Tektronix convention of blue at 0° and depict the model as a double hexcone rather than as a double cone.

	Nominal Range	White	Yellow	Cyan	Green	Magenta	Red	Blue	Black
H	0° to 360°	x	60°	180°	120°	300°	0°	240°	x
S	0 to 1	0	1	1	1	1	1	1	0
I	0 to 1	0.75	0.375	0.375	0.375	0.375	0.375	0.375	0

Table 3.4. 75% Amplitude, 100% Saturated HSI Color Bars. For consistency with the HSV model, we have changed from the Tektronix convention of blue at 0°.

HSV-to-RGB and RGB-to-HSV Conversion

This conversion is similar to that described in the section entitled "HSI-to-RGB and RGB-to-HSI conversion."

RGB-to-HSV Conversion
Setup equations (RGB range of 0 to 1):

$M = \max (R,G,B)$
$m = \min (R,G,B)$
$r = (M - R) / (M - m)$
$g = (M - G) / (M - m)$
$b = (M - B) / (M - m)$

Value calculation (value range of 0 to 1):

$V = \max (R,G,B)$

Saturation calculation (saturation range of 0 to 1):

if $M = 0$ then $S = 0$ and $H = 180°$
if $M \neq 0$ then $S = (M - m) / M$

Hue calculation (hue range of 0 to 360):

if $R = M$ then $H = 60(b - g)$
if $G = M$ then $H = 60(2 + r - b)$
if $B = M$ then $H = 60(4 + g - r)$
if $H \geq 360$ then $H = H - 360$
if $H < 0$ then $H = H + 360$

HSV-to-RGB Conversion
Setup equations:

if $S = 0$ then $H = 180°$, $R = V$, $G = V$, and $B = V$
otherwise

if $H = 360$ then $H = 0$
$h = H / 60$
$i = $ largest integer of h
$f = h - i$
$p = V * (1 - S)$
$q = V * (1 - (S * f))$
$t = V * (1 - (S * (1 - f)))$

RGB calculations (RGB range of 0 to 1)

if $i = 0$ then $(R,G,B) = (V,t,p)$
if $i = 1$ then $(R,G,B) = (q,V,p)$
if $i = 2$ then $(R,G,B) = (p,V,t)$
if $i = 3$ then $(R,G,B) = (p,q,V)$
if $i = 4$ then $(R,G,B) = (t,p,V)$
if $i = 5$ then $(R,G,B) = (V,p,q)$

HSI-to-RGB and RGB-to-HSI Conversion (Method 1)

In this implementation, intensity is calculated as the average of the largest and smallest primary values. Saturation is the ratio between the difference and sum of the two primary values, with the difference corresponding to color content and the sum corresponding to color plus white. Two sets of equations for calculating hue are provided: one set with red at 0° (to be compatible with the HSV convention) and one set with blue at 0° (Tektronix model).

RGB-to-HSI Conversion
Setup equations (RGB range of 0 to 1):

$M = \max (R,G,B)$
$m = \min (R,G,B)$
$r = (M - R) / (M - m)$
$g = (M - G) / (M - m)$
$b = (M - B) / (M - m)$

Intensity calculation (intensity range of 0 to 1):

$I = (M + m) / 2$

Saturation calculation (saturation range of 0 to 1):

if $M = m$ then $S = 0$ and $H = 180°$
if $I \leq 0.5$ then $S = (M - m) / (M + m)$
if $I > 0.5$ then $S = (M - m) / (2 - M - m)$

Hue calculation (hue range of 0 to 360):

red = *0°*
if $R = M$ then $H = 60(b - g)$
if $G = M$ then $H = 60(2 + r - b)$

if B = M then H = 60(4 + g − r)

if H ≥ 360 then H = H − 360
if H < 0 then H = H + 360

blue = 0°
if R = M then H = 60(2 + b − g)
if G = M then H = 60(4 + r − b)
if B = M then H = 60(6 + g − r)

if H ≥ 360 then H = H − 360
if H < 0 then H = H + 360

HSI-to-RGB Conversion

Two sets of equations for calculating RGB values are provided: one set with red at 0° (to be compatible with the HSV convention) and one set with blue at 0° (Tektronix model).

Setup equations:

if I ≤ 0.5 then M = I (1 + S)
if I > 0.5 then M = I + S − IS
m = 2I − M
if S = 0 then R = G = B = I and H = 180°

Equations for calculating R (range of 0 to 1):

red = 0°
if H < 60 then R = M
if H < 120 then R = m + ((M − m) / ((120 − H) / 60))
if H < 240 then R = m
if H < 300 then R = m + ((M − m) / ((H − 240) / 60))
otherwise R = M

blue = 0°
if H < 60 then R = m + ((M − m) / (H / 60))
if H < 180 then R = M
if H < 240 then R = m + ((M − m) / ((240 − H) / 60))
otherwise R = m

Equations for calculating G (range of 0 to 1):

red = 0°
if H < 60 then G = m + ((M − m) / (H / 60))

if H < 180 then G = M
if H < 240 then G = m + ((M − m) / ((240 − H) / 60))
otherwise G = m

blue = 0°
if H < 120 then G = m
if H < 180 then G = m + ((M − m) / ((H − 120) / 60))
if H < 300 then G = M
otherwise G = m + ((M − m) / ((360 − H) / 60))

Equations for calculating B (range of 0 to 1):

red = 0°
if H < 120 then B = m
if H < 180 then B = m + ((M − m) / ((H − 120) / 60))
if H < 300 then B = M
otherwise B = m + ((M − m) / ((360 − H) / 60))

blue = 0°
if H < 60 then B = M
if H < 120 then B = m + ((M − m) / ((120 − H) / 60))
if H < 240 then B = m
if H < 300 then B = m + ((M − m) / ((H − 240) / 60))
otherwise B = M

HSI-to-RGB and RGB-to-HSI Conversion (Method 2)

This implementation is used by Data Translation in their RGB/HSI converters. Intensity is calculated as the average of R, G, and B. Saturation (S) is obtained by subtracting the lowest value of (R/I), (G/I), or (B/I) from 1. The RGB values have a normalized range of 0 to 1.

RGB-to-HSI Conversion

Setup equations

if G = B then F = 0

if $G \neq B$ then $F = ((2R - G - B) / (G - B)) /$ SQRT(3)

if $F \neq 0$ then $A = \arctan(F)$
if $F = 0$ and $R > (G$ or $B)$ then $A = +90$
otherwise $A = -90$

if $G \geq B$ then $X = 0$
if $G < B$ then $X = 180$

Intensity calculation (range of 0 to 1)

$I = (R + G + B) / 3$

Saturation calculation (range of 0 to 1):

if $I = 0$ then $S = 0$
if $I \neq 0$ then $S = 1 - (\min(R,G,B) / I)$

Hue calculation (range of 0 to 360):

$H = 90 - A + X$

HSI-to-RGB Conversion

L equals the $\min(R,G,B)$ value. M is the color 120° counterclockwise from L and N is the color 120° counterclockwise from M. The SEL_0 and SEL_1 signals are then used to map L, M, and N to R, G, and B, as shown below.

	SEL_1	SEL_0	K
0° < H ≤ 120°	0	0	$(\cos H) / (\cos(60° - H))$
120° < H ≤ 240°	0	1	$(\cos(H - 120°)) / (\cos(60° - H + 120°))$
240° < H ≤ 360°	1	1	$(\cos(H - 240°)) / (\cos(60° - H + 240°))$

	SEL_1 = 0 SEL_0 = 0	SEL_1 = 0 SEL_0 = 1	SEL_1 = 1 SEL_0 = 1
$L = I - IS$	blue	red	green
$M = I + ISK$	red	green	blue
$N = 3I - (L + M)$	green	blue	red

CMYK Color Space

The CMYK (cyan, magenta, yellow, black) color space is commonly used in color printers, due to the subtractive properties of inks. Cyan, magenta, and yellow are the complements of red, green, and blue, respectively, as shown in Figure 3.10, and are subtractive primaries because their effect is to subtract some color from white light. Color is specified by what is removed (or subtracted) from white light. When a surface is coated with cyan ink, no red light is reflected. Cyan subtracts red from the reflected white light (which is the sum of red, green, and blue). Therefore, in terms of additive primaries, cyan is blue plus green. Similarly, magenta absorbs green so it is red plus blue, while yellow absorbs blue so it is red plus green. A surface coated with cyan and yellow ink absorbs red and blue, leaving only green to be reflected from white light. A cyan, yellow, and magenta surface absorbs red, green, and blue, and there is black. To maintain black color purity, a separate black ink is used rather than printing cyan, magenta, and yellow to generate black. As an interesting side note, white cannot be generated unless a white paper is used (i.e., white cannot be generated on blue paper).

RGB-to-CMYK Considerations

Lookup tables are typically required to gamma-correct the RGB data prior to converting it to the CMY color space. Note that the gamma correction takes into account the inks and paper used and is different from the RGB gamma correction used when generating video. Some systems have additional bit planes for black data (generated by software), resulting in a 32-bit frame buffer (assuming 8 bits each for red, green, blue, and black). In this case, a lookup table for the black data is also useful.

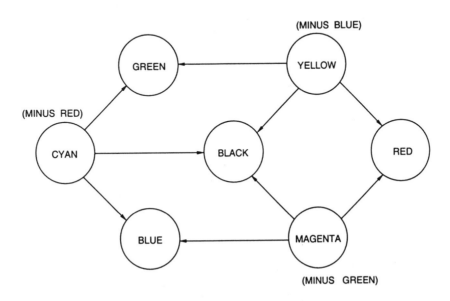

Figure 3.10. Subtractive Primaries (Cyan, Magenta, Yellow) and Their Mixtures.

Since ideally CMY is the complement of RGB, the following linear equations (known also as masking equations) were initially used to convert between RGB and CMY:

$$\begin{bmatrix} C \\ M \\ Y \end{bmatrix} = \begin{bmatrix} 1 \\ 1 \\ 1 \end{bmatrix} - \begin{bmatrix} R \\ G \\ B \end{bmatrix}$$

$$\begin{bmatrix} R \\ G \\ B \end{bmatrix} = \begin{bmatrix} 1 \\ 1 \\ 1 \end{bmatrix} - \begin{bmatrix} C \\ M \\ Y \end{bmatrix}$$

However, more accurate transformations account for the dependency of the inks and paper used. Slight adjustments, such as mixing the CMY data, are usually necessary. Yellow ink typically provides a relatively pure yellow (it absorbs most of the blue light and reflects practically all the red and green light). Magenta ink typically does a good job of absorbing green light, but absorbs too much of the blue light (visually, this makes it too reddish). The extra redness in the magenta ink may be compensated for by a reduction of yellow in areas that contain magenta. Cyan ink absorbs most of the red light (as it should) but also much of the green light (which it should reflect, making cyan more bluish than it should be). The extra blue in cyan ink may be compensated for by a reduction of magenta in areas that contain cyan. All of these simple color adjustments, as well as the linear conversion from RGB to CMY, may be done using a 3 × 3 matrix multiplication:

$$\begin{bmatrix} C \\ M \\ Y \end{bmatrix} = \begin{bmatrix} m1 & m2 & m3 \\ m4 & m5 & m6 \\ m7 & m8 & m9 \end{bmatrix} \begin{bmatrix} 1-R \\ 1-G \\ 1-B \end{bmatrix}$$

The coefficients m1, m5, and m9 are values near unity and the other coefficients are small in comparison. The RGB lookup tables may be used to perform the normalized $(1 - R)$, $(1 - G)$, and $(1 - B)$ conversion, as well as gamma correction. In cases where the inks and paper are known and relatively constant (such as a color laser printer), the coefficients may be determined empirically and fixed coefficient multipliers used. Note that saturation circuitry is required on the outputs of the 3 × 3 matrix multiplier. The circuitry must saturate to the maximum digital value (i.e., 255 in an 8-bit system) when an overflow condition occurs and saturate to the minimum digital value (i.e., 0) when an underflow condition occurs. Without the saturation circuitry, overflow or underflow errors may be generated due to the finite precision of the digital logic.

More sophisticated nonlinear RGB-to-CMY conversion techniques are used in high-end systems. These are typically based on trilinear interpolation (using lookup tables) or the Neugebauer equations (which were originally designed to perform the CMYK-to-RGB conversion).

Under Color Removal

Under color removal (UCR) removes some amount (typically 30%) of magenta under cyan and some amount (typically 50%) of yellow under magenta. This may be done to solve problems encountered due to printing an ink when one or more other layers of ink are still wet.

Black Generation

Ideally, cyan, magenta, and yellow are all that are required to generate any color. Equal amounts of cyan, magenta, and yellow should create the equivalent amount of black. In reality, printing inks do not mix perfectly, and dark brown shades are generated instead. Therefore, real black ink is substituted for the mixed-black color to obtain a truer color print.

Black generation is the process of calculating the amount of black to be used.

There are several methods of generating black information. The applications software may generate black along with CMY data. In this instance, black need not be calculated; however, UCR and gray component replacement (GCR) may still need to be performed. One common method of generating black is to set the black component equal to the minimum value of (C, M, Y). For example, if

(C, M, Y) = (0.25, 0.5, 0.75)

the black component (K) = 0.25.

In many cases, it is desirable to have a specified minimum value of (C,M,Y) before the generation of any black information. For example, K may increase (either linearly or nonlinearly) from 0 at $\min(C,M,Y) \le 0.5$ to 1 at $\min(C,M,Y) = 1$. Adjustability to handle extra black, less black, or no black is also desirable. This can be handled by a programmable lookup table.

Gray Component Replacement

Gray component replacement (GCR) is the process of reducing the amount of cyan, magenta, and yellow components to compensate for the amount of black that is added by black generation. For example, if

(C, M, Y) = (0.25, 0.5, 0.75)

and

black (K) = 0.25

0.25 (the K value) is subtracted from each of the C, M, and Y values, resulting in:

(C, M, Y) = (0, 0.25, 0.5)

black (K) = 0.25

The amount removed from C, M, and Y may be exactly the same amount as the black generation, zero (so no color is removed from the cyan, magenta, and yellow components), or some fraction of the black component. Programmable lookup tables for the cyan, magenta, and yellow colors may be used to implement a nonlinear function on the color data.

Desktop Color Publishing Considerations

Users of color desktop publishing have discovered that the printed colors rarely match what is displayed on the CRT. The reason for this is that several factors affect the color of images on the CRT, such as the level of ambient light and its color temperature, what type of phosphors the CRT uses and their age, the brightness and contrast settings of the display, and what inks and paper the color printer uses. All of these factors should be taken into account when accurate RGB-to-CMYK or CMYK-to-RGB conversion is required. Some high-end systems use an intermediate color space to simplify performing the adjustments. Very experienced users know what color will be printed vs. the displayed color; however, this is unacceptable for the mass market.

Since the CMYK printable color gamut is less than the displayable RGB color gamut, some systems use the CMYK color space in the frame buffer, and perform CMYK-to-RGB conversion to drive the display. This helps prevent the problem of trying to specify an unprintable color.

CIE 1931 Chromaticity Diagram

The color gamut perceived by a person with normal vision (the 1931 CIE Standard Observer) is shown in Figure 3.11. Color perception was measured by viewing combina-

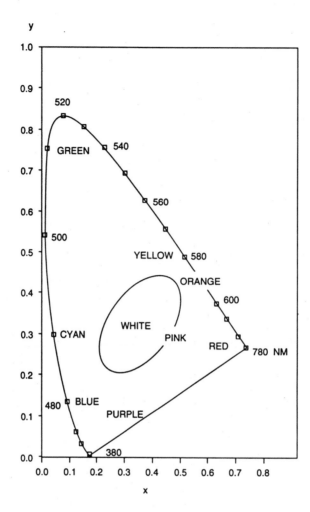

**Figure 3.11. CIE 1931 Chromaticity Diagram
Showing Various Color Regions.**

tions of the three standard CIE (International Commission on Illumination or Commission Internationale de l'Eclairage) primary colors: red with a 700-nm wavelength, green at 546.1 nm, and blue at 435.8 nm. These primary colors, and the other spectrally pure colors resulting in mixing of the primary colors, are located along the outer boundary of the diagram. Colors within the boundary are perceived as becoming more pastel as the center of the diagram (white) is approached.

Each point on the diagram, representing a unique color, may be identified by two coordinates, x and y. Typically, a camera or display specifies three of these (x, y) coordinates to define the three primary colors it uses; the triangle formed by the three (x, y) coordinates encloses the gamut of colors that the camera can capture or the display can reproduce. This is shown in Figure 3.12, which compares the color gamuts of NTSC, PAL/SECAM, and typical inks and dyes.

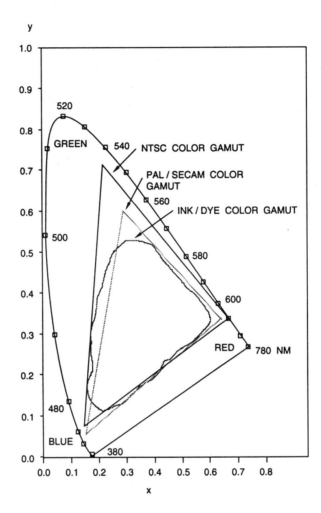

**Figure 3.12. CIE 1931 Chromaticity Diagram
Showing the Color Gamuts of Phosphors Used in
NTSC, PAL, and SECAM Systems and of Typical
Inks and Dyes.**

In addition, a camera or display usually specifies the (x, y) coordinate of the white color used, since pure white is not usually captured or reproduced. White is defined as the color captured or produced when all three primary signals are equal, and it has a subtle shade of color to it. Two of the most common whites in video applications are Illuminant C (at $x = 0.310$, and $y = 0.316$) and D_{65} (at $x = 0.313$ and y = 0.329). Note that luminance, or brightness information, is not included in the standard CIE 1931 chromaticity diagram, but is an axis that is orthogonal to the (x, y) plane. The lighter a color is, the more restricted the chromaticity range is, much like the HSI and HSV color spaces.

It is interesting to note that over the years color accuracy of television receivers has

declined while brightness has increased. Early color televisions didn't sell very well since they were dim compared to their black-and-white counterparts. Television manufacturers have changed the display phosphors from the NTSC/PAL standard colors to phosphors that produce brighter images at the expense of color accuracy. Over the years, brightness has become even more important since television is as likely to be viewed in the afternoon sun as in a darkened room.

Non-RGB Color Space Considerations

When processing information in a non-RGB color space (such as YIQ, YUV, YCrCb, etc.), care must be taken that combinations of values are not created that result in the generation of invalid RGB colors. The term invalid refers to RGB components outside specified normalized RGB limits of (1, 1, 1). For example, if the luminance (Y) component is a its maximum (white) or minimum (black) level, then any nonzero values of the color difference components (IQ, UV, CrCb, etc.) will give invalid values of RGB. As a specific example, given that RGB has a normalized value of (1, 1, 1), the resulting YCrCb value is (235, 128, 128). If Cr and Cb are manipulated to generate a YCrCb value of (235, 64, 73), the corresponding RGB normalized value becomes (0.6, 1.29, 0.56)—note that the green value exceeds the normalized value of 1. From this illustration it is obvious that there are many combinations of Y, Cr, and Cb that result in invalid RGB values; these YCrCb values must be processed so as to generate valid RGB values. Figure 3.13 shows the RGB normalized limits transformed into the YCrCb color space.

Best results are obtained using a constant luminance and constant hue approach—Y is not altered and the color difference values (Cr and Cb in this example) are limited to the maximum valid values having the same hue as the invalid color prior to limiting. The constant hue principle corresponds to moving invalid CrCb combinations directly towards the CrCb origin (128, 128), until they lie on the surface of the valid YCrCb color block.

Color Space Conversion Considerations

ROM lookup tables can be used to implement multiplication factors; however, a minimum of 4 bits of fractional color data (professional applications may require 8 to 10 bits of fractional data) should be maintained up to the final result, which is then rounded to the desired precision.

When converting to the RGB color space from a non-RGB color space, care must be taken to include saturation logic to ensure overflow and underflow conditions do not occur due to the finite precision of digital circuitry. RGB values less than 0 must be set to 0 and values greater than 255 must be set to 255 (assuming 8-bit data).

Adjusting Contrast, Brightness, and Saturation

Working in a luminance and color difference color space (such as YIQ, YUV, YCrCb, etc.) has the advantage of simplifying adjustment of contrast, brightness, and saturation. Contrast and brightness adjustment is done on the luminance (Y) component; contrast adjustment is a multiplication factor and brightness adjustment is added to the Y information. Saturation adjustment is done on the color difference components and is also a multiplication factor.

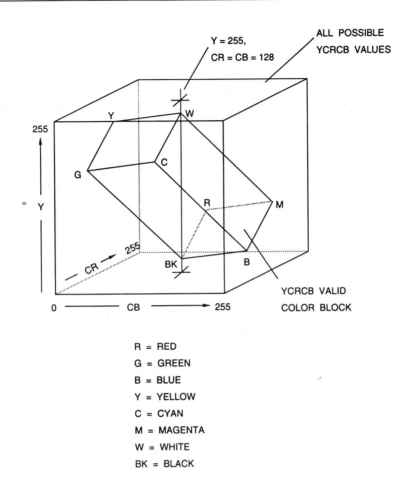

R = RED
G = GREEN
B = BLUE
Y = YELLOW
C = CYAN
M = MAGENTA
W = WHITE
BK = BLACK

Figure 3.13. RGB Limits Transformed into 3-D YCrCb Space.

Note that brightness adjustment may easily be done in the RGB color space (implemented similar to luminance). However, contrast and saturation adjustments are difficult. Figure 3.14 illustrates a typical circuit for enabling adjustment of contrast, brightness, and saturation using a luminance and color difference format.

Note that any DC offset in the luminance or color difference information must be removed before contrast or saturation adjustment is performed. For example, if Y has a DC offset (i.e., Y has a range of 16–235 rather than 0–255), the offset must be subtracted from the Y information, contrast adjustment performed, and the offset added back to the Y information. Otherwise, the result will be a black level shift due to multiplying the DC offset by the contrast adjustment. Similarly, if adjusting saturation on 8-bit Cr and Cb color difference signals, the 128 offset must be subtracted from the Cr and Cb information, saturation adjustment performed, and the 128 offset added back to the Cr and Cb information.

Also note that rounding and limiting must be performed. The rounding circuitry rounds

Figure 3.14. Typical Contrast, Brightness, and Saturation Control Circuitry.

the result to a precision more easily handled by subsequent circuitry. The limiting circuitry saturates the result to a range that may be handled by subsequent circuitry.

The "0 value" as an input to the color difference output multiplexers forces the color difference signals to the appropriate zero value when generating monochrome video. This "0 value" is dependent on the color space used

(for example, it would be 128 for 8-bit Cr and Cb signals and 0 for IQ or UV signals).

Gamma Correction

Many display devices today use the cathode-ray picture tube (CRT). The transfer function of the CRT produces luminance that is propor-

tional to some power (usually between 2 and 3 and referred to as gamma) of the signal voltage. As a result, high-intensity ranges are expanded, and low-intensity ranges are compressed (see Figure 3.15). This is an advantage in combatting noise introduced by the transmission process, as the eye is approximately equally sensitive to equally relative intensity changes. By "gamma correcting" the video signals before transmission, the intensity output of the CRT is roughly linear (the gray line in Figure 3.15), and transmission-induced noise is reduced.

Gamma factors of 2.2 (NTSC) and 2.8 (PAL and SECAM) at the display are common in the video environment. Older systems assumed a simple transformation (values are normalized to have a range of 0 to 1):

receiver gamma = 2.2
$$R_{display} = R_{received}^{2.2}$$
$$G_{display} = G_{received}^{2.2}$$
$$B_{display} = B_{received}^{2.2}$$

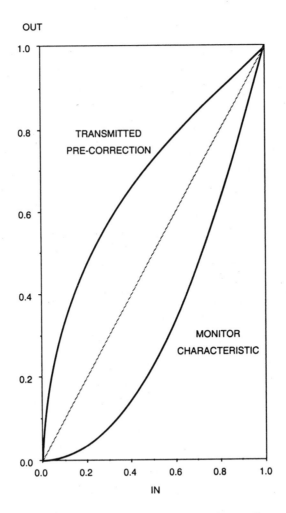

Figure 3.15. The Effect of Gamma Correction.

receiver gamma = 2.8
$$R_{display} = R_{received}^{2.8}$$
$$G_{display} = G_{received}^{2.8}$$
$$B_{display} = B_{received}^{2.8}$$

To compensate for the nonlinear processing at the display, linear RGB data was "gamma-corrected" prior to transmission (values are normalized to have a range of 0 to 1):

receiver gamma = 2.2
$$R_{transmit} = R^{0.45}$$
$$G_{transmit} = G^{0.45}$$
$$B_{transmit} = B^{0.45}$$

receiver gamma = 2.8
$$R_{display} = R^{0.36}$$
$$G_{display} = G^{0.36}$$
$$B_{display} = B^{0.36}$$

Although composite NTSC video signals typically assume the receiver has a gamma of 2.2, a gamma of 2.8 to 3.1 may be more realistic. As a result, blacks may be compressed while whites are overamplified. Thus, improvements in picture quality may be seen if the "linear" RGB outputs of an NTSC decoder are processed using a gamma correction of 0.71 to 0.78.

To minimize noise in the darker areas of the image, modern video systems limit the gain of the curve in the black region. Assuming a gamma of 2.2 and values normalized to have a range of 0 to 1, gamma correction would be applied to linear RGB data prior to transmission as follows:

for R, G, B < 0.018
$$R_{transmit} = 4.5\ R$$
$$G_{transmit} = 4.5\ G$$
$$B_{transmit} = 4.5\ B$$

for R, G, B ≥ 0.018
$$R_{transmit} = 1.099\ R^{0.45} - 0.099$$

$$G_{transmit} = 1.099\ G^{0.45} - 0.099$$
$$B_{transmit} = 1.099\ B^{0.45} - 0.099$$

This limits the gain close to black to 4.5, and stretches the remainder of the curve to place the Y intercept at –0.099 to maintain function and tangent continuity. For systems using a gamma of 2.8, the 0.45 exponent would be replaced with a value of 0.36.

The receiver is assumed to perform the inverse function (values are normalized to have a range of 0 to 1):

for $(R, G, B)_{received} < 0.0812$
$$R_{display} = R_{received} / 4.5$$
$$G_{display} = G_{received} / 4.5$$
$$B_{display} = B_{received} / 4.5$$

for $(R, G, B)_{received} \geq 0.0812$
$$R_{display} = ((R_{received} + 0.099) / 1.099)^{2.2}$$
$$G_{display} = ((G_{received} + 0.099) / 1.099)^{2.2}$$
$$B_{display} = ((B_{received} + 0.099) / 1.099)^{2.2}$$

For systems using a gamma of 2.8, the 2.2 exponent would be replaced with a value of 2.8.

Another problem is the nonadherence of the constant luminance principle, as matrixing is done with gamma-corrected RGB, rather than linear RGB, to obtain luminance. As a result, some of the luminance information is not reproduced, especially for highly saturated, full-amplitude colors.

For example, consider 100% saturated, 100% amplitude blue (R' = 0, G' = 0, B' = 1). Since

$$Y = 0.299R' + 0.587G' + 0.114B' = 0.114$$

and assuming a gamma of 2.2 at the receiver:

$$Y^{2.2} = 0.0084$$

the ratio $Y^{2.2} / Y = 0.0084 / 0.114 = 0.074$. Only about 7% of the intended luminance is reproduced by the receiver. Research is being done

to improve the reproduction of such colors by precorrecting for them in the encoder.

VLSI Solutions

Several "color space converters" are available to ease the conversion from one color space to another. Ideally, the VLSI solutions allow the designer to tailor their use to his or her system-specific requirements. This section is an overview of commercially available VLSI solutions for implementing color space conversion.

Data Translation provides two VLSI chips to implement RGB-to-HSI conversion (the DT7910) and HSI-to-RGB conversion (the DT7911). The DT7910 requires two external $1k \times 8$ registered ROM lookup tables, while the DT7911 requires one external $1k \times 8$ registered ROM lookup table. These ROMs are available from Data Translation and the part numbers are shown in Figure 3.16 (illustrating RGB-to-HSI conversion) and Figure 3.17 (illustrating HSI-to-RGB conversion). Note that the DT7911 automatically adjusts for values of S and I that would result in an illegal RGB color.

Features of the DT7910 and DT7911 include:

- 15-MHz Clock Rate
- TTL Compatible
- RGB Bypass Option
- Support for 10-bit HSI Values
- +5 V Monolithic CMOS
- 68-pin PLCC Package

The SAA7192 from Philips Semiconductors is a dedicated YCrCb-to-RGB color space converter (Figure 3.18). Input data may be 4:1:1, 4:2:2, or 4:4:4 YCrCb; 24-bit RGB data is output. Three 256×8 lookup table RAMs are available on the pixel outputs for gamma correction. Optional interpolation circuitry converts 4:1:1 or 4:2:2 YCrCb video signals to

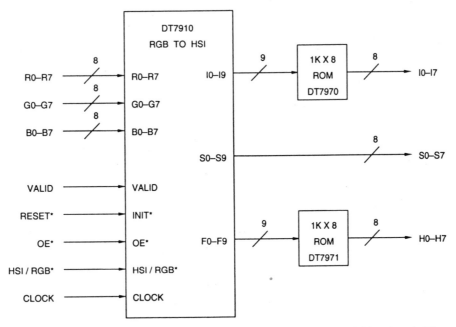

Figure 3.16. Data Translation RGB-to-HSI Conversion (8-bit HSI values). The Data Translation part numbers for the 1k × 8 registered ROMs are indicated.

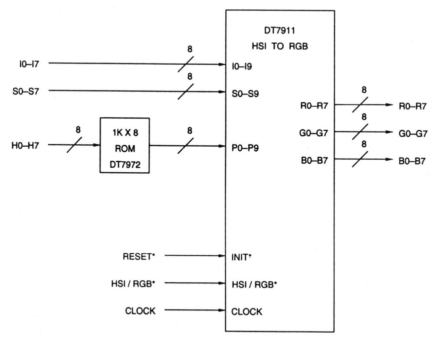

Figure 3.17. Data Translation HSI-to-RGB Conversion (8-Bit HSI Values). The Data Translation part number for the 1k × 8 registered ROM is indicated.

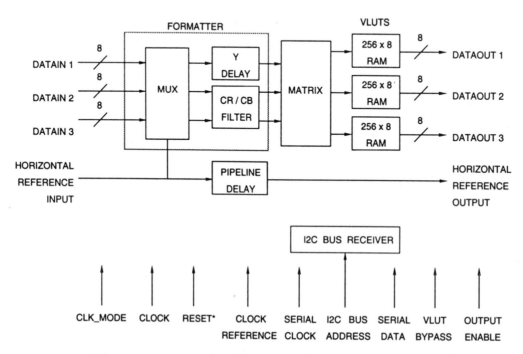

Figure 3.18. Philips Semiconductors SAA7192 Block Diagram.

4:4:4. Saturation logic prevents overflow and underflow conditions from occurring after the matrix multiplier. The matrix, lookup table RAMs, and input format circuitry may all individually bypassed.

Features of the SAA7192 include:

- 16-MHz Clock Rate
- Three 256 × 8 Output Lookup Table RAMs
- I^2C Interface Bus
- TTL Compatible
- +5 V Monolithic CMOS
- 68-pin PLCC Package

The STV3300 from SGS-Thomson is a YCrCb-to-RGB color space converter (Figure 3.19). Input data is 16-bit 4:2:2 YCrCb (clocked in at 13.5 MHz) and 24-bit RGB is generated (clocked out at 27 MHz). A 19-tap digital filter doubles the Y data rate, and includes compensation for the sin x/x attenuation of external D/A converters. The Cr and Cb digital filters oversample by a factor of 4. Two filters are implemented in series; each of them oversamples by a factor of two. The first filter stage allows four different filter selections (selected using the A0 and A1 pins). Compatibility with the MAC (Multiplexed Analog Component) standard is supported by multiplying the Cr and Cb samples by 0.75 (controlled by the MAC pin). The DLY pin enables an additional 27-MHz clock period to be inserted in the output path.

Features of the STV3300 include:

- YCrCb-to-RGB Color Space Conversion
- On-Chip Y and CrCb Oversampling Filters
- MAC Support
- TTL Compatible
- +5 V Monolithic CMOS
- 52-pin PLCC Package

The TMC2272 from Raytheon Semiconductor is a general color space converter (Figure 3.20). Three 12-bit data input ports (A0–A11, B0–B11, C0–C11) accept two's complement integer data. Nine 10-bit user-definable coefficients are input via the KA (0–9), KB (0–9), and KC (0–9) inputs. A general-purpose 3 × 3 matrix multiplier (12 × 10 bits each) is used to perform the actual color space conversion. Saturation logic prevents overflow and underflow conditions from occurring after the matrix multiplier.

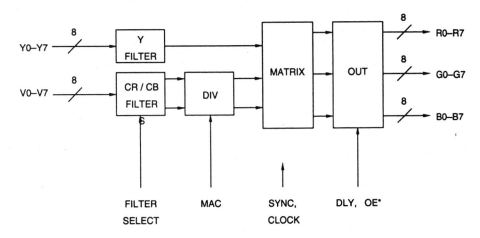

Figure 3.19. SGS-Thomson STV3300 Block Diagram.

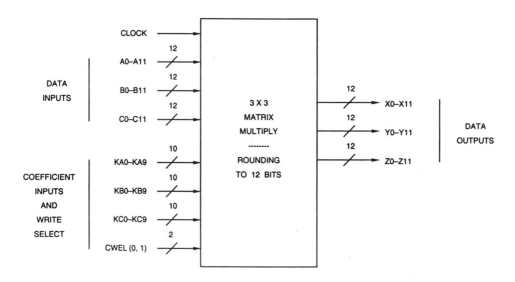

Figure 3.20. Raytheon Semiconductor TMC2272 Block Diagram.

Features of the TMC2272 include:

- 40-MHz Pipelined Clock Rate
- Two's Complement Input and Output Format
- 10-bit User-Defined Matrix Coefficients
- Output Rounding to 12 bits
- TTL Compatible
- +5 V Monolithic CMOS
- 121-pin Plastic PGA Package

References

1. Alexander, George A., *Color Reproduction: Theory and Practice, Old and New. The Seybold Report on Desktop Publishing*, Sept. 20, 1989.
2. Benson, K. Blair, *Television Engineering Handbook*. McGraw-Hill, Inc., 1986.
3. CCIR Report 624-4, 1990, *Characteristics of Television Systems*.
4. Clarke, C.K.P., 1986, *Colour Encoding and Decoding Techniques for Line-Locked Sampled PAL and NTSC Television Signals*, BBC Research Department Report BBC RD1986 / 2.
5. Data Translation, DT7910/DT7911 datasheet, 1989.
6. Devereux, V. G., 1987, *Limiting of YUV digital video signals*, BBC Research Department Report BBC RD1987 22.
7. EIA Standard EIA-189-A, July 1976, *Encoded Color Bar Signal*.
8. Faroudja, Yves Charles, *NTSC and Beyond. IEEE Transactions on Consumer Electronics*, Vol. 34, No. 1, February 1988.
9. Philips Semiconductor, *Video Data Handbook*, 1991.
10. *Specification of Television Standards for 625-Line System-I Transmissions*, 1971. Independent Television Authority (ITA) and British Broadcasting Corporation (BBC).
11. SGS-Thomson Microelectronics, STV3300 datasheet, September 1989.
12. TRW LSI Products, Inc. (now Raytheon Semiconductor), 1991 databook.

Video Overview

To fully understand the NTSC, PAL, and SECAM encoding and decoding processes, it is helpful to review the background of these standards, and how they came about. Although these are the primary consumer video standards, there are several component analog standards used in professional areas (the digital video standards are covered in Chapters 7 and 8).

Many organizations, some of which are listed below, are involved in specifying video standards, depending on the country. Their addresses are included at the end of the chapter.

CCIR	The International Radio Consultative Committee
CCITT	The International Telephone and Telegraph Consultative Committee
EBU	European Broadcasting Union
EIA	Electronic Industries Association
IEEE	Institute of Electrical and Electronics Engineers
SMPTE	Society of Motion Picture and Television Engineers

NTSC Overview

The first color television system was developed in the United States, and on December 17, 1953, the Federal Communications Commission (FCC) approved the transmission standard, with broadcasting approved to begin January 23, 1954. Most of the work for developing a color transmission standard that was compatible with the (then current) 525-line, 60-field/second, 2:1 interlaced monochrome standard was done by the National Television System Committee (NTSC).

The luminance (monochrome) signal is derived from gamma-corrected red, green, and blue signals, tailored in proportion to the standard luminosity curve for the particular values of dominant wavelength represented by the three color primaries chosen for the receiver:

$$Y \text{ (luminance)} = 0.299R' + 0.587G' + 0.114B'$$

Due to the sound subcarrier at 4.5 MHz, a requirement was made that the color signal must occupy the same bandwidth as a monochrome video signal (0–4.2 MHz). For economic reasons, another requirement was made

that monochrome receivers must be able to display the luminance (brightness) portion of a color broadcast and that color receivers must be able to display the luminance (brightness) portion of a monochrome broadcast.

Gamma correction is applied to compensate for the nonlinear voltage-to-light characteristics of the receiver, and provides the additional benefit of increasing the signal-to-noise ratio of low-level signals during transmission. NTSC systems assume a gamma of 2.2 at the receiver; in other words, the transfer function of the receiver is assumed to be (values are normalized to have a value of 0 to 1):

for R', G', $B' < 0.0812$

$$R = R'/4.5$$
$$G = G'/4.5$$
$$B = B'/4.5$$

for R', G', $B' \geq 0.0812$

$$R = ((R' + 0.099)/1.099)^{2.2}$$
$$G = ((G' + 0.099)/1.099)^{2.2}$$
$$B = ((B' + 0.099)/1.099)^{2.2}$$

To have the transfer function from the video source to the receiver display be linear, the total processing of the RGB signals before transmission should therefore be (values are normalized to have a value of 0 to 1):

for R, G, $B < 0.018$

$$R' = 4.5 R$$
$$G' = 4.5 G$$
$$B' = 4.5 B$$

for R, G, $B \geq 0.018$

$$R' = 1.099 R^{0.45} - 0.099$$
$$G' = 1.099 G^{0.45} - 0.099$$
$$B' = 1.099 B^{0.45} - 0.099$$

The eye is most sensitive to spatial and temporal variations in luminance; therefore,

luminance information was allowed the entire bandwidth available (0–4.2 MHz). Color information, to which the eye is less sensitive and which thus requires less bandwidth, is represented as hue and saturation information. This hue and saturation information is transmitted using a 3.58-MHz subcarrier, encoded so that the receiver can separate the hue, saturation, and luminance information and convert it back to RGB signals for display. Although this allows the transmission of color signals in the same bandwidth as monochrome signals, the problem still remains as to how to ideally separate the color and luminance information, since they occupy the same portion of the frequency spectrum.

To transmit hue and saturation color information, color difference signals, which specify the differences between the luminance signal and the basic RGB signals, are used:

$$R' - Y = 0.701R' - 0.587G' - 0.114B'$$
$$B' - Y = -0.299R' - 0.587G' + 0.886B'$$
$$U = 0.492(B' - Y)$$
$$V = 0.877(R' - Y)$$

Many equations for U used a 0.493 scaling factor due to an apparent error in the 1953 calculations (a 0.115 matrix coefficient was used instead of the correct 0.114).

I and Q were chosen as the color difference components since they more closely relate to the variation of color acuity than U and V. The color response of the eye decreases as the size of the viewed object decreases. Small objects, occupying frequencies of 1.3–2.0 MHz, provide little color sensation. Medium objects, occupying the 0.6–1.3 MHz frequency range, are acceptable if reproduced along the orange-cyan axis. Larger objects, occupying the 0–0.6 MHz frequency range, require full three-color reproduction. The I and Q bandwidths were chosen accordingly and the pre-

ferred color reproduction axis was obtained by rotating the R′ – Y and B′ – Y axes by 33°. The Q component, representing the green-purple color axis, was band-limited to about 0.6 MHz. The I component, representing the orange-cyan color axis, was band-limited to about 1.3 MHz.

Advances in electronics, particularly in the digital area, have prompted some changes. Both I and Q may now be bandwidth-limited to 1.3 MHz. Alternately, U and V may be used, rather than I and Q; U and V may be band-width-limited to either 0.6 MHz or 1.3 MHz, depending on the design. A greater amount of processing is required in the decoder to achieve acceptable results when both I and Q, or U and V, have a 1.3-MHz bandwidth due to both components being asymmetrical signals.

I and Q may be derived from gamma-corrected RGB, U and V, or R′ – Y and B′ – Y signals as follows:

$$I = 0.596R' - 0.275G' - 0.321B'$$
$$= V\cos 33° - U\sin 33°$$
$$= 0.736(R' - Y) - 0.268(B' - Y)$$

$$Q = 0.212R' - 0.523G' + 0.311B'$$
$$= V\sin 33° + U\cos 33°$$
$$= 0.478(R' - Y) + 0.413(B' - Y)$$

The IQ vector diagram illustrating the I and Q axes is shown in Figure 4.1.

As a side note, the scaling factors to derive U and V from (B′ – Y) and (R′ – Y) were derived due to overmodulation considerations

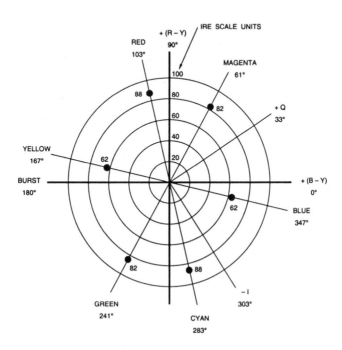

Figure 4.1. IQ Vector Diagram for 75% Amplitude, 100% Saturation EIA Color Bars.

during transmission. If the full range of (B' – Y) and (R' – Y) were to be used, the modulated chrominance levels would exceed what the (then current) black-and-white television transmitters and receivers were capable of supporting. Experimentation determined that modulated subcarrier excursions of 33% of the luminance (Y) signal excursion could be permitted above white and below black. The scaling factors were then selected so that the maximum level of 75% amplitude, 100% saturation yellow and cyan color bars would be at the white level (100 IRE).

I and Q (or U and V) are used to modulate the 3.58-MHz color subcarrier using two balanced modulators operating in phase quadrature (one modulator is driven by the subcarrier at sine phase, the other modulator is driven by the subcarrier at cosine phase). The outputs of the modulators are added together to form the composite chrominance signal:

$$C = Q \sin(\omega t + 33°) + I \cos(\omega t + 33°)$$
$$\omega = 2\pi F_{SC}$$
$$F_{SC} = 3.579545 \text{ MHz} (\pm 10 \text{ Hz})$$

or, if U and V are used instead of I and Q:

$$C = U \sin \omega t + V \cos \omega t$$

Hue information is conveyed by the chrominance phase relative to the subcarrier. Saturation information is conveyed by the ratio of the chrominance amplitude to the corresponding luminance level. In addition, if an object has no color (such as a white, gray, or black object), the subcarrier is suppressed. The modulated chrominance is added to the luminance information along with appropriate horizontal and vertical sync signals, blanking signals, and color burst signals, to generate the composite color video waveform shown in Figure 4.2.

$$\text{composite NTSC} = Y + Q \sin(\omega t + 33°)$$
$$+ I \cos(\omega t + 33°)$$

or, if U and V are used instead of I and Q:

$$\text{composite NTSC} = Y + U \sin \omega t + V \cos \omega t$$

The bandwidth of the resulting composite video signal is shown in Figure 4.3. The amplitude of the modulated chrominance is:

$$\sqrt{I^2 + Q^2}$$

or

$$\sqrt{U^2 + V^2}$$

The I and Q (or U and V) information can be transmitted without loss of identity as long as the proper subcarrier phase relationship is maintained at the encoding and decoding process. The color burst signal, consisting of nine cycles of the subcarrier frequency at a specific phase, follows each horizontal sync pulse and provides the decoder a reference signal so as to be able to properly recover the I and Q (or U and V) signals. The color burst phase is defined to be along the –(B – Y) axis as shown in Figure 4.1.

The specific choice for the color subcarrier frequency was dictated by several factors. The first is the need to provide horizontal interlace to reduce the visibility of the subcarrier, requiring that the subcarrier frequency, F_{SC}, be an odd multiple of one-half the horizontal line rate. The second factor is selection of a high enough frequency that it generates a fine interference pattern having low visibility. Third, double sidebands for I and Q (or U and V) bandwidths below 0.6 MHz must be allowed. The choice of the frequencies is:

$$F_H = (4.5 \times 10^6 / 286) \text{ Hz} = 15{,}734.27 \text{ Hz}$$

$$F_V = F_H / (525/2) = 59.94 \text{ Hz}$$

$$F_{SC} = ((13 \times 7 \times 5)/2) \times F_H = (455/2) \times F_H$$
$$= 3.579545 \text{ MHz}$$

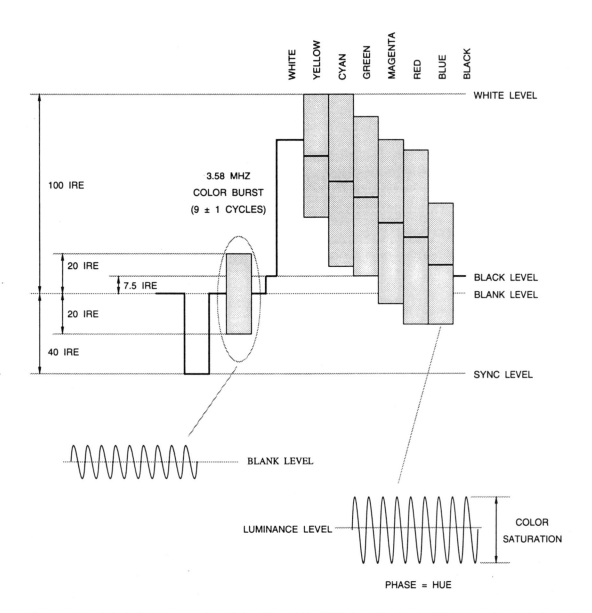

Figure 4.2. (M) NTSC Composite Video Signal for 75% Amplitude, 100% Saturation EIA Color Bars.

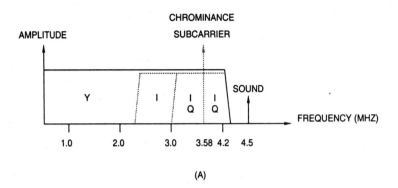

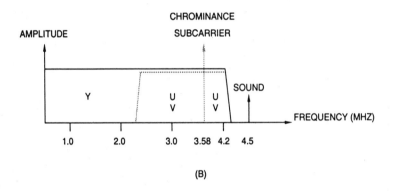

Figure 4.3. Bandwidths of (M) NTSC Systems. (A) Using 1.3-MHz I and 0.6-MHz Q Signals. (B) Using 1.3-MHz U and V Signals.

The resulting F_V (field) and F_H (line) rates were slightly different from the monochrome standards, but fell well within the tolerance ranges and were therefore acceptable. Figure 4.4 illustrates the resulting spectral interleaving. The luminance (Y) components are modulated due to the horizontal blanking process, resulting in bunches of luminance information spaced at intervals of F_H. These signals are further modulated by the vertical blanking process, resulting in luminance frequency components occurring at $NF_H \pm MF_V$ (N has a maximum value of about 277 with a 4.2-MHz bandwidth-limited luminance). Thus, luminance information is limited to areas about

integral harmonics of the line frequency (F_H), with additional spectral lines offset from NF_H by the 30-Hz vertical rate. The area in the spectrum between luminance bunches occurring at odd multiples of one-half the line frequency contains minimal spectral energy and may therefore be used for the transmission of chrominance information. The harmonics of the color subcarrier are separated from each other by F_H since they are odd multiples of 1/2 F_H, providing a half-line offset and resulting in an interlace pattern that moves upward. Four complete fields are required to repeat a specific pixel position, as shown in Figure 4.5.

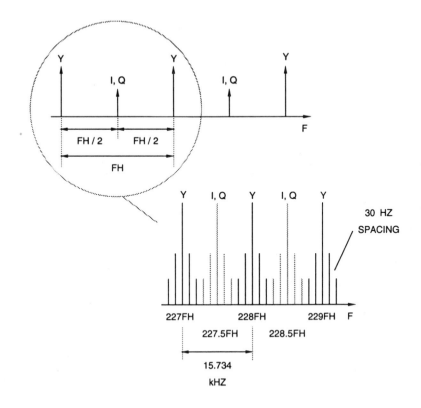

Figure 4.4. Luminance/Chrominance Horizontal Frequency Interleave Principle. Note that $227.5F_H = F_{SC}$.

An advantage of limiting the bandwidth of I and Q to 1.3 MHz and 0.6 MHz, respectively, at the decoder is to minimize crosstalk due to asymmetrical sidebands as a result of lowpass filtering the composite video signal to about 4.2 MHz. With the subcarrier at 3.58 MHz, the Q component is a double sideband signal; however, the I component will be asymmetrical, bringing up the possibility of crosstalk between I and Q. The symmetry of the Q component avoids crosstalk into the I component; since Q is bandwidth limited to 0.6 MHz, I crosstalk falls outside the Q component bandwidth.

There are two unofficial, but common, variations of NTSC. The first, called "NTSC 4.43," is a combination NTSC and PAL video signal sometimes used during standards con-version. The horizontal and vertical timing is the same as (M) NTSC; color encoding uses the (B, D, G, H, I) PAL modulation format and color subcarrier frequency.

The generation of 262-line, 60 frames/sec "noninterlaced NTSC" is also common among low-end consumer video games. This format is identical to standard (M) NTSC, except that there are 262 lines per field (actually, per frame since it is noninterlaced). Having an integer number of scan lines results in a noninterlaced image being displayed. To generate noninterlaced NTSC, the encoder is operated as normally, except for the horizontal and vertical sync timing being noninterlaced.

Figure 4.6 shows the CCIR designations for NTSC systems. The letter "M" refers to the monochrome standard for line and field rates

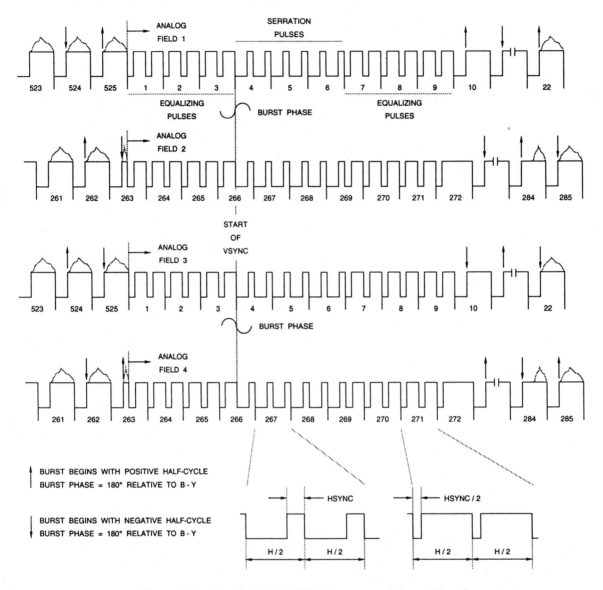

Figure 4.5. Four-field (M) NTSC Format and Burst Blanking.

(525/60), video channel bandwidth (4.2 MHz), and audio carrier relative frequency (4.5 MHz). The NTSC refers to the technique to add color information to the monochrome signal. Detailed timing parameters can be found in Table 4.2.

The following countries use, or are planning to use, the (M) NTSC standard, according to CCIR Report 624-4 (1990) and other sources. Unless otherwise indicated, (M) NTSC is used for both VHF and UHF transmission.

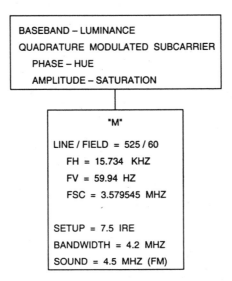

Figure 4.6. Summary CCIR Designation for NTSC Systems.

Antigua
Bahamas (VHF)
Barbados (VHF)
Bermuda (VHF)
Burma (VHF)
Bolivia
Canada
Chile
Colombia
Costa Rica
Cuba
Curacao
Dominican Republic
Ecuador
El Salvador (VHF)
Greenland (VHF)
Guam (VHF)
Guatemala
Honduras

Jamaica
Japan
Korea (South) (VHF)
Mexico
Montserrat (VHF)
Nicaragua
Panama
Peru
Philippines
Puerto Rico
St. Kitts and Nevis (VHF)
Samoa (VHF)
Surinam (VHF)
Taiwan (VHF)
Trinidad/Tobago (VHF)
United States of
 America
Venezuela (VHF)
Virgin Islands (VHF)

Luminance Equation Derivation

The equation for generating luminance from RGB information is determined by the chromaticities of the three primary colors (RGB) used by the receiver and what color white actually is. The chromaticities of the RGB primaries and reference white (defined to be CIE illuminate C) were specified in the 1953 NTSC standard to be:

R: $x_r = 0.67$ $y_r = 0.33$ $z_r = 0.00$

G: $x_g = 0.21$ $y_g = 0.71$ $z_g = 0.08$

B: $x_b = 0.14$ $y_b = 0.08$ $z_b = 0.78$

white: $x_w = 0.3101$ $y_w = 0.3162$
 $z_w = 0.3737$

where x and y are the specified CIE 1931 chromaticity coordinates; z is calculated by knowing that x + y + z = 1. Luminance is calculated as a weighted sum of RGB, with the weights

representing the actual contributions of each of the RGB primaries in generating the luminance of reference white. We find the linear combination of RGB that gives reference white by solving the equation:

$$\begin{bmatrix} x_r & x_g & x_b \\ y_r & y_g & y_b \\ z_r & z_g & z_b \end{bmatrix} \begin{bmatrix} K_r \\ K_g \\ K_b \end{bmatrix} = \begin{bmatrix} x_w/y_w \\ 1 \\ z_w/y_w \end{bmatrix}$$

Rearranging to solve for K_r, K_g, and K_b yields:

$$\begin{bmatrix} K_r \\ K_g \\ K_b \end{bmatrix} = \begin{bmatrix} x_w/y_w \\ 1 \\ z_w/y_w \end{bmatrix} \begin{bmatrix} x_r & x_g & x_b \\ y_r & y_g & y_b \\ z_r & z_g & z_b \end{bmatrix}^{-1}$$

Substituting the known values gives us the solution for K_r, K_g, and K_b:

$$\begin{bmatrix} K_r \\ K_g \\ K_b \end{bmatrix} = \begin{bmatrix} 0.3101/0.3162 \\ 1 \\ 0.3737/0.3162 \end{bmatrix} \begin{bmatrix} 0.67 & 0.21 & 0.14 \\ 0.33 & 0.71 & 0.08 \\ 0.00 & 0.08 & 0.78 \end{bmatrix}^{-1}$$

$$= \begin{bmatrix} 0.9807 \\ 1 \\ 1.1818 \end{bmatrix} \begin{bmatrix} 1.730 & -0.482 & -0.261 \\ -0.814 & 1.652 & -0.023 \\ 0.083 & -0.169 & 1.284 \end{bmatrix}$$

$$= \begin{bmatrix} 0.906 \\ 0.827 \\ 1.430 \end{bmatrix}$$

Y is defined to be
$(K_r y_r)R' + (K_g y_g)G' + (K_b y_b)B'$
$= (0.906)(0.33)R' + (0.827)(0.71)G'$
$+ (1.430)(0.08)B'$ or

$$Y = 0.299R' + 0.587G' + 0.114B'$$

Modern receivers use a different set of RGB phosphors, resulting in slightly different chromaticities of the RGB primaries and reference white (CIE illuminate D_{65}):

R: $x_r = 0.630$ $y_r = 0.340$ $z_r = 0.030$
G: $x_g = 0.310$ $y_g = 0.595$ $z_g = 0.095$
B: $x_b = 0.155$ $y_b = 0.070$ $z_b = 0.775$
white: $x_w = 0.3127$ $y_w = 0.3290$
$z_w = 0.3583$

where x and y are the specified CIE 1931 chromaticity coordinates; z is calculated by knowing that x + y + z = 1. Once again, substituting the known values gives us the solution for K_r, K_g, and K_b:

$$\begin{bmatrix} K_r \\ K_g \\ K_b \end{bmatrix} = \begin{bmatrix} 0.3127/0.3290 \\ 1 \\ 0.3583/0.3290 \end{bmatrix} \begin{bmatrix} 0.630 & 0.310 & 0.155 \\ 0.340 & 0.595 & 0.070 \\ 0.030 & 0.095 & 0.775 \end{bmatrix}^{-1}$$

$$= \begin{bmatrix} 0.6243 \\ 1.1770 \\ 1.2362 \end{bmatrix}$$

Since Y is defined to be
$(K_r y_r)R' + (K_g y_g)G' + (K_b y_b)B'$
$= (0.6243)(0.340)R' + (1.1770)(0.595)G'$
$+ (1.2362)(0.070)B'$, this results in:

$$Y = 0.212R' + 0.700G' + 0.086B'$$

However, the standard Y = 0.299R' + 0.587G' + 0.114B' equation is still used. Adjustments are made at the camera to minimize color errors at the receiver. Newer NTSC spec-

ifications do not preclude the use of equipment designed to use the older RGB chromaticity values. The NTSC specifications still assume the receiver has gamma of 2.2, although the gamma of modern receivers is closer to 3.1; this difference is usually ignored.

PAL Overview

Europe delayed adopting a color television standard, evaluating various systems between 1953 and 1967 that were compatible with their 625-line, 50-field/second, 2:1 interlaced monochrome standard. The NTSC specification was modified to overcome the high order of phase and amplitude integrity required during broadcast to avoid color distortion. The Phase Alternation Line (PAL) system implements a line-by-line reversal of the phase of one of the color signal components, relying on the eye to average any color distortions to the correct color. Broadcasting began in 1967 in Germany and the United Kingdom, with each using a slightly different variant of the PAL system.

The luminance (monochrome) signal is derived from gamma-corrected RGB (gamma = 2.8):

$$Y \text{ (luminance)} = 0.299R' + 0.587G' + 0.114B'$$

Unlike NTSC, PAL has several variations, depending on the video bandwidth and placement of the audio subcarrier. As with NTSC, the PAL luminance signal occupies the entire video bandwidth. The composite video signal has a bandwidth of 4.2, 5.0, 5.5, or 6.0 MHz, depending on the specific standard.

Once again, gamma correction is applied to compensate for the nonlinear voltage-to-light characteristics of the receiver, and to provide the additional benefit of increasing the signal-to-noise ratio of low-level signals during transmission. All PAL systems assume a

gamma of 2.8 at the receiver; in other words, the transfer function of the receiver is assumed to be (values are normalized to have a value of 0 to 1):

for R', G', $B' < 0.0812$

$$R = R'/4.5$$
$$G = G'/4.5$$
$$B = B'/4.5$$

for R', G', $B' \geq 0.0812$

$$R = ((R' + 0.099)/1.099)^{2.8}$$
$$G = ((G' + 0.099)/1.099)^{2.8}$$
$$B = ((B' + 0.099)/1.099)^{2.8}$$

So, to have the transfer function from the video source to the receiver display be linear, the total processing of the RGB signals before transmission should be (values are normalized to have a value of 0 to 1):

for R, G, $B < 0.018$

$$R' = 4.5 R$$
$$G' = 4.5 G$$
$$B' = 4.5 B$$

for R, G, $B \geq 0.018$

$$R' = 1.099 R^{0.36} - 0.099$$
$$G' = 1.099 G^{0.36} - 0.099$$
$$B' = 1.099 B^{0.36} - 0.099$$

To transmit hue and saturation color information, U and V color difference signals, which specify the differences between the luminance signal and the basic RGB signals, are used:

$$U = 0.492(B' - Y)$$
$$V = 0.877(R' - Y)$$

U and V have a typical bandwidth of 1.3 MHz.

Just as in the NTSC system, U and V are used to modulate the color subcarrier using two balanced modulators operating in phase quadrature (one modulator is driven by the subcarrier at sine phase, the other modulator is driven by the subcarrier at cosine phase). The outputs of the modulators are added together to form the composite chrominance signal:

$$C = U \sin \omega t \pm V \cos \omega t$$
$$\omega = 2\pi F_{SC}$$

F_{SC} = 4.43361875 MHz (\pm 5 Hz) for (B, D, G, H, I, N) PAL

F_{SC} = 3.58205625 MHz (\pm 5 Hz) for combination (N) PAL used in Argentina

F_{SC} = 3.57561149 MHz (\pm 10 Hz) for (M) PAL

In PAL, the phase of the V component is reversed 180° every other line. V was chosen for the reversal process since it has a lower gain factor than the U component and is therefore less susceptible to a 1/2 F_H switching rate imbalance. The result of alternating the V phase at the line rate is that any color subcarrier phase errors produce complementary errors, allowing any line-to-line averaging process at the receiver to cancel the phase (hue) error and generate the correct hue with slightly reduced saturation. This technique requires the PAL receiver to be able to determine the correct V phase. This is done using a technique known as A B sync, PAL sync, PAL SWITCH, or "swinging burst," consisting of alternating the phase of the color burst by ±45° at the line rate. The UV vector diagram illustrating the U and V axes and swinging burst is shown in Figure 4.7 and Figure 4.8.

The modulated chrominance is added to the luminance information along with appropriate horizontal and vertical sync signals, blanking signals, and color burst signals, to generate the composite color video waveform shown in Figure 4.9.

$$\text{composite PAL} = Y + U \sin \omega t \pm V \cos \omega t$$

The bandwidth of the resulting composite video signal is shown in Figure 4.10. The amplitude of the modulated chrominance is

$$\sqrt{U^2 + V^2}$$

Like NTSC, the luminance components are also spaced at F_H intervals due to horizontal blanking. Since the V component is switched symmetrically at half the line rate, only odd harmonics are generated, resulting in V components that are spaced at intervals of F_H. The V components are spaced at half-line intervals from the U components, which also have F_H spacing. If the subcarrier had a half-line offset like NTSC uses, the U components would be perfectly interleaved, but the V components would coincide with the Y components and thus not be interleaved, creating vertical stationary dot patterns. For this reason, PAL uses a 1/4 line offset for the subcarrier frequency:

F_{SC} = ((1135/4) + (1/625)) F_H for (B, D, G, H, I, N) PAL

F_{SC} = (909/4) F_H for (M) PAL

F_{SC} = ((917/4) + (1/625)) F_H for combination (N) PAL

The additional (1/625) F_H factor (equal to 25 Hz) provides motion to the color dot pattern, reducing its visibility. Figure 4.11 illustrates the resulting frequency interleaving.

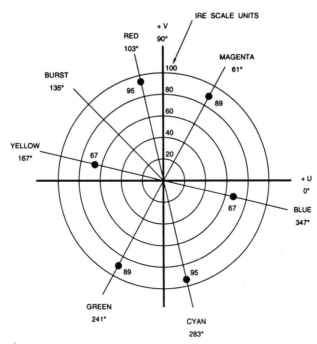

Figure 4.7. UV Vector Diagram for 75% Amplitude, 100% Saturated EBU Color Bars. Line n, PAL SWITCH = zero.

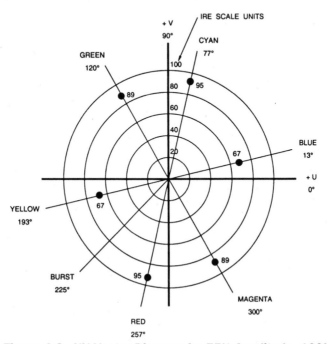

Figure 4.8. UV Vector Diagram for 75% Amplitude, 100% Saturated EBU Color Bars. Line n + 1, PAL SWITCH = one.

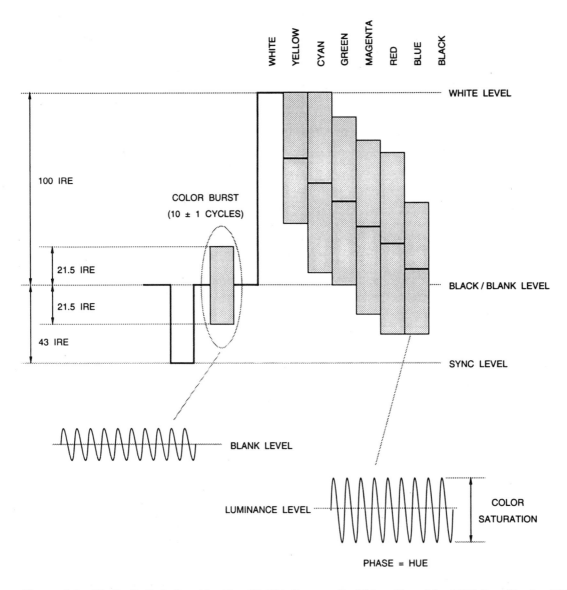

Figure 4.9. (B, D, G, H, I, Combination N) PAL Composite Video Signal for 75% Amplitude, 100% Saturation EBU Color Bars.

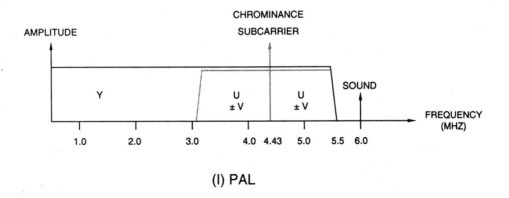

(I) PAL

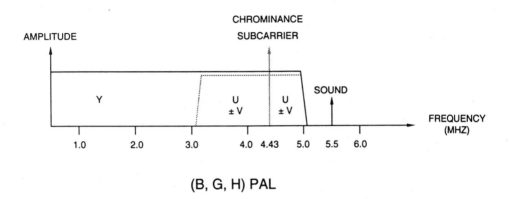

(B, G, H) PAL

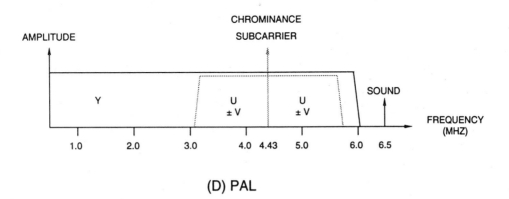

(D) PAL

Figure 4.10. Bandwidths of Some PAL Systems.

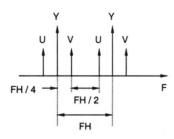

Figure 4.11. Luminance/ Chrominance Horizontal Frequency Interleave Principle.

Eight complete fields are required to repeat a specific pixel position, as shown in Figure 4.12 and Figure 4.13.

"Simple" PAL decoders rely on the eye to average the line-by-line hue errors. This implementation has the problem of Hanover bars, caused by visible luminance changes at the line rate. "Standard" PAL decoders use a 1-H delay line to separate U from V in an averaging process. Hanover bars, in which pairs of adjacent lines have a real and complementary hue error, may also occur. For all PAL systems, chrominance vertical resolution is reduced as a result of the line averaging process.

Figure 4.14 shows the CCIR designations for PAL systems. The letters refer to the monochrome standard for line and field rates (625/ 50), video channel bandwidth (4.2, 5.0, 5.5, or 6.0 MHz), and audio carrier relative frequency. The PAL refers to the technique to add color information to the monochrome signal. Detailed timing parameters may be found in Table 4.2.

The following countries use, or are planning to use, the (I) PAL standard, according to CCIR Report 624-4 (1990) and other sources. Unless otherwise indicated, (I) PAL is used for both VHF and UHF transmission.

Angola	Lesotho
Botswana	Malawi
Gambia	Namibia
Guinea	Nigeria (UHF)

Guinea-Bissau	Tanzania
Hong Kong (UHF)	United Kingdom of
Ireland	Great Britain (UHF)
South Africa	Zanzibar

The following countries use, or are planning to use, the (B) PAL standard, according to CCIR Report 624-4 (1990) and other sources. Unless otherwise indicated, (B) PAL is used for only for VHF transmission.

Albania	Nepal
Algeria	Netherlands
Australia (+ UHF)	New Zealand
Austria	Nigeria
Bahrain	Norway
Bangladesh	Oman
Belgium	Pakistan
Bosnia/Hercegovina	Papua New Guinea
Brunei	Portugal
Cameroon	Qatar
Croatia	Sao Tome and Principe
Cyprus	Saudi Arabia
Denmark	Seychelles
Ethiopia	Sierra Leone
Equatorial Guinea	Singapore
Faeroe Islands	Slovenia
Finland	Somalia
Germany	Spain
Ghana	Sri Lanka
Gibraltar	Sudan
Greenland	Swaziland
Iceland	Sweden
India	Switzerland
Indonesia	Syria
Israel	Thailand
Italy	Tunisia
Jordan	Turkey
Kenya	Uganda
Kuwait	United Arab Emirates
Liberia	Yemen
Luxembourg	Yugoslavia
Malaysia	Zambia
Malta	Zimbabwe

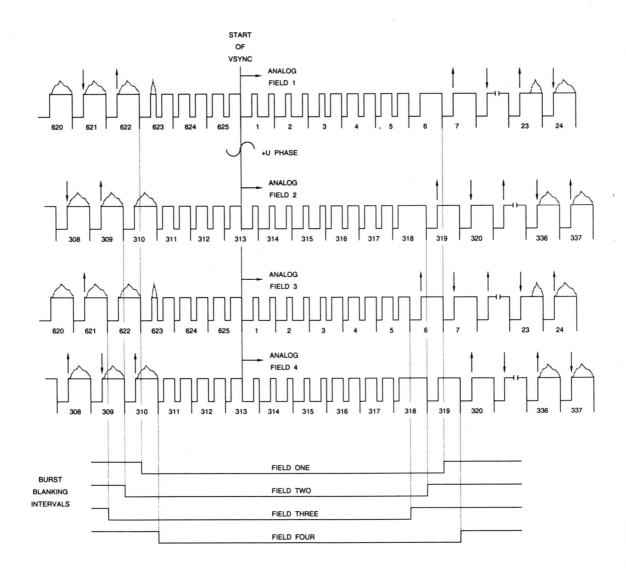

Figure 4.12a. Eight-field (B, D, G, H, I, Combination N) PAL Format and Burst Blanking. (See Figure 4.5 for equalization and serration pulse details.)

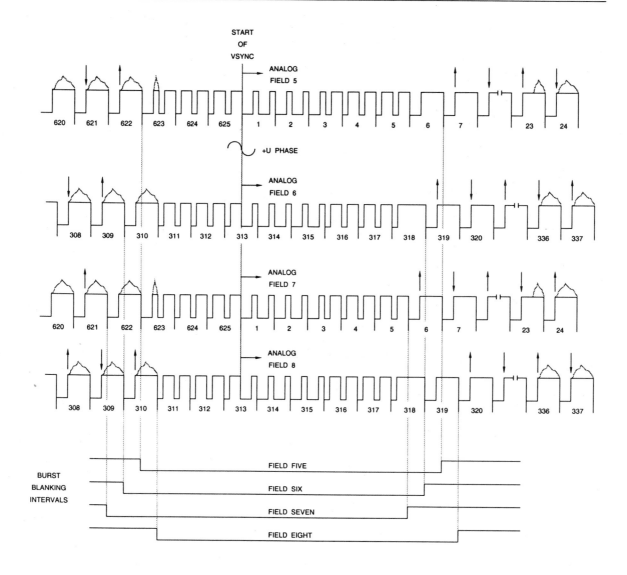

Figure 4.12b. Eight-field (B, D, G, H, I, Combination N) PAL Format and Burst Blanking. (See Figure 4.5 for equalization and serration pulse details.)

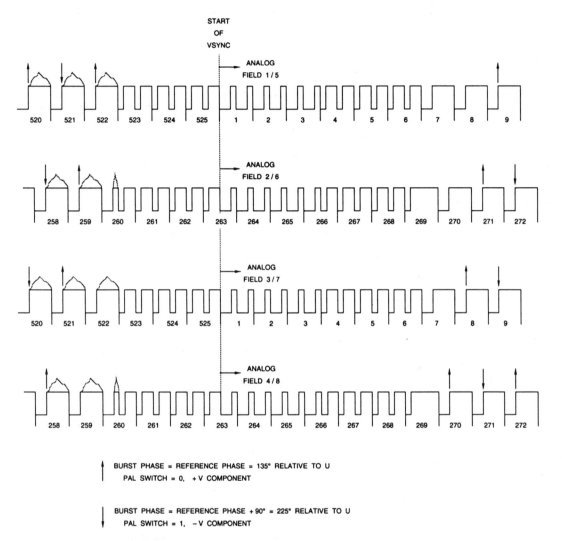

Figure 4.13. Eight-field (M) PAL Format and Burst Blanking. (See Figure 4.5 for equalization and serration pulse details.)

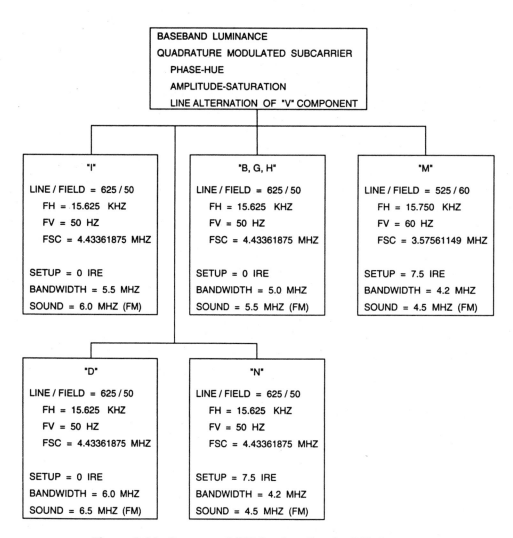

Figure 4.14. Summary CCIR Designation for PAL Systems.

The following countries use, or are planning to use, the (N) PAL standard, according to CCIR Report 624-4 (1990) and other sources. Unless otherwise indicated, (N) PAL is used for both VHF and UHF transmission. Note that Argentina uses a modified (N) PAL standard, called "combination N."

Argentina
Paraguay
Uruguay (VHF)

The following countries use, or are planning to use, the (M) PAL standard, according to CCIR Report 624-4 (1990) and other sources. Unless otherwise indicated, (M) PAL is used for both VHF and UHF transmission.

Brazil

The following countries use, or are planning to use, the (G) PAL standard, according to CCIR Report 624-4 (1990) and other sources. Unless otherwise indicated, (G) PAL is used for only for UHF transmission.

Albania	Italy
Algeria	Jordan
Austria	Kenya
Bahrain	Kuwait
Bosnia/Hercegovina	Luxembourg
Cameroon	Malaysia
Croatia	Monaco
Cyprus	Mozambique
Denmark	(+ VHF)
Ethiopia	Netherlands
Equatorial Guinea	New Zealand
Faeroe Islands	Norway
Finland	Oman
Germany	Pakistan
Ghana	Papua New Guinea
Gibraltar	Portugal
Greenland	Qatar
Iceland	Singapore
Israel	Slovenia

Somalia	Tunisia
Spain	Turkey
Swaziland	Uganda
Sweden	United Arab Emirates
Switzerland	Yugoslavia
Syria	Zambia
Thailand	Zimbabwe

The following countries use, or are planning to use, the (D) PAL standard, according to CCIR Report 624-4 (1990) and other sources. Unless otherwise indicated, (D) PAL is used for both VHF and UHF transmission.

Afghanistan (VHF)
China
Korea (North)
Romania

The following countries use, or are planning to use, the (H) PAL standard, according to CCIR Report 624-4 (1990) and other sources. Unless otherwise indicated, (H) PAL is used for only for UHF transmission.

Belgium

As an interim to HDTV, work is progressing on a 16:9 aspect ratio PAL-compatible signal, called PALplus. A standard PAL-compatible 4:3 picture is transmitted for conventional PAL receivers; the additional information to reconstruct the 16:9 picture is transmitted on a separate channel. Anticipated improvements include a reduction of artifacts during the encoding and decoding processes and possibly digital audio.

Luminance Equation Derivation

The equation for generating luminance from RGB information is determined by the chromaticities of the three primary colors (RGB) used by the receiver and what color white actually is. The chromaticities of the RGB primaries

and reference white (white is defined to be CIE illuminate D_{65}) are:

R: $x_r = 0.64$ $y_r = 0.33$ $z_r = 0.03$

G: $x_g = 0.29$ $y_g = 0.60$ $z_g = 0.11$

B: $x_b = 0.15$ $y_b = 0.06$ $z_b = 0.79$

white: $x_w = 0.3127$ $y_w = 0.3290$
 $z_w = 0.3583$

where x and y are the specified CIE 1931 chromaticity coordinates; z is calculated by knowing that x + y + z = 1. Once again, substituting the known values gives us the solution for K_r, K_g, and K_b:

$$\begin{bmatrix} K_r \\ K_g \\ K_b \end{bmatrix} = \begin{bmatrix} 0.3127/0.3290 \\ 1 \\ 0.3583/0.3290 \end{bmatrix} \begin{bmatrix} 0.64 & 0.29 & 0.15 \\ 0.33 & 0.60 & 0.06 \\ 0.03 & 0.11 & 0.79 \end{bmatrix}^{-1}$$

$$= \begin{bmatrix} 0.674 \\ 1.177 \\ 1.190 \end{bmatrix}$$

Since Y is defined to be
$(K_r y_r)R' + (K_g y_g)G' + (K_b y_b)B'$
$= (0.674)(0.33)R' + (1.177)(0.60)G'$
$+ (1.190)(0.06)B'$,
this results in:

$$Y = 0.222R' + 0.706G' + 0.071B'$$

However, the standard Y = 0.299R' + 0.587G' + 0.114B' equation is still used. Adjustments are made at the camera to minimize color errors at the receiver.

SECAM Overview

SECAM (Sequentiel Couleur Avec Mémoire or Sequential Color with Memory) was developed in France, with broadcasting starting in 1967, by realizing that, if color could be relatively bandwidth-limited horizontally, why not also vertically? The two pieces of color information (hue and saturation) that need to be added to a monochrome signal (intensity) could be transmitted on alternate lines, avoiding the possibility of crosstalk between the color components. The receiver requires a one-line memory to store one line so that it is concurrent with the next line, and also requires the addition of a line-switching identification technique. Like PAL, SECAM is a 625-line, 50-field/second, 2:1 interlaced system. SECAM was adopted by other countries; however, many are planning to change to PAL due to the abundance of professional and consumer PAL equipment.

The luminance (monochrome) signal is derived from gamma-corrected RGB (gamma = 2.8):

$$Y \text{ (luminance)} = 0.299R' + 0.587G' + 0.114B'$$

Unlike NTSC and PAL, SECAM transmits the R' – Y information during one line and B' – Y information during the next line; luminance information is transmitted each line. R' – Y and B' – Y are scaled to generate the Dr and Db color difference signals:

$$Dr = -1.902(R' - Y)$$

$$Db = 1.505(B' - Y)$$

Since there is an odd number of lines, a line contains Dr information on one field and Db information on the next field. The decoder requires a 1-H delay, switched synchronously with the Dr and Db switching, so that simultaneous Dr and Db exist simultaneously in order to convert to RGB.

SECAM uses FM modulation to transmit the Dr and Db color difference information, with each component having its own subcarrier. Dr and Db are lowpass filtered to 1.3 MHz

and pre-emphasis is applied to the low-frequency color difference signals. The curve for the low-frequency pre-emphasis is expressed by:

$$A = \frac{1+j(\frac{f}{85})}{1+j(\frac{f}{255})}$$

where f = signal frequency in kHz.

After low-frequency pre-emphasis, Dr and Db frequency-modulate their respective subcarriers. The frequency of each subcarrier is defined as:

$$F_{OB} = 272\ F_{H} = 4.250000\ \text{MHz}\ (\pm 2\ \text{kHz})$$

$$F_{OR} = 282\ F_{H} = 4.406250\ \text{MHz}\ (\pm 2\ \text{kHz})$$

These frequencies represent zero color difference information. Nominal Dr deviation is ±280 kHz and the nominal Db deviation is ±230 kHz. Figure 4.15 illustrates the frequency modulation process of the color difference signals. The choice of frequency shifts reflects the idea of keeping the frequencies representing critical colors away from the upper limit of the spectrum to minimize distortion.

After modulation of Dr and Db, high-frequency subcarrier pre-emphasis is applied, changing the amplitude of the subcarrier as a function of the frequency deviation. The intention is to reduce the visibility of the subcarriers in areas of low luminance and to improve the

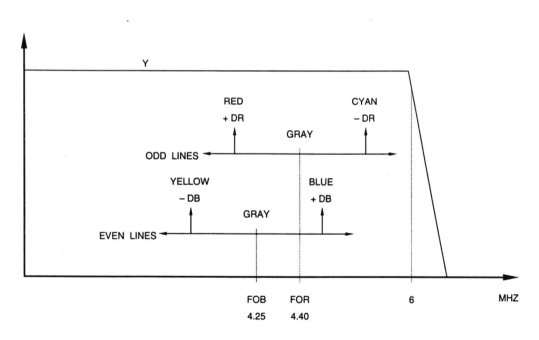

Figure 4.15. SECAM FM color modulation.

signal-to-noise ratio of highly saturated colors. This expression is given as:

$$G = M\frac{1+j16F}{1+j1.26F}$$

where $F = (f/4286) - (4286/f)$, f = instantaneous subcarrier frequency in kHz, and 2M = $23 \pm 2.5\%$ of luminance amplitude.

After high-frequency subcarrier pre-emphasis, the subcarrier data is added to the luminance along with appropriate horizontal and vertical sync signals, blanking signals, and field ID signals, to generate composite video.

As shown in Table 4.1 and Figure 4.16, Dr and Db information is transmitted on alternate scan lines. The phase of the subcarriers is also reversed 180° on every third line and between each field to further reduce subcarrier visibility. Note that subcarrier phase information in the SECAM system carries no picture information.

As with PAL, SECAM requires some means of identifying the line-switching sequence between the encoding and decoding functions. This is done by incorporating alternate Dr and Db color identification signals for nine lines during the vertical blanking interval following the equalizing pulses after vertical sync, as shown in Figure 4.17a. These bottle-shaped signals occupy the entire scan line. Recent practice has been to eliminate the bottle signals and use a F_{OR}/F_{OB} burst after horizontal sync to derive the switching synchronization information, as shown in Figure 4.17b. This method has the advantage of simplifying the exchange of program material.

Field	Line Number		Color		Subcarrier Phase	
odd (1)	N		Dr		0°	
even (2)		N + 313		Db		180°
odd (3)	N + 1		Db		0°	
even (4)		N + 314		Dr		0°
odd (5)	N + 2		Dr		180°	
even (6)		N + 315		Db		180°
odd (7)	N + 3		Db		0°	
even (8)		N + 316		Dr		180°
odd (9)	N + 4		Dr		0°	
even (10)		N + 317		Db		0°
odd (11)	N + 5		Db		180°	
even (12)		N + 318		Dr		180°

Table 4.1. SECAM Color Versus Line and Field Timing.

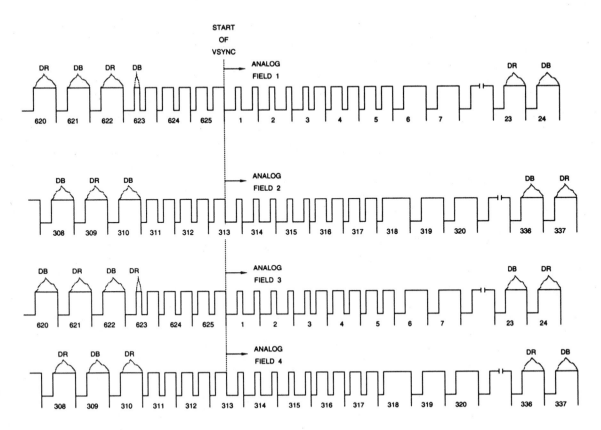

Figure 4.16. Four-field SECAM sequence. (See Figure 4.5 for equalization and serration pulse details.)

Figure 4.18 shows the CCIR designations for SECAM systems. The letters refer to the monochrome standard for line and field rates (625/50), video channel bandwidth (5.0 or 6.0 MHz), and audio carrier relative frequency. The SECAM refers to the technique to add color information to the monochrome signal. Detailed timing parameters may be found in Table 4.2.

The following countries use, or are planning to use, the (B) SECAM standard, according to CCIR Report 624-4 (1990) and other sources. Unless otherwise indicated, (B) SECAM is used for only for VHF transmission.

Djibouti	Libya
Egypt	Mali
Germany	Mauritania
Greece	Mauritius
Iran	Morocco
Iraq	Saudi Arabia
Lebanon	Tunisia

The following countries use, or are planning to use, the (D) SECAM standard, according to CCIR Report 624-4 (1990) and other sources. Unless otherwise indicated, (D) SECAM is used for only for VHF transmission.

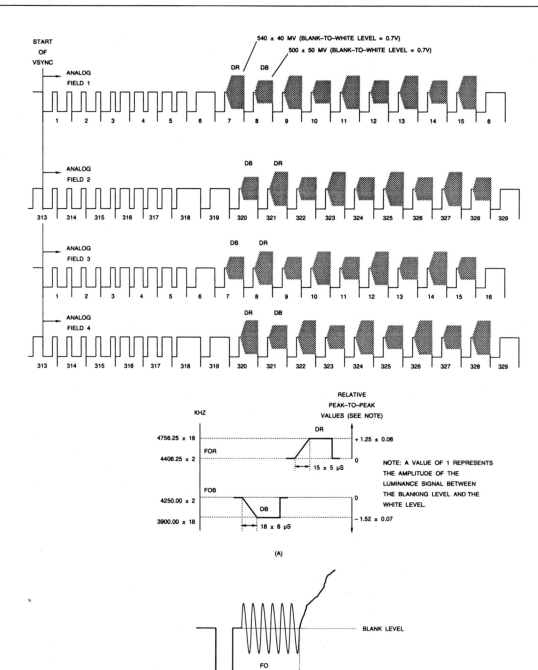

Figure 4.17. SECAM Chrominance Synchronization Signals.

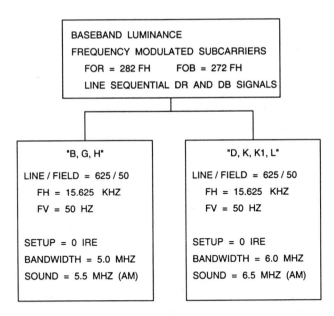

Figure 4.18. Summary CCIR designation for SECAM systems.

Armenia	Lithuania
Azerbaijan	Madagascar
Belarus	Moldova
Bulgaria	Poland
Czechoslovakia	Romania
Estonia	Russia
Georgia	Ukraine
Hungary	Viet Nam
Kazakhstan	

The following countries use, or are planning to use, the (G) SECAM standard, according to CCIR Report 624-4 (1990) and other sources. Unless otherwise indicated, (G) SECAM is used for only for UHF transmission.

Egypt	Mauritius
Germany	Monaco
Greece	Morocco
Iran	Saudi Arabia
Libya	Syria
Mali	Tunisia

The following countries use, or are planning to use, the (K) SECAM standard, according to CCIR Report 624-4 (1990) and other sources. Unless otherwise indicated, (K) SECAM is used for only for UHF transmission.

Armenia	Lithuania
Azerbaijan	Madagascar
Bulgaria	Moldova
Czechoslovakia	Poland
Estonia	Romania
Georgia	Russia
Hungary	Ukraine
Kazakhstan	Viet Nam

The following countries use, or are planning to use, the (K1) SECAM standard, according to CCIR Report 624-4 (1990) and other sources. Unless otherwise indicated, (K1) SECAM is used for both VHF and UHF transmission.

	M	N	B, G	H	I	D, K	K1	L
SCAN LINES PER FRAME	525	625	625					
FIELD FREQUENCY (FIELDS / SECOND)	59.94	50	50					
LINE FREQUENCY (HZ)	15,734	15,625	15,625					
PEAK WHITE LEVEL (IRE)	100	100	100					
SYNC TIP LEVEL (IRE)	−40	−40 (−43)	−43					
SETUP (IRE)	7.5 ± 2.5	7.5 ± 2.5 (0)	0					
PEAK VIDEO LEVEL (IRE)	120		133		133	115	115	125
GAMMA OF RECEIVER	2.2	2.8	2.8	2.8	2.8	2.8	2.8	2.8
VIDEO BANDWIDTH (MHZ)	4.2	4.2	5.0	5.0	5.5	6.0	6.0	6.0
LUMINANCE SIGNAL	$Y = 0.299R' + 0.685G' + 0.114B'$ (RGB ARE GAMMA–CORRECTED)							

Note: Values in brackets apply to combination (N) PAL used in Argentina.

Table 4.2a. Basic Characteristics of Color Video Signals.

Benin
Burkina Faso
Burundi
Central African
 Republic
Chad
Comoros
Congo

Gabon
Guinea (VHF)
Madagascar
Niger
Rwanda
Senegal
Togo (VHF)
Zaire

The following countries use, or are planning to use, the (L) SECAM standard, according to CCIR Report 624-4 (1990) and other sources. Unless otherwise indicated, (L) SECAM is used for both VHF and UHF transmission.

France Luxembourg (UHF)

Luminance Equation Derivation

The equation for generating luminance from RGB information is determined by the chromaticities of the three primary colors (RGB) used by the receiver and what color white actually is. The chromaticities of the RGB primaries and reference white (white is defined to be CIE illuminate D_{65}) are:

$$R: \quad x_r = 0.64 \quad y_r = 0.33 \quad z_r = 0.03$$

$$G: \quad x_g = 0.29 \quad y_g = 0.60 \quad z_g = 0.11$$

$$B: \quad x_b = 0.15 \quad y_b = 0.06 \quad z_b = 0.79$$

$$white: \quad x_w = 0.3127 \quad y_w = 0.3290$$
$$z_w = 0.3583$$

where x and y are the specified CIE 1931 chromaticity coordinates; z is calculated by knowing that $x + y + z = 1$. Once again, substituting the known values gives us the solution for K_r, K_g, and K_b:

Characteristics	M[1]	N	B, D, H, H, I D, K, K1, L, N[2]
Nominal line period (μs)	63.5555 (63.492)	64.	64
Line blanking interval (μs)	10.7 ± 0.1	10.88 ± 0.64	12 ± 0.3
0_H to start of active video (μs)	9.2 ± 0.1 (9.6 ± 0.7)	9.6 ± 0.64	10.5
Front porch (μs)	1.5 ± 0.1 (1.9 ± 0.63)	1.92 ± 0.64	1.65 ± 0.1
Line synchronizing pulse (μs)	4.7 ± 0.1	4.99 ± 0.77	4.7 ± 0.2
Rise and fall time of line blanking (10%, 90%) (ns)	140 ± 20 (≤ 640)	≤ 640	300 ± 100
Rise and fall time of line synchronizing pulses (10%, 90%) (ns)	140 ± 20	≤ 250	250 ± 50

Notes
1. Values in parentheses apply to (M) PAL.
2. Combination (N) PAL used in Argentina.
3. 0_H is at 50% point of falling edge of horizontal sync.
4. In case of different standards having different specifications and tolerances, the tightest specification and tolerance is listed.
5. Timing is measured between half-amplitude points on appropriate signal edges.

Table 4.2b Details of Line Synchronization Signals.

$$\begin{bmatrix} K_r \\ K_g \\ K_b \end{bmatrix} = \begin{bmatrix} 0.3127/0.3290 \\ 1 \\ 0.3583/0.3290 \end{bmatrix} \begin{bmatrix} 0.64 & 0.29 & 0.15 \\ 0.33 & 0.60 & 0.06 \\ 0.03 & 0.11 & 0.79 \end{bmatrix}^{-1}$$

$$= \begin{bmatrix} 0.674 \\ 1.177 \\ 1.190 \end{bmatrix}$$

Since Y is defined to be
$(K_r y_r) R' + (K_g y_g) G' + (K_b y_b) B'$

$= (0.674)(0.33)R' + (1.177)(0.60)G'$
$+ (1.190)(0.06)B'$, this results in:

$$Y = 0.222R' + 0.706G' + 0.071B'$$

However, the standard Y = 0.299R' + 0.587G' + 0.114B' equation is still used. Adjustments are made at the camera to minimize color errors at the receiver.

Characteristics	M[1]	N	B, D, H, H, I D, K, K1, L, N[2]
Field period (ms)	16.6833 (16.667)	20	20
Field blanking interval	20 lines	19–25 lines	25 lines
Rise and fall time of field blanking (10%, 90%) (ns)	140 ± 20	≤ 6350	300 ± 100
Duration of equalizing and synchronizing sequences	3 H	3 H	2.5 H
Equalizing pulse width (µs)	2.3 ± 0.1	2.43 ± 0.13	2.35 ± 0.1
Serration pulse width (µs)	4.7 ± 0.1	4.7 ± 0.8	4.7 ± 0.1
Rise and fall time of synchronizing and equalizing pulses (10%, 90%) (ns)	140 ± 20	< 250	250 ± 50

Notes
1. Values in parentheses apply to (M) PAL.
2. Combination (N) PAL used in Argentina.
3. In case of different standards having different specifications and tolerances, the tightest specification and tolerance is listed.
4. Timing is measured between half-amplitude points on appropriate signal edges.

Table 4.2c. Details of Field Synchronization Signals.

Color Bars

Color bars are one of the standard video test signals, and there are several versions, depending on the video standard and application. For this reason, this section reviews the most common color bar formats. Color bars have two major characteristics: amplitude and saturation.

The amplitude of a color bar signal is determined by:

$$amplitude \ (\%) = \frac{max \ (R,G,B)^a}{max (R,G,B)^b} \times 100$$

where $max(R,G,B)^a$ is the maximum value of the gamma-corrected RGB components during colored bars and $max(R,G,B)^b$ is the maximum value of the gamma-corrected RGB components during reference white.

The saturation of a color bar signal is less than 100% if the minimum value of any one of

	M / NTSC	M / PAL	B, D, G, H, I, N / PAL	B, D, G, K, K1, K / SECAM
ATTENUATION OF COLOR DIFFERENCE SIGNALS	U, V, I, Q: < 2 DB AT 1.3 MHZ > 20 DB AT 3.6 MHZ OR Q: < 2 DB AT 0.4 MHZ < 6 DB AT 0.5 MHZ > 6 DB AT 0.6 MHZ	< 2 DB AT 1.3 MHZ > 20 DB AT 3.6 MHZ	< 3 DB AT 1.3 MHZ > 20 DB AT 4 MHZ (> 20 DB AT 3.6 MHZ)	< 3 DB AT 1.3 MHZ > 30 DB AT 3.5 MHZ (BEFORE LOW FREQUENCY PRE–CORRECTION)
START OF BURST AFTER 0H (µS)	5.3 ± 0.07	5.8 ± 0.1	5.6 ± 0.1	
BURST DURATION (CYCLES)	9 ± 1	9 ± 1	10 ± 1 (9 ± 1)	
BURST PEAK AMPLITUDE	40 ± 10 IRE	42.86 ± 10 IRE	42.86 ± 10 IRE	

Note: Values in parentheses apply to combination (N) PAL used in Argentina.

Table 4.2d. Basic Characteristics of Color Video Signals.

the gamma-corrected RGB components is not zero. The saturation may be determined by:

$$saturation\ (\%) = \left[1 - \left(\frac{min\ (R, G, B)}{max\ (R, G, B)} \right)^{\gamma} \right] \times 100$$

where min(R,G,B) and max(R,G,B) are the minimum and maximum values, respectively, of the gamma-corrected RGB components during colored bars and γ is the gamma exponent (typically 2.2 for NTSC and 2.8 for PAL).

Refer to Appendix A for more information on testing video signals.

NTSC Color Bars

In 1953, it was normal practice for the analog RGB signals to have a 7.5 IRE setup, and the original NTSC equations assumed this form of input to an NTSC encoder. Today, digital RGB signals do not include the 7.5 IRE setup. Analog RGB signals may have a 7.5 IRE setup. If so, it is typically only on the green channel. The 7.5 IRE setup is now typically added within the encoder, and the RGB inputs to the encoder are assumed not to have the 7.5 IRE setup.

The different color bar signals are usually described by four amplitudes, expressed in percent, separated by oblique strokes (100% saturation is implied, so saturation is not specified). The first and second numbers are the white and black amplitudes, respectively. The third and fourth numbers are the white and black amplitudes from which the color bars are derived. For example, 100/0/75/7.5 bars would be 75% bars with 7.5% setup in which the white bar has been set to 100% and the black bar to 0%. Since NTSC systems usually have the 7.5% setup, the two common color bars are 75/7.5/75/7.5 and 100/7.5/100/7.5, which are usually shortened to "75% amplitude, 100% saturation" and "100% amplitude, 100% saturation", or just "75%" and "100%," respectively.

The 75% bars are most commonly used. Television transmitters do not pass chrominance information with an amplitude greater than 120 IRE. Therefore, the 75/7.5/75/7.5 color bars are used for transmitter testing. The 100/7.5/100/7.5 color bars may be used for testing in situations where a direct connection between equipment is possible.

The 75/7.5/75/7.5 color bars may also have the representation 77/7.5/77/7.5 in specifications that assume the RGB data used a 7.5% setup. The 75/7.5/75/7.5 color bars are a part of the Electronic Industries Association EIA-189-A Encoded Color Bar Standard (1976).

Figure 4.19 shows a typical M(NTSC) vectorscope display for full-screen EIA color bars. Some vectorscopes have a 75%/100% switch that changes the calibration of the chrominance gain to accommodate the two types of color bars.

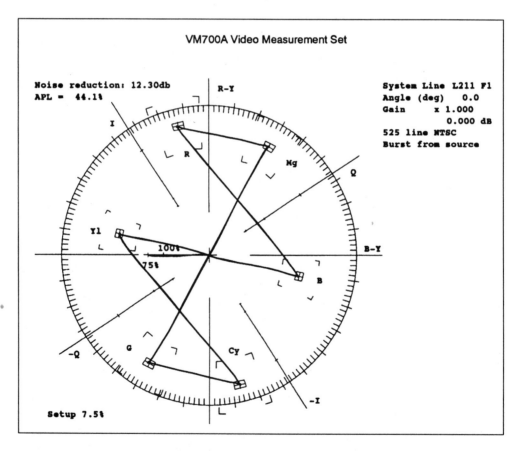

Figure 4.19. Typical Vectorscope Display for M(NTSC) Full-screen EIA Color Bars.

Tables 4.3 through Table 4.5 list the luminance and chrominance levels for the three color bar formats for NTSC.

Figure 4.20 illustrates the video waveform for 75/7.5/75/7.5 color bars, commonly referred to as 75% amplitude, 100% saturation color bars. In order to generate the 100/0/ 100/0 color bars, which are used mostly for testing, the 7.5 IRE setup circuitry within the encoder would have to be disabled and the standard RGB-to-YIQ equations modified to compensate for the loss of the 7.5 IRE setup.

For reference, the RGB and YCrCb values to generate the standard NTSC color bars are

	Luminance (IRE)	Chrominance Level (IRE)	Minimum Chrominance Excursion (IRE)	Maximum Chrominance Excursion (IRE)	Chrominance Phase (degrees)
white	76.9	0	–	–	–
yellow	69.0	62.1	37.9	100.0	167.1
cyan	56.1	87.7	12.3	100.0	283.5
green	48.2	81.9	7.3	89.2	240.7
magenta	36.2	81.9	–4.8	77.1	60.7
red	28.2	87.7	–15.6	72.1	103.5
blue	15.4	62.1	–15.6	46.4	347.1
black	7.5	0	–	–	–

Table 4.3. 75/7.5/75/7.5 NTSC/EIA Color Bars. These are commonly referred to as 75% amplitude, 100% saturation NTSC or EIA color bars.

	Luminance (IRE)	Chrominance Level (IRE)	Minimum Chrominance Excursion (IRE)	Maximum Chrominance Excursion (IRE)	Chrominance Phase (degrees)
white	100.0	0	–	–	–
yellow	89.5	82.8	48.1	130.8	167.1
cyan	72.3	117.0	13.9	130.8	283.5
green	61.8	109.2	7.2	116.4	240.7
magenta	45.7	109.2	–8.9	100.3	60.7
red	35.2	117.0	–23.3	93.6	103.5
blue	18.0	82.8	–23.3	59.4	347.1
black	7.5	0	–	–	–

Table 4.4. 100/7.5/100/7.5 NTSC Color Bars. These are commonly referred to as 100% amplitude, 100% saturation NTSC color bars.

	Luminance (IRE)	Chrominance Level (IRE)	Minimum Chrominance Excursion (IRE)	Maximum Chrominance Excursion (IRE)	Chrominance Phase (degrees)
white	100.0	0	–	–	–
yellow	88.6	89.5	43.9	133.3	167.1
cyan	70.1	126.5	6.9	133.3	283.5
green	58.7	118.1	–0.3	117.7	240.7
magenta	41.3	118.1	–17.7	100.3	60.7
red	29.9	126.5	–33.3	93.1	103.5
blue	11.4	89.5	–33.3	56.1	347.1
black	0	0	–	–	–

Table 4.5. 100/0/100/0 NTSC Color Bars.

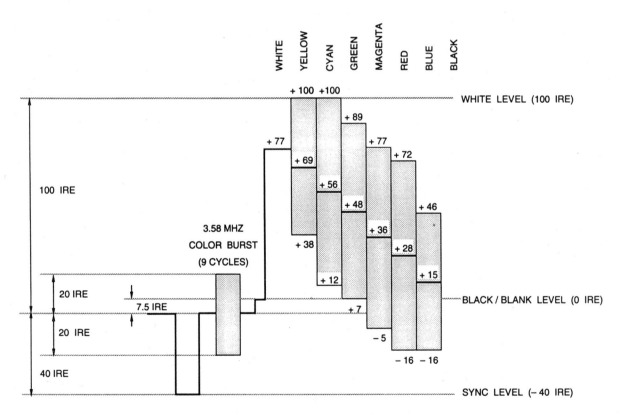

Figure 4.20. IRE values for 75/7.5/75/7.5 NTSC/EIA color bars.

shown in Table 4.6 and Table 4.7. RGB is assumed to have a range of 0–255; YCrCb is assumed to have a range of 16–235 for Y and 16–240 for Cr and Cb. It is assumed the 7.5 IRE setup is implemented within the encoder, except when generating 100/0/100/0 color bars.

	White	Yellow	Cyan	Green	Magenta	Red	Blue	Black
gamma-corrected RGB (gamma = 2.2)								
R′	191	191	0	0	191	191	0	0
G′	191	191	191	191	0	0	0	0
B′	191	0	191	0	191	0	191	0
linear RGB								
R	135	135	0	0	135	135	0	0
G	135	135	135	135	0	0	0	0
B	135	0	135	0	135	0	135	0
YCrCb								
Y	180	162	131	112	84	65	35	16
Cr	128	142	44	58	198	212	114	128
Cb	128	44	156	72	184	100	212	128

Table 4.6. RGB and YCrCb Values for 75/7.5/75/7.5 NTSC/EIA Color Bars.

	White	Yellow	Cyan	Green	Magenta	Red	Blue	Black
gamma-corrected RGB (gamma = 2.2)								
R′	255	255	0	0	255	255	0	0
G′	255	255	255	255	0	0	0	0
B′	255	0	255	0	255	0	255	0
linear RGB								
R	255	255	0	0	255	255	0	0
G	255	255	255	255	0	0	0	0
B	255	0	255	0	255	0	255	0
YCrCb								
Y	235	210	170	145	106	81	41	16
Cr	128	146	16	34	222	240	110	128
Cb	128	16	166	54	202	90	240	128

Table 4.7. RGB and YCrCb Values for 100/7.5/100/7.5 and 100/0/100/0 NTSC Color Bars.

PAL/SECAM Color Bars

Unlike NTSC, PAL and SECAM do not support a 7.5 IRE setup; the black and blank levels are the same. The different color bar signals are usually described by four amplitudes, expressed in percent, separated by oblique strokes. The first and second numbers are the maximum and minimum percentages, respectively, of gamma-corrected RGB values for an uncolored bar. The third and fourth numbers are the maximum and minimum percentages, respectively, of gamma-corrected RGB values for a colored bar. Since PAL and SECAM systems have a 0% setup, the two common color bars are 100/0/75/0 and 100/0/100/0, which are usually shortened to "75% amplitude, 100% saturation" and "100% amplitude, 100% saturation," or just 75% and 100%, respectively. The 100/0/75/0 color bars are used for transmitter testing. The 100/0/100/0 color bars may be used for testing in situations where a direct connection between equipment is possible.

Table 4.8 through Table 4.10 list the luminance and chrominance levels for the three color bar formats for PAL. Figure 4.21 illustrates the video waveform for 100/0/75/0 color bars. The 100/0/75/0 color bars are also referred to as EBU (European Broadcast Union) color bars. All of the color bars discussed in this section are also a part of *Specification of Television Standards for 625-line System-I Transmissions* (1971) published by the Independent Television Authority (ITA) and the British Broadcasting Corporation (BBC) and CCIR Recommendation 471-1 (1986). Figure 4.22 shows a typical (B, D, G, H, I) PAL vectorscope display for full-screen EBU color bars.

	Luminance (volts)	Peak-to-Peak Chrominance			Chrominance Phase (degrees)	
		U axis (volts)	V axis (volts)	Total (volts)	Line n (135° burst)	Line n + 1 (225° burst)
white	0.700	0	–	–	–	–
yellow	0.465	0.459	0.105	0.470	167	193
cyan	0.368	0.155	0.646	0.664	283.5	76.5
green	0.308	0.304	0.541	0.620	240.5	119.5
magenta	0.217	0.304	0.541	0.620	60.5	299.5
red	0.157	0.155	0.646	0.664	103.5	256.5
blue	0.060	0.459	0.105	0.470	347	13.0
black	0	0	0	0	–	–

Table 4.8. 100/0/75/0 PAL/EBU Color Bars (100% Saturation). These are commonly referred to as 75% amplitude, 100% saturation PAL/EBU color bars.

	Luminance (volts)	Peak-to-Peak Chrominance			Chrominance Phase (degrees)	
		U axis (volts)	V axis (volts)	Total (volts)	Line n (135° burst)	Line n + 1 (225° burst)
white	0.700	0	–	–	–	–
yellow	0.620	0.612	0.140	0.627	167	193
cyan	0.491	0.206	0.861	0.885	283.5	76.5
green	0.411	0.405	0.721	0.827	240.5	119.5
magenta	0.289	0.405	0.721	0.827	60.5	299.5
red	0.209	0.206	0.861	0.885	103.5	256.5
blue	0.080	0.612	0.140	0.627	347	13.0
black	0	0	0	0	–	–

Table 4.9. 100/0/100/0 PAL Color Bars (100% Saturation). These are commonly referred to as 100% amplitude, 100% saturation PAL color bars.

	Luminance (volts)	Peak-to-Peak Chrominance			Chrominance Phase (degrees)	
		U axis (volts)	V axis (volts)	Total (volts)	Line n (135° burst)	Line n + 1 (225° burst)
white	0.700	0	–	–	–	–
yellow	0.640	0.459	0.105	0.470	167	193
cyan	0.543	0.155	0.646	0.664	283.5	76.5
green	0.483	0.304	0.541	0.620	240.5	119.5
magenta	0.392	0.304	0.541	0.620	60.5	299.5
red	0.332	0.155	0.646	0.664	103.5	256.5
blue	0.235	0.459	0.105	0.470	347	13.0
black	0	0	0	0	–	–

Table 4.10. 100/0/100/25 PAL Color Bars (98% Saturation). These are commonly referred to as 95% PAL color bars.

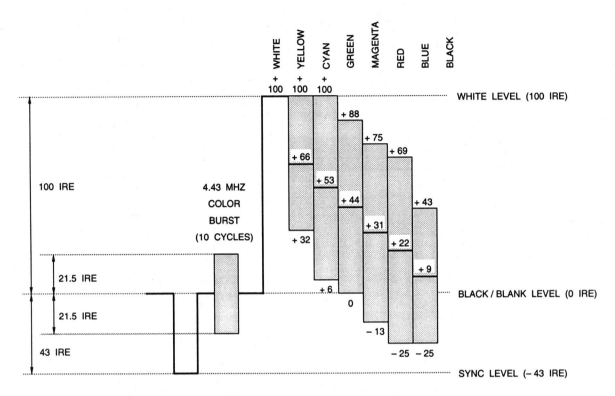

Figure 4.21. IRE values for 100/0/75/0 PAL/EBU Color Bars.

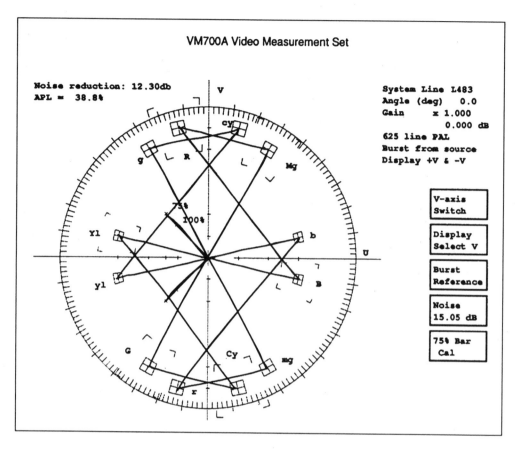

Figure 4.22. Typical (B, D, G, H, I) PAL Vectorscope Display for Full-screen EBU Color Bars.

For reference, the RGB and YCrCb values to generate the standard PAL (and SECAM) color bars are shown in Tables 4.11 through Table 4.13. RGB is assumed to have a range of 0–255; YCrCb is assumed to have a range of 16–235 for Y and 16–240 for Cr and Cb.

		White	Yellow	Cyan	Green	Magenta	Red	Blue	Black
		gamma-corrected RGB (gamma = 2.8)							
R'		255	191	0	0	191	191	0	0
G'		255	191	191	191	0	0	0	0
B'		255	0	191	0	191	0	191	0
		linear RGB							
R		255	114	0	0	114	114	0	0
G		255	114	114	114	0	0	0	0
B		255	0	114	0	114	0	114	0
		YCrCb							
Y		235	162	131	112	84	65	35	16
Cr		128	142	44	58	198	212	114	128
Cb		128	44	156	72	184	100	212	128

Table 4.11. RGB and YCrCb values for 100/0/75/0 PAL/EBU/SECAM Color Bars.

		White	Yellow	Cyan	Green	Magenta	Red	Blue	Black
		gamma-corrected RGB (gamma = 2.8)							
R'		255	255	0	0	255	255	0	0
G'		255	255	255	255	0	0	0	0
B'		255	0	255	0	255	0	255	0
		linear RGB							
R		255	255	0	0	255	255	0	0
G		255	255	255	255	0	0	0	0
B		255	0	255	0	255	0	255	0
		YCrCb							
Y		235	210	170	145	106	81	41	16
Cr		128	146	16	34	222	240	110	128
Cb		128	16	166	54	202	90	240	128

Table 4.12. RGB and YCrCb Values for 100/0/100/0 PAL/SECAM Color Bars.

	White	Yellow	Cyan	Green	Magenta	Red	Blue	Black
gamma-corrected RGB (gamma = 2.8)								
R′	255	255	64	64	255	255	64	64
G′	255	255	255	255	64	64	64	64
B′	255	64	255	64	255	64	255	64
linear RGB								
R	255	255	5	5	255	255	5	5
G	255	255	255	255	5	5	5	5
B	255	5	255	5	255	5	255	5
YCrCb								
Y	235	216	186	167	139	120	90	16
Cr	128	142	44	58	198	212	114	128
Cb	128	44	156	72	184	100	212	128

Table 4.13. RGB and YCrCb Values for 100/0/100/25 PAL/SECAM Color Bars.

SuperNTSC™

SuperNTSC (trademarked by Faroudja Laboratories) was researched and developed by Faroudja Laboratories in an attempt to improve the NTSC video signal to its maximum potential. The intent is to pre-process the video signal, transmit it as a standard NTSC signal, and perform more processing at the receiver to improve the image quality. Note that a standard receiver would properly decode and display the SuperNTSC signal; the image quality would just not be as good as if a SuperNTSC receiver were also used. Many of the techniques, with some modification, could also be applied to PAL signals.

The thinking behind SuperNTSC was that NTSC has three basic weaknesses, listed in the following sections. If these are corrected, then NTSC has the potential to rival RGB or HDTV in video quality:

1. *Visible line structure (525 lines, 2:1 interlaced) and poor horizontal and vertical resolution.*

To reduce the line structure and vertical aliases, television cameras would be 525-line, 30-Hz progressive scan and a conversion from a 30-Hz progressive scan image to a 2:1 interlaced, 60-Hz image would be performed before encoding. At the receiver, the 525-line, 2:1 interlaced image would be converted into a 1050-line, 2:1 interlaced image. The vertical interpolation of the line doubler in the receiver is simplified if the television camera is progressive scan.

Detail processing at the receiver would be done to increase small level details without modifying large transitions. In addition, the rise times of large horizontal transitions would be shortened. Both of these techniques would allow the dis-

played image to appear as though it had a bandwidth of 7.5 MHz (525 lines) or 15 MHz (1050 lines), rather than the usual 4.2 MHz. Figure 4.23 illustrates a typical color transient improvement method that could be used (all times assume minimum rise times according to the transmission standard). The assumption is that luminance and chrominance transitions are normally congruent. However, the chrominance transition is degraded due to the narrow bandwidth of the chrominance information. By monitoring coincident luminance transitions, a faster edge is synthesized for the chrominance transitions.

2. *Intermodulation between luminance and chrominance.*

The standard NTSC signal has three distinct deficiencies: cross color, cross luminance, and limited chrominance bandwidth. Cross color results in high-frequency luminance information being interpreted as chrominance information. The feeling is that cross color has been getting worse due to improved television cameras with extended frequency responses up to 7 MHz and computer-generated images which generate fast transitions at all angles. Cross luminance, visible only with a comb filter decoder, is the result of mistaking chrominance at vertical transitions to be luminance, and is displayed as one or two lines of dots at 3.58 MHz (the "hanging dot" pattern).

Limited chrominance bandwidth is most noticeable at sharp vertical junctures between highly dissimilar colors. For example, the transition from green to

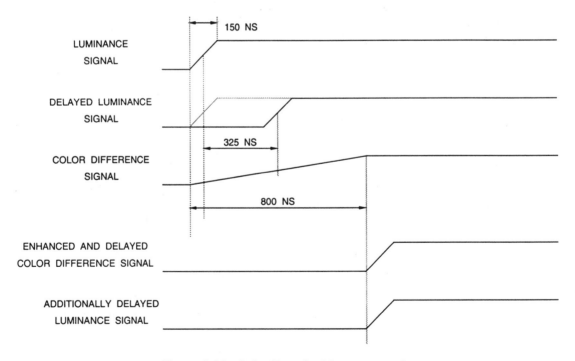

Figure 4.23. Color Transient Improvement.

magenta on the standard color bar pattern shows the effect of the slow decay of green and the slow rise of magenta. During these types of transitions, the subcarrier dot pattern is also noticeable.

The key to reducing these artifacts would be to design a new encoder and decoder. The encoder would prevent the spectral overlap between luminance and chrominance by prefiltering using comb filters, as shown in Figure 4.24. Luminance information between 2.3 MHz and 4.2 MHz is precombed so it will not interfere with chrominance frequencies in that spectrum. The chrominance is also precombed so it will not interfere with luminance frequencies within the 2.3–4.2 MHz spectrum.

The comb filters for the encoder may be of various complexities, from 2H delay designs or more. Trade-offs must be made between circuit complexity, cost, and marginally improved performance (see Figure 4.25). Experiments have determined that 2H comb filters for the encoder are an adequate compromise, especially when used with decoders that use 1H or 2H comb filters (Figure 4.26). The decoder would have a vertical chrominance enhancement circuit to compensate for the loss in vertical chrominance resolution when a 2H encoder is used. In addition, the decoder adjusts the bandwidth of the chrominance channels depending on whether a large transition (wide bandwidth filter for clean, sharp transitions) or a small transition (narrow bandwidth filter to reduce chroma noise and cross color) occurs.

3. *Gamma problems.*

Present day cameras have an average gamma of 0.45, while color receivers have a gamma of 2.8 to 3.1. The overall transfer is not linear and the overall displayed gamma is about 1.35. This results in compressed blacks and disappearing details in dark areas, with whites that are overly amplified. Significant improvements have been observed if the RGB outputs from the

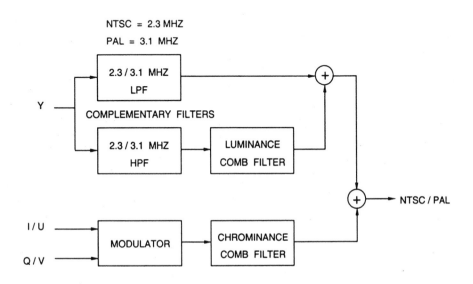

Figure 4.24. Improved Encoder.

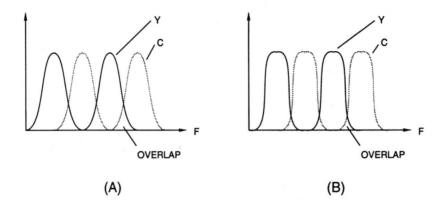

Figure 4.25. **Various Encoder Comb Filter and Spectral Overlay Configurations. (a) 2H comb. (b) 6H comb.**

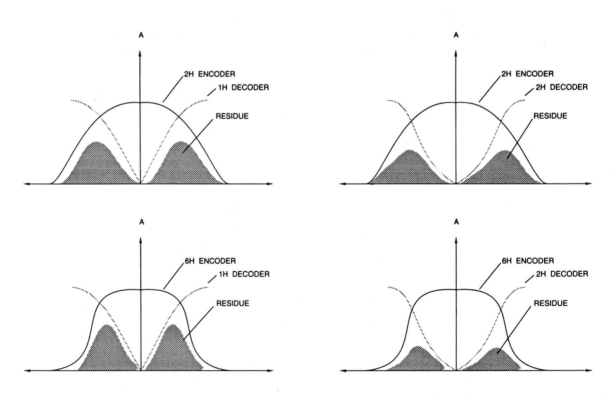

Figure 4.26. Various Encoder and Decoder Comb Filter Configurations and the Resulting Spectral Overlay.

NTSC decoder are subjected to a gamma correction of 0.74, reestablishing proper gray scale and generating more natural blacks without white saturation.

Component Analog Video (CAV) Formats

In addition to the standard NTSC, PAL, and SECAM composite video formats, several component analog video formats may be used in the editing and production process. These provide the advantage of maintaining separate luminance and color difference signals throughout the editing and storage processes. Most CAV formats have no use for the 7.5 IRE setup used in NTSC, which represents a 7.5% loss in dynamic range, so the newer CAV formats do not use a setup pedestal. CAV formats may sample the color difference components at half the rate of the luminance signal. Table 4.14 lists the common CAV formats. Figure 4.27 and Figure 4.28 illustrate the vertical blanking intervals of the luminance channel for 525-line and 625-line systems, respectively.

Format	Output Signal	Signal Amplitudes (volts)	Notes
BetaCam (see Note 1)	Y	+ 0.714	7.5% setup on Y only 75% saturation three wire = (Y + sync), (R′ – Y), (B′– Y)
	sync	– 0.286	
	R′ – Y, B′ – Y	± 0.350	
M-2 (see Note 2)	Y	+ 0.700	7.5% setup on Y only 100% saturation three wire = (Y + sync), (R′ – Y), (B′– Y)
	sync	– 0.300	
	R′ – Y, B′ – Y	± 0.324	
SMPTE (see Note 3)	Y	+ 0.700	0% setup on Y 100% saturation three wire = (Y + sync), (Pr + sync), (Pb + sync)
	sync	– 0.300	
	Pr, Pb	± 0.350	
	G′	+ 0.700	0% setup on R′, G′, and B′ 100% saturation three wire = (G′ + sync), (B′ + sync), (R′ + sync)
	B′	+ 0.700	
	R′	+ 0.700	
	sync	– 0.300	

Notes:
1. Trademark of Sony Corporation.
2. Trademark of Matsushita Corporation.
3. SMPTE 253 proposed standard. GBR notation is used to differentiate from standard RGB signals.

Table 4.14. Popular Component Analog Video Formats.

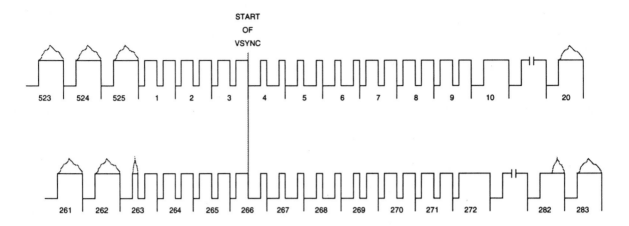

Figure 4.27. 525-line Luminance Channel Vertical Intervals. Timing is the same as for (M) NTSC, except pulse rise/fall times are 140 ±20 ns. (See Figure 4.5 for equalization and serration pulse details.)

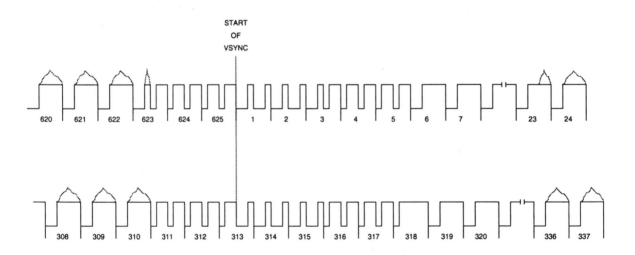

Figure 4.28. 625-line Luminance Channel Vertical Intervals. Timing is the same as for (B, D, G, H, I) PAL, except pulse rise/fall times are 140 ±20 ns. (See Figure 4.5 for equalization and serration pulse details.)

SMPTE High-Definition Production Standard

The SMPTE 240M-1988 standard was developed to standardize the production of 1125/60 high-definition source material in the United States. The main timing parameters are:

Total scan lines per frame:	1125
Active lines per frame:	1035
Scanning format:	2:1 interlaced
Aspect ratio:	16:9
Field rate:	60.00 Hz
Line rate:	33,750 Hz
Total pixels per line:	2200
Active pixels per line:	1920
Pixel clock frequency:	74.25 MHz

The chromaticity reference of the primaries are specified to be:

G: x = 0.310 y = 0.595
B: x = 0.155 y = 0.070
R: x = 0.630 y = 0.340

where x and y are CIE 1931 chromaticity coordinates. Reference white was chosen to match those of CIE illuminate D_{65}:

x = 0.3127 y = 0.3291

The optoelectronic transfer characteristics of the reference camera are specified to be:

$V = 1.1115L^{0.45} - 0.1115$ for $L \geq 0.0228$
$V = 4.0L$ for $L < 0.0228$

where V is the video signal output of the reference camera and L is the light input to the reference camera, both normalized to reference white. Therefore, the electro-optical transfer characteristics of the reference receiver are specified to be:

$L = ((V + 0.1115)/1.1115)^{2.2}$ for $V \geq 0.0913$
$L = V/4.0$ for $V < 0.0913$

where V is the video signal driving the reference receiver and L is the light output from the reference receiver, both normalized to reference white.

Y, Pr, and Pb are derived from gamma-corrected RGB signals as follows:

$Y = 0.212R' + 0.701G' + 0.087B'$
$Pr = (R' - Y)/1.576$
$Pb = (B' - Y)/1.826$

A gamma factor of 2.2 is used. Conversion between YPrPb and gamma-corrected RGB may also be expressed using matrix notation:

$$\begin{bmatrix} G' \\ B' \\ R' \end{bmatrix} = \begin{bmatrix} 1.000 & -0.227 & -0.477 \\ 1.000 & 1.826 & 0.000 \\ 1.000 & 0.000 & 1.576 \end{bmatrix} \begin{bmatrix} Y \\ Pb \\ Pr \end{bmatrix}$$

$$\begin{bmatrix} Y \\ Pb \\ Pr \end{bmatrix} = \begin{bmatrix} 0.701 & 0.087 & 0212 \\ -0.384 & 0.500 & -0.116 \\ -0.445 & -0.055 & 0.500 \end{bmatrix} \begin{bmatrix} G' \\ B' \\ R' \end{bmatrix}$$

The analog video signals for Y, R', G', and B' have the following levels assigned (note the use of the trilevel sync pulse):

Reference black level:	0 mV
Reference white level:	700 mV
Synchronizing level:	± 300 mV

The bandwidth of the analog Y, R, G, and B signals is 30 MHz. The analog video signals for Pr and Pb have the following levels assigned:

Reference zero level:	0 mV
Reference peak levels	±350 mV
Synchronizing level:	±300 mV

The bandwidth of the analog Pr and Pb signals is 30 MHz for analog-originating equipment and 15 MHz for digital originating equipment.

The horizontal timing is illustrated in Figure 4.29. All events are specified in terms of the reference clock period, and at the midpoint of transitions. The major timing events of a video line, and the reference clock count at which they occur, are:

Rising edge of sync (timing reference):	0
Trailing edge of sync:	44
Start of active video:	192
End of active video:	2112
Leading edge of sync:	2156

The duration of video and sync waveforms, as shown in Figure 4.30, are:

	clocks	μsec
a	44	0.593
b	88	1.185
c	44	0.593
d	132	1.778
e	192	2.586
sync rise time	4	0.054
total line	2200	29.63
active line	1920	25.86

Figure 4.31 and Figure 4.32 illustrate the field synchronizing pulse and field blanking intervals, respectively.

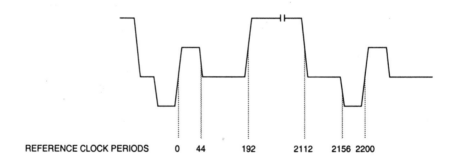

REFERENCE CLOCK PERIODS 0 44 192 2112 2156 2200

Figure 4.29. Major timing events within a video line.

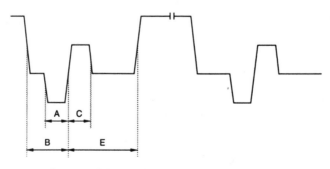

Figure 4.30. Horizontal Timing Waveforms.

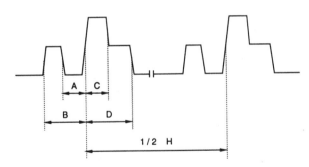

Figure 4.31. Field synchronizing pulse.

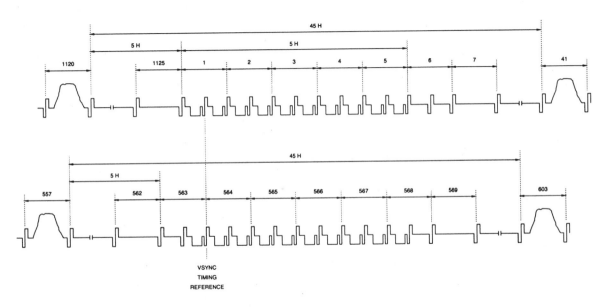

Figure 4.32. Field Blanking Intervals.

Both the total (1125) and active (1035) scan lines per frame are simply related to both the current 525-line and 625-line systems, easing the standards down-conversion process, while maintaining the goal of at least 1000 scan lines:

for 525-line system:
1125 = (15/7) 525
1035 = (15/7) 483

for 625-line system:
1125 = (9/5) 625
1035 = (9/5) 575

Work is progressing on a digital representation (SMPTE 260M) based on the 22:11:11 member of the CCIR Recommendation 601 hierarchy. Both 8 and 10 bits per sample are supported, with the quantization levels and sampling structure the same as used for CCIR Recommendation 601.

CCIR High-Definition Production Standard

Work is also progressing on CCIR Recommendation 709 (1990). This specifies the basic parameter values for studio and international program exchange of HDTV. The chromaticity coordinates (CIE 1931), which are subject to change, are different from those specified by the SMPTE HDTV production standard:

G: x = 0.300 y = 0.600
B: x = 0.150 y = 0.060
R: x = 0.640 y = 0.330

Reference white was chosen to match those of CIE illuminate D_{65}:

x = 0.3127 y = 0.3291

The optoelectronic transfer characteristics of the reference camera are currently:

$V = 1.099L^{0.45} - 0.099$ for $L \geq 0.018$
$V = 4.5L$ for $L < 0.018$

where V is the video signal output of the reference camera and L is the light input to the reference camera, both normalized to reference white. Y, Pr, and Pb are derived from gamma-corrected RGB signals as follows:

$Y = 0.2125R' + 0.7154G' + 0.0721B'$
$Pr = 0.6349 (R' - Y)$
$Pb = 0.5389 (B' - Y)$

The goal of CCIR Recommendation 709 is to eventually support noninterlaced scanning, while allowing current implementations to use 2:1 interlaced scanning. Currently, only the active number of pixels per scan line (1920) is specified, along with a 16:9 aspect ratio. The sampling frequency is to be an integer multiple of 2.25 MHz, with the sampling structure compatible with CCIR Recommendation 601.

References

1. Benson, K. Blair, 1986, *Television Engineering Handbook*, McGraw-Hill, Inc.
2. CCIR Report 624-4, 1990, *Characteristics of Television Systems*.
3. CCIR Recommendation 471-1, 1986, *Nomenclature and Description of Colour Bar Signals*.
4. CCIR Recommendation 472-3, 1990, *Video Frequency Characteristics of a Television System to Be Used for the International Exchange of Programmes Between Countries that Have Adopted 625-Line Colour or Monochrome Systems*.
5. CCIR Recommendation 709, 1990, *Basic Parameter Values for the HDTV Standard for the Studio and for International Programme Exchange*.
6. *Encoded Color Bar Signal*, EIA-189-A, July 1976, Electronic Industries Association.
7. Faroudja, Yves Charles, *NTSC and Beyond*, *IEEE Transactions on Consumer Electronics*, Vol. 34, No. 1, February 1988.
8. Pritchard, D.H. and Gibson, J.J., *Worldwide Color Television Standards—Similarities and Differences*, Volume 80, February 1980, SMPTE Journal.
9. *SMPTE Standard for Television*, SMPTE 240M-1988, Signal Parameters for 1125/60 High-Definition Production System, March 14, 1988.
10. *SMPTE 230M-1987, American National Standard for Video Recording, 1/2-in Type L Mode 1 Electrical Parameters—Video, Audio, Time and Control Code and Tracking Control*, September 2, 1987.
11. *Specification of Television Standards for 625-Line System-I Transmissions*, 1971, Independent Television Authority (ITA) and British Broadcasting Corporation (BBC).

Addresses

CCIR The International Radio
Consultative Committee
International Telecommunications
Union
Place Des Nations
CH-1211 Geneva
20 Switzerland
(011) 4122 730 5800

CCITT The International Telephone and
Telegraph Consultative
Committee
International Telecommunications
Union
Place Des Nations
CH-1211 Geneva
20 Switzerland
(011) 4122 730 5851

EBU European Broadcasting Union
The Technical Center of the EBU
32, Avenue Albert Lancaster
B-1180 Brussels
Belgium

EIA Electronic Industries Association
2001 Pennsylvania Avenue, NW
Washington, DC 20006
Headquarters: (202) 457 4936
Standards: (800) 854 7179

IEEE Institute of Electrical and
Electronics Engineers
Headquarters:
345 East 47th Street
New York, NY 10017
(212) 705 7900
Standards Office:
IEEE Service Center
P.O. Box 1331
Piscataway, NJ 00855
(908) 981 0060

SMPTE Society of Motion Picture and
Television Engineers
595 W. Hartsdale Ave.
White Plains, NY 10607
(914) 761 1100

NTSC/PAL
Digital Encoding

Although not exactly "digital" video, the NTSC and PAL composite color video formats are currently the most common formats for video, and therefore should be supported in a graphics/video system. Although the video signals themselves are analog, they can be generated almost entirely digitally. Analog NTSC and PAL encoders have been around for some time. However, they have been difficult to use, required adjustment, and offered limited video quality. Using digital techniques to implement NTSC and PAL encoding offers many advantages, such as ease of use, minimum analog adjustments, and excellent video quality.

In addition to generating composite video, S-video should also be supported in graphics/video systems, as many high-end consumer and industrial implementations are based on S-VHS or Hi-8. S-video uses separate luminance and chrominance analog video signals so higher quality may be maintained by eliminating the Y/C separation process.

A NTSC/PAL encoder designed for the computer environment requires several unique features. First, it should implement a simple, drop-in solution, as easy to use as any other MPU peripheral. Both the RGB and YCrCb input formats, with programmable input lookup tables, should be supported to allow the system designer flexibility in interfacing to a processing function or frame store before the encoder. RGB is a common input format, as many computer systems use the RGB color space for graphics, while the YCrCb input format is useful if video processing (such as decompression or scaling) is to be done.

A digital encoder should support several pixel clock rates and pixel input configurations, as shown in /Table 5.1. Supporting square pixels directly as an input format on an encoder greatly simplifies integrating video into the computer environment. The other formats shown are commonly used in video editing equipment.

Standard computer-oriented video timing signals should be used by the encoder. These include horizontal sync, vertical sync, and blanking. Additional input control signals to ease system design include field identification signals, useful for video editing.

A robust encoder design will also provide test functions to allow the designer to debug the encoder, and the system, as easily as possible. Color bar generation can easily be added

	Pixel Clock Rate	Applications	Horizontal Resolution (pixels-total)	Horizontal Resolution (pixels-active)	Vertical Resolution (total)
(M) NTSC	12.27 MHz	square pixels PCs, workstations	780	640	525
	13.5 MHz	CCIR 601	858	720	
	14.32 MHz	studio editing	910	768	
(B, D, G, H, I) PAL	14.75 MHz	square pixels PCs, workstations	944	768	625
	13.5 MHz	CCIR 601	864	720	
	17.72 MHz	studio editing	1135	948	

Table 5.1. Common Input Pixel Rates and Resolutions.

to the encoder to ease system and device checking.

In some applications, both NTSC/PAL video and 4:2:2 digital component video (Chapter 8) are video output formats. In this instance, since the NTSC/PAL encoder has all of the necessary timing information, it may be advantageous for it to generate the H (horizontal blanking), V (vertical blanking), and F (field) control signals required by the 4:2:2 encoder.

This chapter discusses the design of a digital encoder (whose block diagram is shown in Figure 5.1) that generates baseband composite (M) NTSC and (B, D, G, H, I) PAL video signals, and also has separate Y/C outputs for supporting S-video. (M) and (N) PAL are easily accommodated with some slight modifications. The highest possible quality video should be used in video editing environments to minimize artifacts produced during editing and mixing. Timecode support (vertical interval timecode or VITC, and longitudinal timecode or LTC) is reviewed here, along with various video test signals.

Baseband audio is transmitted using one or two (for stereo) conventional analog or digital audio channels.

Color Space Conversion

At a minimum, the digital RGB and YCrCb color spaces should be supported as input formats. These are converted to the YIQ (for NTSC) or YUV (for PAL) color spaces for further processing. Where ranges of values are mentioned, it is assumed 8-bit (plus sign) data values are used; 9-bit or 10-bit (plus sign) data values will result in more accurate computations at the expense of more circuitry. Encoders supporting only pseudo-color as an input pixel format could perform the color space conversion in the software driver that loads the lookup table RAMs, reducing the hardware requirements in the encoder.

The YCrCb input data has a nominal range of 16–235 for Y and 16–240 for Cr and Cb. As YCrCb values outside these ranges result in overflowing the standard YIQ or YUV ranges

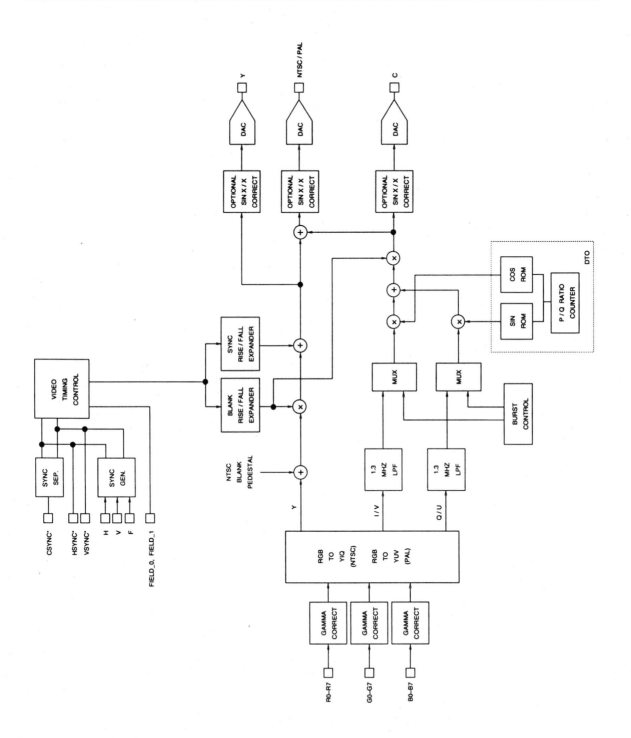

Figure 5.1. Typical NTSC/PAL Digital Encoder Implementation.

for some color combinations, one of four things may be done, in order of preference: (a) allow the NTSC/PAL video signal to be generated using the extended YIQ or YUV ranges; (b) limit the color saturation after chrominance modulation to ensure a legal video signal is generated; (c) clip the YIQ or YUV levels to the valid ranges; or (d) clip the YCrCb input values to 16–235 for Y and 16–240 for Cr and Cb. Note that 4:2:2 YCrCb data must be converted to 4:4:4 YCrCb data before being converted to YIQ or YUV data. The chrominance lowpass digital filters will not perform the interpolation properly. YCrCb data must be derived from gamma-corrected RGB data assuming a gamma value of 2.2 (NTSC operation) or 2.8 (PAL operation).

NTSC Color Space Conversion

Arbitrarily choosing to generate the NTSC digital composite video levels (white = 200, blank = 60, sync = 4), and knowing that the blank-to-white amplitude is 0.714 V, the full-scale output of the D/A converters is therefore set to 1.3 V. Of the 140 levels between blank and white, 129.5 are used for luminance. Since computers commonly use linear RGB data, linear RGB data is converted to gamma-corrected RGB data as follows (values are normalized to have a value of 0 to 1):

for R, G, B < 0.018

$$R' = 4.5\,R$$
$$G' = 4.5\,G$$
$$B' = 4.5\,B$$

for R, G, B \geq 0.018

$$R' = 1.099\,R^{0.45} - 0.099$$
$$G' = 1.099\,G^{0.45} - 0.099$$
$$B' = 1.099\,B^{0.45} - 0.099$$

The gamma-corrected digital RGB data is then converted to YIQ data by scaling the general RGB-to-YIQ equations in Chapter 3 by 129.5/255:

RGB to YIQ

$$Y = 0.152R' + 0.298G' + 0.058B'$$
$$I = 0.303R' - 0.140G' - 0.163B'$$
$$Q = 0.108R' - 0.266G' + 0.158B'$$

YCrCb to YIQ

$$Y = 0.591(Y - 16)$$
$$I = 0.597(Cr - 128) - 0.274(Cb - 128)$$
$$Q = 0.387(Cr - 128) + 0.422(Cb - 128)$$

The color space conversion should maintain a minimum of 4 bits of fractional data with the final results rounded to the desired accuracy. The RGB input data has a range of 0 to 255. Rounding to eight bits, Y has a range of 0 to 130, I a range of 0 to ±78, and Q a range of 0 to ±68.

Professional video systems may use the gamma-corrected RGB color space, with RGB having a nominal range of 16 to 235. Occasional values less than 16 and greater than 235 are allowed, resulting in YIQ values outside their nominal ranges. In this instance, RGB may be converted to YIQ by scaling the RGB-to-YIQ equations by 255/219:

$$Y = 0.177(R' - 16) + 0.347(G' - 16) + 0.067(B' - 16)$$

$$I = 0.353(R' - 16) - 0.163(G' - 16) - 0.190(B' - 16)$$

$$Q = 0.126(R' - 16) - 0.310(G' - 16) + 0.184(B' - 16)$$

PAL Color Space Conversion

The color space conversion equations for PAL operation are derived so that the full-scale output of the D/A converters is still 1.3 V to avoid

using two D/A voltage references. Using the same sync tip value of 4 and white value of 200 to generate a 1-V signal places the blanking level at 63, resulting in 137 levels being used for luminance. Since computers commonly use linear RGB data, linear RGB data is converted to gamma-corrected RGB data as follows (values are normalized to have a value of 0 to 1):

for R, G, B < 0.018

$$R' = 4.5\,R$$
$$G' = 4.5\,G$$
$$B' = 4.5\,B$$

for R, G, B ≥ 0.018

$$R' = 1.099\,R^{0.36} - 0.099$$
$$G' = 1.099\,G^{0.36} - 0.099$$
$$B' = 1.099\,B^{0.36} - 0.099$$

The gamma-corrected digital RGB data is then converted to YUV data by scaling the general RGB-to-YUV equations in Chapter 2 by 137/255:

RGB to YUV

$$Y = 0.161R' + 0.315G' + 0.061B'$$
$$U = -0.079R' - 0.155G' + 0.234B'$$
$$V = 0.330R' - 0.277G' - 0.053B'$$

YCrCb to YUV

$$Y = 0.626(Y - 16)$$
$$U = 0.533(Cb - 128)$$
$$V = 0.752(Cr - 128)$$

The color space conversion should maintain a minimum of 4 bits of fractional data with the final results rounded to the desired accuracy. The RGB input data has a range of 0 to 255.

Rounding to eight bits, Y has a range of 0 to 137, U a range of 0 to ±60, and V a range of 0 to ±85.

Low-cost PAL encoders may also use YCrCb-to-YUV or RGB-to-YUV color space conversion based on simple shifts and adds at the expense of color accuracy:

YCrCb to YUV

$$Y = (1/2)(Y - 16) + (1/8)(Y - 16)$$
$$U = (1/2)(Cb - 128) + (1/32)(Cb - 128)$$
$$V = (1/2)(Cr - 128) + (1/4)(Cr - 128)$$

RGB to YUV

$$Y = (1/8)R' + (1/32)R' + (1/4)G' + (1/16)G' + (1/16)B'$$

$$U = -(1/16)R' - (1/32)R' - (1/8)G' - (1/32)G' + (1/4)B'$$

$$V = (1/4)R' + (1/16)R' + (1/32)R' - (1/4)G' - (1/32)G' - (1/16)B'$$

Professional video systems may use the gamma-corrected RGB color space, with RGB having a nominal range of 16 to 235. Occasional values less than 16 and greater than 235 are allowed, resulting in YUV values outside their nominal ranges. In this instance, RGB may be converted to YUV by scaling the RGB-to-YUV equations by 255/219:

$$Y = 0.187(R' - 16) + 0.367(G' - 16) + 0.071(B' - 16)$$

$$U = -0.092(R' - 16) - 0.180(G' - 16) + 0.272(B' - 16)$$

$$V = 0.384(R' - 16) - 0.322(G' - 16) - 0.062(B' - 16)$$

Composite Luminance Generation

NTSC Operation

As NTSC requires a 7.5 IRE blanking pedestal, a value of 10 must be added to the digital luminance data during active video (0 is added during the blank time). The digital luminance data (after the blanking pedestal is added) is multiplied by a blanking signal that has a Gaussian distribution (between 0 and 1) to slow the slew rate of the blanked video signal to within composite video specifications and avoid ringing. A typical blank rise/fall time for NTSC and PAL is 140 and 300 ns, respectively. All of the Gaussian blanking coefficients should fall within a TTL blanking control signal.

Digital composite sync information must also be added to the luminance data after the blank processing has been performed. Digital values of 4 (sync present) or 60 (no sync) are assigned. The sync rise and fall times should be processed so as to generate a Gaussian distribution (between 4 and 60) to slow the slew rate of the sync signal to within composite video specifications and avoid ringing. A typical sync rise/fall time for NTSC is 140 ns, although the encoder should generate sync rise/fall edges of about 100 ns to compensate for the analog output filters slowing down the sync edges. The edges of a TTL sync control signal should be coincident with the center value (32) of the Gaussian distribution. At this point, we have luminance with sync and blanking information, as shown in Table 5.2.

PAL Operation

When generating (B, D, G, H, I) PAL composite video, there is a 0 IRE blanking pedestal. Thus, no blanking pedestal is added to the digital luminance data. Luminance video blanking should be performed in the same manner as that used for NTSC.

Digital composite sync information must also be added to the luminance data after the blank processing has been performed. Digital values of 4 (sync present) or 63 (no sync) are assigned. The sync rise and fall times should be processed so as to generate a Gaussian distribution (between 4 and 63) to slow the slew rate of the sync signal to within composite video specifications and avoid ringing. A typical sync rise/fall time for PAL is 250 ns, although the encoder should generate sync rise/fall edges of about 170 ns to compensate for the analog output filters slowing down the sync edges. The edges of a TTL sync control signal should be coincident with the center value (33.5) of the Gaussian distribution. At this point, we have luminance with sync and blanking information, as shown in Table 5.3.

Video Level	8-bit digital value	10-bit digital value
white	200	800
black	70	280
blank	60	240
sync	4	16

Table 5.2. (M) NTSC Composite Luminance Digital Values.

Video Level	8-bit digital value	10-bit digital value
white	200	800
black	63	252
blank	63	252
sync	4	16

Table 5.3. (B, D, G, H, I) PAL Composite Luminance Digital Values.

Analog Luminance Generation

The digital composite luminance data (ignoring the sign information) may drive an 8-bit D/A converter that generates a 0–1.3 V output to generate the Y video signal of an S-video (Y/C) interface. Figure 5.2 and Figure 5.3 show the luminance video waveforms for 75% amplitude, 100% saturated EIA (NTSC) and EBU (PAL) color bars. The numbers on the luminance levels indicate the data value for an 8-bit D/A converter with a full-scale output value of 1.3 V. Table 5.4 and Table 5.5 show the luminance IRE levels. Luminance IRE levels may be calculated by adding 0 (PAL) or 10.5 (NTSC) to the Y value and dividing the result by 1.37 (PAL) or 1.4 (NTSC). The 8-bit and 10-bit D/A values also contain sync and blank information.

As the sample-and-hold action of the D/A converter introduces a $\sin x/x$ characteristic, the digital composite Y data may be digitally filtered by a $\sin x/x$ correction filter to compensate. Alternately, as an analog lowpass filter (after the D/A converter) is usually used to limit the luminance bandwidth, the $\sin x/x$ correction may take place in the analog filter. The video signal at the connector should have a source impedance of 75 Ω.

As an option, the ability to delay the digital Y information a programmable number of clock cycles before driving the D/A converter may be useful. If the analog luminance video is lowpass filtered after the D/A conversion, and the analog chrominance video is bandpass filtered after the D/A conversion (see Analog Chrominance Generation), the chrominance video path will have a longer delay (typically up to about 400 ns) than the luminance video path. By adjusting the delay of the digital Y data before the D/A conversion, the analog luminance and chrominance video after filtering may be more closely aligned (to within one clock cycle), simplifying the analog design.

Color Difference Lowpass Digital Filters

The type of digital filters used to lowpass filter the I and Q (NTSC operation) or U and V (PAL operation) color difference signals are dependent on the application. Although early NTSC specifications called for 0.6-MHz lowpass filtering for Q, many current designs maintain the full 1.3-MHz bandwidth of both color difference signals and also use the U and V color difference signals instead of I and Q; the NTSC specifications have been modified to reflect this changing technology.

The color difference signals are usually digitally lowpass filtered using a Gaussian filter to minimize ringing and overshoot. Typical filter characteristics for a 1.3-MHz lowpass fil-

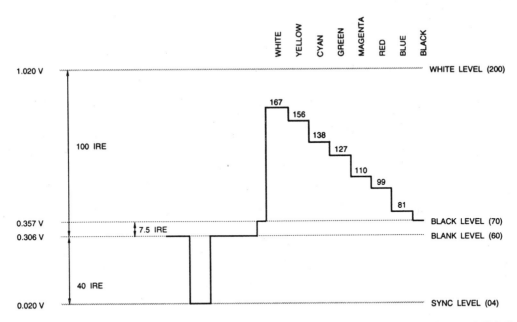

Figure 5.2. (M) NTSC Luminance (Y) Video Signal for 75% Amplitude, 100% Saturated EIA Color Bars. Indicated luminance levels are 8-bit values.

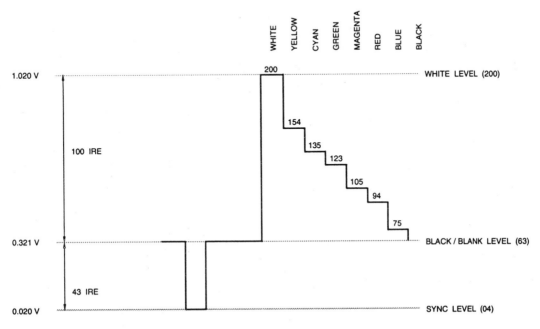

Figure 5.3. (B, D, G, H, I) PAL Luminance (Y) Video Signal for 75% Amplitude, 100% Saturated EBU Color Bars. Indicated luminance levels are 8-bit values.

	Nominal Range	White	Yellow	Cyan	Green	Magenta	Red	Blue	Black
R′	0 to 255	191	191	0	0	191	191	0	0
G′	0 to 255	191	191	191	191	0	0	0	0
B′	0 to 255	191	0	191	0	191	0	191	0
Y	0 to 130	97	86	68	57	40	29	11	0
I	0 to ±78	0	31	−58	−27	27	58	−31	0
Q	0 to ±68	0	−30	−21	−51	51	21	30	0
luminance IRE		77	69	56	48	36	28	15	7.5
8-bit D/A value		167	156	138	127	110	99	81	70
10-bit D/A value		668	624	552	508	440	396	324	280

Table 5.4. 75% Amplitude, 100% Saturated EIA Luminance Bars for (M) NTSC. RGB values are gamma-corrected RGB values.

	Nominal Range	White	Yellow	Cyan	Green	Magenta	Red	Blue	Black
R′	0 to 255	255	191	0	0	191	191	0	0
G′	0 to 255	255	191	191	191	0	0	0	0
B′	0 to 255	255	0	191	0	191	0	191	0
Y	0 to 137	137	91	72	60	42	31	12	0
U	0 to ±60	0	−45	15	−30	30	−15	45	0
V	0 to ±85	0	10	−63	−53	53	63	−10	0
luminance IRE		100	66	53	44	31	23	9	0
8-bit D/A value		200	154	135	123	105	94	75	63
10-bit D/A value		800	616	540	492	420	376	300	252

Table 5.5. 75% Amplitude, 100% Saturated EBU Luminance Bars for (B, D, G, H, I) PAL. RGB values are gamma-corrected RGB values.

ter (see Figure 5.4) are less than 2 dB (NTSC) or 3 dB (PAL) attenuation at 1.3 MHz and more than 20 dB attenuation at 3.6 MHz (more than 30 dB attenuation at 3.5 MHz if the design is to also support SECAM). If a 0.6-MHz low-pass filter for Q is used, typical filter characteristics are less than 2 dB attenuation at 0.4 MHz, less than 6 dB attenuation at 0.5 MHz,

and more than 6 dB attenuation at 0.6 MHz (see Figure 5.5).

If the encoder is to be used in a video editing environment, the digital filters should have a maximum ripple of ±0.1 dB in the passband (0–0.6 MHz or 0–1.3 MHz). This is needed to minimize the cumulation of gain and loss artifacts due to the filters, especially when multi-

Figure 5.4. Typical 1.3-MHz Lowpass Digital Filter Characteristics.

Figure 5.5. Typical 0.6-MHz Lowpass Digital Filter Characteristics.

ple passes through the encoding and decoding processes are required. At the final encoding point, the Gaussian filters may be used.

Filter Considerations

The modulation process is shown in spectral terms in Figures 5.6 through 5.9. The frequency spectra of the modulation process are the same as those if the modulation process were analog, but are also repeated at harmonics of the sample rate. Using wide-band (i.e.,

1.3 MHz) filters, the modulated chrominance spectra may overlap near the zero frequency regions, resulting in aliasing. Also, there may be considerable aliasing just above the subcarrier frequency. For these reasons, the use of narrower-band lowpass filters may be more appropriate.

Wide-band Gaussian filters ensure optimum compatibility with monochrome displays by minimizing the artifacts at the edges of colored objects. A narrower, sharper-cut lowpass filter would emphasize the subcarrier signal at

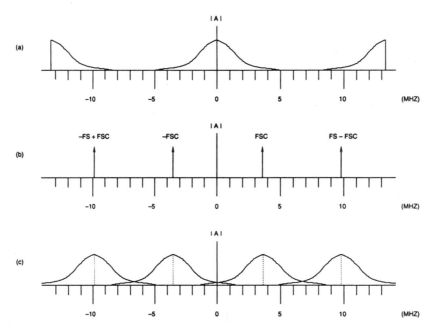

Figure 5.6. Frequency Spectra in Digital NTSC Chrominance Modulation (F_S = 13.5 MHz, F_{SC} = 3.58 MHz): (a) Gaussian Filtered I and Q Signals, (b) Subcarrier Sinewave, (c) Modulated Chrominance Spectrum Produced by Convolving (a) and (b).

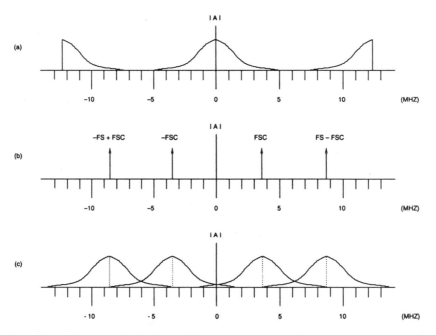

Figure 5.7. Frequency Spectra in Digital NTSC Chrominance Modulation (F_S = 12.27 MHz, F_{SC} = 3.58 MHz): (a) Gaussian Filtered I and Q Signals, (b) Subcarrier Sinewave, (c) Modulated Chrominance Spectrum Produced by Convolving (a) and (b).

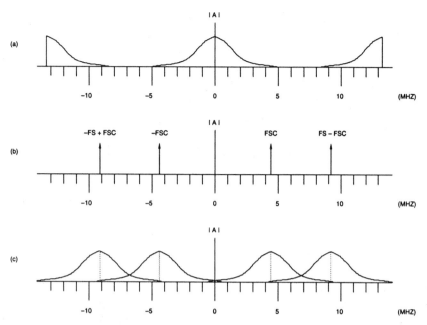

Figure 5.8. Frequency Spectra in Digital PAL Chrominance Modulation (F_S = 13.5 MHz, F_{SC} = 4.43 MHz): (a) Gaussian Filtered U and V Signals, (b) Subcarrier Sinewave, (c) Modulated Chrominance Spectrum Produced by Convolving (a) and (b).

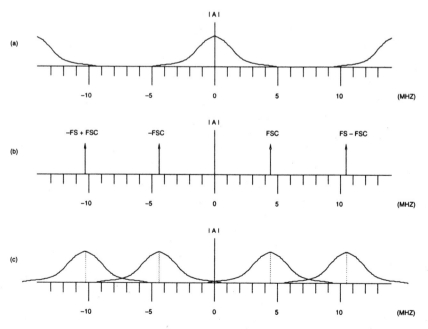

Figure 5.9. Frequency Spectra in Digital PAL Chrominance Modulation (F_S = 14.75 MHz, F_{SC} = 4.43 MHz): (a) Gaussian Filtered U and V Signals, (b) Subcarrier Sinewave, (c) modulated Chrominance Spectrum Produced by Convolving (a) and (b).

these edges, resulting in ringing. If mono-chrome compatibility can be ignored, a benefi-cial effect of narrower filters would be to reduce the spread of the chrominance into the low-frequency luminance (resulting in low-fre-quency cross-luminance), which is difficult to suppress in a decoder.

Also, although the encoder may maintain a wide chrominance bandwidth, the bandwidth of the color difference signals in a decoder are usually much narrower. In the decoder, loss of the chrominance upper sidebands (due to low-pass filtering the video signal to 4.2–5.5 MHz, depending on the video standard) contributes to ringing and IQ or UV crosstalk on color transitions. Any increase in the decoder chrominance bandwidth causes a proportion-ate increase in cross-color.

Chrominance (C) Generation

During active video, the I and Q (NTSC) or U and V (PAL) data are modulated with sin and cos subcarrier data, resulting in digital chromi-nance (C) data. As described in Chapter 4, the (M) NTSC chrominance signal is represented by:

$$Q \sin(\omega t + 33°) + I \cos(\omega t + 33°)$$
$$\omega = 2\pi F_{SC}$$
$$F_{SC} = 3.579545 \text{ MHz } (\pm 10 \text{ Hz})$$

The (B, D, G, H, I, N) PAL chrominance signal is represented by:

$$U \sin \omega t \pm V \cos \omega t$$

$$\omega = 2\pi F_{SC}$$

F_{SC} = 4.43361875 MHz (±5 Hz) for (B, D, G, H, I, N) PAL

F_{SC} = 3.58205625 MHz (±5 Hz) for the version of (N) PAL used in Argentina

with the sign of V alternating from one line to the next (known as the PAL SWITCH). The color difference components are multiplied by their respective subcarrier phases, as shown in Figure 5.1. Note that for this design during NTSC operation, the 11-bit reference subcar-rier phase (see Figure 5.20) and the burst phase are the same (180°). Thus, 213° must be added to the 11-bit reference subcarrier phase during active video time so the output of the sin and cos ROMs have the proper subcarrier phases (33° and 123°, respectively).

During PAL operation, when PAL SWITCH = zero, the 11-bit reference subcar-rier phase (see Figure 5.20) and the burst phase are the same (135°). Therefore, 225° must be added to the 11-bit reference subcar-rier phase during active video time so the out-put of the sin and cos ROMs have the proper subcarrier phases (0° and 90°, respectively). When PAL SWITCH = one, 90° is added to the 11-bit reference subcarrier phase, resulting in a 225° burst phase, and an additional 135° must be added to the 11-bit reference subcar-rier phase during active video time so the out-put of the sin and cos ROMs have the proper phases (0° and 90°, respectively). Note that while PAL SWITCH = one, the –V subcarrier is generated, effectively implementing the –V component required.

The subcarrier sin and cos values should have a minimum of 7 bits plus sign of accuracy, resulting in a range of 0 to ±127/128. The mod-ulation multipliers must have saturation logic on the outputs to ensure overflow and under-flow conditions are saturated to the maximum and minimum values, respectively. After the modulated I and Q (NTSC) or U and V (PAL) signals are added together, the result is rounded to the desired accuracy (it should be the same accuracy as the luminance to ease adding the two together later). At this point, the digital modulated chrominance, rounded to eight bits, has a range of 0 to ±82 for NTSC and 0 to ±87 for PAL. The resulting digital

chrominance data is multiplied by a blanking signal that has the same Gaussian rise and fall values and timing as the one used to blank the luminance data.

Note that if YCrCb input data is used, and the YUV color space is used for both NTSC and PAL generation, the values in the sin and cos ROMs may be adjusted to allow the modulation multipliers to accept (Cr – 128) and (Cb – 128) data directly, avoiding separate color space conversion. During NTSC operation, the sin ROM should have a range of 0 to ±258/512 and the cos ROM should have a range of 0 to ±364/512. During PAL operation, the sin ROM should have a range of 0 to ±273/512 and the cos ROM should have a range of 0 to ±385/512.

PAL SWITCH

In theory, since the sin ωt and cos ωt subcarriers are orthogonal, the I and Q (NTSC) or U and V (PAL) signals can be perfectly separated from each other in the decoder. However, if the modulated chrominance signal is subjected to distortion, such as asymmetrical attenuation of the sidebands or differential phase distortion, the orthogonality is degraded, resulting in crosstalk between the I and Q (NTSC) or U and V (PAL) signals.

PAL uses alternate line switching of the V signal to provide a frequency offset between the U and V subcarriers, in addition to the subcarrier phase offset. When decoded, crosstalk components appear modulated onto the alternate line carrier frequency, in solid color areas producing a moving pattern known as Hanover bars. This pattern may be suppressed in the decoder by a comb filter that averages equal contributions from switched and unswitched lines.

Burst Generation

As shown in Figure 5.1, the lowpass filtered I and Q (NTSC) or U and V (PAL) data are mul-

tiplexed with the color burst gate information. During the color burst time, the color difference data should be ignored, and the burst envelope signal inserted on the Q (NTSC) or U (PAL) channel (the I or V channel is forced to zero).

The burst gate rise and fall times should be processed to generate a Gaussian distribution (between 0 and 28 for NTSC, between 0 and 30 for PAL), to slow the slew rate of the burst envelope to within composite video specifications. A typical burst envelope rise/fall time is 300 ±100 ns. The burst envelope signal should be wide enough to generate either nine cycles of burst information for (M) NTSC and (M) PAL, and combination (N) PAL, or ten cycles of burst information for (B, D, G, H, I, N) PAL, with an amplitude of 50% or greater. When the burst envelope signal is multiplied by the output of the sin ROM (which has a range of 0 to ± 1), the color burst is generated and will have a range of 0 to ± 28 (NTSC) or 0 to ± 30 (PAL).

For a multistandard encoder that may operate at various clock rates (and therefore have various numbers of pixels per scan line), note that the beginning and end of the burst gate envelope signal may be calculated based on the total number of pixels per scan line (HCOUNT). These calculations specify the 50% point of the burst envelope amplitude. A value of half the rise and fall time (in clock cycles) must be added to the (stop) value and subtracted from the (start) value to allow for the Gaussian rise and fall times. Truncation is assumed in the division process.

For (M) NTSC:

burst gate start = (HCOUNT/16) + (HCOUNT/64) + (HCOUNT/256) + (HCOUNT/512) + 1

burst gate stop = burst gate start + (HCOUNT/32) + (HCOUNT/128) + 1

For (B, D, G, H, I, N) and combination (N) PAL:

burst gate start = (HCOUNT/16) + (HCOUNT/64) + (HCOUNT/128) + 3

burst gate stop = burst gate start + (HCOUNT/32) + (HCOUNT/256) + 1

The phase of the color burst should be user programmable over a 0 to 360° range to provide optional system phase matching with external video signals. This can be done by adding a programmable value to the 11-bit subcarrier reference phase during the burst time (see Figure 5.20). Table 5.6 shows the results of adding the digital chrominance and burst information.

Analog Chrominance Generation

The digital chrominance data may drive an 8-bit D/A converter that generates a 0–1.3 V output to generate the C video signal of an S-video (Y/C) interface. Figures 5.10 and 5.11 show the modulated chrominance video waveforms for 75% amplitude, 100% saturated EIA (NTSC) and EBU (PAL) color bars. The numbers in parentheses indicate the data value for an 8-bit D/A converter with a full-scale output value of 1.3 V. If the D/A converter can't handle the generation of bipolar video signals, an offset must be added to the chrominance data (and the sign information dropped) before driving

the D/A converter. In this instance, an 8-bit offset of +128 was used, positioning the blanking level at the midpoint of the D/A converter output level, as shown in Figures 5.10 and 5.11.

Chrominance ranges are

$$\pm\sqrt{I^2 + Q^2}$$

for NTSC, or

$$\pm\sqrt{U^2 + V^2}$$

for PAL. Chrominance IRE levels may be calculated by dividing the peak chrominance range by 1.4 (NTSC) or 1.37 (PAL). Tables 5.7 and 5.8 show the chrominance IRE levels and phase angles for 75% amplitude, 100% saturated EIA (NTSC) and EBU (PAL) color bars, respectively. Figure 5.12 illustrates the IQ vector diagram and values for 75% amplitude, 100% saturated EIA (NTSC) color bars. Figure 5.13 and Figure 5.14 illustrate the UV vector diagrams and values for 75% amplitude, 100% saturated EBU (PAL) color bars.

As the sample-and-hold action of the D/A converter introduces a sin x/x characteristic, the digital chrominance data may be digitally filtered by a sin x/x correction filter to compensate. Alternately, as an analog lowpass filter (after the D/A converter) is usually used to limit the chrominance bandwidth, the sin x/x correction may take place in the analog filter. The video signal at the connector should have a source impedance of 75 Ω.

Video Level	NTSC 8-bit digital value	NTSC 10-bit digital value	PAL 8-bit digital value	PAL 10-bit digital value
peak chroma	82	328	87	347
peak burst	28	112	30	118
blank	0	0	0	0
peak burst	−28	−112	−30	−118
peak chroma	−82	−328	−87	−347

Table 5.6. Chrominance Digital Values for (M) NTSC and (B, D, G, H, I) PAL.

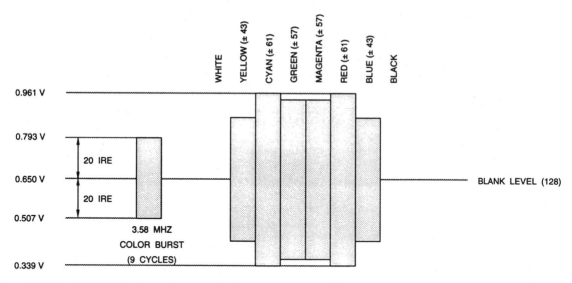

Figure 5.10. (M) NTSC Chrominance (C) Video Signal for 75% Amplitude, 100% Saturated EIA Color Bars. Indicated video levels are 8-bit values.

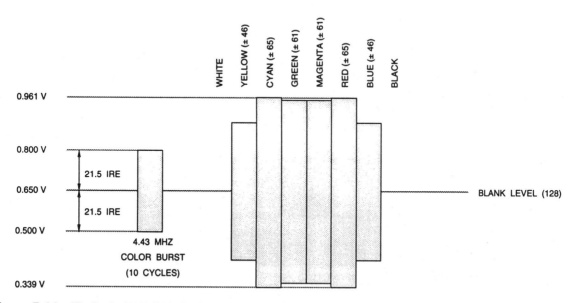

Figure 5.11. (B, D, G, H, I) PAL Chrominance (C) Video Signal for 75% Amplitude, 100% Saturated EBU Color Bars. Indicated video levels are 8-bit values.

	Nominal Range	White	Yellow	Cyan	Green	Magenta	Red	Blue	Black
R′	0 to 255	191	191	0	0	191	191	0	0
G′	0 to 255	191	191	191	191	0	0	0	0
B′	0 to 255	191	0	191	0	191	0	191	0
Y	0 to 130	97	86	68	57	40	29	11	0
I	0 to ±78	0	31	−58	−27	27	58	−31	0
Q	0 to ±68	0	−30	−21	−51	51	21	30	0
chroma IRE		0	62	88	82	82	88	62	0
8-bit D/A value		0	±43	±61	±57	±57	±61	±43	0
10-bit D/A value		0	±173	±245	±229	±229	±245	±173	0
phase		−	167°	283°	241°	61°	103°	347°	−

Table 5.7. 75% Amplitude, 100% Saturated EIA Color Bars for (M) NTSC. Chrominance IRE levels are peak-to-peak. RGB values are gamma-corrected RGB values.

	Nominal Range	White	Yellow	Cyan	Green	Magenta	Red	Blue	Black
R′	0 to 255	255	191	0	0	191	191	0	0
G′	0 to 255	255	191	191	191	0	0	0	0
B′	0 to 255	255	0	191	0	191	0	191	0
Y	0 to 137	137	91	72	60	42	31	12	0
U	0 to ±60	0	−45	15	−30	30	−15	45	0
V	0 to ±85	0	10	−63	−53	53	63	−10	0
chroma IRE		0	67	95	89	89	95	67	0
8-bit D/A value		0	±46	±65	±61	±61	±65	±46	0
10-bit D/A value		0	±184	±260	±242	±242	±260	±184	0
phase: line n (burst = 135°)		−	167°	283°	241°	61°	103°	347°	−
phase: line n + 1 (burst = 225°)		−	193°	77°	120°	300°	257°	13°	−

Table 5.8. 75% Amplitude, 100% Saturated EBU Color Bars for (B, D, G, H, I) PAL. Chroma IRE levels are peak-to-peak. RGB values are gamma-corrected RGB values. Line n corresponds to odd-numbered scan lines in fields 1, 2, 5, and 6; even numbered scan lines in fields 3, 4, 7, and 8. Line n + 1 corresponds to even-numbered scan lines in fields 1, 2, 5, and 6; odd-numbered scan lines in fields 3, 4, 7, and 8.

Video Level	NTSC 8-bit digital value	NTSC 10-bit digital value	PAL 8-bit digital value	PAL 10-bit digital value
peak chroma	243	972	245	980
white	200	800	200	800
peak burst	88	352	93	370
black	70	280	63	252
blank	60	240	63	252
peak burst	32	128	33	134
peak chroma	26	104	18	72
sync	4	16	4	16

Table 5.9. Composite (M) NTSC and (B, D, G, H, I) PAL Digital Video Levels.

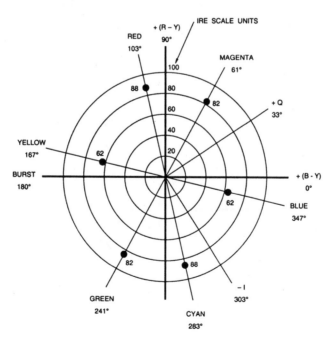

Figure 5.12. IQ Vector Diagram for 75% Amplitude, 100% Saturated EIA Color Bars.

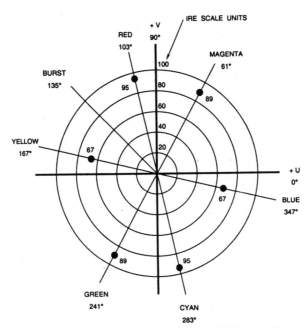

Figure 5.13. UV Vector Diagram for 75% Amplitude, 100% Saturated EBU Color Bars. Line n, PAL SWITCH = zero.

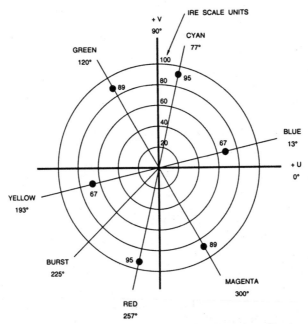

Figure 5.14. UV Vector Diagram for 75% Amplitude, 100% Saturated EBU Color Bars. Line n + 1, PAL SWITCH = one.

Analog Composite Video

The digital composite luminance (Y) data and the digital chrominance (C) data are added together, generating digital composite color video with the levels shown in Table 5.9.

The result may drive an 8-bit D/A converter that generates a 0–1.3 V output to generate the composite video signal. Figures 5.15 and 5.16 show the video waveforms for 75% amplitude, 100% saturated EIA (NTSC) and EBU (PAL) color bars. The numbers in parentheses indicate the data value for an 8-bit D/A converter with a full-scale output value of 1.3 V.

As the sample-and-hold action of the D/A converter introduces a sin x/x characteristic,

the digital composite data may be digitally filtered by a sin x/x correction filter to compensate. Alternately, as an analog lowpass filter (after the D/A converter) is usually used to limit the video bandwidth, the sin x/x correction may take place in the analog filter. The video signal at the connector should have a source impedance of 75 Ω.

As an option, the encoder can generate a black burst (or house black) video signal that can be used to synchronize multiple video sources. Figures 5.17 and 5.18 show the video waveforms for NTSC and PAL black burst video signals. Note that these are the same as analog composite, but do not contain any active video information. The numbers in

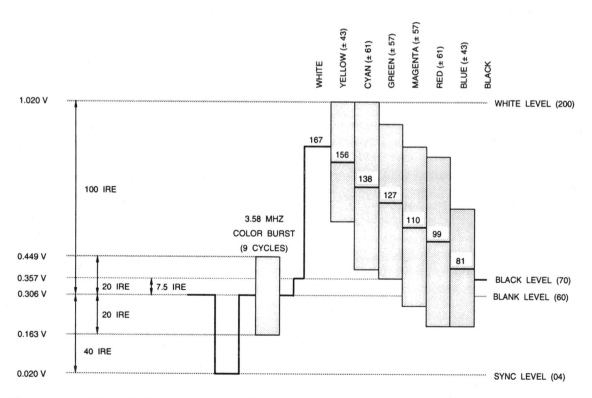

Figure 5.15. (M) NTSC Composite Video Signal for 75% Amplitude, 100% Saturated EIA Color Bars. Indicated video levels are 8-bit values.

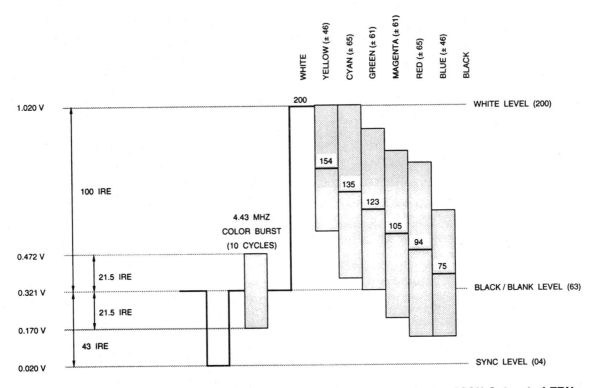

Figure 5.16. (B, D, G, H, I) PAL Composite Video Signal for 75% Amplitude, 100% Saturated EBU Color Bars. Indicated video levels are 8-bit values.

parentheses indicate the data value for an 8-bit D/A converter with a full-scale output value of 1.3 V.

Subcarrier Generation

The color subcarrier can be generated from the pixel clock using p:q ratio counter techniques. When generating video that may be used for editing, it is important to maintain the phase relationship between the color subcarrier and sync information. Unless the subcarrier phase relative to the sync phase is properly maintained, an edit may result in a momentary color shift. PAL also requires the addition of a PAL SWITCH, which is used to invert the polarity of the V video data every other scan line. Note that the polarity of the PAL SWITCH should be maintained through the encoding and decoding process.

Since in this design the subcarrier is derived from the pixel clock, any jitter in the pixel clock frequency will result in a corresponding subcarrier frequency jitter. In some computer systems, the pixel clock is generated using a phase-lock loop (PLL), which may not have the necessary pixel clock stability to keep the subcarrier phase jitter below 2°–3°. In this case, a PLL and voltage-controlled crystal oscillator (VCXO) may be used to regenerate a stable pixel clock. Back-to-back registers are used to load pixel and control data. The first register is clocked by the external pixel clock; the second register is clocked by the regenerated pixel clock. The PLL requires a long time

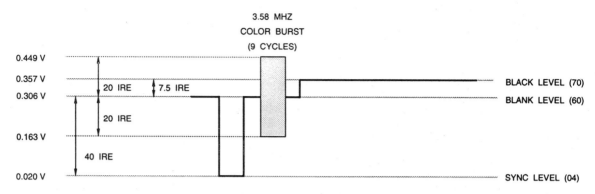

Figure 5.17. (M) NTSC Black Burst Video Signal. Indicated video levels are 8-bit values.

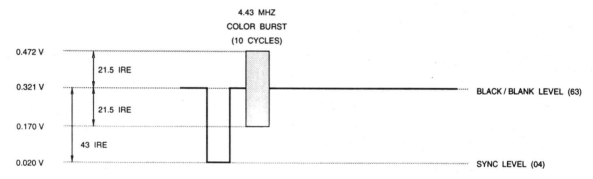

Figure 5.18. (B, D, G, H, I) PAL Black Burst Video Signal. Indicated video levels are 8-bit values.

constant to minimize jitter in the regenerated clock.

Frequency Relationships

In the (M) NTSC and (B, D, G, H, I, N) PAL color composite video standards, there are defined relationships between the subcarrier frequency (F_{SC}) and the line frequency (F_H):

PAL: $F_{SC}/F_H = (1135/4) + (1/625)$

NTSC: $F_{SC}/F_H = 910/4$

Assuming (for example only) a 13.5-MHz pixel clock rate (F_S):

PAL: $F_S = 864 F_H$

NTSC: $F_S = 858 F_H$

Combining these equations produces the relationship between F_{SC} and F_S:

PAL: $F_{SC}/F_S = 709379/2160000$

NTSC: $F_{SC}/F_S = 35/132$

which may also be expressed in terms of the pixel clock period (T_S) and the subcarrier period (T_{SC}):

PAL: $T_S/T_{SC} = 709379/2160000$

NTSC: $T_S/T_{SC} = 35/132$

The color subcarrier phase must be advanced by this fraction of a subcarrier cycle each pixel clock.

In the combination (N)PAL color composite video standard used in Argentina, there are slightly different relationships between the subcarrier frequency (F_{SC}) and the line frequency (F_H):

$$F_{SC}/F_H = (917/4) + (1/625)$$

Assuming (for example only) a 13.5-MHz pixel clock rate (F_S):

(N) PAL for Argentina: $F_S = 864\ F_H$

Combining these equations produces the relationship between F_{SC} and F_S:

$$F_{SC}/F_S = 573129/2160000$$

which may also be expressed in terms of the pixel clock period (T_S) and the subcarrier period (T_{SC}):

$$T_S/T_{SC} = 573129/2160000$$

The color subcarrier phase must be advanced by this fraction of a subcarrier cycle each pixel clock. Otherwise, this version of combination (N) PAL has the same timing as (B, D, G, H, I) PAL.

Quadrature Subcarrier Generation

A ratio counter consists of an accumulator in which a smaller number p is added modulo another number q. The counter consists of an adder and a register as shown in Figure 5.19. The contents of the register are constrained so that if they exceed or equal q, q is subtracted from the contents. The output signal (X_N) of the adder is:

$$X_N = (X_{N-1} + p)\ \text{modulo}\ q$$

With each clock cycle, p is added to produce a linearly increasing series of digital values. It is important that q not be an integer multiple of p so that the generated values are continuously different and the remainder changes from one cycle to the next. Note that the DTO may be used to reduce an input frequency F_S (in this case the pixel clock frequency) to another frequency, F_{SC} (in this case the subcarrier frequency):

$$F_{SC} = (p/q)\ F_S$$

Since the p value is of finite word length, the DTO output frequency can only be varied in steps. With a p word length of w, the lowest p step is 0.5w and the lowest DTO frequency step is:

$$F_{SC} = F_S/2^w$$

Note that the output frequency cannot be greater than half the input frequency. This means that the output frequency F_{SC} can only be varied by the increment p and within the range:

$$0 < F_{SC} < F_S/2$$

In this application, an overflow corresponds to the completion of a full cycle of the subcarrier. Since only the remainder (which represents the subcarrier phase) is required,

Figure 5.19. p:q Ratio Counter.

the number of whole cycles completed is of no interest. During each clock cycle, the output of the q register shows the relative phase of a subcarrier frequency in qths of a subcarrier period. By using the q register contents to address a ROM containing a sine wave characteristic, a numerical representation of the sampled subcarrier sine wave can be generated.

Note that, although a brute force approach to generating the 132 phases that NTSC requires is not a problem, PAL would require a ROM with 2,160,000 words of storage. To avoid this, a single 24-bit modulo q register may be used, with the 11 most significant bits providing the subcarrier reference phase. Alternately, more accuracy is achieved if the ratio is partitioned into two fractions, the more significant of which provides the subcarrier reference phase, as shown in Figure 5.20. To use the full capacity of the ROM and make the overflow of the ratio counter automatic, the denominator of the more significant fraction is made a power of two (in this instance, a value of 2048 is used). The 4x HCOUNT denominator of the least significant fraction is used to simplify hardware calculations.

Subdividing the subcarrier period into 2048 phase steps, and using the total number of pixels per scan line (HCOUNT), the ratio may be partitioned as follows:

$$\frac{FSC}{FS} = \frac{P1 + \dfrac{(P2)}{(4)\,(HCOUNT)}}{2048}$$

P1 and P2 may therefore be programmed to generate correct chrominance subcarrier frequencies although different pixel clock rates (which result in different values of HCOUNT) may be used.

The subcarrier generation ratio counters are shown in Figure 5.20. The modulo 4x HCOUNT and modulo 2048 counters should be reset at the beginning of each vertical sync of field one to ensure the generation of the correct subcarrier reference (as shown in Figures 5.21 and 5.22). The less significant stage produces a sequence of carry bits which correct the approximate ratio of the upper stage by altering the counting step by one: from P1 to P1 + 1. The upper stage then produces an accurate 11-bit subcarrier phase output to address the sine and cosine ROMs.

While the upper stage adder automatically overflows to provide modulo 2048 operation, the lower stage requires additional circuitry because 4x HCOUNT may not be (and usually isn't) an integer power of two. In this case, the 16-bit register has a maximum capacity of 65535 and the adder generates a carry for any value greater than this. To produce the correct carry sequence, it is necessary, each time the adder overflows, to adjust the next number added to make up the difference between 65535 and 4x HCOUNT. This requires:

$$P3 = 65536 - (4)\,(HCOUNT) + P2$$

Although this changes the contents of the lower stage register, the sequence of carry bits is unchanged, ensuring that the correct phase values are generated.

The P1 and P2 values are determined for (M) NTSC operation using the following equation:

$$\frac{FSC}{FS} = \frac{P1 + \dfrac{(P2)}{(4)\,(HCOUNT)}}{2048}$$

$$= \left(\frac{910}{4}\right)\left(\frac{1}{HCOUNT}\right)$$

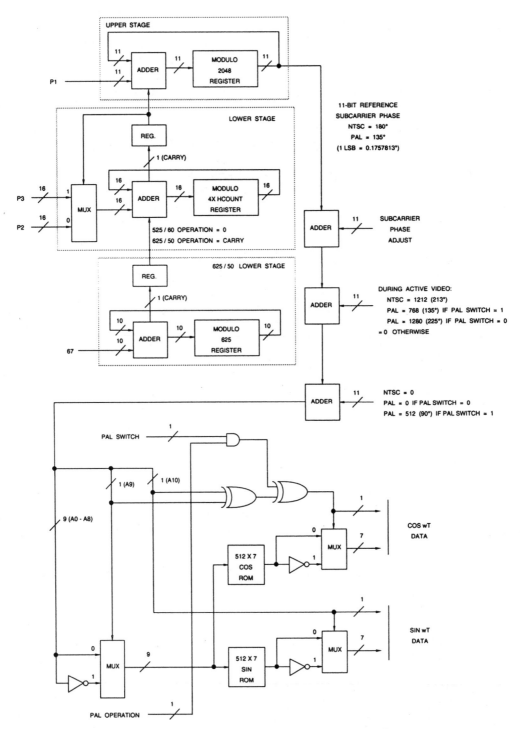

Figure 5.20. Chrominance Subcarrier Generation.

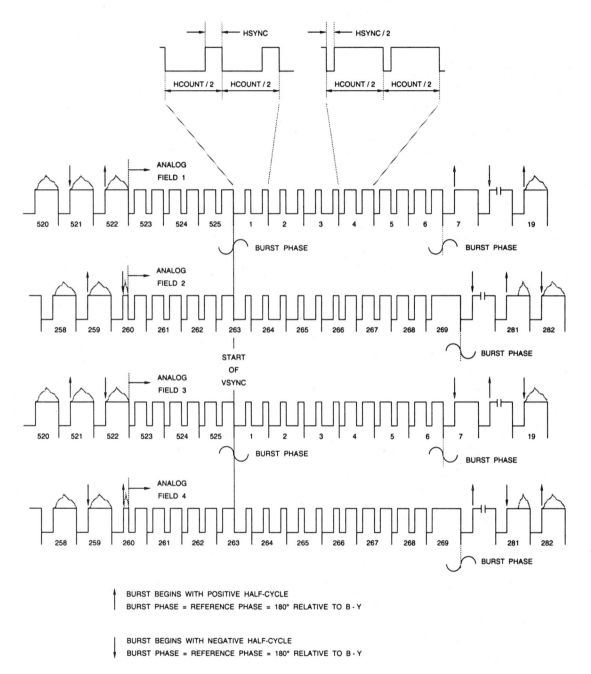

Figure 5.21. Four-field (M) NTSC Format. Note: to simplify the implementation, the line numbering does not match that used in standard practice for NTSC video signals.

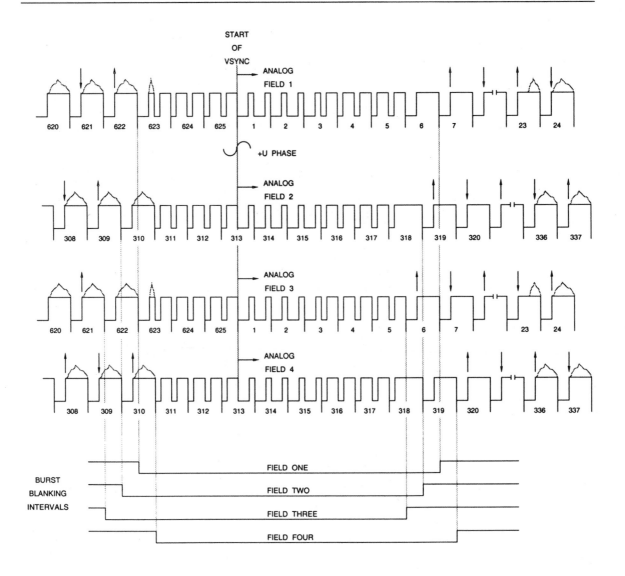

Figure 5.22a. Eight-field (B, D, G, H, I, Combination N) PAL Format. (See Figure 5.21 for equalization and serration pulse details.)

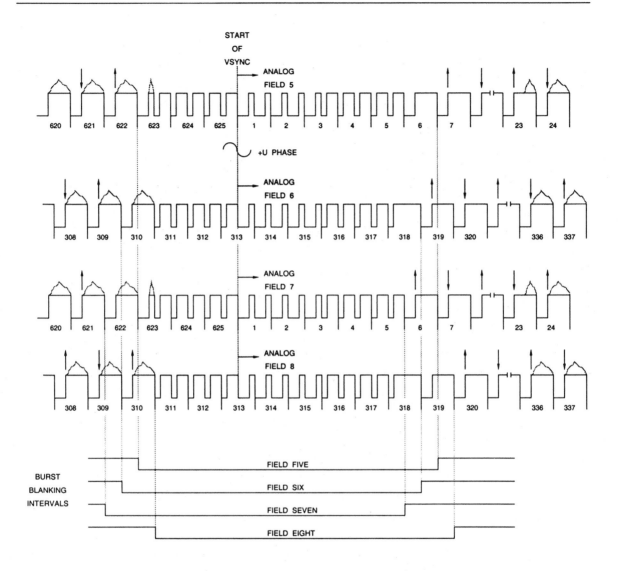

Figure 5.22b. Eight-field (B, D, G, H, I, Combination N) PAL Format. (See Figure 5.21 for equalization and serration pulse details.)

The P1 and P2 values are determined for (B, D, G, H, I, N) PAL operation using the following equation:

$$\frac{FSC}{FS} = \frac{P1 + \dfrac{P2}{(4)\,(HCOUNT)}}{2048}$$

$$= \left(\frac{1135}{4} + \frac{1}{625}\right)\left(\frac{1}{HCOUNT}\right)$$

The P1 and P2 values are determined for the version of combination (N)PAL used in Argentina using the following equation:

$$\frac{FSC}{FS} = \frac{P1 + \dfrac{P2}{(4)\,(HCOUNT)}}{2048}$$

$$= \left(\frac{917}{4} + \frac{1}{625}\right)\left(\frac{1}{HCOUNT}\right)$$

The modulo 625 counter, with a "p value" of 67, is used during 625/50 operation (shown in Figure 5.20) to more accurately adjust subcarrier generation due to the 0.1072 remainder after calculating the P1 and P2 values. During 525/60 operation, the carry signal should always be forced to be zero. Table 5.10 lists some of the common horizontal resolutions, pixel clock rates, and their corresponding HCOUNT, P1, and P2 values.

Each value of the 11-bit subcarrier phase signal corresponds to one of 2048 waveform values taken at a particular point in the subcarrier cycle period and stored in ROM. The sample points are taken at odd multiples of one 4096th of the total period to avoid end-effects when the sample values are read out in reverse order. Note only one quadrant of the subcarrier wave shape is stored in ROM, as shown in Figure 5.23. The values for the other quadrants are produced using the symmetrical properties of the sinusoidal waveform. The maximum phase error using this technique is ± 0.09°

Typical Application	Total Pixels per Scan Line (HCOUNT)	Active Pixels	4x HCOUNT	P1	P2
13.5 MHz (M) NTSC	858	720	3432	543	104
13.5 MHz 4.43 NTSC				672	2047
13.5 MHz (B, D, G, H, I) PAL	864	720	3456	672	2061
12.27 MHz (M) NTSC	780	640	3120	597	1040
12.27 MHz 4.43 NTSC				739	2671
14.75 MHz (B, D, G, H, I) PAL	944	768	3776	615	2253
4x F_{SC} (M) NTSC	910	768	3640	512	0
4x F_{SC} (B, D, G, H, I) PAL	1135	948	4540		

Notes
1. "4.43 NTSC" is standard NTSC video signal with 4.43-MHz color subcarrier. Standard SCH phase relationship is not valid.
2. "12.27-MHz NTSC" and "14.75-MHz PAL" are square pixel formats.
3. "4x F_{SC} (M) NTSC" clock rate is 14.32 MHz; "4x F_{SC} (B, D, G, H, I) PAL" clock rate is 17.72 MHz.

Table 5.10. Typical HCOUNT, P1, and P2 Values.

Figure 5.23. Positions of the 512 Stored Sample Values in the sin and cos ROMs for One Quadrant of a Subcarrier Cycle. Samples for other quadrants can be generated by inverting the addresses and/or sign values.

(half of 360/2048), which corresponds to a maximum amplitude error of ±0.08%, relative to the peak-to-peak amplitude, at the steepest part of the sine wave signal.

Better color accuracy in areas of highly saturated colors is attained if the subcarrier information is stored and read out at two times the pixel clock. This also implies that two times interpolation is performed on the luminance and color difference data. In addition to minimizing the sin x/x frequency roll-off due to the D/A converters, the extra oversampling results in less subcarrier amplitude error after analog lowpass filtering.

Figure 5.20 shows a circuit arrangement for generating quadrature subcarriers from an 11-bit subcarrier phase signal. This uses two ROMs with 9-bit addresses to store quadrants

of sine and cosine waveforms. XOR gates invert the addresses for generating time-reversed portions of the waveforms and to invert the output polarity to make negative portions of the waveforms. An additional gate is provided in the sign bit for the V subcarrier to allow injection of a PAL SWITCH square wave to implement phase inversion of the V signal on alternate scan lines.

Horizontal and Vertical Timing

To control the horizontal and vertical timing, either separate horizontal and vertical sync signals (notated as HSYNC* and VSYNC*,

respectively, and assumed to be active low) or a composite sync signal (notated as CSYNC* and also assumed to be active low) may be used. The CSYNC* signal is separated into the necessary horizontal and vertical sync signals needed by the encoder to control horizontal and vertical counters. The HSYNC* and VSYNC* signals (or CSYNC*) may be control inputs or optionally they may be generated by the encoder since it has the ability to provide all of the necessary timing information.

In a 4:2:2 digital component video application (discussed in Chapter 8), horizontal blanking (H), vertical blanking (V), and even/odd field (F) information are used. In this application, the encoder would operate at 13.5 MHz, and would use (or optionally generate) the H, V, and F control signals directly, rather than depending on HSYNC* and VSYNC*. Logically NORing the H and F signals will generate the composite blanking signal (BLANK*) which should be processed to have the Gaussian rise/fall time required for blanking the active video.

General Horizontal Timing

An 11-bit horizontal counter is used to determine where along each scan line to enable and disable sync information, burst information, and serration and equalization pulses, and it should increment on each rising edge of the pixel clock. The horizontal counter value is compared to various values to determine when to assert and negate various control signals, such as burst gate, etc. It may optionally be reset to 001_H after reaching the count specified by HCOUNT (the total number of pixels per scan line) in case a horizontal sync control pulse is missing.

If the HSYNC* control signal is an input, the falling edge should reset the horizontal counter to 001_H. If HSYNC* is an output, it should be asserted to a logical zero when the

horizontal counter resets to 001_H due to reaching the HCOUNT value, and be negated to a logical one when the horizontal counter reaches a value of 64. In many cases, the encoder may be automatically configured by counting the number of pixel clock cycles between leading edges of HSYNC*—as shown in Table 5.10, each mode of operation has a unique number of pixel clock cycles per scan line. As an output, it may be desirable to generate the HSYNC* output signal a clock cycle early, or have it be only one clock cycle wide, to ease interfacing to other parts of the system.

If the H, V, and F control signals are used as timing control inputs in a 13.5-MHz 4:2:2 digital component video application, the horizontal counter should be reset to 001_H 16 (525/60 operation) or 12 (625/50 operation) clock cycles after the rising edge of H. Note that 525/60 or 625/50 operation may be automatically determined by counting the number of clock cycles between rising edges of H.

If the encoder is generating H, V, and F control signals as outputs, H should be asserted to a logical one upon the horizontal counter reaching a value of 842 (525/60 operation) or 852 (625/50 operation), and negated to a logical zero upon the horizontal counter reaching a value of 260 (525/60 operation) or 276 (625/50 operation). As an output, it may be desirable to generate the H output signal a clock cycle early to ease timing constraints to other parts of the system.

Note the HSYNC value (which specifies the width of the horizontal analog sync pulse to generate) may be automatically determined from the HCOUNT value (the total number of pixels per scan line) as follows:

HSYNC (start) = when the horizontal counter is reset to 001_H

HSYNC (stop) = (HCOUNT/16)
+ (HCOUNT/128) + (HCOUNT/256) + 1

These calculations are valid for (M) NTSC, (B, D, G, H, I) PAL, and combination (N) PAL, and specify the 50% point of the sync rising and falling edges. A value of half the rise/fall time (in clock cycles) must be added to the (stop) value and subtracted from the (start) value to allow for the Gaussian rise and fall times. Truncation is assumed in the division process.

Table 5.11 lists the typical horizontal blank timing for the common pixel clock rates.

General Vertical Timing

A 10-bit vertical counter, which increments on each falling edge of HSYNC*, provides information on which scan line is being generated. The vertical counter may optionally also be reset to 001_H after reaching a count of 525 (525/60 operation) or 625 (625/50 operation) in case a vertical control pulse is missing. To simplify the implementation, the line numbering in Figure 5.21 does not match that used in standard practice for NTSC video signals.

If the HSYNC* and VSYNC* control signals are inputs, coincident falling edges of VSYNC* and HSYNC* should reset the horizontal counter to 001_H (assuming the number one scan line is the first scan line of the vertical sync interval at the beginning of field one as shown in Figures 5.21 and 5.22). Rather than exactly coincident falling edges, a "coincident window" of about 64 clock cycles should be used to ease interfacing to some video timing controllers; if both the HSYNC* and VSYNC* falling edges are detected within 64 clock cycles of each other, it is assumed to be the beginning of an odd field and the vertical counter should be reset to 001_H.

If VSYNC* is an output, it should be asserted to a logical zero for three scan lines, starting when the vertical counter resets to 001_H due to reaching the 525 (525/60 operation) or 625 (625/50 operation) value. This fall-ing edge of VSYNC* should be coincident with the falling edge of HSYNC*. VSYNC* should also be asserted to a logical zero for three scan lines starting at horizontal count (HCOUNT/2) + 1 on scan line 263 (525/60 operation) or 313 (625/50 operation). Note that it may be desirable to generate 2.5 scan line VSYNC* pulses during 625/50 operation. As an output, it may be desirable to generate the VSYNC* output signal a clock cycle early, or have it be only one clock cycle wide, to ease interfacing to other parts of the system.

If the H, V, and F control signals are used as timing control inputs in a 13.5-MHz 4:2:2 digital component video application, the F signal should be synchronized to the internally generated HSYNC* signal, and the vertical counter should be reset to 001_H when a falling edge of F has been detected while both H and V are a logical one.

If the encoder is generating H, V, and F control signals as outputs in a 13.5-MHz 4:2:2 digital component video application, the vertical counter should reset to 001_H after reaching the count of 525 (525/60 operation) or 625 (625/50 operation). V should be asserted to a logical one upon the vertical counter reaching values of 261 and 523 (525/60 operation) or 311 and 624 (625/50 operation) and should be negated to a logical zero upon the vertical counter reaching values of 17 and 280 (525/60 operation) or 23 and 336 (625/50 operation). F should be asserted to a logical one upon the vertical counter reaching values of 263 (525/60 operation) or 313 (625/50 operation) and should be negated to a logical zero upon the vertical counter being reset to 001_H. Note that F must be output coincident with the rising edge of H to meet 4:2:2 digital component video timing requirement, and that the rising edge of H occurs 16 (525/60 operation) or 12 (625/50 operation) clock cycles before the horizontal sync pulse.

Typical Application	Sync + Back Porch Blanking (Pixels)	Front Porch Blanking (Pixels)
13.5 MHz NTSC	121	17
13.5 MHz PAL	131	13
12.27 MHz NTSC (square pixels)	125	15
14.75 MHz PAL (square pixels)	166	10
14.32 MHz NTSC (4x F_{SC})	126	16
17.72 MHz PAL (4x F_{SC})	177	10

Table 5.11. Typical BLANK* Input Horizontal Timing.

NTSC Timing

The composite sync timing must be generated from the vertical and horizontal counters, including all of the required serration and equalization pulses (see Figure 5.21). By noting that all timing parameters and positions are a fixed percentage of HCOUNT (the total number of pixels per scan line), the calculations to determine what to do and when are easily automatically done within the encoder, regardless of the pixel clock rate. Note that the line numbering in Figure 5.21 does not conform to standard NTSC notation, to ease the design.

Color burst information should be disabled on scan lines 1–6, 261–269, and 523–525, inclusive. On the remaining scan lines, color burst information should be enabled and disabled at the calculated horizontal count values. A blanking control signal (BLANK*) is used to specify when to generate active video.

PAL Timing

The composite sync timing must be generated from the vertical and horizontal counters, including all of the required serration and equalization pulses (see Figure 5.22). By noting that all timing parameters and positions are a fixed percentage of HCOUNT (the total number of pixels per scan line), the calculations to determine what to do and when are easily automatically done within the encoder, regardless of the pixel clock rate.

For (B, D, G, H, I, N) PAL, during fields 1, 2, 5, and 6, color burst information should be disabled on scan lines 1–6, 310–318, and 623–625, inclusive. During fields 3, 4, 7, and 8, color burst information should be disabled on scan lines 1–5, 311–319, and 622–625, inclusive. Early receivers produced colored "twitter" at the top of the picture due to the swinging burst. To fix this, Bruch blanking was implemented to ensure that the phase of the first burst is the same following each vertical sync pulse. Analog encoders used a "meander gate" to control the burst reinsertion time by shifting one line at the vertical field rate. A digital encoder simply keeps track of the scan line and field number. Modern receivers do not require Bruch blanking, but it is useful for determining which field is being processed.

On the remaining scan lines, color burst information should be enabled and disabled at the calculated horizontal count values. A blanking control signal (BLANK*) is used to specify when to generate active video.

NTSC Field ID

Although the timing relationship between the horizontal sync (HSYNC*) and vertical sync (VSYNC*) signals, or the F signal, may be used to specify whether to generate an even or odd field, another signal must also be used to specify which one of four fields to generate. This additional signal (which we will refer to as FIELD_0), specifies whether to generate fields 1 and 2 (FIELD_0 = logical zero) or fields 3 and 4 (FIELD_0 = logical one). As an input to the encoder, FIELD_0 should change state only at the beginning of vertical sync during fields 1 and 3. If an output from the encoder, FIELD_0 should change state at the beginning of vertical sync during fields 1 and 3 (this may be done by monitoring the subcarrier phase). If the encoder is generating a FIELD_0 control signal as an output in a 13.5-MHz 4:2:2 digital component video application, FIELD_0 should change state coincident with F.

PAL Field ID

Although the timing relationship between the horizontal sync (HSYNC*) and vertical sync (VSYNC*) signals, or the F signal, may be used to specify whether to generate an even or odd field, two additional signals must also be used to specify which one of eight fields to generate. We will refer to these additional control signals as FIELD_0 and FIELD_1.

As an input to the encoder, FIELD_0 should change state only at the beginning of vertical sync during fields 1, 3, 5, and 7. FIELD_1 should change state only at the beginning of vertical sync during fields 1 and 5.

As outputs from the encoder circuit, FIELD_0 should change state only at the beginning of vertical sync during fields 1, 3, 5, and 7. FIELD_1 should change state only at the beginning of vertical sync during fields 1 and 5 (this may be done by monitoring the subcarrier phase). If the encoder is generating FIELD_0 and FIELD_1 control signals as outputs in a 13.5-MHz 4:2:2 digital component video application, they should change state coincident with F.

FIELD_0 Signal	HSYNC*/VSYNC* Timing Relationship or F Indicator	Generated Field
0	odd field	1
0	even field	2
1	odd field	3
1	even field	4

Table 5.12. (M) NTSC Field Generation.

FIELD_1 Signal	FIELD_0 Signal	HSYNC*/VSYNC* Timing Relationship or F Indicator	Generated Field
0	0	odd field	1
0	0	even field	2
0	1	odd field	3
0	1	even field	4
1	0	odd field	5
1	0	even field	6
1	1	odd field	7
1	1	even field	8

Table 5.13. (B, D, G, H, I, M, N) PAL Field Generation.

NTSC Encoding Using YUV

For NTSC, the YUV color space may be used rather than the YIQ color space. Since computers commonly use linear RGB data, linear RGB data is converted to gamma-corrected RGB data as follows (values are normalized to have a value of 0 to 1):

for R, G, B < 0.018

$$R' = 4.5\,R$$
$$G' = 4.5\,G$$
$$B' = 4.5\,B$$

for R, G, B ≥ 0.018

$$R' = 1.099\,R^{0.45} - 0.099$$
$$G' = 1.099\,G^{0.45} - 0.099$$
$$B' = 1.099\,B^{0.45} - 0.099$$

The gamma-corrected RGB with a range of 0 to 255 or the YCrCb data is then converted to YUV data by scaling all the coefficients in the PAL RGB-to-YUV and YCrCb-to-YUV equa-

tions by 0.945 (129.5/137) to provide the proper YUV levels for NTSC:

RGB to YUV

$$Y = 0.152R' + 0.298G' + 0.058B'$$
$$U = -0.074R' - 0.147G' + 0.221B'$$
$$V = 0.312R' - 0.262G' - 0.050B'$$

YCrCb to YUV

$$Y = 0.592(Y - 16)$$
$$U = 0.504(Cb - 128)$$
$$V = 0.711(Cr - 128)$$

The 33° subcarrier phase shift during active video is not required since sampling is along the U and V axes. Thus, the Q sin (ωt + 33°) + I cos (ωt + 33°) equation for generating modulated chrominance may be simplified to be U sin (ωt) + V cos (ωt). Standard NTSC decoders are capable of decoding these NTSC YUV-oriented video signals. If, however, the same encoder design is to implement both analog composite NTSC and digital composite

NTSC video (discussed in Chapter 7), the YIQ color space should be used.

Low-cost NTSC encoders may use YCrCb-to-YUV or RGB-to-YUV color space conversion based on simple shifts and adds at the expense of color accuracy:

YCrCb to YUV

$$Y = (1/2)(Y - 16) + (1/16)(Y - 16)$$
$$+ (1/32)(Y - 16)$$
$$U = (1/2)(Cb - 128) + (1/256)(Cb - 128)$$
$$V = (1/2)(Cr - 128) + (1/8)(Cr - 128)$$
$$+ (1/16)(Cr - 128) + (1/64)(Cr - 128)$$
$$+ (1/128)(Cr - 128)$$

RGB to YUV

$$Y = (1/8)R' + (1/32)R' + (1/4)G'$$
$$+ (1/32)G' + (1/64)G' + (1/16)B'$$
$$U = -(1/16)R' - (1/64)R' - (1/8)G'$$
$$- (1/64)G' + (1/8)B' + (1/16)B'$$
$$+ (1/32)B'$$
$$V = (1/4)R' + (1/16)R' - (1/4)G'$$
$$- (1/64)G' - (1/32)B' - (1/64)B'$$

Professional video systems may use the gamma-corrected RGB color space, with RGB having a nominal range of 16 to 235. Occasional values less than 16 and greater than 235 are allowed, resulting in YUV values outside their nominal ranges. In this instance, RGB may be converted to YUV by scaling the previous RGB-to-YUV equations by 255/219:

$$Y = 0.177(R' - 16) + 0.347(G' - 16)$$
$$+ 0.067(B' - 16)$$
$$U = -0.086(R' - 16) - 0.171(G' - 16)$$
$$+ 0.257(B' - 16)$$
$$V = 0.363(R' - 16) - 0.305(G' - 16)$$
$$- 0.058(B' - 16)$$

NTSC/PAL Encoding Using YCrCb

For (M) NTSC and (B, D, G, H, I) PAL, by adjusting the sin and cos subcarrier full-scale amplitudes, the modulator may directly accept Cr and Cb data, rather than U and V. Cr and Cb have a range of 16 to 240, with 128 equal to zero. The luminance information, with a range of 16 to 235, must be scaled and offset to have a range of either 0 to 130 (NTSC) or 0 to 137 (PAL).

Since computers commonly use linear RGB data with a range of 0 to 255, linear RGB data is converted to gamma-corrected RGB data as follows (values are normalized to have a value of 0 to 1):

(M) NTSC systems:

for R, G, B < 0.018

$$R' = 4.5 R$$
$$G' = 4.5 G$$
$$B' = 4.5 B$$

for R, G, B ≥ 0.018

$$R' = 1.099 R^{0.45} - 0.099$$
$$G' = 1.099 G^{0.45} - 0.099$$
$$B' = 1.099 B^{0.45} - 0.099$$

(B, D, G, H, I) PAL systems:

for R, G, B < 0.018

$$R' = 4.5 R$$
$$G' = 4.5 G$$
$$B' = 4.5 B$$

for R, G, B ≥ 0.018

$$R' = 1.099 R^{0.36} - 0.099$$
$$G' = 1.099 G^{0.36} - 0.099$$
$$B' = 1.099 B^{0.36} - 0.099$$

Gamma-corrected RGB data with a range of 0 to 255 may be converted to YCrCb data as follows:

$$Y = 0.257R' + 0.504G' + 0.098B' + 16$$
$$Cr = 0.439R' - 0.368G' - 0.071B' + 128$$
$$Cb = -0.148R' - 0.291G' + 0.439B' + 128$$

The 33° subcarrier phase shift during active video is not required since sampling is along the U and V axes. Thus, the Q sin (ωt + 33°) + I cos (ωt + 33°) equation for generating modulated chrominance may be simplified to be U sin (ωt) + V cos (ωt). If, however, the same encoder design is to implement both analog composite and digital composite video (discussed in Chapter 7), the YIQ (NTSC) and YUV (PAL) color spaces should be used.

Professional video systems may use the gamma–corrected RGB color space, with RGB having a nominal range of 16 to 235. Occasional values less than 16 and greater than 235 are allowed, resulting in YCrCb values outside their nominal ranges. In this instance, RGB may be converted to YCrCb as follows:

$$Y = (77/256)R' + (150/256)G' + (29/256)B'$$
$$Cr = (131/256)R' - (110/256)G'$$
$$\quad - (21/256)B' + 128$$
$$Cb = -(44/256)R' - (87/256)G'$$
$$\quad + (131/256)B' + 128$$

(N) PAL Encoding Considerations

Although (B, D, G, H, I) PAL are the common PAL formats, there are two variations of PAL referred to as (N) PAL and combination (N) PAL. Combination (N) PAL is used in Argentina and has been covered in the previous subcarrier generation discussion, since the only difference between baseband combination

(N) PAL and baseband (B, D, G, H, I) PAL video signals is the change in subcarrier frequency.

Standard (N) PAL is also a 625/50 system and is used in Uruguay and Paraguay. Some of the timing is different from that of baseband (B, D, G, H, I) PAL baseband video signals, such as having serration and equalization pulses for three scan lines rather than 2.5 scan lines, as shown in Chapter 4. Since computers commonly use linear RGB data, linear RGB data is converted to gamma-corrected RGB data as follows (values are normalized to have a value of 0 to 1):

for R, G, B < 0.018

$$R' = 4.5 R$$
$$G' = 4.5 G$$
$$B' = 4.5 B$$

for R, G, B \geq 0.018

$$R' = 1.099 R^{0.36} - 0.099$$
$$G' = 1.099 G^{0.36} - 0.099$$
$$B' = 1.099 B^{0.36} - 0.099$$

The gamma-corrected RGB data is then converted to YUV data by scaling all the coefficients in the standard PAL RGB-to-YUV and YCrCb-to-YUV equations by 0.945 (129.5/137) to compensate for the addition of a 7.5 IRE blanking pedestal:

RGB to YUV

$$Y = 0.152R' + 0.298G' + 0.058B'$$
$$U = -0.074R' - 0.147G' + 0.221B'$$
$$V = 0.312R' - 0.262G' - 0.050B'$$

YCrCb to YUV

$$Y = 0.592(Y - 16)$$
$$U = 0.504(Cb - 128)$$
$$V = 0.711(Cr - 128)$$

A gamma of 2.8 is assumed at the receiver and the sync tip is –40 IRE rather than –43 IRE. Therefore, the luminance and composite digital video levels are as shown in Tables 5.2 and 5.9, respectively.

Due to the timing differences from (B, D, G, H, I) PAL, standard (N) PAL and combination (N) PAL are not compatible with the digital composite video standards discussed in Chapter 7. As many of the timing parameters (such as horizontal sync width, start and end of burst, etc.) are different from standard (B, D, G, H, I) PAL, the equations used by the encoder to automatically calculate these parameters must be modified for standard (N) PAL operation.

(M) PAL Encoding Considerations

Although (B, D, G, H, I) PAL are the common PAL formats, there is another variation of PAL referred to as (M) PAL, which is an 8-field 525/60 system with slight timing differences from baseband (M) NTSC, and is used in Brazil.

(M) PAL uses the same RGB-to-YUV and YCrCb-to-YUV equations as standard (N) PAL to compensate for the addition of a 7.5 IRE blanking pedestal. A gamma of 2.8 is assumed

at the receiver and the sync tip is –40 IRE rather than –43 IRE. The luminance and composite digital video levels are the same as standard (N) PAL, as shown in Table 5.14 and Table 5.15, respectively.

The subcarrier frequency generation for (M) PAL is implemented in the encoder as:

$$\frac{FSC}{FS} = \frac{P1 + \dfrac{(P2)}{(4)\,(HCOUNT)}}{2048}$$

$$= \left(\frac{909}{4}\right)\left(\frac{1}{HCOUNT}\right)$$

resulting in a subcarrier frequency of 3.57561149 MHz (± 10 Hz). Note that the third stage p:q ratio counter in the subcarrier generator circuit shown in Figure 5.20 should be disabled.

For (M) PAL, during fields 1, 2, 5, and 6, color burst information should be disabled on scan lines 1–8, 260–270, and 523–525, inclusive. During fields 3, 4, 7, and 8, color burst information should be disabled on scan lines 1–7, 259–269, and 522–525, inclusive. On the remaining scan lines, color burst information should be enabled and disabled at the calculated horizontal count values. Figure 5.24 illustrates the 8-field (M) PAL timing and burst

Video Level	8-bit digital value	10-bit digital value
white	200	800
black	70	280
blank	60	240
sync	4	16

Table 5.14. (N) PAL Composite Luminance Digital Values.

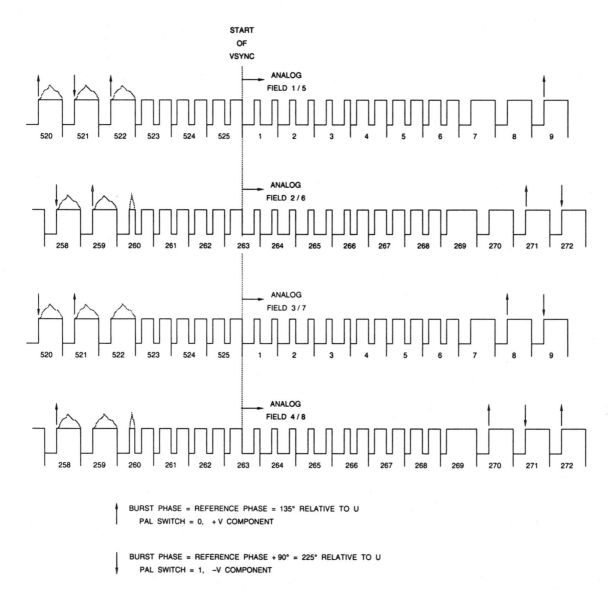

Figure 5.24. Eight-field (M) PAL Format. (See Figure 5.21 for equalization and serration pulse details.)

Video Level	8-bit digital value	10-bit digital value
peak chroma	243	972
white	200	800
peak burst	90	360
black	70	280
blank	60	240
peak burst	30	120
peak chroma	27	108
sync	4	16

Table 5.15. Composite (N) PAL Digital Video Levels.

blanking intervals. Due to the timing differences from (B, D, G, H, I) PAL and (M) NTSC, (M) PAL is not compatible with the digital composite video standards discussed in Chapter 7. As many of the timing parameters (such as horizontal sync width, start and end of burst, etc.) are different from (B, D, G, H, I) PAL or (M) NTSC, the equations used by the encoder to automatically calculate these parameters must be modified for (M) PAL operation.

SECAM Encoding Considerations

The horizontal and vertical timing for baseband (B, D, G, H, K, K1, L) SECAM III is the same as for baseband (B, D, G, H, I) PAL; the main difference is that SECAM uses FM modulation to convey color information. SECAM uses the YDrDb color space, and the color space conversion equations for SECAM operation are derived so that the full-scale output of the D/A converters is still 1.3 V to avoid using multiple D/A voltage references. Using the same sync tip value of 4 and white value of

200 to generate a 1-V signal places the blanking level at 63, resulting in 137 levels being used for luminance. Since computers commonly use linear RGB data, linear RGB data is converted to gamma-corrected RGB data as follows (values are normalized to have a value of 0 to 1):

for R, G, B < 0.018

$R' = 4.5 R$
$G' = 4.5 G$
$B' = 4.5 B$

for R, G, B ≥ 0.018

$R' = 1.099 R^{0.36} - 0.099$
$G' = 1.099 G^{0.36} - 0.099$
$B' = 1.099 B^{0.36} - 0.099$

The gamma-corrected digital RGB data is then converted to YDrDb data by scaling the general RGB-to-YDrDb equations in Chapter 3 by 137/255:

RGB to YDrDb

$Y = 0.161R' + 0.315G' + 0.061B'$
$Db = -0.242R' - 0.474G' + 0.716B'$
$Dr = -0.716R' + 0.600G' + 0.116B'$

YCrCb to YDrDb

$$Y = 0.625(Y - 16)$$
$$Db = 1.630(Cb - 128)$$
$$Dr = -1.630(Cr - 128)$$

However, Dr and Db are processed by a low-frequency pre-emphasis filter that has a maximum gain of + 9.125 dB. To drive the FM modulation process, Dr (after low-frequency pre-emphasis) must have a range of 0 to ±17.92 and Db (after low-frequency pre-emphasis) must have a range of 0 to ±14.72. For these reasons the color space conversion equations are changed to be:

RGB to YDrDb

$$Y = 0.161R' + 0.315G' + 0.061B'$$
$$Db = -0.0024R' - 0.0047G' + 0.0071B'$$
$$Dr = -0.0086R' + 0.0072G' + 0.0014B'$$

YCrCb to YDrDb

$$Y = 0.625(Y - 16)$$
$$Db = 0.0161(Cb - 128)$$
$$Dr = -0.0196(Cr - 128)$$

In an 8-bit digital system, for RGB values with a range of 0 to 255, Y has a range of 0 to 137, Dr has a range of 0 to ±2.193, and Db has a range of 0 to ±1.810. At least nine fractional data bits should be maintained for the Dr and Db data due to further processing.

After the lowpass filtering of Dr and Db to 1.3 MHz, low-frequency pre-emphasis is applied. The curve for the low-frequency pre-emphasis amplitude is shown in Figure 5.25a, and is expressed by:

$$A = \frac{1 + j(\frac{f}{85})}{1 + j(\frac{f}{255})}$$

where f = signal frequency in kHz. The 1.3 MHz lowpass filter cascaded with the low-frequency pre-emphasis filter should result in the maximum pre-emphasis (9.123 dB) occurring around 750 kHz. Figure 5.25b shows the resulting frequency response above 750 kHz as a result of cascading the 1.3-MHz lowpass and low-frequency pre-emphasis filters. At this point, Dr has a range of 0 to ±17.94 and Db has a range of 0 to ±14.76.

Dr and Db, after low-frequency pre-emphasis, are used to frequency modulate their respective subcarriers, F_{OR} and F_{OB}, as shown in Figure 5.26. The nominal center frequencies and tolerances for the subcarriers are:

$$F_{OR} = 4.406250 \text{ MHz} \pm 2000 \text{ Hz} = 282F_H$$
$$F_{OB} = 4.250000 \text{ MHz} \pm 2000 \text{ Hz} = 272F_H$$

The nominal deviations of F_{OR} and F_{OB} are:

$$\Delta F_{OR} = 280 \pm 9 \text{ kHz}$$
$$\Delta F_{OB} = 230 \pm 7 \text{ kHz}$$

The FM modulation may be done using two p:q ratio counters, as shown in Figure 5.27. Although only one color difference signal is sent per scan line, two subcarrier counters are required to maintain correct subcarrier timing for each of the color difference signals. The output of the appropriate p:q ratio counter is used to address the cos ROM, as determined by whether the scan line is an even or odd scan line. Both p:q counters should maintain a minimum of nine fractional bits of data due to the low integer range of Dr and Db. Dr information is transmitted on even scan lines and Db information is transmitted on odd scan lines.

To generate the nominal deviations of F_{OR} and F_{OB}, Dr (after low-frequency pre-emphasis) requires a range of 0 to ±17.92 and Db (after low-frequency pre-emphasis) requires a range of 0 to ±14.72. As shown previously, the Dr and Db we generated have ranges of 0 to

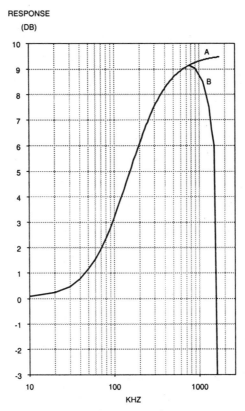

Figure 5.25. (a) SECAM Low Frequency Pre-emphasis. (b) Result of Cascading Low-frequency Pre-emphasis and 1.3-MHz Lowpass Filtering.

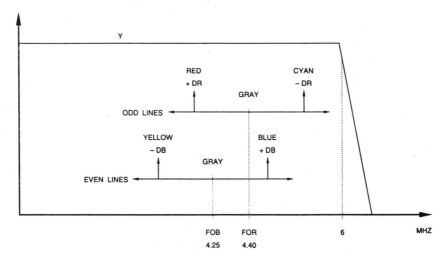

Figure 5.26. SECAM FM Color Modulation System.

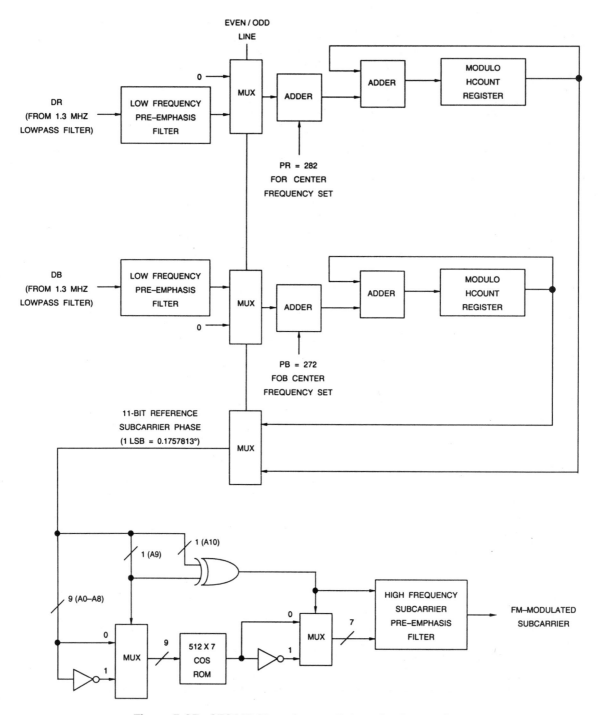

Figure 5.27. SECAM Chrominance Subcarrier Generation.

17.94 and 0 to ± 14.76, respectively, resulting in nominal deviations of F_{OR} and F_{OB} of 280.3 kHz and 230.6 kHz, respectively. These are well within the tolerances previously specified.

A high-frequency subcarrier pre-emphasis is implemented on the subcarrier, where the amplitude of the subcarrier is changed as a function of the frequency deviation. The intention is to reduce the visibility of the subcarriers in areas of low luminance and to improve the signal-to-noise ratio of highly saturated colors. The expression is given as:

$$G = M\frac{1+j16F}{1+j1.26F}$$

where $F = (f/4286) - (4286/f)$, f = instantaneous subcarrier frequency in kHz, and 2M = 23 ±2.5% of luminance amplitude (100 IRE). Figure 5.28 illustrates the frequency response. After high-frequency pre-emphasis, the subcarrier data is added to the luminance, horizontal and vertical sync information, and field ID data to generate composite video.

As shown in Table 5.16 and Figure 5.29, Dr and Db information is transmitted alternate scan lines. The phase of the subcarriers is also reversed 180° on every third line and between each field to further reduce subcarrier visibility. Note that subcarrier phase information in the SECAM system carries no picture information.

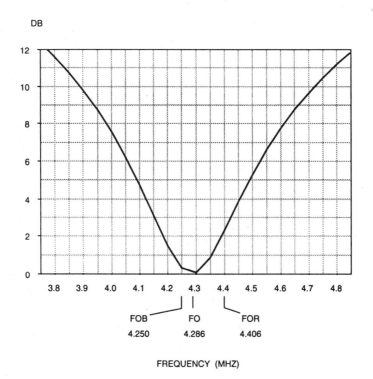

Figure 5.28. SECAM High-Frequency Subcarrier Pre-emphasis.

Field	Line Number		Color		Subcarrier Phase	
odd	N		F_{OR}		0°	
even		N + 313		F_{OB}		180°
odd	N + 1		F_{OB}		0°	
even		N + 314		F_{OR}		0°
odd	N + 2		F_{OR}		180°	
even		N + 315		F_{OB}		180°
odd	N + 3		F_{OB}		0°	
even		N + 316		F_{OR}		180°
odd	N + 4		F_{OR}		0°	
even		N + 317		F_{OB}		0°
odd	N + 5		F_{OB}		180°	
even		N + 318		F_{OR}		180°

Table 5.16. SECAM Color Versus Line and Field Timing.

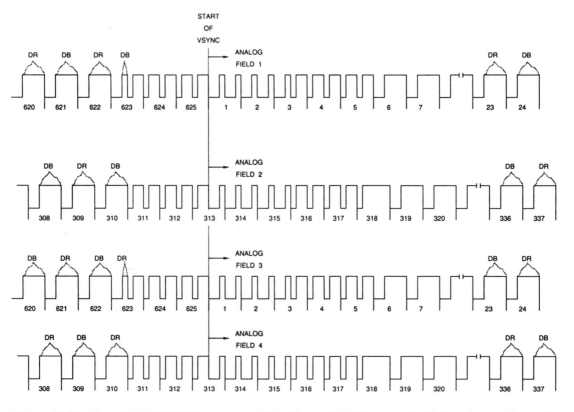

Figure 5.29. Four-field SECAM Sequence. (See Figure 5.21 for equalization and serration pulse details.)

As with PAL, SECAM requires some means of identifying the line-switching sequence between the encoding and decoding functions. This is done by incorporating alter- nate Dr and Db color identification signals for nine lines during the vertical blanking interval following the equalizing pulses after vertical sync, as shown in Figure 5.30a. These bottle-

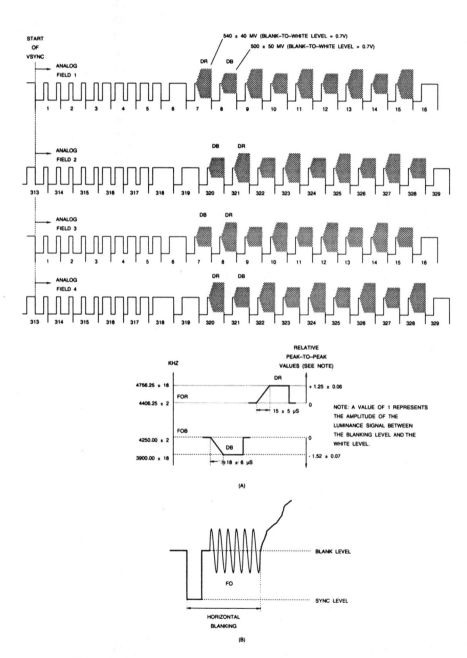

Figure 5.30. SECAM Chrominance Synchronization Signals.

shaped signals occupy the entire scan line. Recent practice has been to eliminate the bottle signals and use a F_{OR}/F_{OB} burst after horizontal sync to derive the switching synchronization information, as shown in Figure 5.30b. This method has the advantage of simplifying the exchange of program material.

Clean Encoding Systems

Typically, the only filters present in a conventional encoder are the color difference lowpass filters. This results in considerable spectral overlap between the luminance and chrominance components, making it almost impossible to separate the signals completely at the decoder using simple filtering. However, additional filtering at the encoder can be used to reduce the severity of subsequent cross-color (luminance-to-chrominance crosstalk) and cross-luminance (chrominance-to-luminance crosstalk) artifacts. Cross-color appears as a coarse rainbow pattern or random colors in regions of fine detail. Cross-luminance appears as a fine pattern on chrominance edges which are mostly vertical.

Cross-color in a simple decoder may be reduced by removing some of the high-frequency luminance data in the encoder (using a notch or lowpass digital filter). However, while reducing the cross-color, luminance detail is lost.

A better method is to use vertical and temporal comb filtering on either (or both as shown in Figure 5.31) the luminance or modulated chrominance information in the encoder. Luminance information above 2.3 MHz (NTSC) or 3.1 MHz (PAL) is precombed to minimize interference with chrominance frequencies in that spectrum. Chrominance information is also combed by averaging over a number of lines, reducing cross-luminance or the "hanging dot" pattern. This technique allows fine, moving luminance (which tends to generate cross-color at the decoder) to be removed while retaining full resolution for static luminance. Note, however, that there is a

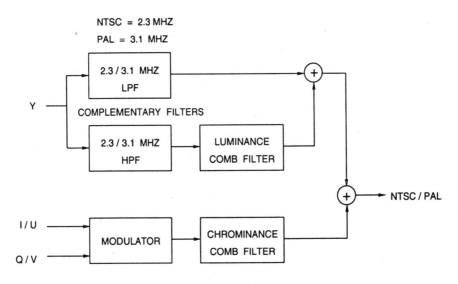

Figure 5.31. Removal of Vertical and Temporal Chrominance to Reduce Cross-luminance Vertical and Temporal Luminance to Reduce Cross-color.

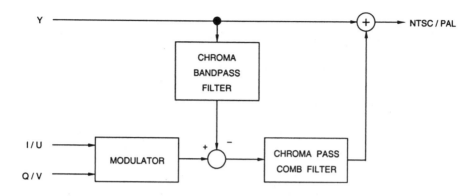

Figure 5.32. Complementary Clean Coder Example.

small loss of diagonal luminance resolution due to it being averaged over three lines (assuming two line stores are used to implement the comb filter). This is offset by an improvement in the chrominance signal-to-noise ratio (SNR) in low-luminance-level areas. Figure 5.32 shows another arrangement to help suppress cross-color and cross-luminance at the decoder.

Bandwidth-Limited Edge Generation

Smooth sync edges, blanking edges, and burst envelope may be generated by integrating a raised-cosine impulse (Figure 5.33). This signal, and the edge produced from it, have virtually no signal energy beyond the $f = 1/T$.

Figure 5.33. Bandwidth-limited Edge Generation: (a) the T Pulse, and (b) the Result of Integrating the T Pulse.

This implementation provides a fast risetime, without ringing, within a well-defined bandwidth. The risetime of the edge between the 10% and 90% points is 0.964T. By choosing appropriate sample values for the sync edges, blanking edges, and burst envelope, these values can be stored in a small ROM, which is triggered at the appropriate horizontal count. By reading the contents of the ROM out forwards and backwards, both rising and falling edges may be generated.

Level Limiting

Certain highly saturated colors produce composite video levels that may cause problems in downstream equipment. Invalid active video levels greater than 100 IRE or less than –20 IRE (relative to the blank level) may be transmitted, but may cause distortion in VCRs or demodulators, and sync separation problems. Illegal video levels greater than 120 IRE (NTSC), 133 IRE (PAL), or 115 IRE (SECAM) or less than –40 IRE (NTSC) or –43 IRE (PAL and SECAM), relative to the blank level, may not be transmitted. Unfortunately, some fully saturated colors generate NTSC composite video levels approaching 131 IRE, exceeding the 100 IRE white level; PAL and SECAM encoders have similar restrictions.

Although usually not a problem in a conventional video environment, computer graphics systems commonly use highly saturated colors, which may generate invalid or illegal video levels. It may be desirable to optionally limit these invalid or illegal video signal levels to around 110 IRE, compromising between limiting the available colors and generating legal video levels. In a professional editing environment, the option of transmitting all the video information (including invalid and illegal levels) between equipment is required to minimize editing and processing artifacts.

One method of correction is to adjust the luminance or saturation (within the encoder) of invalid and illegal pixels until the desired peak limits are attained. Alternately, the frame buffer contents may be scanned, and pixels flagged that would generate an invalid or illegal video level (using a separate overlay plane or color change). The user may then change the color to one more suitable.

Video Test Signals

Many industry-standard video test signals have been defined to help test the relative quality of video encoders, decoders, and the transmission path, and to perform calibration. By providing the appropriate RGB or YCrCb data to the encoder to generate these test signals, video test equipment may be used to evaluate the encoder's performance. Note that some video test signals cannot be properly generated by providing RGB data to a digital encoder; in this case, YCrCb data may be used. If the video standard uses a 7.5-IRE setup, typically only test signals used for visual examination use the 7.5-IRE setup. Test signals designed for measurement purposes typically use a 0-IRE setup, providing the advantage of defining a known blanking level.

Refer to Appendix A for more information on video test signals.

EIA Color Bars (NTSC)

The EIA color bars (Figure 5.34 and Table 5.17) are a part of the EIA-189-A standard. The seven bars (gray, yellow, cyan, green, magenta, red, and blue) are at 75% amplitude, 100% saturation. The duration of each color bar is 1/7 ±10% of the active portion of the scan line. Note that the black bar in Figure 5.34 and Table 5.17 is not part of the standard, and is shown for reference only. The color bar

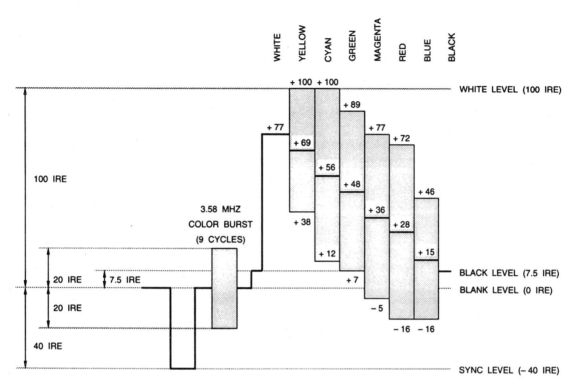

Figure 5.34. IRE Values of EIA Color Bars for (M) NTSC (75% Amplitude, 100% Saturation).

	Nominal Range	White	Yellow	Cyan	Green	Magenta	Red	Blue	Black
R′	0 to 255	191	191	0	0	191	191	0	0
G′	0 to 255	191	191	191	191	0	0	0	0
B′	0 to 255	191	0	191	0	191	0	191	0
Y	16 to 235	180	162	131	112	84	65	35	16
Cr	16 to 240	128	142	44	58	198	212	114	128
Cb	16 to 240	128	44	156	72	184	100	212	128
luminance (IRE)		77	69	56	48	36	28	15	7.5
chrominance (IRE)		0	62	88	82	82	88	62	0
chrominance (phase)		–	167°	283°	241°	61°	103°	347°	–

Table 5.17. EIA Color Bars for (M) NTSC (75% Amplitude, 100% Saturation). Chroma IRE levels are peak-to-peak. RGB values are gamma corrected RGB values.

test signal allows checking for hue and color saturation accuracy.

EBU Color Bars (PAL)

The EBU color bars are similar to the EIA color bars, except a 100 IRE white level is used (see Figure 5.35 and Table 5.18). Again, these color bars are easily generated by supplying the appropriate RGB values internally within the encoder, rather than inputting RGB or YCrCb video pixel data. The duration of each color bar is 1/7 ±10% of the active portion of the scan line. Note that the black bar in Figure 5.34 and Table 5.18 is not part of the standard, and is shown for ref-

erence only. The color bar test signal allows checking for hue and color saturation accuracy.

Reverse Blue Bars

The Reverse Blue bars are composed of the blue, magenta, and cyan colors bars from the EIA/EBU color bars, but are arranged in a different order—blue, black, magenta, black, cyan, black, and white. The duration of each color bar is 1/7 ±10% of the active portion of the scan line. Typically, Reverse Blue bars are used with the EIA/EBU color bars signal in a split-field arrangement, with the EIA/EBU color bars comprising the first 3/4 of the field,

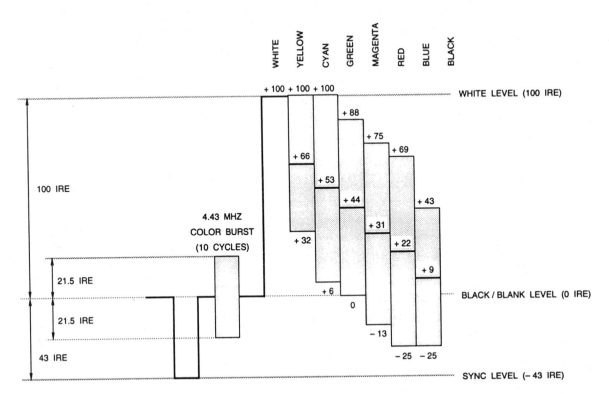

Figure 5.35. IRE Values of EBU Color Bars for (B, D, G, H, I) PAL (75% Amplitude, 100% Saturation).

	Nominal Range	White	Yellow	Cyan	Green	Magenta	Red	Blue	Black
R'	0 to 255	255	191	0	0	191	191	0	0
G'	0 to 255	255	191	191	191	0	0	0	0
B'	0 to 255	255	0	191	0	191	0	191	0
Y	16 to 235	235	162	131	112	84	65	35	16
Cr	16 to 240	128	142	44	58	198	212	114	128
Cb	16 to 240	128	44	156	72	184	100	212	128
luminance (IRE)	100	66	53	44	31	22	9	0	
chrominance (IRE)	0	67	95	89	89	95	67	0	
chrominance phase burst = 135°	–	167°	283°	241°	61°	103°	347°	–	
chrominance phase burst = 225°	–	193°	77°	120°	300°	257°	13°	–	

Table 5.18. EBU Color Bars for (B, D, G, H, I) PAL (75% Amplitude, 100% Saturation). Chroma IRE levels are peak-to-peak. Line n corresponds to odd-numbered scan lines in fields 1, 2, 5, and 6; even-numbered scan lines in fields 3, 4, 7, and 8. Line n + 1 corresponds to even-numbered scan lines in fields 1, 2, 5, and 6; odd-numbered scan lines in fields 3, 4, 7, and 8. RGB values are gamma-corrected RGB values.

and the Reverse Blue bars comprising the remainder of the field (also see SMPTE Bars). This split-field arrangement eases adjustment of chrominance and hue on a color monitor.

SMPTE Bars (NTSC)

This split-field test signal is composed of the EIA color bars for the first 2/3 of the field, the Reverse Blue bars for the next 1/12 of the field, and the PLUGE test signal for the remainder of the field. For PAL, a split-field test signal composed of the EBU color bars for the first 2/3 of the field, the Reverse Blue bars for the next 1/12 of the field, and the PLUGE test signal for the remainder of the field may be used.

PLUGE (Picture Line-Up Generating Equipment)

PLUGE is a visual black reference, with one area blacker-than-black, one area at black, and one area lighter-than-black. The brightness of the monitor is adjusted so that the black and blacker-than-black areas are indistinguishable from each other and the lighter-than-black area is slightly lighter (the contrast should be at the normal setting). Additional test signals, such as a white pulse and modulated IQ or UV signals are usually added to facilitate testing and monitor alignment.

The NTSC PLUGE test signal (shown in Figure 5.36) is composed of a 7.5 IRE (black level) pedestal with a 40 IRE "– I" phase modu-

lation, a 100 IRE white pulse, a 7.5 IRE (black level) pedestal with a 40 IRE "+ Q" phase modulation, and a 7.5 IRE pedestal with 3.5 IRE, 7.5 IRE, and 11.5 IRE pedestals. Typically, PLUGE is used with the EIA color bars signal in a split-field arrangement, with the EIA color bars comprising the first 3/4 of the field, and the PLUGE test signal comprising the remainder of the field (also see SMPTE Bars).

For PAL, each country has its own slightly different PLUGE configuration, with most differences being the black pedestal level used, and work is being done on a standard test signal. Figure 5.37 illustrates a typical PAL PLUGE test signal. Usually used as a full-screen test signal, it is composed of a 0 IRE pedestal with PLUGE (–2 IRE, 0 IRE, and 2 IRE pedestals), and a white pulse. The white pulse may have five levels of brightness (0,

25, 50, 75, and 100 IRE), depending on the scan line number, as shown in Figure 5.37. The PLUGE is displayed on scan lines that have non-zero IRE white pulses. As an option, a 0 IRE pedestal with a 43 IRE "–V" phase modulation, and a 0 IRE pedestal with a 43 IRE "+U" phase modulation could be added before and after the white pulse, respectively, to provide additional testing and monitor alignment. CCIR Report 1221 discusses considerations for various PAL systems.

Y Color Bars

The Y color bars consist of the luminance-only levels of the EIA/EBU color bars; however, the black level (7.5 IRE for NTSC and 0 IRE for PAL) is included and the color burst is still present. The duration of each luminance bar is

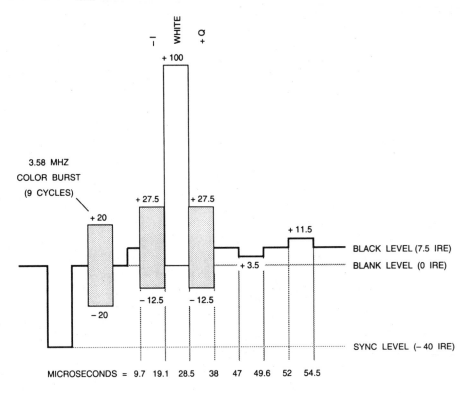

Figure 5.36. IRE Values of PLUGE Test Signal for (M) NTSC. IRE values are indicated.

therefore 1/8 ±10% of the active portion of the scan line. Y color bars are useful for color monitor adjustment and measuring luminance nonlinearity. Typically, the Y color bars signal is used with the EIA/EBU color bars signal in a split-field arrangement, with the EIA/EBU color bars comprising the first 3/4 of the field, and the Y color bars signal comprising the remainder of the field.

Red Field

The Red Field signal consists of a 75% amplitude, 100% saturation red chrominance signal. This is useful as the human eye is sensitive to static noise intermixed in a red field. Distortions that cause small errors in picture quality can be visually examined for the effect on the picture. Typically, the Red Field signal is used with the EIA/EBU color bars signal in a split-field arrangement, with the EIA/EBU color bars comprising the first 3/4 of the field, and the Red Field signal comprising the remainder of the field.

10-Step Staircase

This test signal is composed of ten unmodulated luminance steps of 10 IRE each, ranging from 0 IRE to 100 IRE, shown in Figure 5.38. This test signal may be used to measure luminance nonlinearity.

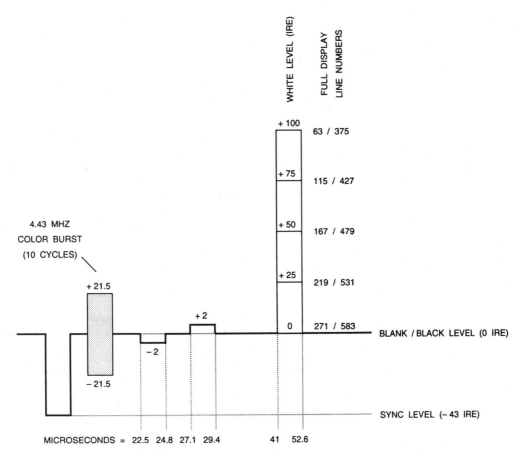

Figure 5.37. IRE Values of Typical PAL PLUGE Test Signal. IRE values are indicated.

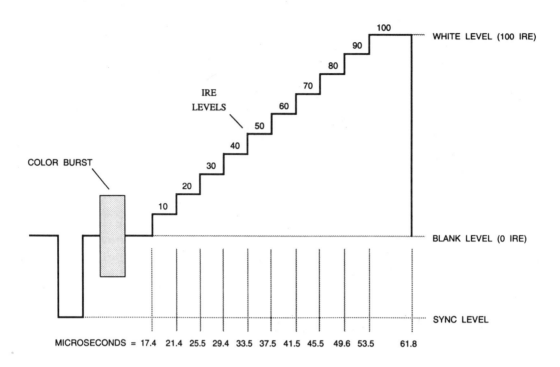

Figure 5.38. Ten-step Staircase Test Signal for NTSC and PAL.

Modulated Ramp

The modulated ramp test signal, shown in Figure 5.39, is composed of a luminance ramp from 0 IRE to either 80 or 100 IRE. The peak-to-peak modulated chrominance is 40 ±0.5 IRE for (M) NTSC and 43 ±0.5 IRE for (B, D, G, H, I) PAL. The modulated chrominance has a phase of 0° ±1° relative to the burst. Note a 0 IRE setup is used. This test signal may be used to measure differential gain. The 80 IRE ramp provides testing of the normal operating range of the system; a 100 IRE ramp may be used to optionally test the entire operating range. The modulated ramp signal is preferred over a 5-step or 10-step modulated staircase signal when testing digital systems.

Modulated Staircase

The 5-step modulated staircase signal (a 10-step version is also used), shown in Figure 5.40, consists of 5 luminance steps. The peak-to-peak modulated chrominance is 40 ±0.5 IRE for (M) NTSC and 43 ±0.5 IRE for (B, D, G, H, I) PAL. The modulated chrominance has a phase of 0° ±1° relative to the burst. Note a 0 IRE setup is used. The rise and fall times of each modulation packet envelope is 400 ±25 ns. The luminance IRE levels for the 5-step modulated staircase signal are shown in Figure 5.40. This test signal may be used to measure differential gain. The modulated ramp signal is preferred over a 5-step or 10-step modulated staircase signal when testing digital systems.

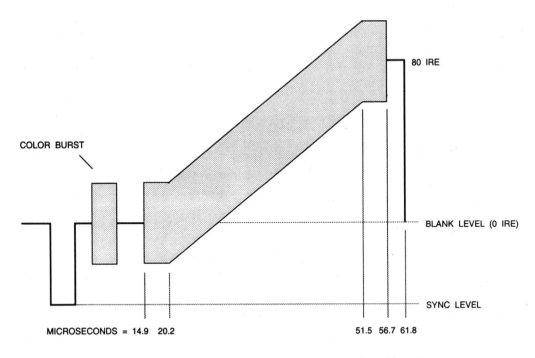

COLOR BURST

80 IRE

BLANK LEVEL (0 IRE)

SYNC LEVEL

MICROSECONDS = 14.9 20.2 51.5 56.7 61.8

Figure 5.39. 80 IRE Modulated Ramp Test Signal.

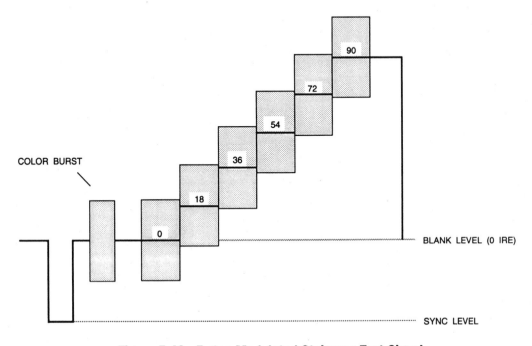

COLOR BURST

90

72

54

36

18

0

BLANK LEVEL (0 IRE)

SYNC LEVEL

Figure 5.40. 5-step Modulated Staircase Test Signal.

Modulated Pedestal

The modulated pedestal test signal, shown in Figure 5.41, is composed of a 50 IRE luminance pedestal, with three amplitudes of modulated chrominance with a phase relative to the burst of –90° ±1°. The peak-to-peak amplitudes of the modulated chrominance are 20 ±0.5, 40 ±0.5, and 80 ±0.5 IRE for (M) NTSC and 20 ±0.5, 60 ±0.5, and 100 ±0.5 IRE for (B, D, G, H, I) PAL. Note a 0 IRE setup is used. This test signal may be used to measure chrominance-to-luminance intermodulation and chrominance nonlinear gain.

Multiburst

The multiburst test signal for (M) NTSC, shown in Figure 5.42, consists of a white flag with a peak amplitude of 100 ±1 IRE and six frequency packets, each a specific frequency. The packets have a 40 ±1 IRE pedestal with peak-to-peak amplitudes of 60 ±0.5 IRE. Note a 0 IRE setup is used and the starting point of each packet is at zero phase.

The multiburst test signal for (B, D, G, H, I) PAL, shown in Figure 5.43, consists of a white flag with a peak amplitude of 100 ±1 IRE and six frequency packets, each a specific frequency. The packets have a 60.75 ±1 IRE pedestal with peak-to-peak amplitudes of 78.5 ±0.5 IRE. Note the starting point of each packet is at zero phase.

The multiburst signals are used to test the frequency response of the system by measuring the peak-to-peak amplitudes of the packets.

Line Bar

The line bar is a single 100 ±0.5 IRE (reference white) pulse of 10 μs (PAL), 18 μs (NTSC), or 25 μs (PAL) that occurs anywhere within the

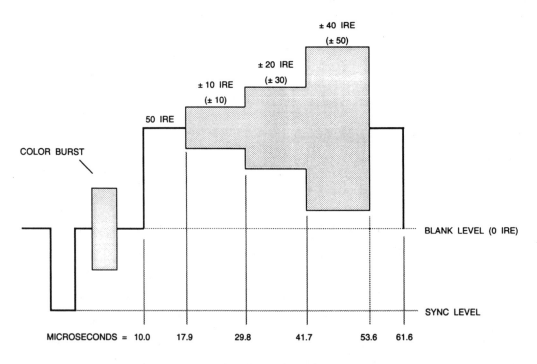

Figure 5.41. Modulated Pedestal Test Signal. PAL IRE values are shown in parentheses.

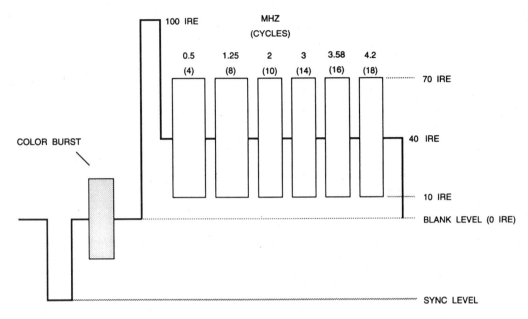

Figure 5.42. (M) NTSC Multiburst Test Signal.

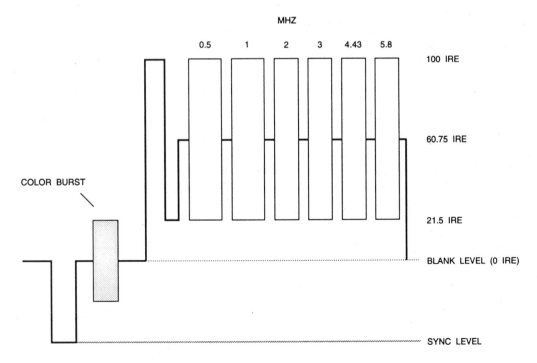

Figure 5.43. (B, D, G, H, I) PAL Multiburst Test Signal.

active scan line time (rise and fall times are ≤ 1 μs). Note the color burst is not present, and a 0 IRE setup is used. This test signal is used to measure line time distortion (line tilt or H tilt). A digital encoder does not generate line time distortion; the distortion is primarily generated by the analog filters and transmission medium.

Field Square Wave

The field square wave contains 100 ±0.5 IRE pulses for the entire active line time for odd fields and blanked scan lines for even fields. Note the color burst is not present and a 0 IRE setup is used. This test signal is used to measure field time distortion (field tilt or V tilt). A digital encoder does not generate field time distortion; the distortion is primarily generated by the analog filters and transmission medium.

Multipulse

The multipulse contains modulated 25T and 12.5T sine-squared pulses with various high-frequency components. Figure 5.44 illustrates a typical multipulse test signal for (M) NTSC. This test signal is typically used to measure the frequency response of the transmission medium.

Composite Test Signal

The NTC (U. S. Network Transmission Committee) has developed a composite test signal that may be used to test several video parameters, rather than using multiple test signals. The NTC composite test signal for NTSC systems (shown in Figure 5.45) consists of a 100 IRE line bar, a 2T pulse, a chrominance pulse, and a 5-step modulated staircase signal.

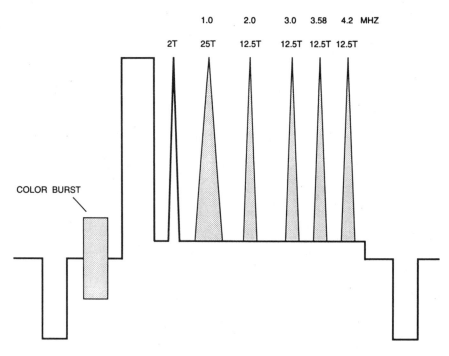

Figure 5.44. (M) NTSC Multipulse Test Signal.

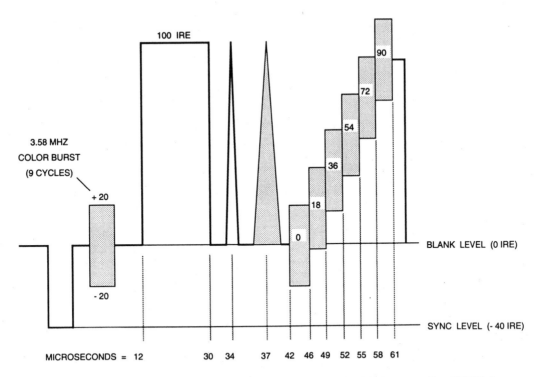

Figure 5.45. NTC (M) NTSC Composite Test Signal, with Corresponding IRE Values.

The line bar has a peak amplitude of 100 ±0.5 IRE, and 10%–90% rise and fall times of 125 ±5 ns with an integrated sine-squared shape. It has a width at the 60 IRE level of 18 µs.

The 2T pulse has a peak amplitude of 100 ±0.5 IRE, with a half-amplitude width of 250 ±10 ns.

The chrominance pulse has a peak amplitude of 100 ±0.5 IRE, with a half-amplitude width of 1562.5 ±50 ns.

The 5-step modulated staircase signal consists of 5 luminance steps that have a 40 ±0.5 IRE chrominance amplitude with a chrominance phase relative to the burst of 0° ±1°. The rise and fall times of each modulation packet envelope is 400 ±25 ns. The luminance IRE levels for the 5-step modulated staircase signal are shown in Figure 5.45.

Combination Test Signal

The NTC (U. S. Network Transmission Committee) has also developed a combination test signal that may be used to test several NTSC video parameters, rather than using multiple test signals. The NTC combination test signal for NTSC systems (shown in Figure 5.46) consists of a white flag, a multiburst, and a modulated pedestal signal.

The white flag has a peak amplitude of 100 ±1 IRE and a width of 4 µs.

The multiburst has a 50 ±1 IRE pedestal with peak-to-peak amplitudes of 50 ±0.5 IRE. The starting point of each frequency packet is at zero phase. The width of the 0.5 MHz packet is 5 µs; the width of the remaining packets is 3 µs.

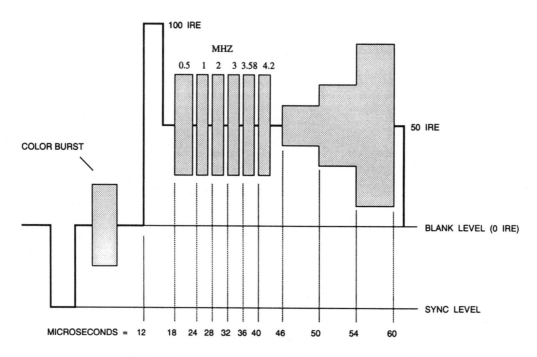

Figure 5.46. NTC (M) NTSC Combination Test Signal.

The 3-step modulated pedestal is composed of a 50 IRE luminance pedestal, with three amplitudes of modulated chrominance (20 ±0.5, 40 ±0.5, and 80 ±0.5 IRE peak-to-peak) with a phase relative to the burst of –90° ±1°. The rise and fall times of each modulation packet envelope is 400 ±25 ns.

The combination test signal may be easily modified for use with (B, D, G, H, I) PAL systems by substituting the 3.58 and 4.2 MHz multiburst packets with 4.43 and 5.8 MHz packets, respectively. The peak-to-peak amplitudes of the 3-step modulated pedestal would be 21.5 ±0.5, 43 ±0.5, and 86 ±0.5 IRE.

Video Parameters

Many industry-standard video parameters have been defined to specify the relative quality of NTSC/PAL encoders. To measure these parameters, the output of the NTSC/PAL encoder (while generating various video test signals such as those previously described) is monitored using video test equipment. Along with a description of several of these parameters, typical AC parameter values for both consumer and studio-quality encoders are shown in Table 5.19.

Several AC parameters, such as group delay and K factors, are very dependent on the quality of the analog video filters, and are not discussed here. In addition to the AC parameters discussed in this section, there are several others that should be included in an encoder specification, such as burst frequency and tolerance, horizontal frequency, horizontal blanking time, sync rise and fall times, burst envelope rise and fall times, video blanking rise and fall times, and the bandwidths of the YIQ or YUV baseband video signals.

Parameter	Consumer Quality		Studio Quality		Units
	NTSC[1]	PAL[2]	NTSC[1]	PAL[2]	
differential phase	4		≤ 1		degrees
differential gain	4		≤ 1		%
luminance nonlinearity	2		≤ 1		%
hue accuracy	3		≤ 1		degrees
color saturation accuracy	3		≤ 1		%
residual subcarrier	0.5		0.01		IRE
SNR (per CCIR 410 or EIA RS-250-B)	48		> 60		dB
SCH phase	0 ± 40	0 ± 20	0 ± 2		degrees
analog Y/C video output skew	5		≤ 2		ns
H tilt	< 1		< 1		%
V tilt	< 1		< 1		%
subcarrier tolerance	10	5	10	5	Hz

Notes
1. (M) NTSC.
2. (B, D, G, H, I) PAL.

Table 5.19. Typical Video AC Parameters for NTSC and PAL Encoders.

There are also several DC parameters (such as white level and tolerance, blanking level and tolerance, sync height and tolerance, peak-to-peak burst amplitude and tolerance) that should be specified, as shown in Table 5.20.

Differential Phase

Differential phase distortion, commonly referred to as differential phase, specifies how much the chrominance phase is affected by the luminance level—in other words, how much hue shift occurs when the luminance level changes. Both positive and negative phase errors may be present, so differential phase is expressed as a peak-to-peak measurement, expressed in degrees of subcarrier phase. This parameter is measured using a test signal of uniform phase and amplitude chrominance superimposed on different luminance levels, such as the modulated ramp test signal, or the modulated 5-step portion of the composite test signal. The differential phase parameter for a studio-quality analog encoder may approach 0.2° or less.

Differential Gain

Differential gain distortion, commonly referred to as differential gain, specifies how much the chrominance gain is affected by the luminance level—in other words, how much color saturation shift occurs when the luminance level changes. Both attenuation and amplification may occur, so differential gain is

Parameter	NTSC[1]	PAL[2]	Units
white relative to blank	714 ±7	700 ±7	mV
black relative to blank	54 ±7	0	mV
sync relative to blank	−286 ±7	−300 ±7	mV
burst amplitude (nominal, peak-to-peak)	286 ±7	300 ±7	mV

Notes
1. (M) NTSC.
2. (B, D, G, H, I) PAL.

Table 5.20. Typical Video DC Parameters for NTSC and PAL Encoders.

expressed as the largest amplitude change between any two levels, expressed as a percent of the largest chrominance amplitude. This parameter is measured using a test signal of uniform phase and amplitude chrominance superimposed on different luminance levels, such as the modulated ramp test signal, or the modulated 5-step portion of the composite test signal. The differential gain parameter for a studio-quality analog encoder may approach 0.2% or less.

Luminance Nonlinearity

Luminance nonlinearity, also referred to as differential luminance and luminance nonlinear distortion, specifies how much the luminance gain is affected by the luminance level. In other words, there is a nonlinear relationship between the generated luminance level and the ideal luminance level. Using an unmodulated 5-step or 10-step staircase test signal, or the modulated 5-step portion of the composite test signal, the difference between the largest and smallest steps, expressed as a percentage of the largest step, is used to specify the luminance nonlinearity. Although this parameter is included within the differential gain and phase

parameters, it is traditionally specified independently.

Chrominance Nonlinear Phase Distortion

Chrominance nonlinear phase distortion specifies how much the chrominance phase (hue) is affected by the chrominance amplitude (saturation)—in other words, how much hue shift occurs when the saturation changes. Using a modulated pedestal test signal, or the modulated pedestal portion of the combination test signal, the phase differences between each chrominance packet and the burst is measured. The difference between the largest and the smallest measurements are the peak-to-peak value, expressed in degrees of subcarrier phase. This parameter is not usually independently specified, but is included within the differential gain and phase parameters.

Chrominance Nonlinear Gain Distortion

Chrominance nonlinear gain distortion specifies how much the chrominance gain is affected by the chrominance amplitude (saturation)—in other words, there is a nonlinear

relationship between the generated chrominance amplitude levels and the ideal chrominance amplitude levels—this is usually seen as an attenuation of highly saturated chrominance signals. Using a modulated pedestal test signal, or the modulated pedestal portion of the combination test signal, the test equipment is adjusted so that the middle chrominance packet is 40 IRE. The largest difference between the measured and nominal values of the amplitudes of the other two chrominance packets specifies the chrominance nonlinear gain distortion, expressed in IRE or as a percentage of the nominal amplitude of the worst-case packet. This parameter is not usually independently specified, but is included within the differential gain and phase parameters.

Chrominance-to-Luminance Intermodulation

Chrominance-to-luminance intermodulation, commonly referred to as cross-modulation, specifies how much the luminance level is affected by the chrominance. This may be the result of clipping highly saturated chrominance levels or quadrature distortion, and show up as irregular brightness variations due to changes in color saturation. Using a modulated pedestal test signal, or the modulated pedestal portion of the combination test signal, the largest difference between the normalized 50 IRE pedestal level and the measured luminance levels (after removal of chrominance information) specifies the chrominance-to-luminance intermodulation, expressed in IRE or as a percentage. This parameter is not usually independently specified, but is included within the differential gain and phase parameters.

Hue Accuracy

Hue accuracy specifies how closely the generated hue is to the ideal hue value. Both positive and negative phase errors may be present, so hue accuracy is the difference between the worst-case positive and worst-case negative measurements from nominal, expressed in degrees of subcarrier phase. This parameter is measured using EIA or EBU color bars as a test signal.

Color Saturation Accuracy

Color saturation accuracy specifies how closely the generated saturation is to the ideal saturation value, using EIA or EBU color bars as a test signal. Both gain and attenuation may be present, so color saturation accuracy is the difference between the worst-case gain and worst-case attenuation measurements from nominal, expressed as a percentage of nominal.

Residual Subcarrier

The residual subcarrier parameter specifies how much subcarrier information is present during white or gray (note that, ideally, none should be present). Excessive residual subcarrier is visible as noise during white or gray portions of the picture. Using an unmodulated 5-step or 10-step staircase test signal, the maximum peak-to-peak measurement of the subcarrier (expressed in IRE) during active video is used to specify the residual subcarrier relative to the burst amplitude.

SCH Phase

SCH (Subcarrier to Horizontal) phase refers to the phase relationship between the leading edge of horizontal sync (at the 50% amplitude point) and the zero crossings of the color burst (by extrapolating the color burst to the leading edge of sync). The error is referred to as SCH phase, and is expressed in degrees of subcarrier phase.

For PAL, the definition of SCH phase is slightly different due to the more complicated relationship between the sync and subcarrier frequencies—the SCH phase relationship for a given line repeats only once every eight fields. Therefore, PAL SCH phase is defined, per EBU Technical Statement D 23-1984 (E), as "the phase of the +U component of the color burst extrapolated to the half-amplitude point of the leading edge of the synchronizing pulse of line 1 of field 1."

SCH phase in important when merging two or more video signals. To avoid color shifts or "picture jumps," the video signals must have the same horizontal, vertical, and subcarrier timing and the phases must be closely matched. To achieve these timing constraints, the video signals must have the same SCH phase relationship since the horizontal sync and subcarrier are continuous signals with a defined relationship. It is common for an encoder to allow adjustment of the SCH phase to simplify merging two or more video signals together. Maintaining proper SCH phase is also important since NTSC and PAL decoders may monitor the SCH phase to determine which color field is being decoded.

Analog Y/C Video Output Skew

The output skew between the analog luminance (Y) and modulated chrominance (C) video signals should be minimized to avoid phase shift errors between the luminance and chrominance information. Excessive output skew is visible as artifacts along sharp vertical edges when viewed on a monitor.

H Tilt

H tilt, also known a line tilt and line time distortion, causes a tilt in line-rate signals, predominantly white bars. This type of distortion causes variations in brightness between the left and right edges of an image. For a digital encoder, such as that described in this chapter, H tilt is primarily an artifact of the analog output filters and the transmission medium. H tilt is measured using a line bar (such as the one in the NTC NTSC composite test signal) and measuring the peak-to-peak deviation of the tilt (in IRE or percent of white bar amplitude), ignoring the first and last microsecond of the white bar.

V Tilt

V tilt, also known as field tilt and field time distortion, causes a tilt in field-rate signals, predominantly white bars. This type of distortion causes variations in brightness between the top and bottom edges of an image. For a digital encoder, such as that described in this chapter, V tilt is primarily an artifact of the analog output filters and the transmission medium. V tilt is measured using a 18 µs, 100 IRE white bar in the center of 130 lines in the center of the field or using a field square wave. The peak-to-peak deviation of the tilt is measured (in IRE or percent of white bar amplitude), ignoring the first and last three lines.

Genlocking

In many instances, it is desirable to be able to genlock the output (align the sync signals) of an encoder to another video signal to facilitate downstream video processing. This requires locking the horizontal, vertical, and color subcarrier frequencies and phases together as we will discuss in Chapter 6. However, unlike the NTSC/PAL decoder discussed in Chapter 6, the genlock probably does not have to be robust enough to handle the "special feature" modes of video tape recorders, such as fast-forwarding or pause.

One method of genlocking is to send an advance house sync (black burst) to the encoder. The advancement compensates for

the delay from the house sync generator to the encoder output being used in the downstream processor, such as a mixer. Each video source has its own advanced house sync signal, so each video source is time-aligned at the mixing or processing point.

Another method of genlocking allows adjustment of the subcarrier phase so it can be matched with other video sources at the mixing or processing point. The subcarrier phase must be able to be adjusted from 0° to 360°. Either zero SCH phase is always maintained or another adjustment is allowed to independently position the sync and luminance information in about 10-ns steps.

An encoder designed for the video editing environment should also support an alpha channel. Eight or ten bits of digital alpha data are input, pipelined to match the pipeline of the encoding process, and converted to an analog alpha signal (discussed in Chapter 9). In computer systems that support 32-bit pixels, 8 bits are typically available for alpha information. Including the alpha channel on the encoder allows designers to change encoders (which may have different pipeline delays) to fit specific applications without worrying about the alpha channel pipeline delay. Alpha is usually linear, with the digital data generating an analog alpha signal (also called a key) with a range of 0 to 100 IRE. There is no blanking pedestal or sync information present.

For our encoder design, 8-bit alpha values with a range of 0–255 would be translated to have a range of 0–140 (NTSC operation) or 0–137 (PAL or SECAM operation), assuming the alpha 8-bit D/A converter has the same full-scale output voltage as the video D/A converters.

Timecode Generation

Two types of time coding are commonly used, as defined by ANSI/SMPTE 12M and IEC 461:

longitudinal timecode (LTC) and vertical interval timecode (VITC). The LTC is recorded on a separate audio track; as a result, the VTR must use high-bandwidth amplifiers and audio heads. This is due to the time code frequency increasing as tape speed increases, until the point that the frequency response of the system results in a distorted time code signal that may not be read reliably. At slower tape speeds, the time code frequency decreases, until at very low tape speeds or still pictures, the time code information is no longer recoverable. The VITC is recorded as part of the video signal; as a result, the time code information is always available, regardless of the tape speed. However, the LTC allows the time code signal to be written without writing a video signal; the VITC requires the video signal to be changed if a change in time code information is required. The LTC is therefore useful for synchronizing multiple audio or audio/video sources.

Longitudinal Timecode (LTC)

The LTC information is transmitted using a separate serial interface, using the same electrical interface as the AES/EBU digital audio interface standard, AES3 (ANSI S4.40), and is recorded on a separate audio channel. The basic structure of the time data is based upon the BCD system. Tables 5.21 and 5.22 list the LTC bit assignments and arrangement. Note the 24-hour clock system is used.

LTC Timing

The modulation technique is such that a transition occurs at the beginning of every bit period. "1" is represented by a second transition one half a bit period from the start of the bit. "0" is represented when there is no transition within the bit period (see Figure 5.47). The rise and fall times are to be 25 ±5 μs (10% to 90% amplitude points).

Bit(s)	Function	Note	Bit(s)	Function	Note
0–3	units of frames		59 (525/60)	binary group flag	
4–7	user group 1		59 (625/50)	phase correction	note 3
8–9	tens of frames		60–63	user group 8	
10	drop frame flag	note 1	64	sync bit	fixed"0"
11	color frame flag	note 2	65	sync bit	fixed"0"
12–15	user group 2		66	sync bit	fixed"1"
16–19	units of seconds		67	sync bit	fixed"1"
20–23	user group 3		68	sync bit	fixed"1"
24–26	tens of seconds		69	sync bit	fixed"1"
27 (525/60)	phase correction	note 3	70	sync bit	fixed"1"
27 (625/50)	binary group flag		71	sync bit	fixed"1"
28–31	user group 4		72	sync bit	fixed"1"
32–35	units of minutes		73	sync bit	fixed"1"
36–39	user group 5		74	sync bit	fixed"1"
40–42	tens of minutes		75	sync bit	fixed"1"
43	binary group flag		76	sync bit	fixed"1"
44–47	user group 6		77	sync bit	fixed"1"
48–51	units of hours		78	sync bit	fixed"0"
52–55	user group 7		79	sync bit	fixed"1"
56–57	tens of hours				
58	unassigned	fixed "0"			

Notes
1. 525/60 systems: "1" if frame numbers are being dropped; "0" if no frame dropping is done. 625/50 systems: "0". See Frame Dropping—(M) NTSC and (M) PAL.
2. 525/60 systems: "1" if even units of frame numbers identify fields 1 and 2 and odd units of field numbers identify fields 3 and 4. 625/50 systems: "1" if timecode is locked to the video signal in accordance with 8-field sequence and the video signal has the "preferred subcarrier-to-line-sync phase."
3. This bit shall be put in a state so that every 80-bit word contains an even number of logical zeros.

Table 5.21. LTC Bit Assignments.

Frames (count 0–29 for 525/60 systems, 0–24 for 625/50 systems)	
units (bits 0–3)	4-bit BCD arranged 1, 2, 4, 8 (count 0–9); bit 0 is LSB
tens of units (bits 8–9)	2-bit BCD arranged 1, 2 (count 0–2); bit 8 is LSB

Seconds	
units (bits 16–19)	4-bit BCD arranged 1, 2, 4, 8 (count 0–9); bit 16 is LSB
tens of units (bits 24–26)	3-bit BCD arranged 1, 2, 4 (count 0–5); bit 24 is LSB

Minutes	
units (bits 32–35)	4-bit BCD arranged 1, 2, 4, 8 (count 0–9); bit 32 is LSB
tens of units (bits 40–42)	3-bit BCD arranged 1, 2, 4 (count 0–5); bit 40 is LSB

Hours	
units (bits 48–51)	4-bit BCD arranged 1, 2, 4, 8 (count 0–9); bit 48 is LSB
tens of units (bits 56–57)	2-bit BCD arranged 1, 2 (count 0–2); bit 56 is LSB

Table 5.22. LTC Bit Arrangement.

Figure 5.47. LTC Data Bit Transition Format.

As the entire frame time is used to generate the 80-bit LTC information, the bit rate (in bits per second) may be determined by:

$$F_C = 80 \, F_V$$

where F_V is the vertical frame rate in frames per second. The 80 bits of time code information are output serially, with bit 0 being first. The LTC word occupies the entire frame time, and the data must be evenly spaced throughout this time. The start of the LTC word occurs at the beginning of line 2 (±1 line) in fields 1 and 3 for 525/60 systems and at the beginning of line 2 (±1 line) in fields 1, 3, 5, and 7 for 625/50 systems. Note these 525/60 system scan line numbers correspond to the line numbering scheme as shown in Figure 5.21.

User Bits

The user group bits are intended for storage of data by users, and the 32 bits within the 8 groups may be assigned in any manner without restriction if the character set used for the data is not specified and both binary group flag bits are zero. The binary group flag bits shall be set as shown in Table 5.23.

If an 8-bit character set conforming to ISO Standards 646 and 2022 is indicated by the binary group flags, the characters are to be inserted as shown in Figure 5.48. Note that some user bits will be decoded before the binary group flags are decoded; therefore, the decoder must store the early user data before any processing is done.

Frame Dropping—(M) NTSC and (M) PAL

One second of real time is defined as the time elapsed during the scanning of 60 fields (or any multiple). One second of color time is defined as the time elapsed during the scanning of 60 fields (or any multiple) of a system that has a vertical field rate of about 59.94 fields per second.

Since the vertical field rate of the color signal is not exactly 60, straight counting at 30 frames per second (60 fields per second) yields an error of 108 frames (216 fields) for each hour of running time. This may be corrected in one of two ways:

Nondrop frame: During a continuous recording, each time count increases by 1 frame. In this mode, the drop frame flag shall be a "0."

Drop frame for (M) NTSC: To resolve the color timing error, the first two frame numbers (0 and 1) at the start of each minute, except for minutes 0, 10, 20, 30, 40, and 50, are omitted from the count. In this mode, the drop frame flag shall be a "1."

	Bit 43	Bit 59
525/60 systems	Bit 43	Bit 59
625/50 systems	Bit 27	Bit 43
character set not specified	0	0
8-bit character set*	0	1
reserved	1	0
reserved	1	1

* conforming to ISO Standards 646 and 2022.

Table 5.23. Binary Group Flag Bit Definitions.

Figure 5.48. Use of Binary Groups to Describe ISO Characters Coded with 7 or 8 Bits.

Drop frame for (M) PAL: To resolve the color timing error, the first four frame numbers (1 to 4) at the start of every second minute (even minute numbers) are omitted from the count, except for minutes 0, 20, and 40. In this mode, the drop frame flag shall be a "1."

Vertical Interval Time Code (VITC)

The VITC is recorded during the vertical blanking interval of a composite video signal onto two nonconsecutive scan lines in both fields. Since it is recorded with the video, it can be read in still mode. However, it cannot be rerecorded (or restriped). Restriping requires dubbing down a generation, deleting and inserting a new time code. Note that for S-video signals (separate luminance and chrominance signals), the VITC is present only on the Y channel.

As with the LTC, the basic structure of the time data is based upon the BCD system. Tables 5.24 and 5.25 list the VITC bit assignments and arrangement. Note the 24-hour clock system is used.

VITC Timing

The modulation technique is such that each state corresponds to a binary state and a transition occurs only when there is a change in the data between adjacent bits from a "1" to "0" or "0" to "1". No transitions occur when adjacent bits contain the same data. This is commonly referred to as "non-return to zero" (NRZ). Synchronization bit pairs are inserted throughout the VITC data to assist the receiver in maintaining the correct frequency lock.

The bit rate (F_C) is defined to be (with an allowable error of ±200 bits per second):

525/60 systems: $F_C = (455/4) F_H = F_{SC}/2$

625/50 systems: $F_C = 116 F_H$

where F_H is the horizontal line frequency. The 90 bits of time code information are output serially during video blanking, with bit 0 being first. Two nonconsecutive available scan lines per field during the vertical retrace interval are used (to protect the VITC reading process against drop-outs). Which scan lines are to be used are not defined. However, it may not be earlier than lines 7 or 270 (525/60 systems) or lines 6 or 319 (625/50 systems) or later than lines 17 or 279 (525/60 systems) or lines 22 or 335 (625/50 systems). For 525/60 systems, lines 7, 11, 270, and 274 are commonly used for the VITC. Note these 525/60 system scan line numbers correspond to the line numbering scheme as shown in Figure 5.21.

Bit(s)	Function	Note	Bit(s)	Function	Note
0	sync bit	fixed "1"	42–45	units of minutes	
1	sync bit	fixed "0"	46–49	user group 5	
2–5	units of frames		50	sync bit	fixed "1"
6–9	user group 1		51	sync bit	fixed "0"
10	sync bit	fixed "1"	52–54	tens of minutes	
11	sync bit	fixed "0"	55	binary group flag	
12–13	tens of frames		56–59	user group 6	
14	drop frame flag	note 1	60	sync bit	fixed "1"
15	color frame flag	note 2	61	sync bit	fixed"0"
16–19	user group 2		62–65	units of hours	
20	sync bit	fixed "1"	66–69	user group 7	
21	sync bit	fixed "0"	70	sync bit	fixed"1"
22–25	units of seconds		71	sync bit	fixed"0"
26–29	user group 3		72–73	tens of hours	
30	sync bit	fixed "1"	74	unassigned	fixed "0"
31	sync bit	fixed "0"	75 (525/60)	binary group flag	
32–34	tens of seconds		75 (625/50)	field mark flag	note 4
35 (525/60)	field mark flag	note 3	76–79	user group 8	
35 (625/50)	binary group flag		80	sync bit	fixed"1"
36–39	user group 4		81	sync bit	fixed"0"
40	sync bit	fixed "1"	82–89	CRC group	
41	sync bit	fixed "0"			

Notes
1. 525/60 systems: "1" if frame numbers are being dropped; "0" if no frame dropping is done. 625/50 systems: "0". See Frame Dropping—(M) NTSC and (M) PAL.
2. 525/60 systems: "1" if even units of frame numbers identify fields 1 and 2 and odd units of field numbers identify fields 3 and 4. 625/50 systems: "1" if timecode is locked to the video signal in accordance with 8-field sequence and the video signal has the "preferred subcarrier-to-line-sync phase".
3. 525/60 systems: "0" during fields 1 and 3. "1" during fields 2 and 4.
4. 625/50 systems: "0" during fields 1, 3, 5, and 7. "1" during fields 2, 4, 6, and 8.

Table 5.24. VITC Bit Assignments.

Frames (count 0–29 for 525/60 systems, 0–24 for 625/50 systems)	
units (bits 2–5)	4-bit BCD arranged 1, 2, 4, 8 (count 0–9); bit 2 is LSB
tens of units (bits 12–13)	2-bit BCD arranged 1, 2 (count 0–2); bit 12 is LSB

Seconds	
units (bits 22–25)	4-bit BCD arranged 1, 2, 4, 8 (count 0–9); bit 22 is LSB
tens of units (bits 32–34)	3-bit BCD arranged 1, 2, 4 (count 0–5); bit 32 is LSB

Minutes	
units (bits 42–45)	4-bit BCD arranged 1, 2, 4, 8 (count 0–9); bit 42 is LSB
tens of units (bits 52–54)	3-bit BCD arranged 1, 2, 4 (count 0–5); bit 52 is LSB

Hours	
units (bits 62–65)	4-bit BCD arranged 1, 2, 4, 8 (count 0–9); bit 62 is LSB
tens of units (bits 72–73)	2-bit BCD arranged 1, 2 (count 0–2); bit 72 is LSB

Table 5.25. VITC Bit Arrangement.

Figure 5.49 illustrates the timing of the VITC data on the scan line. The data must be evenly spaced throughout the VITC word. The rise and fall times of the VITC bit data should be limited to about 200 ns before adding it to the video signal to avoid possible distortion of the VITC signal by downstream chrominance circuits. In most circumstances, the analog lowpass filters after the video D/A converters should suffice for the filtering.

User Bits

The user group bits are intended for storage of data by users, and the 32 bits within the 8 groups may be assigned in any manner without restriction if the character set used for the data is not specified and both binary group flag bits are zero. The binary group flag bits shall be set as shown in Table 5.26.

If an 8-bit character set conforming to ISO Standards 646 and 2022 is indicated by the binary group flags, the characters are to be inserted as shown in Figure 5.48. Note that user data must be the same in both fields of a frame to avoid problems when transferring from VITC to LTC. Also, some user bits will be decoded before the binary group flags are decoded; therefore, the decoder must store the early user data before any processing is done.

VITC Cyclic Redundancy Check

Eight bits (82–89) are reserved for the code word for error detection by means of cyclic

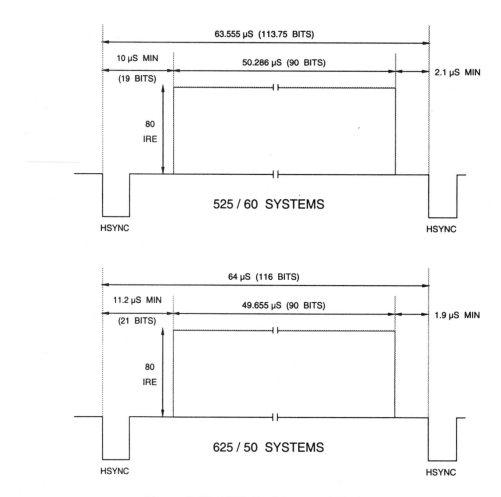

Figure 5.49. VITC Positions and Timing.

redundancy checking. The generating polynomial, $x^8 + 1$, applies to all bits from 0 to 81, inclusive. Figure 5.50 illustrates implementing the polynomial using a shift register. During passage of information data, the multiplexer is in position 0 and the data is output while the division is done simultaneously by the shift register. After all the information data has been output, the shift register contains the CRC value and switching the multiplexer to position 1 enables the CRC value to be output. When the process is repeated on decoding, the shift register should contain all zeros if no errors exist.

Closed Captioning (USA)

This section reviews closed captioning for the deaf for use in the United States. Closed captioning is transmitted during the blanked active line-time portion of line 21 of fields 1, 3, 5, and 7 (line 18 using the nonstandard line numbering as shown in Figure 5.21). The data format consists of a clock run-in signal, a start bit, and two 7-bit plus parity words of US ASCII data (per X3.4-1967); the effective data rate is roughly 480 baud and either captioning or full-page text may be displayed. To support S-video

525/60 systems	Bit 55	Bit 75
625/50 systems	Bit 35	Bit 55
character set not specified	0	0
8-bit character set*	0	1
reserved	1	0
reserved	1	1

* conforming to ISO Standards 646 and 2022.

Table 5.26. Binary Group Flag Bit Definitions.

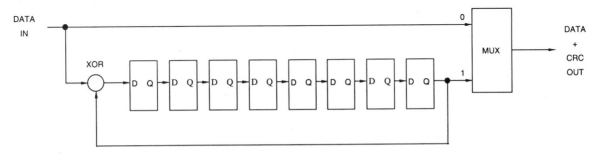

Figure 5.50. CRC Generation.

applications, caption information should also be available on the Y channel.

Figure 5.51 illustrates the waveform and timing for transmitting the closed captioning information, and conforms to the standard Television Synchronizing Waveform for Color Transmission in Subpart E, Part 73 of the FCC Rules and Regulations (1990). The clock run-in is a 7-cycle sinusoidal burst that is frequency and phase-locked to the caption data, and is used to provide synchronization for the decoder. The nominal data rate is 32x F_H. However, decoders should not rely on this timing relationship due to possible horizontal timing variations introduced by video processing circuitry and VTRs. After the clock run-in signal, the blanking level is maintained for a two data bit duration, followed by a "1" start bit. The start bit is followed by 16 bits of data, composed of two 7-bit + odd parity US ASCII char-

acters. Caption data is transmitted using a non–return-to-zero (NRZ) code; a digital "1" corresponds to the 50 IRE level and a digital "0" corresponds to the blanking level (0–2 IRE). The negative-going crossings of the clock are coherent with the data bit transitions.

Typical decoders specify the time between the 50% points of sync and clock run-in to be 10.5 ±0.5 µs, with a ±3% tolerance on F_H, 50 ±10 IRE for a logical one bit, and 0–10 IRE for a logical zero bit. Decoders must also handle bit rise/fall times of 192–480 µs.

NUL characters should be sent when no display or control characters are being transmitted. This, in combination with the clock run-in, enables the decoder to determine whether or not captioning or text transmission is being implemented.

The 0.5034965-MHz clock run-in may be easily generated by adding another two-stage

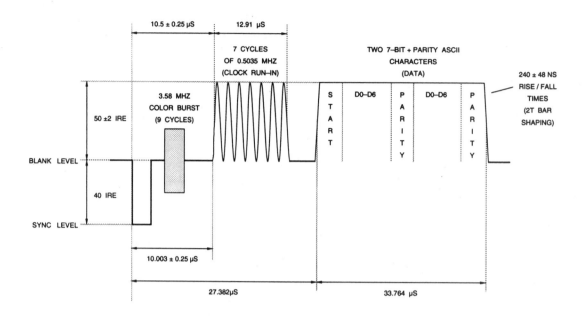

Figure 5.51. Closed captioning Line 21 Timing During Fields 1, 3, 5, and 7. Horizontal dimensions are not to scale.

p:q ratio counter, similar to the one used for subcarrier generation. (The p:q ratio counter used for subcarrier generation can't be used for this function, since the subcarrier phase must be maintained.) During the clock run-in time, this p:q ratio counter addresses the sin ROM normally used for subcarrier generation. The P1 and P2 values for the p:q ratio counter are determined as follows:

$$\frac{FC}{FS} = \frac{P1 + \dfrac{P2}{(4)\,(HCOUNT)}}{2048} = \frac{32}{HCOUNT}$$

For 13.5-MHz operation, where HCOUNT = 858 (CCIR601 operation), P1 and P2 have values of 76 and 1312, respectively. For 12.2727 MHz operation, where HCOUNT = 780 (square pixel NTSC operation), P1 and P2 have values of 84 and 64, respectively.

At the decoder, as shown in Figure 5.52, the black display area is 15 rows high and 34 columns wide. The vertical display area begins on line 43 and ends on line 237. The horizontal display area begins 13 µs, and ends 58 µs, after the leading edge of horizontal sync. In text mode, all rows are used to display text; each row contains a maximum of 32 characters, with at least a one-column wide space on the left and right of the text. The only transparent area is around the outside of the display area. In caption mode, text appears only on rows 1–4 and 12–15; rows 5–11 are always transparent, as is outside the display area. Each row contains a maximum of 32 characters and each character is always preceded and followed by another character or a space at least one column wide.

There are two types of display formats: text and captioning. In understanding the operation of the decoder, it is easier to visualize an invisible cursor that marks the position where

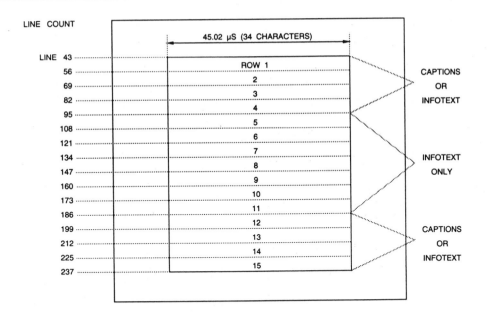

Figure 5.52. Display Format. The line numbering corresponds to that used in standard practice for NTSC.

the next character will be displayed. Note that if you are designing a decoder, you should obtain the latest FCC Rules and Regulations to ensure correct operation, as this section is only a summary.

Text mode uses all 15 rows of the display and is enabled upon receipt of the Resume Text Display code. When text mode has first been selected, and the text memory is empty, the cursor starts at row 1, character 1. Once the first 15 rows of text are displayed, scrolling is enabled. With each carriage return received, row 1 text is erased, text on rows 2–15 are rolled up one row (at the rate of one dot per frame), row 15 is erased, and the cursor is moved to row 15, character 1. Should new text be received while scrolling, it is seen scrolling up from the bottom of the display area. If a carriage return is received while scrolling, rows 2–15 are immediately moved to their final position. Once the cursor moves to character 32 on any row, any text received before a carriage return, preamble address code, or backspace,

will be displayed at character 32, replacing any previous character at that position. The Text Restart command erases the display and moves the cursor to row 1, character 1.

Captioning has several modes available, including roll-up, pop-on, and paint-on. Roll-up captioning is enabled by receiving one of the miscellaneous control codes to select the number of rows displayed. "Roll-up captions, 2 rows" enables rows 14 and 15; "roll-up captions, 3 rows" enables rows 13–15, "roll-up captions, 4 rows" enables rows 12–15. Regardless of the number of rows enabled, the cursor remains on row 15. Once row 15 is full, the rows are scrolled up one row (at the rate of one dot per frame), and the cursor is moved back to row 15, character 1. Pop-on captioning may use rows 1–4 or 12–15, and is initiated by the Resume Caption Loading command. The display memory is essentially double-buffered. While memory buffer 1 is displayed, memory buffer 2 is being loaded with caption data. At the receipt of a End of Caption code, memory

buffer 2 is displayed while memory buffer 1 is being loaded with new caption data. Paint-on captioning, enabled by the Resume Direct Captioning command, is similar to Pop-on captioning, but no double-buffering is used; caption data is loaded directly into display memory.

Three types of control codes (preamble address codes, midrow codes, and miscellaneous control codes) are used to specify the format, location, and attributes of the characters. Each control code consists of two bytes, transmitted together on line 21, and normally transmitted twice in succession to help ensure correct reception. The first byte is a nondisplay control byte with a range of 10_H to $1F_H$; the second byte is a display control byte in the range of 20_H to $7F_H$. At the beginning of each row, a control code is sent to initialize the row. Caption roll-up and text modes allow either a preamble address code or midrow control code at the start of a row; the other caption modes use a preamble address code to initial-

ize a row. The preamble address codes are illustrated in Figure 5.53 and Table 5.27.

The midrow codes are typically used within a row to change the color, italics, underline, and flashing attributes, and should occur only between words. Color, italics, and underline are controlled by the preamble address and midrow codes; flash on is controlled by a miscellaneous control code. An attribute remains in effect until another control code is received or the end of row is reached. Each row starts with a control code to set the color and underline attributes (white nonunderlined is the default if no control code is received before the first character on an empty row). The color attribute can only be changed by the midrow code of another color; the italics attribute do not change the color attribute. However, a color attribute turns off the italics attribute. The flash on command does not alter the status of the color, italics, or underline attributes, however, a color or italics midrow

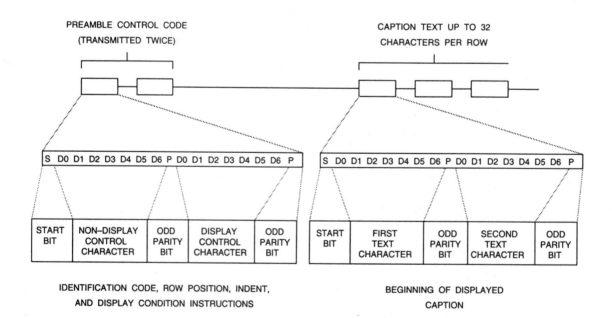

Figure 5.53. Caption Preamble Address Code Format.

non-display control byte							display control byte							row position
D6	D5	D4	D3	D2	D1	D0	D6	D5	D4	D3	D2	D1	D0	row position
0	0	1	F	0	0	1	1	0	A	B	C	D	U	1
0	0	1	F	0	0	1	1	1	A	B	C	D	U	2
0	0	1	F	0	1	0	1	0	A	B	C	D	U	3
0	0	1	F	0	1	0	1	1	A	B	C	D	U	4
0	0	1	F	0	1	1	1	0	A	B	C	D	U	12
0	0	1	F	0	1	1	1	1	A	B	C	D	U	13
0	0	1	F	1	0	0	1	0	A	B	C	D	U	14
0	0	1	F	1	0	0	1	1	A	B	C	D	U	15

U: "0" = no underline, "1" = underline
F: "0" = data channel 1, "1" = data channel 2

A	B	C	D	attribute
0	0	0	0	white
0	0	0	1	green
0	0	1	0	blue
0	0	1	1	cyan
0	1	0	0	red
0	1	0	1	yellow
0	1	1	0	magenta
0	1	1	1	italics
1	0	0	0	indent 0, white
1	0	0	1	indent 4, white
1	0	1	0	indent 8, white
1	0	1	1	indent 12, white
1	1	0	0	indent 16, white
1	1	0	1	indent 20, white
1	1	1	0	indent 24, white
1	1	1	1	indent 28, white

Table 5.27. Preamble Address Codes. In text mode, the indent codes may be used to perform indentation; in this instance, the row information is ignored.

control code turns off the flash. Note that the underline color is the same color as the character being underlined; the underline resides on dot row 11 and covers the entire width of the character column.

Table 5.28, Figure 5.54, and Table 5.29 illustrate the midrow and miscellaneous control code operation. For example, if it were the end of a caption, the control code could be End of Caption (transmitted twice). It could be followed by a preamble address code (transmitted twice) to start another line of captioning.

Characters are displayed using a dot matrix format. Each character cell is typically

non-display control byte							display control byte							attribute
D6	D5	D4	D3	D2	D1	D0	D6	D5	D4	D3	D2	D1	D0	
										0	0	0		white
										0	0	1		green
										0	1	0		blue
										0	1	1		cyan
0	0	1	F	0	0	1	0	1	0	1	0	0	U	red
										1	0	1		yellow
										1	1	0		magenta
										1	1	1		italics

U: "0" = no underline, "1" = underline F: "0" = data channel 1, "1" = data channel 2
Note: Italics is implemented as a two-dot slant to the right over the vertical range of the character. Underline resides on dot row 11 and covers the entire column width.

Table 5.28. Midrow Codes.

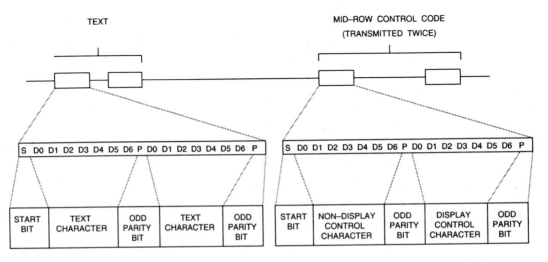

Figure 5.54. Caption Midrow Code Format. Miscellaneous control codes may also be transmitted in place of the midrow control code.

non-display control byte							display control byte							command
D6	D5	D4	D3	D2	D1	D0	D6	D5	D4	D3	D2	D1	D0	
0	0	1	F	1	0	0	0	1	0	0	0	0	0	resume caption loading
										0	0	0	1	backspace
										0	0	1	0	reserved
										0	0	1	1	reserved
										0	1	0	0	delete to end of row
										0	1	0	1	roll-up captions, 2 rows
										0	1	1	0	roll-up captions, 3 rows
										0	1	1	1	roll-up captions, 4 rows
										1	0	0	0	flash on
										1	0	0	1	resume direct captioning
										1	0	1	0	text restart
										1	0	1	1	resume text display
										1	1	0	0	erase displayed memory
										1	1	0	1	carriage return
										1	1	1	0	erase nondisplayed memory
										1	1	1	1	end of caption (flip memories)
0	0	1	F	1	1	1	0	1	0	0	0	0	1	tab offset (1 column)
										0	0	1	0	tab offset (2 columns)
										0	0	1	1	tab offset (3 columns)

F: "0" = data channel 1, "1" = data channel 2
Note: "flash on" blanks associated characters for 0.25 seconds once per second.

Table 5.29. Miscellaneous Control Codes.

13 dots high and 8 dots wide, as shown in Figure 5.55. Each vertical dot is one pair of interlaced scan lines; therefore, with a video field, a character cell is 13 scan lines high, and within a video frame a character cell is 26 scan lines high. Dot rows 0 and 12 are usually blanked to provide vertical spacing between characters, and underlining is typically done on dot row 11. Dot rows 1–9 are usually used for actual character outlines, leaving dot row 10 as a space between the bottom of a character and the underline attribute. Dot columns 0 and 7 are blanked to provide horizontal spacing between characters, except on dot row 11 when the underline is displayed. Table 5.30 shows the complete character set.

Anti-Taping Process for (M) NTSC Systems

Macrovision has developed an anti-taping process for pay-per-view applications that generate (M) NTSC from a digital video source. The digital video may be from a satellite (DBS), fiber or coaxial cable system, digital VTR, etc. The ability to enable or disable the anti-taping process is embedded within the digital video

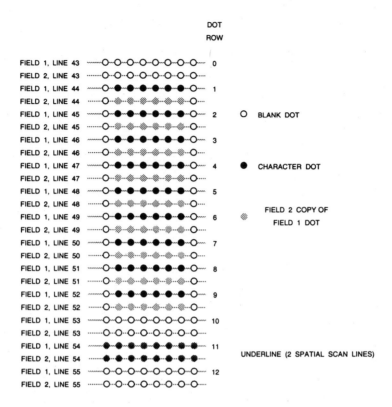

Figure 5.55. Typical Character Cell Format. Line numbers correspond to row 1. The line numbering corresponds to that used in standard practice for NTSC.

stream or transmitted on a separate control channel. This information may be used to control a register bit or pin on the encoder to enable or disable the anti-taping process.

Level Shifting

When anti-taping is enabled, all sync heights are modified to be 30 IRE, rather than the standard 40 IRE. This may easily be done within the NTSC encoder by using an 8-bit value of 18, rather than 4, for the sync tip. During the vertical blanking intervals (scan lines 1–18, 261–281, and 523–525, inclusive, using the line numbering shown in Figure 5.21), the blank level is modified to be at +10 IRE and the sync amplitude is modified so that the sync tip is at

–30 IRE (–40 IRE from the +10 IRE blanking level). Table 5.31 shows the digital values used by the NTSC encoder to implement the level shifting during vertical blanking.

Burst Inversion

The color burst is inverted 180° on specially selected lines that cause distortion when recorded (since the analog VTR responds to instantaneous color burst phase), but result in minimum artifacts when displayed directly (since the TV responds to the long-term average color burst phase). Scan lines with the color burst inverted are (using the line numbering shown in Figure 5.21) shown in Table 5.32. This particular technique is not compati-

nondisplay control byte							display control byte							special characters
D6	D5	D4	D3	D2	D1	D0	D6	D5	D4	D3	D2	D1	D0	
										0	0	0	0	®
										0	0	0	1	°
										0	0	1	0	1/2
										0	0	1	1	¿
										0	1	0	0	™
										0	1	0	1	ç
										0	1	1	0	£
0	0	1	F	0	0	1	0	1	1	0	1	1	1	music note
										1	0	0	0	à
										1	0	0	1	transparent space
										1	0	1	0	è
										1	0	1	1	â
										1	1	0	0	ê
										1	1	0	1	î
										1	1	1	0	ô
										1	1	1	1	û

D6 D5 D4 D3	0100	0101	0110	0111	1000	1001	1010	1011	1100	1101	1110	1111
D2 D1 D0												
000		(0	8	@	H	P	X	ú	h	p	x
001	!)	1	9	A	I	Q	Y	a	i	q	y
010	"	á	2	:	B	J	R	Z	b	j	r	z
011	#	+	3	;	C	K	S	[c	k	s	ç
100	$,	4	<	D	L	T	é	d	l	t	÷
101	%	−	5	=	E	M	U]	e	m	u	Ñ
110	&	.	6	>	F	N	V	í	f	n	v	ñ
111	'	/	7	?	G	O	W	ó	g	o	w	■

Table 5.30. Character Set.

Video Level	8-bit digital value	10-bit digital value
AGC pulse	237	948
blank	74	296
sync	18	72

Table 5.31. (M) NTSC Digital values of Vertical Blanking Interval During Anti-taping.

fields 1 and 3				fields 2 and 4			
15	16	17	18	278	279	280	281
35	36	37	38	307	308	309	310
55	56	57	58	327	328	329	330
75	76	77	78	347	348	349	350
95	96	97	98	367	368	369	370
115	116	117	118	387	388	389	390
135	136	137	138	407	408	409	410
155	156	157	158	427	428	429	430
175	176	177	178	447	448	449	450
195	196	197	198	467	468	469	470

Table 5.32. Scan Lines with Burst Inversion.

ble with conventional analog video tapes due to the way subcarrier information is processed within the VTR.

Pseudo-Sync Pulses

Four pseudo-sync pulses are inserted on each scan line for scan lines 9–15 and 272–278 (using the line numbering shown in Figure 5.21), inclusive. There are 28 pseudo-sync pulses per field. The first pseudo-sync pulse starts 8.5 ±0.25 µs after the leading edge of the normal horizontal sync pulse, and the spacing between successive pseudo-sync pulses is 8.0 ±0.25 µs. Each pseudo-sync pulse has an amplitude of 40 ±2 IRE (descending from the +10 IRE blanking level to –30 IRE) and are 2.25 ±0.05 µs wide. Rise and fall times are 0–250 ns, with a back porch of 0–140 ns, and a minimum front porch of 1.45 µs.

VBI AGC Pulses

The VBI AGC pulses are super-white pulses that begin 0–140 ns after the end of each pseudo-sync pulse, and are 3.0 ±0.1 µs wide.

The VBI AGC pulse tips are at the 121–127 IRE level (111–117 IRE above the +10 IRE vertical blanking level and 151–157 IRE above the pseudo-sync tip level). Rise and fall times are 0–250 ns. Table 5.29 shows the digital values used by the NTSC encoder to implement the VBI AGC pulses.

The VBI AGC pulses may optionally decay to the +10 IRE blanking level about every 32 seconds. The cycling may be done by maintaining the normal AGC pulse level for about 24 seconds, ramp down to the blanking level over 1.5–2 seconds, stay at the blanking interval for about 5 seconds, and ramp up to the normal AGC pulse level over 1.5–2 seconds.

Figure 5.56 illustrates the positioning of the pseudo-sync and VBI AGC pulses for one scan line. The numbers indicate at what horizontal count (assuming the leading edge of horizontal sync corresponds to a count of one) to start or stop the pulse if a 13.5-MHz pixel clock is used.

End-of-Field AGC Pulses

A single AGC pulse is added to the back porch on each of the last 10 scan lines preceding the vertical sync of each field. These occur on scan lines 516–525 and 254–263, inclusive, using the line numbering shown in Figure 5.21. The AGC pulses start immediately after the trailing edge of the normal horizontal sync or equalizing pulse, and have the same amplitude as the VBI AGC pulses. On scan lines 523, 524, 525, 261, 262, and 263, the AGC pulse is added only after the first equalizing pulse, which occurs at the F_H rate.

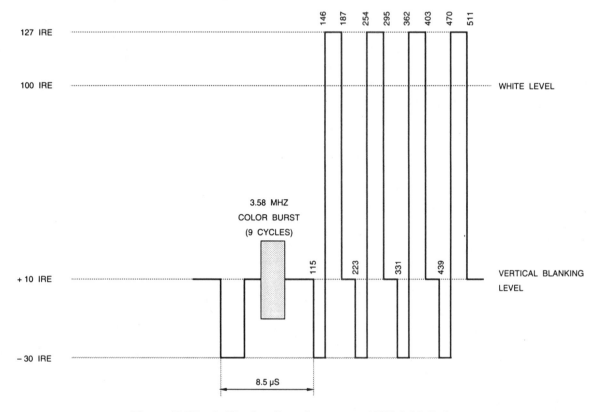

Figure 5.56. Antitaping Pseudo-sync and VBI AGC Pulses.

VLSI Solutions

This section is an overview of commercially available VLSI solutions that use digital techniques for encoding NTSC and PAL video signals.

The Bt858 (Figure 5.57) from Brooktree Corporation is a digital NTSC/PAL encoder, generating composite NTSC or PAL and Y/C S-video. RGB (15-bit, 16-bit, or 24-bit), YCrCb (16-bit 4:2:2 or 24-bit 4:4:4), or 8-bit pseudo-color data may be input and it operates at clock rates of 12–18 MHz, enabling the support of NTSC and PAL square pixel, CCIR601, and 4x F_{SC} formats. The FIELD_0 and FIELD_1 pins may be configured as inputs or outputs. The subcarrier phase is also MPU adjustable. The Bt858 uses 10-bit D/A converters coupled with sin x/x correction digital filters for maximum video quality.

Features of the Bt858 include:

- (M) NTSC, 4.43 NTSC, or (B, D, G, H, I, N) PAL Composite Video Output
- Separate Y/C Video (S-video) Outputs
- 10-bit D/A Converters
- Digital RGB, YCrCb, and Pseudo-Color Data Input Formats
- 4-Field NTSC or 8-Field PAL Generation
- Three 256 x 8 Input Lookup Table RAMs
- 15 x 24 Overlay Registers
- Standard MPU Interface
- Power-Down Mode
- Built-In Color Bar Generation
- +5 V CMOS Monolithic Construction
- 160-pin PQFP Package

The Bt855 (Figure 5.58) from Brooktree Corporation is a digital NTSC/PAL encoder that is pin and software compatible with the Bt858. The Bt855 uses 8-bit D/A converters and simpler digital filters than the Bt858.

The SAA7199 (Figure 5.59) from Philips Semiconductors is a digital NTSC/PAL encoder, generating composite NTSC or PAL and Y/C S-video. RGB data, YCrCb data (4:4:4, 4:2:2, or 4:1:1), or 8-bit pseudo-color data may be input and it operates at clock rates of 12.27, 13.5, and 14.75 MHz, enabling the support of NTSC and PAL square pixel or CCIR601 formats.

Features of the SAA7199 include:

- (M) NTSC, 4.43 NTSC, or (B, G, M, N) PAL Composite Video Output
- Separate Y/C Video (S-video) Outputs
- 9-bit D/A Converters
- Digital RGB and YCrCb Data Input Formats
- Genlock Support (Requires TDA8708 A/D Converter and SAA7197 Clock Generator)
- Optional Graphics/Video Mixing (Pixel Basis)
- Three 256 x 8 Input Lookup Table RAMs
- Standard MPU and I^2C Interface
- +5 V CMOS Monolithic Construction
- 84-pin PLCC Package

The TMC22090 (Figure 5.60) and TMC22190 (Figure 5.61) from Raytheon Semiconductor are digital NTSC/PAL encoders, generating composite NTSC or PAL and Y/C S-video. RGB (15-bit or 24-bit), YCrCb (16-bit 4:2:2 or 24-bit 4:4:4), or 8-bit pseudo-color data may be input and it operates at pixel clock rates of 20–30 MHz (pixel rates of 10–15 MHz with 2x oversampling), enabling the support of NTSC and PAL square pixel, CCIR601, and NTSC 4x F_{SC} formats. The TMC22090 uses 10-bit D/A converters for maximum video quality.

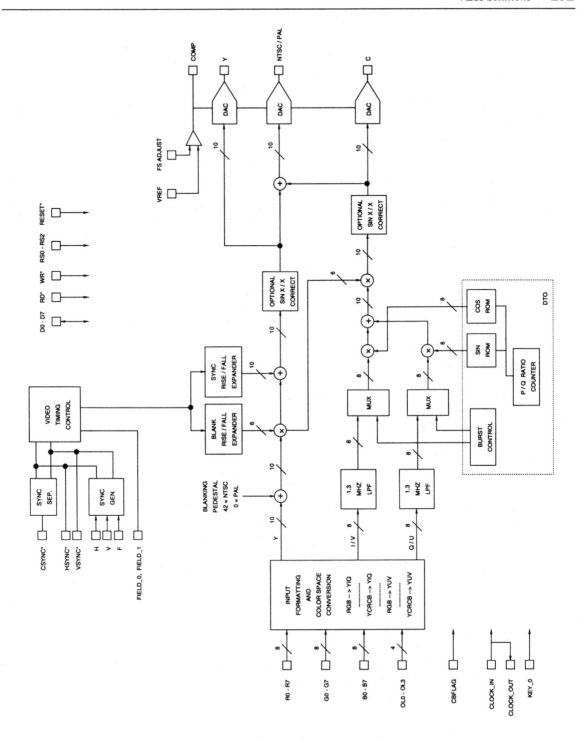

Figure 5.57. Brooktree Corporation Bt858 NTSC/PAL Encoder Block Diagram.

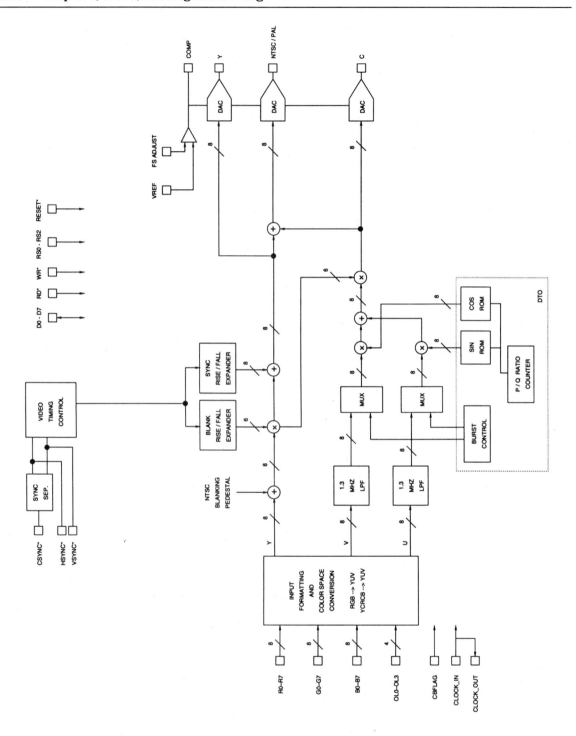

Figure 5.58. Brooktree Corporation Bt855 NTSC/PAL Encoder Block Diagram.

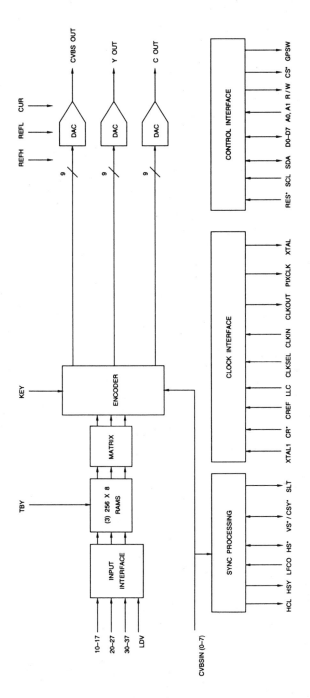

Figure 5.59. Philips Semiconductors SAA7199 NTSC/PAL Encoder Block Diagram.

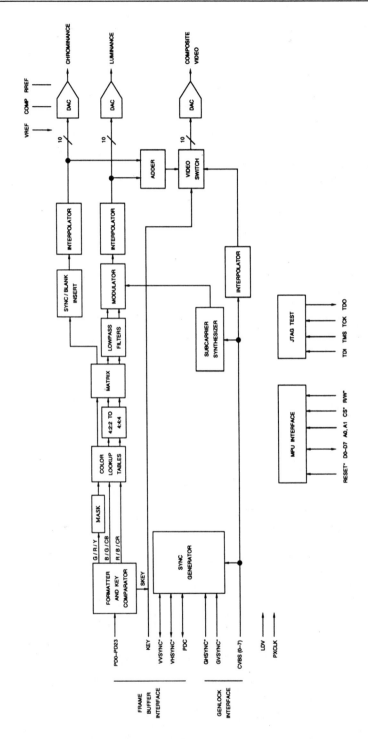

Figure 5.60. Raytheon Semiconductor TMC22090 NTSC/PAL Encoder Block Diagram.

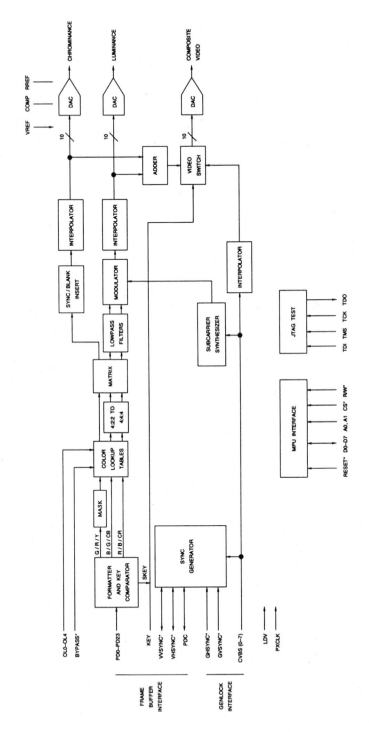

Figure 5.61. Raytheon Semiconductor TMC22190 NTSC/PAL Encoder Block Diagram.

Features of the TMC22090 include:

- (M) NTSC, 4.43 NTSC, or (B, D, G, H, I, N) PAL Composite Video Output

- Separate Y/C Video (S-video) Outputs

- 10-bit D/A Converters

- Digital RGB, YCrCb, and Pseudo-Color Data Input Formats

- Genlock Support (Requires TMC22070 Genlocked A/D Converter)

- Three 256 x 8 Input Lookup Table RAMs

- Standard MPU Interface

- JTAG Test Interface

- Power-Down Mode

- Built-In Color Bar Generation and 80 IRE Modulated Ramp

- +5 V CMOS Monolithic Construction

- 84-pin PLCC Package

The TMC22190 adds:

- Up to 30 Overlays (4:2:2 YCrCb Pixel Mode Only)

- Optional Bypass of Lookup Tables (Pixel Basis)

- 5 Layering Modes

References

1. Arvo, James, *Graphics Gems II*, Academic Press, Inc., 1991.
2. Benson, K. Blair, 1986, *Television Engineering Handbook*, McGraw-Hill, Inc.
3. Brooktree Corporation, Bt855 Datasheet, L855001 Rev. A, 1992.
4. Brooktree Corporation, Bt858 Datasheet, L858001 Rev. B, 1992.
5. CCIR Report 624-4, 1990, *Characteristics of Television Systems*.
6. CCIR Report 1221, 1990, *Specifications and Alignment Procedures to Picture Signal Sources and Displays*.
7. Clarke, C.K.P., 1986, *Colour Encoding and Decoding Techniques for Line-Locked Sampled PAL and NTSC Television Signals*, BBC Research Department Report BBC RD1986/2.
8. Faroudja, Yves Charles, 1988, *NTSC and Beyond. IEEE Transactions on Consumer Electronics*, Vol. 34, No. 1, February 1988.
9. National Captioning Institute, *TeleCaption II Decoder Modulate Performance Specification*, November, 1985.
10. Philips Semiconductor, *Video Data Handbook*, 1991.
11. Public Broadcasting Service, Report No. E-7709-C, *Television Captioning for the Deaf: Signal and Display Specifications*, May 1980.
12. *Specification of Television Standards for 625-Line System-I Transmissions*, 1971, Independent Television Authority (ITA) and British Broadcasting Corporation (BBC).
13. *Television Measurements, NTSC Systems*, Tektronix, Inc., July 1990.
14. *Television Measurements, PAL Systems*, Tektronix, Inc., September 1990.
15. TRW LSI Products, Inc., (now Raytheon Semiconductor) TMC22090 Datasheet, October 4, 1991.
16. TRW LSI Products, Inc., (now Raytheon Semiconductor) TMC22190 Datasheet, Rev. A, June, 1992.
17. U. S. Public Broadcasting Service, NTC Report No. 7, 1976.

NTSC/PAL
Digital Decoding

Although the luminance and chrominance components in a NTSC/PAL encoder are usually combined by simply adding the two signals together, separating them in a decoder is much more difficult. Analog NTSC and PAL decoders have been around for some time. However, they have been difficult to use, required adjustment, and offered limited video quality. Using digital techniques to implement NTSC and PAL decoding offers many advantages, such as ease of use, minimum analog adjustments, and excellent video quality. The use of digital circuitry also enables the design of much more robust and sophisticated Y/C separator and genlock implementations. In addition to baseband composite NTSC and PAL, support for S-video (Y/C) is easily incorporated. S-video uses separate luminance and chrominance analog video signals so higher quality may be maintained by eliminating the composite encoding and decoding processes.

A NTSC/PAL decoder designed for the computer environment requires several unique features. First, it should implement a simple, drop-in solution, as easy to use as any other MPU peripheral. MPU-adjustable saturation, contrast, brightness, and hue are required. Otherwise, adjusting the video data will modify the graphics data. Both the RGB and YCrCb output formats, with programmable output lookup tables, should be supported to allow the system designer flexibility in interfacing to a processing function or frame store after the decoder. Linear RGB is a common output format, as many computer systems use the linear RGB color space for graphics, while the 4:2:2 YCrCb output format is useful if video processing (such as compression, deinterlacing, or scaling) is to be done.

In addition, although it may not be a direct function of the decoder, a video multiplexer is usually required in the system so that one of several video sources may be decoded. The genlock must be robust enough to handle any video source reasonably, as users expect their expensive computers to handle video problems just as well as, if not better, than a low-cost television. In the absence of a video signal, the genlock should be designed to optionally free-run, continually generating the video timing to the system, without missing a beat. During the loss of an input signal, the decoder

should provide the option to either be transparent (so the input source can be monitored), to auto-freeze the output data (to compensate for short duration dropouts), or to autoblack the output data (to avoid potential problems driving a mixer or video tape recorder).

As with the digital encoder, a digital decoder should support several pixel clock rates and pixel output configurations, as shown in Table 6.1. Supporting square pixels directly as an output format on a decoder greatly simplifies integrating video into the computer environment. The other formats are commonly used in video editing equipment.

Standard computer-oriented video timing signals should be generated by the decoder. These include horizontal sync, vertical sync, and blanking. Blanking should be user-programmable to enable cropping of the video image to a region of interest. Additional output control signals to ease system design include field identification signals, useful for video

editing. The ability to optionally output only odd or even fields simplifies interfacing to video compression encoders; the ability to monitor video timecode information is useful in editing situations.

The quality of Y/C separation plays a major role in the overall video quality generated by the decoder. Still video requires field-based Y/C separation to minimize artifacts, while active video will probably want to use some type of comb filtering. Recent advances in semiconductor processes allow these capabilities to be cost-effectively incorporated. If MPEG or JPEG encoding or re-encoding into NTSC/PAL video signals, many of the "visually pleasing" enhancements done for viewing consumer video should not be used. These purposely induced high-frequency video components may introduce objectional artifacts when re-encoded into NTSC/PAL video signals and will also affect MPEG and JPEG compression ratios.

	Pixel Clock Rate	Applications	Horizontal Resolution (total pixels)	Horizontal Resolution (active pixels)	Vertical Resolution (total)
(M) NTSC	12.27 MHz	square pixels PCs, workstations	780	640	525
	13.5 MHz	CCIR 601	858	720	
	14.32 MHz	studio editing	910	768	
(B, D, G, H, I) PAL	14.75 MHz	square pixels PCs, workstations	944	768	625
	13.5 MHz	CCIR 601	864	720	
	17.72 MHz	studio editing	1135	948	

Table 6.1. Common Output Pixel Rates and Resolutions.

This chapter discusses a typical digital decoder that decodes baseband composite (M) NTSC and (B, D, G, H, I, N) PAL video signals, and also has separate Y/C inputs for supporting S-video (the block diagram is shown in Figure 6.1). Also reviewed are various Y/C separation techniques. It is recommended that the reader review Chapter 5 on digital encoding before attempting to understand digital decoding.

Digitizing the Analog Video

The first step in digital decoding of NTSC or PAL video signals is to digitize the entire composite video signal using an A/D converter. For our example, 8-bit A/D converters are used; therefore, indicated values are 8-bit values. Video inputs to equipment are usually AC-coupled and have a 75-Ω input impedance; therefore, the video signal must be DC restored every scan line during horizontal sync to position the sync tips at a known voltage level. The video signal must also be low-pass filtered (typically to 4–6 MHz) prior to digitization to remove any high-frequency components that may result in aliasing. Although the video bandwidth for broadcast is rigidly defined (4.2 MHz for NTSC and 5.0–5.5 MHz for PAL), there is no standard for consumer equipment. The video source generates as much bandwidth as it can; the receiving equipment accepts as much bandwidth as it can process.

Video signals with active video and/or sync amplitudes of 0.5 to 2 times nominal are common, especially in the consumer arena. The active video and/or sync signal may change amplitude, especially in editing situations where the video signal may be composed of several different video sources merged together.

Composite Video

When decoding composite video signals, the analog video signal is DC restored to ground during the horizontal sync time, setting the sync tip to a zero value. An automatic gain control is used to ensure that 56 (NTSC) or 59 (PAL) is generated during blanking, and a value of four is added as a constant to generate the same video levels (see Table 6.2) as used in the digital encoder (discussed in Chapter 5). Figure 6.2 and Figure 6.3 show the composite video levels and the corresponding digital values for NTSC and PAL composite video signals, respectively, after DC restoration and offset addition.

If the digital blanking level is low or high, the video signal may be amplified or attenuated (preferably in the analog domain), until the digital blanking level is correct. One method of determining the blanking level is to digitally lowpass filter the video signal (to remove subcarrier information and noise) and sample the back porch multiple times to determine the average value. To limit line-to-line variations and clamp streaking (the result of quantizing errors), the back porch level may be averaged using values from four consecutive blanked scan lines (at the end of vertical blanking during each field) and the result used for the entire field. The difference between the calculated back porch level and 56 (NTSC) or 59 (PAL) is the error value. This error value can be processed and used in several ways to generate the correct blanking level:

(a) controlling a voltage-controlled video amplifier
(b) adjusting the REF+ voltage of the A/D converter
(c) multiplying the outputs of the A/D converter
(d) adding a constant DC offset to the video signal

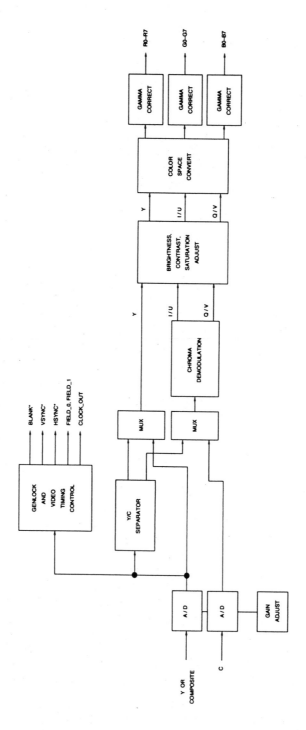

Figure 6.1. Typical NTSC/PAL Digital Decoder Implementation.

Video Level	NTSC	PAL
peak chroma	243	245
white	200	200
peak burst	88	93
black	70	63
blank	60	63
peak burst	32	33
peak chroma	26	18
sync	4	4

Table 6.2. Digital Composite Video Levels after Digitization and Gain Correction.

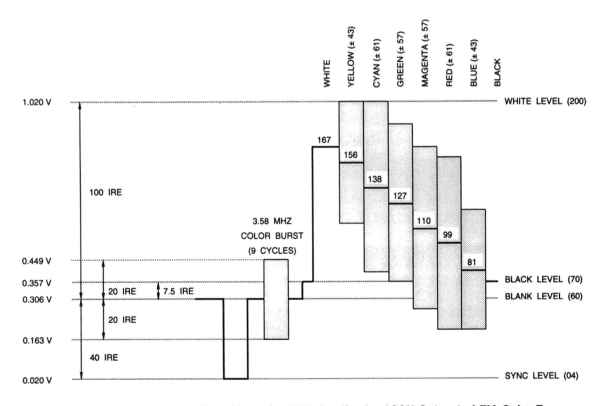

Figure 6.2. NTSC Composite Video Signal for 75% Amplitude, 100% Saturated EIA Color Bars. Indicated video levels are 8-bit values after DC restoration and offset during sync tip.

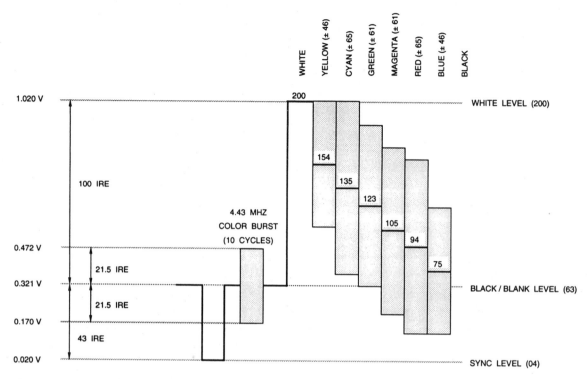

Figure 6.3. PAL Composite Video Signal for 75% Amplitude, 100% Saturated EBU Color Bars. Indicated video levels are 8-bit values after DC restoration and offset during sync tip.

Approaches (a), (b), and (c) increase or decrease the entire video signal by the amount of sync height adjustment. In some instances this is unacceptable, as there may be no correlation between sync height and active video. This is the case if a video signal was edited, resulting in the active video and sync information being generated by different sources. Another approach is to modify luminance levels between 80 and 120 IRE so they are positioned at 100 IRE, after adjusting the blanking level to 56 (NTSC) or 59 (PAL)—adjusting the blanking level should have no effect on the burst or active video amplitude. The disadvantage with this method is that minor scene-to-scene variations will occur.

The third, and probably the best, method of automatic amplitude adjustment is to monitor the color burst information. Many times, there is a strong correlation between the burst amplitude and the active video amplitude. After adjusting the blanking level to 56 (NTSC) or 59 (PAL)—adjusting the blanking level should have no effect on the burst or active video amplitude—the burst amplitude is determined. This is compared to the ideal burst amplitude and the difference used to calculate how much to increase or decrease the gain of the subcarrier and active video signal.

For some applications, such as if the video signal levels are known to be correct, if all the video levels except the sync height are

correct, or if there is excessive noise on the video signal, it is desirable to be able to disable the automatic gain control. In this instance, which is approach (d), the blanking level error signal is processed and used to adjust the blanking level by adding a constant DC offset to the video signal (preferably in the analog domain).

An analog signal for controlling the gain of a video amplifier or the voltage level on the REF+ pin of the video A/D converter may be generated by either a D/A converter or charge pump. If a D/A converter is used, it should have twice the resolution of the A/D converter to avoid quantizing noise. For this reason, a charge pump implementation may be more suitable.

Figure 6.4 and Table 6.3 show the chrominance IRE levels and phase angles for 75% amplitude, 100% saturation EIA color bars for NTSC. Figure 6.5, Figure 6.6, and Table 6.4 show the chrominance IRE levels and phase angles for 75% amplitude, 100% saturation EBU color bars for PAL.

S-Video (Y/C)

When decoding S-video (which consists of separate Y and C analog video signals), the analog Y video signal is processed by the same method as that used when digitizing composite analog video (see the previous section). The only difference is the analog Y video signal has no burst or modulated chrominance

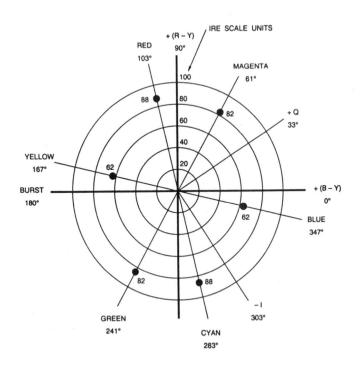

Figure 6.4. IQ Vector Diagram for 75% Amplitude, 100% Saturated EIA Color Bars.

	Nominal Range	White	Yellow	Cyan	Green	Magenta	Red	Blue	Black
R′	0 to 255	191	191	0	0	191	191	0	0
G′	0 to 255	191	191	191	191	0	0	0	0
B′	0 to 255	191	0	191	0	191	0	191	0
Y	0 to 130	97	86	68	57	40	29	11	0
I	0 to ±78	0	31	−58	−27	27	58	−31	0
Q	0 to ±68	0	−30	−21	−51	51	21	30	0
chroma IRE		0	62	88	82	82	88	62	0
chroma range (8-bit)		0	±43	±61	±57	±57	±61	±43	0
phase		–	167°	283°	241°	61°	103°	347°	–

Table 6.3. 75% Amplitude, 100% Saturated EIA Color Bars for (M) NTSC. Chrominance IRE levels are peak-to-peak. RGB values are gamma-corrected RGB values.

	Nominal Range	White	Yellow	Cyan	Green	Magenta	Red	Blue	Black
R′	0 to 255	255	191	0	0	191	191	0	0
G′	0 to 255	255	191	191	191	0	0	0	0
B′	0 to 255	255	0	191	0	191	0	191	0
Y	0 to 137	137	91	72	60	42	31	12	0
U	0 to ±60	0	−45	15	−30	30	−15	45	0
V	0 to ±85	0	10	−63	−53	53	63	−10	0
chroma IRE		0	67	95	89	89	95	67	0
chroma range (8-bit)		0	±46	±65	±61	±61	±65	±46	0
phase: line n (burst = 135°)		–	167°	283°	241°	61°	103°	347°	–
phase: line n + 1 (burst = 225°)		–	193°	77°	120°	300°	257°	13°	–

Table 6.4. 75% Amplitude, 100% Saturated EBU Color Bars for (B, D, G, H, I) PAL. Chroma IRE levels are peak-to-peak. RGB values are gamma-corrected RGB values. Line n corresponds to odd-numbered scan lines in fields 1, 2, 5, and 6, even-numbered scan lines in fields 3, 4, 7, and 8. Line n + 1 corresponds to even-numbered scan lines in fields 1, 2, 5, and 6, odd-numbered scan lines in fields 3, 4, 7, and 8.

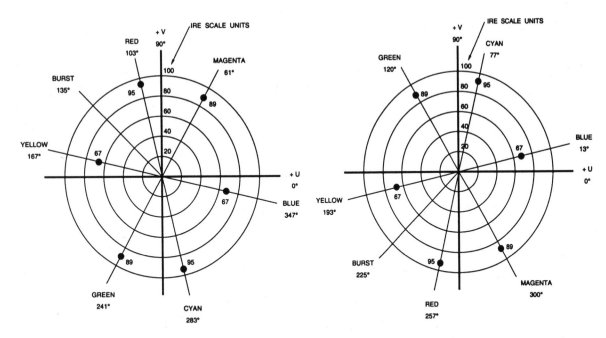

Figure 6.5. UV Vector Diagram for 75% Amplitude, 100% Saturated EBU Color Bars. Line n, PAL SWITCH = zero.

Figure 6.6. UV Vector Diagram for 75% Amplitude, 100% Saturated EBU Color Bars. Line n + 1, PAL SWITCH = one.

information. After the A/D conversion, a value of four is added to the digitized Y data, to match composite video levels. At this point, we have digital composite luminance data as shown in Table 6.5. Figure 6.7 and Figure 6.8 show the luminance video levels and the corresponding digital values for NTSC and PAL,

respectively, after DC restoration of the analog video signal.

The analog C video signal must be DC restored during the sync time to a voltage level that is the midpoint of the reference ladder on the A/D converter (this is because the modulated chrominance video signal is bipolar—see

Video Level	NTSC	PAL
white	200	200
black	70	63
blank	60	63
sync	4	4

Table 6.5. Digital Luminance Levels after Digitization and Gain Correction.

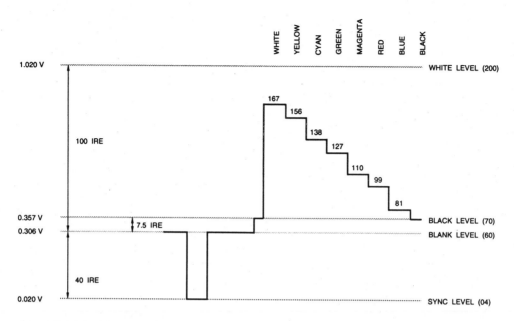

Figure 6.7. NTSC Luminance (Y) Sideo signal for 75% Amplitude, 100% Saturated EIA Color Bars. Indicated video levels are 8-bit values after DC restoration and offset during sync tip.

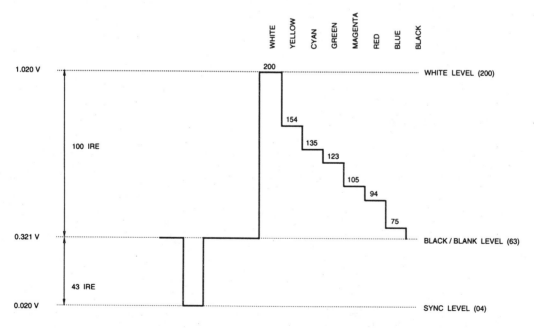

Figure 6.8. PAL Luminance (Y) Video Signal for 75% Amplitude, 100% Saturated EBU Color Bars. Indicated video levels are 8-bit values after DC restoration and offset during sync tip.

Figure 6.9 and Figure 6.10). Thus, the blanking level of the modulated chrominance video signal will generate a 128 value from the A/D converter. The same amount of automatic gain applied to the luminance video signal should also be applied to the chrominance video signal. At this point, we have digital chrominance data as shown in Table 6.6. Figure 6.9 and Figure 6.10 show the chrominance video levels and the corresponding digital values for NTSC and PAL, respectively.

Y/C Separation

When decoding composite video, the luminance (Y) and chrominance (C) must be separated. The many techniques for doing this are discussed in detail later in the chapter. After Y/ C separation, Y has a range of 4–200; note that the luminance still contains sync and blanking information. Modulated chrominance has a range of 0 to ±82 (NTSC) or 0 to ±87 (PAL).

Chrominance Demodulator

The chrominance demodulator (Figure 6.11) accepts modulated digital chrominance information from either the Y/C separator (when digitizing composite NTSC or PAL) or the chrominance A/D converter (when digitizing Y/C), and generates baseband IQ (NTSC) or UV (PAL) color difference video data.

NTSC Operation

The (M) NTSC chrominance signal processed by the demodulator may be represented by:

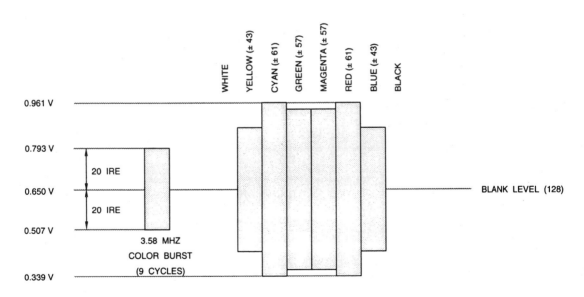

Figure 6.9. NTSC Chrominance (C) Video Signal for 75% Amplitude, 100% Saturated EIA Color Bars. Indicated video levels are 8-bit values after DC restoration to the midpoint of the A/D ladder during the luminance sync tip.

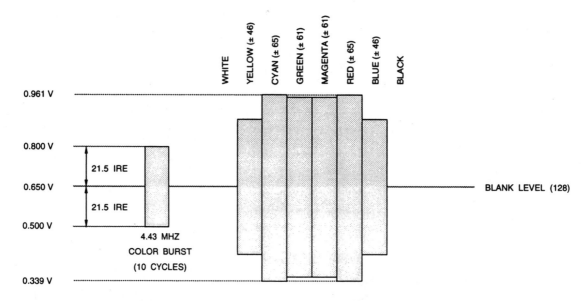

Figure 6.10. PAL Chrominance (C) Video Signal for 75% Amplitude, 100% Saturated EBU Color Bars. Indicated video levels are 8-bit values after DC restoration to the midpoint of the A/D ladder during the luminance sync tip.

Video Level	NTSC	PAL
peak chroma	210	215
peak burst	156	158
blank	128	128
peak burst	100	98
peak chroma	46	41

Table 6.6. Digital Chrominance Levels after Digitization and Gain Correction.

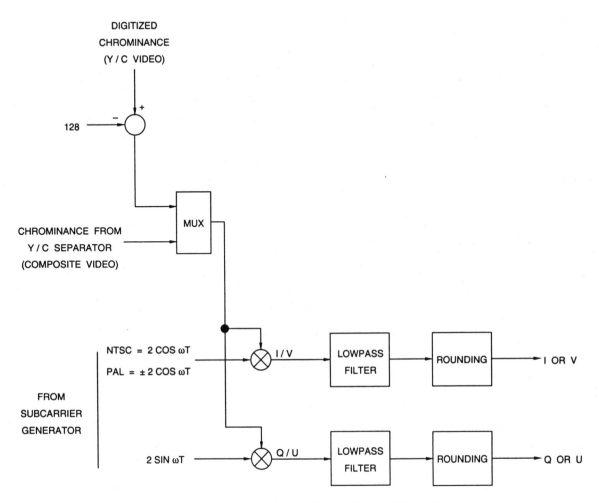

Figure 6.11. Chrominance Demodulation Example.

$$Q \sin \omega t + I \cos \omega t$$
$$\omega = 2\pi F_{SC}$$
$$F_{SC} = 3.579545 \text{ MHz}$$

The subcarrier generator of the decoder provides a 33° phase offset during active video, cancelling the sin and cos 33° phase term normally in the equation. The color information is demodulated by multiplying the chrominance signal by appropriate phases of a locally generated subcarrier and lowpass filtering the results. Q is obtained by multiplying the

chrominance data by 2 sin ωt and I is obtained by multiplying by 2 cos ωt:

$$(Q \sin \omega t + I \cos \omega t)(2 \sin \omega t)$$
$$= Q - Q \cos 2\omega t + I \sin 2\omega t$$

$$(Q \sin \omega t + I \cos \omega t)(2 \cos \omega t)$$
$$= I + I \cos 2\omega t + Q \sin 2\omega t$$

The two times subcarrier frequency components (2ωt) are removed by lowpass filtering, resulting in the I and Q signals being recov-

ered. I has a range of 0 to ±78, and Q has a range of 0 to ±68.

The (2 sin ωt) and (2 cos ωt) values should have at a minimum 8 bits of accuracy plus sign, with a range of 0 to ±511/256 (note the modulated digital chrominance has a range of 0 to ±82 for NSTC). The multipliers should have saturation logic to ensure overflow and underflow conditions are saturated to the maximum and minimum values, respectively. The color difference signals generated are rounded to a minimum of 8 bits plus sign (to keep the digital filters a reasonable size) and digitally lowpass filtered. Note that if generating YCrCb output data, and the YUV color space is used, the values in the sin and cos ROMs may be adjusted to allow the demodulation multipliers to generate (Cr − 128) and (Cb − 128) data directly, avoiding separate color space conversion. The sin ROM should have a range of 0 to ±1018/256 and the cos ROM should have a range of 0 to ±721/256.

PAL Operation

The (B, D, G, H, I, N) PAL chrominance signal is represented by:

$$U \sin \omega t \pm V \cos \omega t$$
$$\omega = 2\pi F_{SC}$$

F_{SC} = 4.43361875 MHz for (B, D, G, H, I) PAL

F_{SC} = 3.58205625 MHz for (N) PAL

with the sign of V alternating from one line to the next. The color information is demodulated by multiplying the chrominance signal by appropriate phases of the locally generated subcarrier and lowpass filtering the results. U is obtained by multiplying the chrominance data by 2 sin ωt and V is obtained by multiplying by ±2 cos ωt:

$$(U \sin \omega t \pm V \cos \omega t) \ (2 \sin \omega t)$$
$$= U - U \cos 2\omega t \pm V \sin 2\omega t$$

$$(U \sin \omega t \pm V \cos \omega t) \ (\pm 2 \cos \omega t)$$
$$= V \pm U \sin 2\omega t + V \cos 2\omega t$$

The two times subcarrier frequency components (2ωt) are removed by lowpass filtering, resulting in the U and V signals being recovered. Using a switched subcarrier waveform in the V channel also removes the PAL SWITCH modulation. Thus, +2 cos ωt is used while the PAL SWITCH is a logical zero (burst phase = +135°) and −2 cos ωt is used while the PAL SWITCH is a logical one (burst phase = 225°). U has a range of 0 to ±60, and V has a range of 0 to ±85.

The (2 sin ωt) and (2 cos ωt) values should have at a minimum 8 bits of accuracy plus sign, with a range of 0 to ±511/256 (note the modulated digital chrominance has a range of 0 to ±87 for PAL). The multipliers should have saturation logic to ensure overflow and underflow conditions are saturated to the maximum and minimum values, respectively. The color difference signals generated are rounded to a minimum of 8 bits plus sign (to keep the digital filters a reasonable size) and digitally lowpass filtered. Note that if generating YCrCb output data, the values in the sin and cos ROMs may be adjusted to allow the demodulation multipliers to generate (Cr − 128) and (Cb − 128) data directly, avoiding separate color space conversion. The sin ROM should have a range of 0 to ±961/256 and the cos ROM should have a range of 0 to ±681/256.

If the locally generated subcarrier phase is incorrect, a line-to-line pattern known as Hanover bars results in which pairs of adjacent lines have a real and complementary hue error. As shown in Figure 6.12 with an ideal color of green, two adjacent lines of the display have a hue error (towards yellow), the next two have the complementary hue error (towards cyan), and so on.

Figure 6.12. Example Display of Hanover Bars. Green is the ideal color.

This can be shown by introducing a phase error (θ) in the locally generated subcarrier:

(U sin ωt ± V cos ωt) (2 sin (ωt – θ))
= (after lowpass filtering) U cos θ –/+ Vsin θ

(U sin ωt ± V cos ωt) (±2 cos (ωt – θ))
= (after lowpass filtering) V cos θ +/– Usin θ

In areas of constant color, averaging equal contributions from even and odd lines (either visually or because of a delay line, for example), cancels the alternating crosstalk component, leaving only a desaturation of the true component by cos θ.

Introducing a phase error (θ) in the locally generated subcarrier of NTSC decoders yields:

(Q sin ωt + I cos ωt) (2 sin (ωt – θ))
= (after lowpass filtering) Q cos θ – I sin θ

(Q sin ωt + I cos ωt) (2 cos (ωt – θ))
= (after lowpass filtering) I cos θ + Q sin θ

which are the same equations shown later for adjusting the hue using baseband I and Q signals, without adjusting the subcarrier.

Color Difference Lowpass Digital Filters

The decoder requires sharper roll-off filters than the digital encoder to ensure adequate suppression of the sampling alias components—note that with a 13.5-MHz sampling frequency, they start to become significant above 3 MHz. The demodulation process for NTSC is shown spectrally in Figure 6.13 and Figure 6.14; the process is similar for PAL. In both figures, (a) represents the baseband spectrum of the video signal and (b) represents the spectrum of the subcarrier used for demodulation. Convolution of (a) and (b), equivalent to multiplication in the time domain, produces the spectrum shown in (c), in which the baseband spectrum has been shifted to be centered about F_{SC} and $-F_{SC}$. The chrominance is now a baseband signal, which may be separated from the low-frequency luminance, centered at F_{SC}, and the chrominance, centered at $2F_{SC}$, by a lowpass filter.

NTSC may be demodulated along either the I and Q or U and V axes. If demodulating along the I and Q axes, Q may be either a 0.6-MHz double sideband signal or a 1.3-MHz asymmetrical sideband signal, while I will probably be a 1.3-MHz asymmetrical sideband

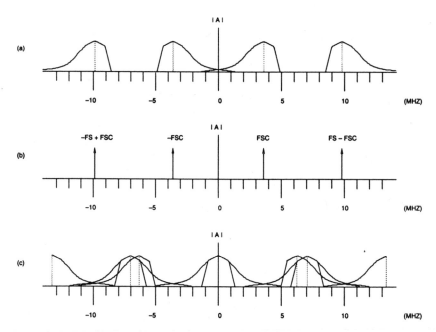

Figure 6.13. Frequency Spectra in Digital NTSC Chrominance Demodulation (F_S = 13.5 MHz, F_{SC} = 3.58 MHz) (a) Gaussian Filtered I and Q Signals, (b) Subcarrier Sinewave, (c) Modulated Chrominance Spectrum Produced by Convolving (a) and (b).

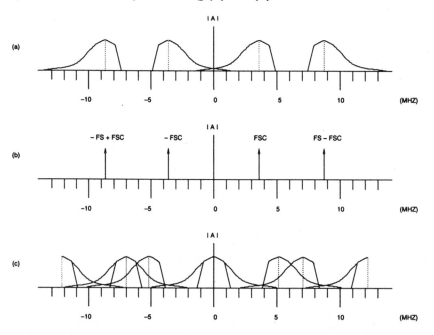

Figure 6.14. Frequency Spectra in Digital NTSC Chrominance Demodulation (F_S = 12.27 MHz, F_{SC} = 3.58 MHz): (a) Gaussian Filtered I and Q Signals, (b) Subcarrier Sinewave, (c) Modulated Chrominance Spectrum Produced by Convolving (a) and (b).

signal. If demodulating along the U and V axes, both U and V are either a 0.6-MHz double side-band signal or a 1.3-MHz asymmetrical side-band signal, depending on the encoding process. For PAL, U and V will probably be 1.3-MHz asymmetrical sideband signals. The asymmetrical sideband signals are a result of lowpass filtering the composite video signals to 4.2 MHz (NTSC) or 5.5 MHz (PAL) during the encoding process, removing most of the upper sidebands.

The lowpass filters after the demodulator are a compromise between several factors. Simply using a 1.3-MHz filter, such as the one shown in Figure 6.15, to extract all of the available chrominance information increases the amount of cross-color since a greater number of luminance frequencies are included. When using lowpass filters with a passband greater than 0.6 MHz for NTSC (4.2 MHz–3.58 MHz) or 1.07 MHz for PAL (5.5 MHz–4.43 MHz), the loss of the upper sidebands of chrominance also introduces ringing and color difference crosstalk. Filters with a sharp cutoff accentuate chrominance edge ringing; for these reasons slow roll-off 0.6-MHz filters, such as the one shown in Figure 6.16, are usually used, resulting in poorer color resolution but mini-

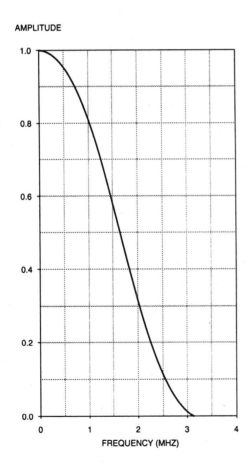

Figure 6.15. Typical 1.3-MHz Lowpass Digital Filter Characteristics.

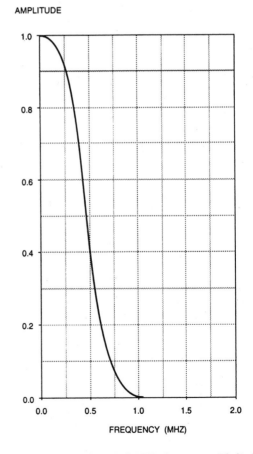

Figure 6.16. Typical 0.6-MHz Lowpass Digital Filter Characteristics.

mizing cross-color, ringing, and color difference crosstalk on edges. If a 1.3-MHz lowpass filter is used, the filter may include some gain for frequencies between 0.5 MHz and 1.3 MHz to compensate for the loss of part of the upper sideband.

If the decoder is to be used in a video editing environment, the digital filters should have a maximum ripple of ±0.1 dB in the passband. This is needed to minimize the cumulation of gain and loss artifacts due to the filters, especially when multiple passes through the encoding and decoding processes are required.

Hue Adjustment

Programmable hue adjustment is a popular requirement and is easily implemented. For NTSC, a programmable hue value (which is really a subcarrier phase offset) may be added to the 11-bit reference subcarrier phase during the active video time (see Figure 6.20). The result is to shift the phase (by a constant amount) of the sin and cos subcarrier information going to the chrominance demodulator. An 11-bit hue adjustment value allows adjustments in hue from 0° to 360°, in increments of 0.176°.

This may be shown by introducing a phase offset (θ) in the locally generated subcarrier of NTSC decoders, yielding:

$$(Q \sin \omega t + I \cos \omega t)\ (2 \sin (\omega t - \theta))$$
$$= \text{(after lowpass filtering) } Q \cos \theta - I \sin \theta$$

$$(Q \sin \omega t + I \cos \omega t)\ (2 \cos (\omega t - \theta))$$
$$= \text{(after lowpass filtering) } I \cos \theta + Q \sin \theta$$

This technique must be modified to work with PAL to avoid the desaturation of colors as a function of the amount of hue shift. This is shown by introducing a simple phase offset (θ) in the locally generated subcarrier:

$$(U \sin \omega t \pm V \cos \omega t)\ (2 \sin (\omega t - \theta))$$
$$= \text{(after lowpass filtering) } U \cos \theta\ -/+\ V \sin \theta$$

$$(U \sin \omega t \pm V \cos \omega t)\ (\pm 2 \cos (\omega t - \theta))$$
$$= \text{(after lowpass filtering) } V \cos \theta\ +/-\ U \sin \theta$$

In areas of constant color, averaging equal contributions from even and odd lines (either visually or because of a delay line, for example), cancels the alternating crosstalk component, leaving only a desaturation of the true component by cos θ. To avoid this, the sign of the phase offset (θ) is set to be the opposite of the V component:

$$(U \sin \omega t \pm V \cos \omega t)\ (2 \sin (\omega t\ -/+\ \theta))$$
$$= \text{(after lowpass filtering) } U \cos \theta + V \sin \theta$$

$$(U \sin \omega t \pm V \cos \omega t)\ (\pm 2 \cos (\omega t\ -/+\ \theta))$$
$$= \text{(after lowpass filtering) } V \cos \theta - U \sin \theta$$

A negative sign of the phase offset (θ) is equivalent to adding 180° to the desired phase shift. PAL decoders do not usually have a hue adjustment feature.

An alternate implementation, that works with both NTSC and PAL, is to mix the I and Q or U and V baseband color difference signals after demodulation and lowpass filtering (θ is the hue angle in degrees):

$$U' = U \cos \theta + V \sin \theta$$
$$V' = V \cos \theta - U \sin \theta$$
$$I' = I \cos \theta + Q \sin \theta$$
$$Q' = Q \cos \theta - I \sin \theta$$

Contrast, Brightness, and Saturation Adjustment

Programmable brightness, contrast, and saturation controls are also popular requirements and are also easily implemented, as shown in Figure 6.17.

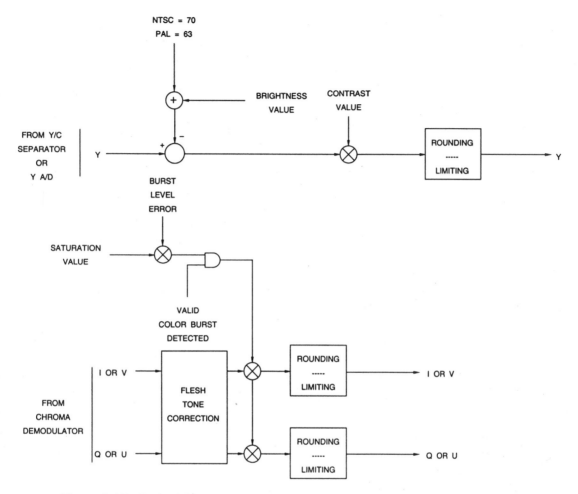

Figure 6.17. Typical Contrast, Brightness, and Saturation Adjustment Circuitry.

Brightness information is added or subtracted from the digital luminance data. Although a dedicated adder for adjusting the brightness could be used, the same adder that is used to subtract the black level (70 for NTSC or 63 for PAL) from the digital luminance data may be used to minimize the amount of circuitry in the luminance data path. The brightness adjustment value may be added to either 70 (NTSC) or 63 (PAL) and the result subtracted from the Y data to minimize the amount of circuitry in the luminance path.

Contrast adjustment is done by multiplying the digital luminance data (after sync and blank information have been removed) by a constant. After the multiplier, the result should be rounded to a minimum of 8 bits plus sign. Values greater than 130 (NTSC) or 137 (PAL) should be made 130 (NTSC) or 137 (PAL); values less than 0 should be made 0. At this point, Y has a range of 0 to 130 (NTSC) or 0 to 137 (PAL).

Saturation is adjusted by multiplying the digital color difference signals, as shown in

Figure 6.17. After the multipliers, the results should be rounded to a minimum of 7 bits plus sign. Note that excessive saturation will result in illegal values for IQ and UV.

The "burst level error" signal and the saturation value are multiplied together, and the result is used to adjust the gain or attenuation of the color difference signals. The intent here is to minimize the amount of circuitry in the color difference signal path. The "burst level error" signal is used in the event the burst (and thus the modulated chrominance information) is not at the correct amplitude and adjusts the saturation of the color difference signals appropriately.

Alternately, the saturation and the "burst level error" adjustments may done on the sin ωt and cos ωt subcarriers driving the demodulator. This implementation has the advantage of minimizing the circuitry in the data path, reducing the noise introduced into the color difference signals.

Automatic Flesh Tone Correction

Flesh tone correction is used in decoders since the eye is very sensitive to flesh tones and the actual colors may become slightly corrupted during the broadcast processes. If the grass is not quite the proper color of green, it is not noticeable; however, a flesh tone that has a green or orange tint is unacceptable. Since the flesh tones are located close to the +I axis, a typical flesh tone corrector looks for colors in a specific area (Figure 6.18), and any colors within that area are made a color that is closer to the flesh tone.

A simple flesh tone corrector may simply halve the Q value for all colors that have a corresponding +I value. However, this implementation also changes nonflesh tone colors. A more sophisticated typical implementation (easily implemented digitally) is if I is positive and has a value between 25% and 75% of full-

scale, and is within ±30° of the + I axis, then Q is halved. This moves any colors within the flesh tone region closer to "ideal" flesh tone. It should be noted that the phase angle for flesh tone varies between equipment manufacturers; phase angles from 116° to 126° are used (the +I axis is at 123°); however, using 123° (the +I axis) simplifies the processing.

Valid Color Burst Detection/Correction

If a color burst of 30% or less of normal amplitude is detected for 128 consecutive scan lines, the color difference signals should be forced to zero. Once a color burst of 40% or more of normal amplitude is detected for 128 consecutive scan lines, the color differences signals may again be enabled. The burst-amplitude hysteresis prevents wandering back and forth between enabling and disabling the color information in the event the burst amplitudes are borderline. Providing the ability for the MPU to disable the color information (by forcing the color difference data to zero) is also useful for special effects.

The color burst level may be detected by forcing all burst samples positive and sampling the result multiple times to determine the average value. This can be averaged with the previous three active scan lines to limit line-to-line variations. If the average result is greater than 40% of the ideal burst amplitude, the burst is valid. The "burst level error" is the ideal amplitude divided by the average result. If no burst is detected, this may be used to automatically disable any filtering in the luminance path, allowing maximum resolution luminance to be output.

Color Space Conversion

At a minimum, the digital RGB and YCrCb color spaces should be supported as output

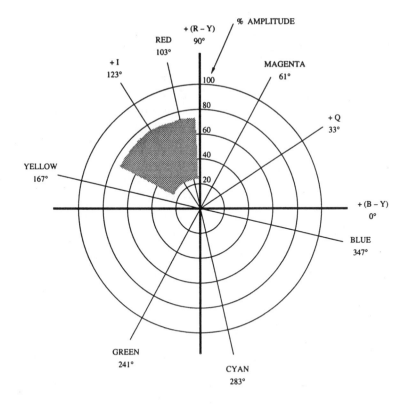

Figure 6.18. NTSC Subcarrier Phases and a Typical Flesh Tone Color Range.

formats in a graphics/video system. These must be generated from the YIQ (for NTSC) or YUV (for PAL) color spaces.

NTSC Color Space Conversion

When generating gamma-corrected RGB or YCrCb data, it may be converted from YIQ data using the following equations (which are the inverse used for the digital encoder discussed in Chapter 5):

YIQ to RGB

$$R' = 1.969Y + 1.879I + 1.216Q$$
$$G' = 1.969Y - 0.534I - 1.273Q$$
$$B' = 1.969Y - 2.183I + 3.354Q$$

YIQ to YCrCb

$$Y = 1.692Y + 16$$
$$Cr = 1.179I + 0.765Q + 128$$
$$Cb = -1.081I + 1.668Q + 128$$

The RGB output data has a range of 0 to 255. Values less than 0 should be made 0 and values greater than 255 should be made 255. The YCrCb output data has a nominal range of 16 to 235 for Y; the Cr and Cb output data has a nominal range of 16 to 240, with 128 equal to zero. For both sets of equations, a minimum of 4 bits of fractional data should be maintained with the final results rounded to the desired accuracy. YIQ input ranges for both sets of equations are 0 to 130 for Y, 0 to ±78 for I, and 0 to ±68 for Q.

For computer applications, the gamma-correction may be removed to generate linear RGB data (values are normalized to have a value of 0 to 1):

for R', G', B' < 0.0812

$$R = R'/4.5$$
$$G = G'/4.5$$
$$B = B'/4.5$$

for R', G', B' ≥ 0.0812

$$R = ((R' + 0.099)/1.099)^{2.2}$$
$$G = ((G' + 0.099)/1.099)^{2.2}$$
$$B = ((B' + 0.099)/1.099)^{2.2}$$

Professional video systems may use the gamma-corrected RGB color space, with RGB having a nominal range of 16 to 235. Occasional values less than 16 and greater than 235 are allowed. In this instance, YIQ may be converted to RGB by scaling the previous YIQ-to-RGB equations by 219/255 and adding an offset of 16:

$$R' = 1.691Y + 1.614I + 1.044Q + 16$$
$$G' = 1.691Y - 0.459I - 1.093Q + 16$$
$$B' = 1.691Y - 1.875I + 2.880Q + 16$$

PAL Color Space Conversion

When generating (gamma corrected) RGB or YCrCb data, it may be converted from YUV data using the following equations (which are the inverse used for the digital encoder discussed in Chapter 5).

YUV to RGB

$$R' = 1.862Y - 0.005U + 2.121V$$
$$G' = 1.862Y - 0.731U - 1.083V$$
$$B' = 1.862Y + 3.788U - 0.002V$$

YUV to YCrCb

$$Y = 1.597Y + 16$$

$$Cr = 1.330V + 128$$
$$Cb = 1.876U + 128$$

The RGB output data has a range of 0 to 255. Values less than 0 should be made 0 and values greater than 255 should be made 255. The YCrCb output data has a nominal range of 16 to 235 for Y; the Cr and Cb output data has a nominal range of 16 to 240, with 128 equal to zero. For both sets of equations, a minimum of 4 bits of fractional data should be maintained with the final results rounded to the desired accuracy. YUV input ranges for both sets of equations are 0 to 137 for Y, 0 to ±60 for U, and 0 to ±85 for V.

Low-cost PAL decoders may also use a YUV-to-YCrCb and YUV-to-RGB color space conversion based on simple shifts and adds at the expense of color accuracy:

$$Y = Y + (1/2)Y + (1/16)Y + (1/32)Y + 16$$
$$Cr = V + (1/4)V + (1/16)V + (1/64)V + 128$$
$$Cb = U + (1/2)U + (1/4)U + (1/8)U + 128$$

$$R' = Y + (1/2)Y + (1/4)Y + (1/8)Y + 2V$$
$$+ (1/8)V$$
$$G' = Y + (1/2)Y + (1/4)Y + (1/8)Y$$
$$- (1/2)U - (1/4)U - V - (1/16)V$$
$$B' = Y + (1/2)Y + (1/4)Y + (1/8)Y + 3U$$
$$+ (1/2)U + (1/4)U + (1/32)U$$

The gamma-corrected RGB values have a range of 0 to 255; values less than zero should be made zero and values greater than 255 should be made 255. For computer applications, gamma-corrected RGB data may be converted to linear RGB data as follows (values are normalized to have a value of 0 to 1):

for R', G', B' < 0.0812

$$R = R' / 4.5$$
$$G = G' / 4.5$$
$$B = B' / 4.5$$

for R′, G′, B′ ≥ 0.0812

$$R = ((R' + 0.099) / 1.099)^{2.8}$$
$$G = ((G' + 0.099) / 1.099)^{2.8}$$
$$B = ((B' + 0.099) / 1.099)^{2.8}$$

Professional video systems may use the gamma-corrected RGB color space, with RGB having a nominal range of 16 to 235. Occasional values less than 16 and greater than 235 are allowed. In this instance, YUV may be converted to RGB by scaling the PAL YUV-to-RGB equations by 219/255 and adding an offset of 16:

$$R' = 1.599Y - 0.004U + 1.822V + 16$$
$$G' = 1.599Y - 0.628U - 0.930V + 16$$
$$B' = 1.599Y + 3.253U - 0.002V + 16$$

Subcarrier Generation

As with the digital encoder (discussed in Chapter 5), the color subcarrier is generated from the pixel clock using a p:q ratio counter. Unlike the encoder, the phase of the generated subcarrier must be continuously adjusted to match that of the video signal being digitized.

Frequency Relationships

In the (M) NTSC and (B, D, G, H, I, N) PAL color composite video standards, there are defined relationships between the subcarrier frequency (F_{SC}) and the line frequency (F_H):

PAL: $F_{SC}/F_H = (1135/4) + (1/625)$

NTSC: $F_{SC}/F_H = 910/4$

Assuming (for example only) a 13.5-MHz pixel clock rate (F_S):

PAL: $F_S = 864 F_H$

NTSC: $F_S = 858 F_H$

Combining these equations produces the relationship between F_{SC} and F_S:

PAL: $F_{SC}/F_S = 709379/2160000$

NTSC: $F_{SC}/F_S = 35/132$

which may also be expressed in terms of the pixel clock period (T_S) and the subcarrier period (T_{SC}):

PAL: $T_S/T_{SC} = 709379/2160000$

NTSC: $T_S/T_{SC} = 35/132$

The color subcarrier phase must be advanced by this fraction of a subcarrier cycle each pixel clock.

In the combination (N) PAL color composite video standard used in Argentina, there are slightly different relationships between the subcarrier frequency (F_{SC}) and the line frequency (F_H):

$$F_{SC}/F_H = (917/4) + (1/625)$$

Assuming (for example only) a 13.5-MHz pixel clock rate (F_S):

$$F_S = 864 F_H$$

Combining these equations produces the relationship between F_{SC} and F_S:

$$F_{SC}/F_S = 573129/2160000$$

which may also be expressed in terms of the pixel clock period (T_S) and the subcarrier period (T_{SC}):

$$T_S/T_{SC} = 573129/2160000$$

The color subcarrier phase must be advanced by this fraction of a subcarrier cycle each pixel

clock. Otherwise, combination (N) PAL has the same timing as (B, D, G, H, I) PAL.

Quadrature Subcarrier Generation

A ratio counter consists of an accumulator in which a smaller number p is added modulo another number q. The counter consists of an adder and a register as shown in Figure 6.19. The contents of the register are constrained so that if they exceed or equal q, q is subtracted from the contents. The output signal (X_N) of the adder is:

$$X_N = (X_{N-1} + p) \text{ modulo } q$$

With each clock cycle, p is added to produce a linearly increasing series of digital values. It is important that q is not an integer multiple of p so that the generated values are continuously different and the remainder changes from one cycle to the next. Note that the discrete time oscillator (DTO) may be used to reduce an input frequency F_S (in this case the pixel clock frequency) to another frequency F_{SC} (in this case the subcarrier frequency):

$$F_{SC} = (p/q) \, F_S$$

Since the p value is of finite word length, the DTO output frequency can only be varied in steps. With a p word length of w, the lowest p step is 0.5w and the lowest DTO frequency step is:

$$F_{SC} = F_S/2^w$$

Note that the output frequency cannot be greater than half the input frequency. Thus, the output frequency F_{SC} can only be varied by the increment p and within the range:

$$0 < F_{SC} < F_S/2$$

In this application, an overflow corresponds to the completion of a full cycle of the subcarrier. Since only the remainder (which represents the subcarrier phase) is required, the number of whole cycles completed is of no interest. During each clock cycle, the output of the q register shows the relative phase of a subcarrier frequency in qths of a subcarrier period. By using the q register contents to address a ROM containing a sine wave characteristic, a numerical representation of the sampled subcarrier sine wave can be generated.

Figure 6.20 shows a circuit arrangement for generated quadrature subcarriers from an 11-bit subcarrier phase signal. This uses two ROMs with 9-bit addresses to store quadrants of sine and cosine waveforms. XOR gates invert the addresses for generating time-reversed portions of the waveforms and to invert the output polarity to make negative portions of the waveforms. An additional gate is provided in the sign bit for the V subcarrier to allow injection of a PAL SWITCH square wave to implement phase inversion of the V signal on alternate scan lines.

Figure 6.19. p:q Ratio Counter.

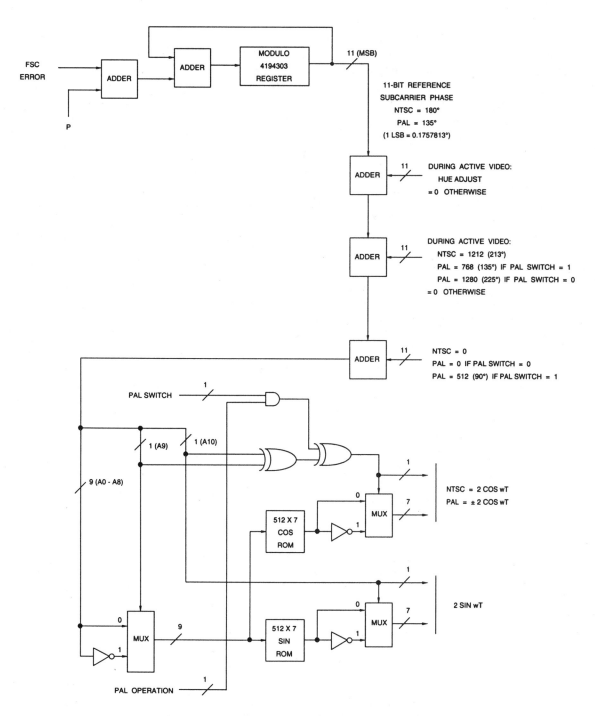

Figure 6.20. Chrominance Subcarrier Generator.

Unlike the subcarrier circuit used by the digital encoder discussed in Chapter 5, the decoder uses a single-stage ratio counter, as shown in Figure 6.20, due to the difficulty in dividing the F_{SC} phase error signal into multiple pieces to drive each segment of a partitioned ratio counter. Also, the decoder need not have the subcarrier accuracy of the encoder, since there will be variations in subcarrier frequency due to genlocking.

Each value of the 11-bit subcarrier phase signal corresponds to one of 2048 waveform values taken at a particular point in the subcarrier cycle period and stored in ROM. The sample points are taken at odd multiples of one 4096th of the total period to avoid end-effects when the sample values are read out in reverse

order. Note only one quadrant of the subcarrier wave shape is stored in ROM as shown in Figure 6.21. The values for the other quadrants are produced using the symmetrical properties of the sinusoidal waveform. The maximum phase error using this technique is ±0.09° (half of 360/2048), which corresponds to a maximum amplitude error of ±0.08%, relative to the peak-to-peak amplitude, at the steepest part of the sine wave signal.

An F_{SC} error signal is added to the p value to continually adjust the step size of the p:q ratio counter, adjusting the phase of the generated subcarrier to match that of the video signal being digitized. The subcarrier locking circuitry phase compares the generated subcarrier and the incoming subcarrier, resulting

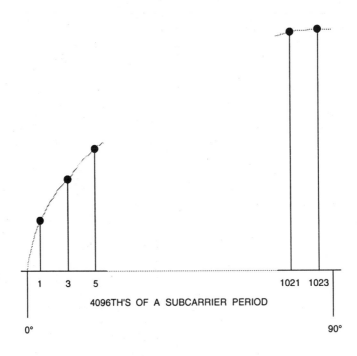

Figure 6.21. Positions of the 512 Stored Sample Values in the sin and cos ROMs for One Quadrant of a Subcarrier Cycle. Samples for other quadrants can be generated by inverting the addresses and/or sign values.

in an F_{SC} error signal indicating the amount of phase error (Figure 6.25).

As the p:q ratio counter is used to divide down a frequency (in this case the pixel clock) to generate the subcarrier, the P value is determined as follows:

$$F_{SC}/F_S = (P/4194303)$$

where F_{SC} = the desired subcarrier frequency and F_S = the pixel clock rate. Some values of P for popular pixel clock rates are shown in Table 6.7.

Genlocking

The purpose of the genlock circuitry is to recover the original pixel clock and timing control signals (such as horizontal sync, vertical sync, and the color subcarrier) from the video signal. Since the pixel clock is not directly available, it is usually generated by multiplying the horizontal line frequency, F_H, by the desired number of pixel clocks per scan line, using a phase-lock loop (PLL). Also, the subcarrier must be regenerated and locked to the subcarrier of the video signal being digitized.

There are, however, several problems. Video signals may contain a lot of noise, making the determination of the sync edges unreliable. The amount of time between horizontal sync edges may vary slightly each scan line, particularly in video tape recorders (VTRs) due to mechanical limitations. For VTRs, instantaneous line-to-line variations are up to ±100 ns; line variations between the beginning and end of a field are up to ±1–5 µs. When VTRs are in a "special feature" mode, such as fast-forwarding or still-picture, the amount of time between horizontal sync signals may vary up to ±20% from nominal.

Vertical sync, as well as horizontal sync, information must be recovered. Unfortunately, analog VTRs, in addition to destroying the SCH phase relationship, perform head switching at field boundaries, usually somewhere between the end of active video and the start of vertical sync. When head switching occurs, one video signal (for field n) is replaced by another video signal (for field n + 1) which has an unknown phase offset from the first video signal. There may be up to a ±1/2 line variation in vertical timing each field. As a result, longer-than-normal horizontal or vertical syncs may be generated.

By monitoring the horizontal line timing, it is possible to automatically determine whether the video source is in the "normal" or "special feature" mode. During "normal" operation, the horizontal line time typically varies by no more

Pixel Clock	P
12.27 MHz (M) NTSC	1,223,338
13.5 MHz (M) NTSC	1,112,126
14.32 MHz (M) NTSC	1,048,576
13.5 MHz (B, D, G, H, I) PAL	1,377,477
14.75 MHz (B, D, G, H, I) PAL	1,260,742
17.72 MHz (B, D, G, H, I) PAL	1,048,576

Table 6.7. Values of P for Several Common Pixel Clock Rates.

than ±5 µs over an entire field. Line timing outside this ±5 µs window may be used to enable "special feature" mode timing. Hysteresis should be used in the detection algorithm to prevent wandering back and forth between the "normal" and "special feature" operations in the event the video timing is borderline between the two modes. A typical digital circuit for performing the horizontal and vertical sync detection is shown in Figure 6.22.

Horizontal Sync Detection

Early decoders typically used analog sync slicing techniques to determine the midpoint of the falling edge of the sync pulse, and used a PLL to multiply the horizontal sync rate up to the pixel clock rate. However, the lack of accuracy of the analog sync slicer, combined with the limited stability of the PLL, resulted in excessive pixel clock jitter and noise amplification. When using comb filters for Y/C separation, the long delay between writing and reading the digitized video data means that even a small pixel clock frequency error results in a delay that is a significant percentage of the subcarrier period, negating the effectiveness of the comb filter. Therefore, a digital solution is preferred, as shown in Figure 6.22.

Initially, a coarse indication of the falling edge of horizontal sync is established by an analog sync slicer that is AC-coupled to the analog video source. This initializes the digital timing and performs initial timing for DC restoring the video signals. The analog circuitry should be used for a minimum of 16 consecutive lines to "sail through" the vertical intervals. The analog sync slicer initially determines the leading edge of horizontal sync and resets the 11-bit horizontal counter (clocked by pixel clock) to 001_H. After operating for 16

consecutive lines, sync detection operation and DC restoration timing may switch over to all digital operation.

Coarse Horizontal Sync Locking

The coarse sync locking enables a faster lock-up time to be achieved than if only the fine sync locking circuitry was used. Digitized video is digitally lowpass filtered to about 0.5 MHz (using a sharp cutoff filter) to remove high-frequency information, such as noise and subcarrier information. Performing the sync detection on lowpass filtered data also provides edge shaping for fast sync edges (rise and fall times less than one clock cycle).

The 11-bit horizontal counter is incremented each pixel clock cycle, resetting to 001_H after counting up to the HCOUNT value, where HCOUNT specifies the number of total clock cycles, or pixels, per scan line. A value of 001_H indicates that the beginning of a horizontal sync is expected. When the horizontal counter value is (HCOUNT – 64), a noise gate is enabled, allowing recovered sync information to be detected. Up to five consecutive missing sync pulses should be detected before any correction to the clock frequency or other adjustments are done. Once recovered sync information has been detected, the noise gate is disabled until the next time the horizontal counter value is (HCOUNT – 64). This helps filter out noise, serration, and equalization pulses. If the falling edge of recovered horizontal sync is not within ±64 clock cycles (approximately ±5 µs) of where it is expected to be, the horizontal counter is reset to 001_H to more closely realign the edges.

Additional circuitry may be included to monitor the width of the recovered horizontal sync pulse. If the horizontal sync pulse is not approximately the correct pulse width (too narrow or too wide), ignore it and treat it as a

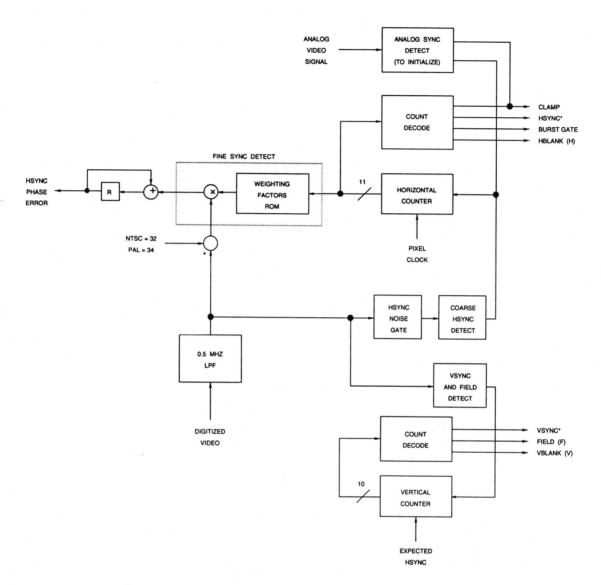

Figure 6.22. Sync Detection and Phase Comparator Circuitry.

missing sync pulse. The nominal horizontal sync pulse may be calculated for any pixel clock rate using the following equation:

$$HSYNC \ width = (HCOUNT/16)$$
$$+ (HCOUNT/128)$$
$$+ (HCOUNT/256) + 1$$

If the falling edge of recovered horizontal sync is within ±64 clock cycles (approximately ±5 μs) of where it is expected to be, the fine horizontal sync locking circuitry is used to fine-tune the pixel clock frequency.

Fine Horizontal Sync Locking

32 (NTSC) or 34 (PAL) is subtracted from the 0.5-MHz lowpass-filtered video data so the sync timing reference point (50% sync amplitude) is at zero. The recovered falling horizontal sync edge may be determined by summing a series of weighted samples from the region of the digital sync edge. To perform the filtering, the weighting factors are read from a ROM by a counter triggered by the horizontal counter. When the central weighting factor (A0) is coincident with the falling edge of sync, the result integrates to zero. Typical weighting factors are:

$$A0 = 102/4096$$
$$A1 = 90/4096$$
$$A2 = 63/4096$$
$$A3 = 34/4096$$
$$A4 = 14/4096$$
$$A5 = 5/4096$$
$$A6 = 2/4096$$

The 50% sync amplitude point should align with A0 weighting factor. This arrangement uses more of the timing information from the sync edge and suppresses noise. Note that circuitry should be included to avoid processing the rising edge of horizontal sync.

Figure 6.23 shows the operation of the fine sync phase comparator. Figure 6.23(a) shows the falling sync edge for NTSC. Figure 6.23(b) shows the weighting factors being generated, and when multiplied by the sync information (after it has 32 subtracted from it), produces the waveform shown in Figure 6.23(c). When the A0 coefficient is coincident with the 50% amplitude point of sync, the waveform integrates to zero. Distortion of sync edges, resulting in the locking point being slightly shifted, is minimized by the lowpass filtering, effectively shaping the sync edges prior to processing.

Pixel Clock Generation

The horizontal sync phase error signal from the sync detection and phase comparison circuit (Figure 6.22) is used to adjust the frequency of a free-running VCO or VCXO, as shown in Figure 6.24. The free-running frequency of the VCO or VCXO should be the nominal pixel clock frequency required (for example, 13.5 MHz).

Using the VCO has the advantages of a wider range of pixel clock frequency adjustment, useful for handling video timing variations outside the normal video specifications. A disadvantage is that, due to jitter in the pixel clock, there may be visible hue artifacts and poor Y/C separation. The VCXO has the advantage of having minimal pixel clock jitter. However, the pixel clock frequency range may be adjusted only a small amount, limiting the ability of the decoder to handle nonstandard video timing. Ideally, with both designs, the pixel clock is aligned with the falling edge of horizontal sync, with a fixed number of pixel clock cycles per scan line (HCOUNT).

An alternate method is to asynchronously sample the video signal with a fixed-frequency clock (for example, 13.5 MHz). Since in this

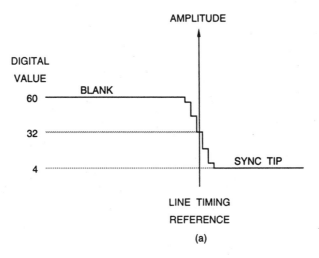

(a)

(b)

(c)

Figure 6.23. Fine Lock Phase Comparator Waveforms. (a) The NTSC sync leading edge, (b) The series of weighting factors, and (c) The weighted sync leading edges samples.

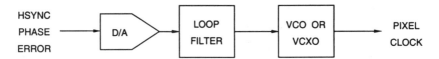

Figure 6.24. Pixel Clock Generation.

case the pixel clock is not aligned with horizontal sync, there is a phase difference between the actual sample position and the ideal sample position. As with the standard genlock solution, this phase difference is determined by the phase difference between the recovered and expected horizontal syncs. The ideal sample position is defined to be aligned with a pixel clock generated by a standard genlock solution using a VCO or VCXO. Rather than controlling the pixel clock frequency, the horizontal sync phase error signal is used to control interpolation between two actual samples of YCrCb or RGB data to generate the ideal YCrCb or RGB sample value. If using comb filtering for Y/C separation, the digitized composite video may be interpolated to generate the ideal sample points, providing better Y/C separation by aligning the pixels more precisely.

Vertical Sync Detection

Sync detection is done digitally on the digitized composite video. Digitized video is digitally lowpass filtered to about 0.5 MHz (using a sharp cutoff filter) to remove high-frequency information, such as noise and subcarrier information. The vertical counter is incremented by each expected horizontal sync, resetting to 001_H after counting up to 525 (NTSC) or 625 (PAL). A value of 001_H indicates that the beginning of a vertical sync for an odd field is expected.

The end of vertical sync intervals is detected and used to set the value of the 10-bit vertical counter according to the mode of operation (NTSC or PAL). By monitoring the relationship of recovered vertical sync to the expected horizontal sync, even and odd field information is detected. If a recovered horizontal sync occurs more than 64, but less than (HCOUNT/2), clock cycles after expected horizontal sync, the vertical counter is not adjusted to avoid double incrementing the vertical counter. If a recovered horizontal sync occurs (HCOUNT/2) or more clock cycles after the vertical counter has been incremented, the vertical counter is again incremented.

During "special feature" operation, there is no longer any correlation between the vertical and horizontal timing information, so even or odd field detection cannot be done. Thus, every other detection of the end of vertical sync should set the vertical counter accordingly in order to synthesize even/odd field timing.

Subcarrier Locking

The purpose of the subcarrier locking circuitry (Figure 6.25) is to phase lock the generated subcarrier to the subcarrier of the video signal being digitized. Digital composite video has 60 (NTSC) or 63 (PAL) subtracted from it, while digital chrominance video has 128 subtracted from it, to position the burst at 0 to

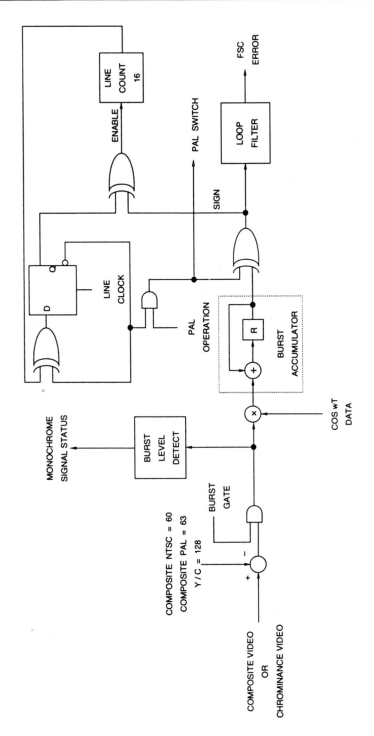

Figure 6.25. Subcarrier Phase Comparator Circuitry.

±28 (NTSC) or 0 to ±30 (PAL). It is also gated with the burst gate to ensure that the video data has a value of zero outside the burst time. The burst gate control signal is generated by the video timing circuitry, and is enabled at horizontal count:

$$(HCOUNT/16) + (HCOUNT/64)$$
$$+ (HCOUNT/256)$$
$$+ (HCOUNT/512) + 9$$

and is disabled 16 clock cycles later. This is to eliminate the edges of the burst, which may have transient distortions that will reduce the accuracy of the phase measurement. Also, some low-cost VTRs may generate a burst that starts during horizontal sync and ends just before active video. Note that the HCOUNT value specifies the total number of pixels per scan line.

The digital burst data is phase compared to the locally generated burst. Note that the sign information must also be compared so lock will not occur on 180° out-of-phase signals. The burst accumulator averages the 16 samples and the accumulated values from two adjacent scan lines are averaged to produce the error signal. When the local subcarrier is correctly phased, the accumulated values from alternate lines cancel, and the phase error signal is zero. The error signal is sampled at the line rate and processed by the loop filter, which should be designed to achieve a lock-up time of about ten lines (50 or more lines may be required for noisy video signals). It is desirable to avoid updating the error signal during vertical intervals due to the lack of burst. The resulting F_{SC} error signal is used to adjust the p:q ratio counter that generates the local subcarrier (Figure 6.20).

During PAL operation, the phase detector also recovers the PAL SWITCH information used in generating the switched V subcarrier.

The PAL SWITCH D flip-flop is synchronized to the incoming signal by comparing the local switch sense with the sign of the accumulated burst values. If the sense is consistently incorrect for 16 lines, then the flip-flop is reset.

Note the subcarrier locking circuit should be able to handle short-term frequency variations (over a few frames) of ±200 Hz, long-term frequency variations of ±500 Hz, and color burst amplitudes of 50–150% of normal with short-term amplitude variations (over a few frames) of up to 5%. The lock-up time of 10 lines is desirable to accommodate video signals that may have been incorrectly edited (i.e., not careful about the SCH phase relationship) or nonstandard video signals due to freeze-framing, special effects, etc. The 10 lines enable the subcarrier to be locked before the active video time, ensuring correct color representation at the beginning of the picture.

Field Identification

In some instances, particularly in editing situations, it may be desirable for the decoder to indicate which one of four (NTSC) or eight (PAL) fields are being decoded. The field may be indicated by two additional output signals from the decoder, which we call FIELD_0 and FIELD_1.

NTSC Field Identification

Although the timing relationship between the horizontal sync (HSYNC*) and vertical sync (VSYNC*) output signals, or the F output signal, may be used to specify whether an even or odd field is being decoded, another signal must also be used to specify which one of four fields is being decoded, as shown in Table 6.8. This additional signal (which we will refer to as FIELD_0), specifies whether fields 1 and 2 (FIELD_0 = logical zero) or fields 3 and 4

FIELD_0 Signal	HSYNC*/VSYNC* Timing Relationship or F Indicator	Decoded Field
0	odd field	1
0	even field	2
1	odd field	3
1	even field	4

Table 6.8. NTSC Field Indication.

(FIELD_0 = logical one) are being decoded. FIELD_0 should change state at the beginning of vertical sync during fields 1 and 3.

The beginning of field 1 and field 3 may be determined by monitoring the relationship of the subcarrier phase relative to sync. As shown in Figure 6.26, at the beginning of field 1, the subcarrier phase is ideally 0° relative to sync; at the beginning of field 3, the subcarrier phase is ideally 180° relative to sync. In the real world, there is a tolerance in the SCH phase relationship. For example, although the ideal SCH phase relationship may be perfect at the source, transmitting the video signal over a coaxial cable may result in a shift of the SCH phase relationship due to cable characteristics. Thus, the ideal phase plus or minus a tolerance should be used. Although ±40° (NTSC) or ±20° (PAL) is specified as an acceptable tolerance by the video standards, many designs use a tolerance of up to ±80°. In the event that a SCH phase relationship not within the proper tolerance is detected, the decoder should proceed as if nothing were wrong; if the condition persists for several frames, indicating that the video source may no longer be a "stable" video source, operation should change to be that for an "unstable" video source.

For "unstable" video sources that do not maintain the proper SCH relationship (such as

VTRs), a synthesized FIELD_0 output should be generated (for example, by dividing the F output signal by two) in the event the signal is required for memory addressing or downstream processing.

By monitoring the SCH phase relationship, the decoder can automatically determine whether the input video source is "stable" (such as from a camera or video generator) or "unstable" (such as from a VTR), and configure for optimum operation.

PAL Field Identification

Although the timing relationship between the horizontal sync (HSYNC*) and vertical sync (VSYNC*) output signals, or the F output signal, may be used to specify whether an even or odd field is being decoded, two additional signals must also be used to specify which one of eight fields is being decoded, as shown in Table 6.9. We will refer to these additional control signals as FIELD_0 and FIELD_1. FIELD_0 should change state at the beginning of vertical sync during fields 1, 3, 5, and 7. FIELD_1 should change state at the beginning of vertical sync during fields 1 and 5.

The beginning of field 1 and field 5 may be determined by monitoring the relationship of the subcarrier phase relative to sync. As shown in Figure 6.27, at the beginning of field

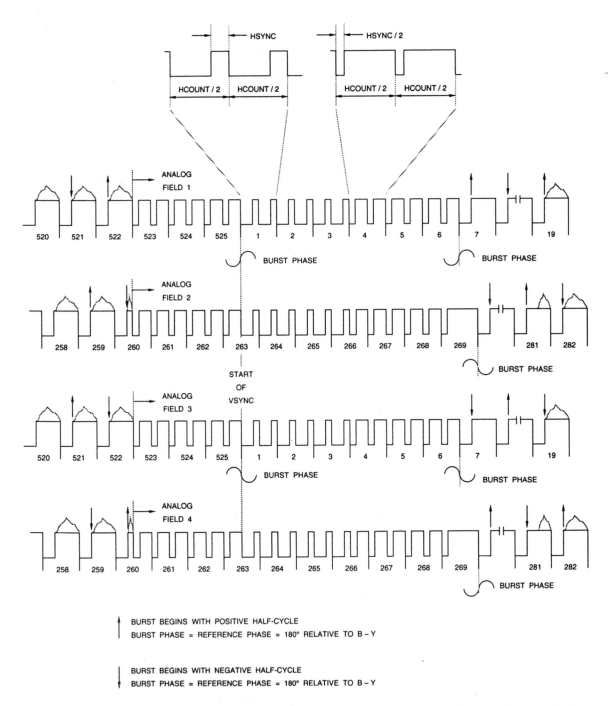

Figure 6.26. Four-field (M) NTSC Format. Note: to simplify the implementation, the line numbering does not match that used in standard practice for NTSC video signals.

FIELD_1 Signal	FIELD_0 Signal	HSYNC*/VSYNC* Timing Relationship or F Indicator	Decoded Field
0	0	odd field	1
0	0	even field	2
0	1	odd field	3
0	1	even field	4
1	0	odd field	5
1	0	even field	6
1	1	odd field	7
1	1	even field	8

Table 6.9. PAL Field Indication.

1, the subcarrier phase is ideally 0° relative to sync; at the beginning of field 5, the subcarrier phase is ideally 180° relative to sync. Either the burst blanking sequence or the subcarrier phase may be used to differentiate between fields 1 and 3, fields 2 and 4, fields 5 and 7, and fields 6 and 8. All of the considerations discussed for NTSC in the previous section also apply for PAL.

Video Timing Generation

Horizontal Sync HSYNC*) Generation
Each time the 11-bit horizontal counter (incremented on each rising edge of the pixel clock) is reset to 001_H, the HSYNC* output should be asserted to a logical zero for 64 clock cycles.

Horizontal Blanking (H) Generation
The H output should be asserted to a logical one (blanking) when the horizontal counter is reset to 001_H. A programmable value (HBLANK) specifies the horizontal count value at which active video begins. The H output is negated to a logical zero (indicating active video) when the horizontal counter reaches the HBLANK register value. A programmable value (HACTIVE) specifies the number of active pixels per scan line. H is again asserted to a logical one (indicating blanking) when the horizontal counter reaches the value (HACTIVE + HBLANK). If the H signal is used in a 4:2:2 digital component video application, the timing should be configured to be as described in Chapter 8.

Vertical Sync (VSYNC*) Generation
Each time the 10-bit vertical counter is reset to 001_H, the VSYNC* output should be a logical zero for 3 scan lines, starting coincident with the falling edge of HSYNC* for odd fields. The VSYNC* output should also be a logical zero for 3 scan lines starting at horizontal count (HCOUNT/2) + 1 on scan line 263 (NTSC) or 313 (PAL) for even fields.

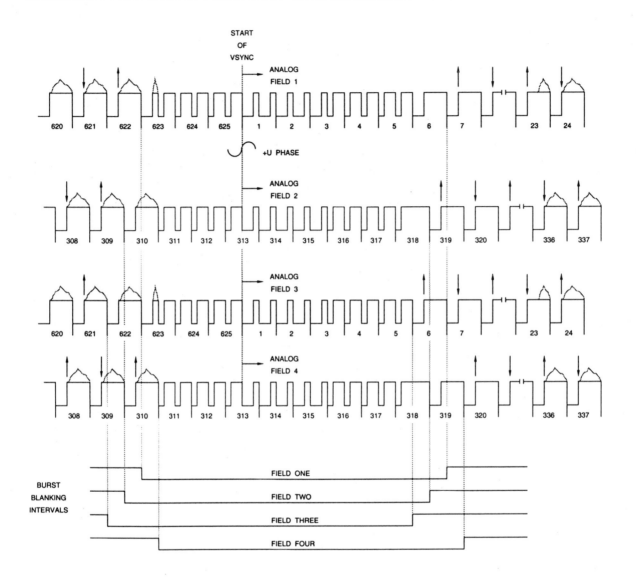

Figure 6.27a. Eight-field (B, D, G, H, I, Combination N) PAL Format. (See Figure 6.26 for equalization and serration pulse details.)

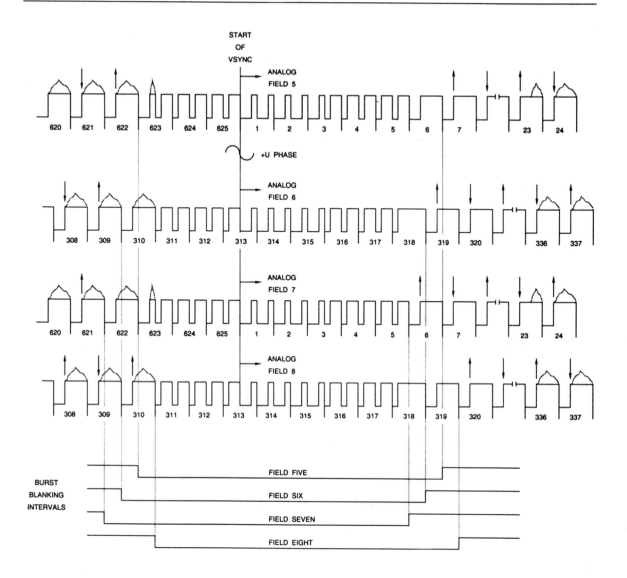

START
OF
VSYNC

ANALOG
FIELD 5

620 621 622 623 624 625 1 2 3 4 5 6 7 23 24

+U PHASE

ANALOG
FIELD 6

308 309 310 311 312 313 314 315 316 317 318 319 320 336 337

ANALOG
FIELD 7

620 621 622 623 624 625 1 2 3 4 5 6 7 23 24

ANALOG
FIELD 8

308 309 310 311 312 313 314 315 316 317 318 319 320 336 337

BURST
BLANKING
INTERVALS

FIELD FIVE

FIELD SIX

FIELD SEVEN

FIELD EIGHT

BURST PHASE = REFERENCE PHASE = 135° RELATIVE TO U
PAL SWITCH = 0, + V COMPONENT

BURST PHASE = REFERENCE PHASE + 90° = 225° RELATIVE TO U
PAL SWITCH = 1, −V COMPONENT

Figure 6.27b. Eight-field (B, D, G, H, I, Combination N) PAL Format. (See Figure 6.26 for equalization and serration pulse details.)

In instances where the output of a VTR is being decoded, and the VTR is in a special effects mode (such as still or fast-forward), there is no longer enough timing information to separate odd and even field timing from the vertical intervals. Thus, the odd/even field timing as specified by the VYSNC*/HSYNC* relationship (or the F output) is synthesized, and may not reflect the true odd/even field timing of the video signal being decoded.

Vertical Blanking (V) Generation
Note that VCOUNT has a value of 525 when digitizing NTSC video signals and a value of 625 when digitizing PAL video signals; x = 263 for NTSC and 313 for PAL. A programmable value (VACTIVE) specifies the number of active scan lines per frame. Another programmable value (VBLANK – 1) specifies the number of blanked scan lines from the beginning of vertical sync to active video.

The V output should be asserted to a logical one (blanking) when the vertical counter is reset to 001_H. The V output is negated to a logical zero (indicating active video) when the vertical counter increments to the VBLANK register value. V should be asserted to a logical one when the vertical counter increments to the integer value of VBLANK + ((VACTIVE + 1)/2).

V is negated to a logical zero when the vertical counter increments to the value VBLANK + x. The V output is again asserted to a logical one when the vertical counter increments to the integer value of VBLANK + x + (VACTIVE/2). V should be pipelined to maintain synchronization with the pixel data. If the V signal is used in a 4:2:2 digital component video application, the timing should be compatible with the requirements described in Chapter 8.

Composite Blanking (BLANK*) Output
The composite blanking output, BLANK*, is the logical NOR of the H and V signals. While BLANK* is a logical zero, RGB data may optionally be forced to be a logical zero; YCrCb data may be forced to a value of 16 (for Y) and 128 (for Cr and Cb). Alternately, the RGB or YCrCb data outputs may not be blanked, allowing vertical interval test signals, closed captioned signals, and vertical interval timecode information to be passed through the decoder.

FIELD (F) Output
The field output, F, specifies whether an even or odd field is being decoded. It is primarily used in 4:2:2 digital component video applications. The timing of F should be compatible with the requirements described in Chapter 8.

NTSC Decoding Using YUV

For (M) NTSC, the YUV color space may be used rather than the YIQ color space. The equations are determined by taking the inverse matrix of the equations used for encoding (discussed in Chapter 5). Y has a range of 0 to 130, U has a range of 0 to ±57, and V has a range of 0 to ±80.

YUV to RGB

R' = 1.969Y – 0.009U + 2.244V
G' = 1.969Y – 0.775U – 1.143V
B' = 1.969Y + 4.006U – 0.009V

YUV to YCrCb

Y = 1.689Y + 16
Cb = 1.984U + 128
Cr = 1.406V + 128

The 33° subcarrier phase shift during active video is not required if the YUV color space is used. If the same decoder design is to implement both analog composite NTSC and digital composite NTSC video (discussed in Chapter 7), the YIQ color space should be

used. The gamma–corrected RGB values have a range of 0 to 255; values less than zero should be made zero and values greater than 255 should be made 255.

Low-cost (M) NTSC decoders that use the YUV color space may use YUV-to-YCrCb or YUV-to-RGB color space conversion based on simple shifts and adds at the expense of color accuracy:

$$Y = Y + (1/2)Y + (1/8)Y + (1/16)Y + 16$$

$$Cr = V + (1/4)V + (1/8)V + (1/32)V + 128$$

$$Cb = U + (1/2)U + (1/4)U + (1/8)U$$
$$\quad + (1/16)U + (1/32)U + (1/64)U + 128$$

$$R' = 2Y - (1/128)U + 2V + (1/4)V$$

$$G' = 2Y - (1/2)U - (1/4)U - V - (1/8)V$$
$$\quad - (1/64)V$$

$$B' = 2Y + 4U - (1/128)V$$

The gamma-corrected RGB values have a range of 0 to 255; values less than zero should be made zero and values greater than 255 should be made 255. For computer applications, gamma-corrected RGB data may be converted to linear RGB data as follows (values are normalized to have a value of 0 to 1):

for R', G', B' < 0.0812

$$R = R'/4.5$$
$$G = G'/4.5$$
$$B = B'/4.5$$

for R', G', B' ≥ 0.0812

$$R = ((R' + 0.099)/1.099)^{2.2}$$
$$G = ((G' + 0.099)/1.099)^{2.2}$$
$$B = ((B' + 0.099)/1.099)^{2.2}$$

Professional video systems may use the gamma-corrected RGB color space, with RGB having a nominal range of 16 to 235. Occa-

sional values less than 16 and greater than 235 are allowed. In this instance, YUV may be converted to RGB by scaling the previous YUV-to-RGB equations by 219/255 and adding an offset of 16:

$$R' = 1.691Y - 0.008U + 1.927V + 16$$
$$G' = 1.691Y - 0.666U - 0.982V + 16$$
$$B' = 1.691Y + 3.440U - 0.008V + 16$$

NTSC/PAL Decoding Using YCrCb

For (M) NTSC and (B, D, G, H, I) PAL, by adjusting the full-scale amplitudes of the sin and cos subcarriers, the demodulator may directly generate Cr and Cb, rather than U and V. Cr and Cb have a range of 16 to 240, with 128 equal to zero. The luminance information, after Y/C separation, has a range of either 0 to 130 (NTSC) or 0 to 137 (PAL); this must be scaled and offset to have a range of 16 to 235. The YCrCb data may be converted to gamma-corrected RGB data as follows:

$$R' = 1.164(Y - 16) + 1.596(Cr - 128)$$
$$G' = 1.164(Y - 16) - 0.813(Cr - 128)$$
$$\quad - 0.391(Cb - 128)$$
$$B' = 1.164(Y - 16) + 2.018(Cb - 128)$$

For NTSC, the 33° subcarrier phase shift during active video is not required since demodulation occurs along the U and V axes. If the same decoder design is to implement both analog composite and digital composite video (discussed in Chapter 7), the YIQ (NTSC) and YUV (PAL) color spaces should be used. The gamma-corrected RGB values have a range of 0 to 255; values less than zero should be made zero and values greater than 255 should be made 255.

For computer applications, the gamma-correction may be removed to generate linear

RGB data (values are normalized to have a value of 0 to 1):

(M) NTSC systems:

for R', G', B' < 0.0812

$$R = R' / 4.5$$
$$G = G' / 4.5$$
$$B = B' / 4.5$$

for R', G', B' ≥ 0.0812

$$R = ((R' + 0.099) / 1.099)^{2.2}$$
$$G = ((G' + 0.099) / 1.099)^{2.2}$$
$$B = ((B' + 0.099) / 1.099)^{2.2}$$

(B, D, G, H, I) PAL systems:

for R', G', B' < 0.0812

$$R = R' / 4.5$$
$$G = G' / 4.5$$
$$B = B' / 4.5$$

for R', G', B' ≥ 0.0812

$$R = ((R' + 0.099) / 1.099)^{2.8}$$
$$G = ((G' + 0.099) / 1.099)^{2.8}$$
$$B = ((B' + 0.099) / 1.099)^{2.8}$$

Professional video systems may use the gamma-corrected RGB color space, with RGB having a nominal range of 16 to 235. Occasional values less than 16 and greater than 235 are allowed. In this instance, YCrCb may be converted to RGB as follows:

$$R' = Y + 1.366(Cr - 128) - 0.002(Cb - 128)$$
$$G' = Y - 0.700(Cr - 128) - 0.334(Cb - 128)$$
$$B' = Y - 0.006(Cr - 128) + 1.732(Cb - 128)$$

(N) PAL Decoding Considerations

Although (B, D, G, H, I) PAL are the common PAL formats, there are two variations of PAL

referred to as (N) PAL and combination (N) PAL. Combination (N) PAL is used in Argentina and has been covered in the previous subcarrier generation discussion, since the only difference between baseband combination (N) PAL and baseband (B, D, G, H, I) PAL baseband video signals is the change in subcarrier frequency.

Standard (N) PAL is also a 625/50 system and is used in Uruguay and Paraguay. Some of the timing is different from that of baseband (B, D, G, H, I) PAL baseband video signals, such as having serration and equalization pulses for three scan lines rather than 2.5 scan lines, as shown in Chapter 4. The YUV-to-RGB and YUV-to-YCrCb equations are determined by taking the inverse matrix of the equations used for encoding:

YUV to RGB

$$R' = 1.969Y - 0.009U + 2.244V$$
$$G' = 1.969Y - 0.775U - 1.143V$$
$$B' = 1.969Y + 4.006U - 0.009V$$

YUV to YCrCb

$$Y = 1.698Y + 16$$
$$Cb = 1.984U + 128$$
$$Cr = 1.406V + 128$$

A gamma of 2.8 is assumed at the receiver and the sync tip is −40 IRE rather than −43 IRE. Therefore, the luminance and composite digital video levels are as shown in Table 6.10 and Table 6.11, respectively. Once again, for computer applications, the gamma-correction may be removed to generate linear RGB data (values are normalized to have a value of 0 to 1):

for R', G', B' < 0.0812

$$R = R'/4.5$$
$$G = G'/4.5$$
$$B = B'/4.5$$

Video Level	8-bit digital value	10-bit digital value
white	200	800
black	70	280
blank	60	240
sync	4	16

Table 6.10. (N) PAL Composite Luminance Digital Values.

Video Level	8-bit digital value	10-bit digital value
peak chroma	243	972
white	200	800
peak burst	90	360
black	70	280
blank	60	240
peak burst	30	120
peak chroma	27	108
sync	4	16

Table 6.11. Composite (N) PAL Digital Video Levels.

for $R', G', B' \geq 0.0812$

$$R = ((R' + 0.099)/1.099)^{2.8}$$
$$G = ((G' + 0.099)/1.099)^{2.8}$$
$$B = ((B' + 0.099)/1.099)^{2.8}$$

Due to the timing differences from (B, D, G, H, I) PAL, standard (N) PAL and combination (N) PAL are not compatible with the digital composite video standards discussed in Chapter 7. As many of the timing parameters (such as horizontal sync width, start and end of burst, etc.) are different from standard (B, D, G, H, I) PAL, the equations used by the decoder to automatically calculate these parameters must be modified for standard (N) PAL operation.

(M) PAL Decoding Considerations

There is still another variation of PAL, referred to as (M) PAL, which is an 8-field 525/60 system with slight timing differences from baseband (M) NTSC. It is used in Brazil.

(M) PAL uses the same YUV-to-RGB and YUV-to-YCrCb equations as standard (N) PAL to compensate for the addition of a 7.5 IRE blanking pedestal. A gamma of 2.8 is assumed at the receiver and the sync tip is –40 IRE rather than –43 IRE. The luminance and composite digital video levels are the same as standard (N) PAL, as shown in Tables 6.10 and 6.11, respectively.

The subcarrier frequency generation for (M) PAL is implemented in the decoder as:

$$\frac{FSC}{FS} = \frac{P}{4194303} = \left(\frac{909}{4}\right)\left(\frac{1}{HCOUNT}\right)$$

resulting in a subcarrier frequency of 3.57561149 MHz.

Figure 6.28 illustrates the 8-field (M) PAL timing and burst blanking intervals. Due to the timing differences from (B, D, G, H, I) PAL and (M) NTSC, (M) PAL is not compatible with the digital composite video standards discussed in Chapter 7. As many of the timing parameters (such as horizontal sync width, start and end of burst, etc.) are different from (B, D, G, H, I) PAL or (M) NTSC, the equations used by the decoder to automatically calculate these parameters must be modified for (M) PAL operation.

Y/C Separation

The encoder typically combines the luminance and chrominance signals by adding them together; the result is that chrominance and high-frequency luminance signals occupy the same portion of the frequency spectrum. As a result, separating them in the decoder is difficult. When the signals are decoded, some luminance information is decoded as color information (referred to as cross-color) and some chrominance information remains in the luminance signal (referred to as cross-luminance). Due to the stable performance of digital decoders, much more complex separation techniques can be used than is possible with analog decoders.

The presence of crosstalk is bad news in editing situations; crosstalk components from the first decoding are encoded, possibly caus-

ing new or additional artifacts when decoded the next time. In addition, when a still frame is captured from a decoded signal, the frozen residual subcarrier on edges may beat with the subcarrier of any following encoding process, resulting in edge flicker in colored areas. Although the crosstalk problem cannot be entirely solved at the decoder, more elaborate Y/C separation minimizes the problem. The intent is to separate more accurately the chrominance and luminance signals, mixing horizontal and vertical filtering (also known as comb filtering).

If the decoder is to be used in an editing environment, the suppression of cross-luminance and cross-chrominance is more important that the appearance of the decoded picture. When a picture is decoded, processed, encoded, and again decoded, cross-effects can introduce substantial artifacts. It may be better to limit the luminance bandwidth (to reduce cross-luminance), producing "softer" pictures. Also, limiting the chrominance bandwidth to less than 1 MHz reduces cross-color, at the expense of losing chrominance definition.

Complementary filtering preserves all of the input signal, either in the chrominance or luminance signal. If the separated chrominance and luminance signals are again added together, the original composite video signal is generated (assuming proper recoding phase). Noncomplementary filtering introduces some irretrievable loss, resulting in gaps in the frequency spectrum when the separated chrominance and luminance signals are again added together to generate a composite video signal. The loss is due to the use of narrower filters to reduce cross-color and cross-luminance. Noncomplementary filtering is therefore usually unsuitable when multiple encoding and decoding operations must be performed, as the frequency spectrum gaps continually increase as the number of decoding operations increase. It does, however, enable the "tweaking" of lumi-

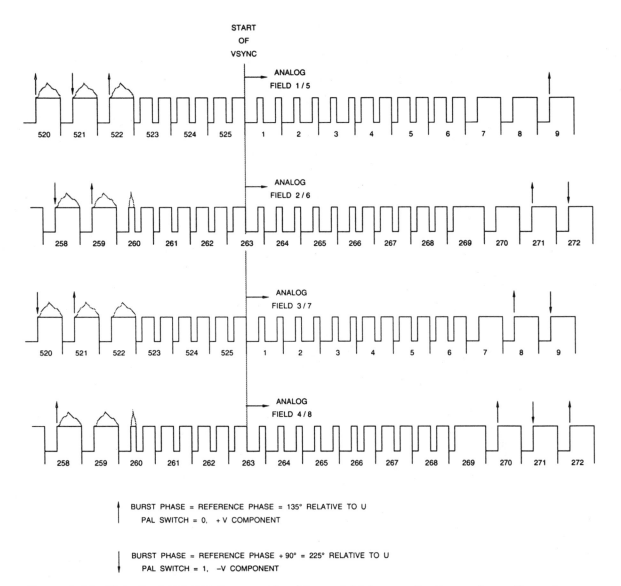

Figure 6.28. Eight-field (M) PAL Format. (See Figure 6.26 for equalization and serration pulse details.)

nance and chrominance response for optimum viewing.

Simple Y/C Separation

This implementation assumes frequencies above 2 MHz (NTSC) or 3 MHz (PAL) are chrominance. There is no loss of vertical chrominance resolution, but there is also no suppression of cross-color. For PAL, line-to-line errors due to differential phase distortion are not suppressed, resulting in the vertical pattern known as Hanover bars. The combined effect of the chrominance bandpass filter and

subtracter is to lowpass filter the luminance. A little cross-luminance remains from signals below 2–3 MHz, but real luminance above 2–3 MHz is also suppressed. There are essentially three implementations as shown in Figures 6.29 through 6.31.

PAL Delay Line

As mentioned before, PAL uses "normal" and "inverted" scan lines, referring to whether the V component is normal or inverted, to help correct color shifting effects due to differen-

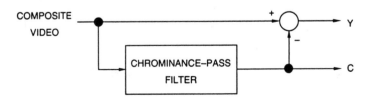

Figure 6.29. Simple Y/C Separator Using Complementary Filtering.

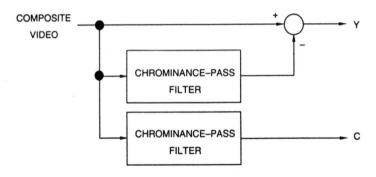

Figure 6.30. Simple Y/C Separator Using Noncomplementary Filtering.

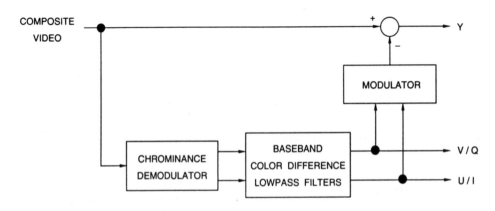

Figure 6.31. Simple Y/C Separator Using Complementary Filtering of Baseband Color Difference Signals.

tial phase distortions. Shown in Figure 6.32, the green vector at 241° is the ideal output; however, for example, differential phase distortion may cause the vector angle on "normal" scan lines to lag by 45° (from the ideal 241°), shifting the resulting color towards yellow. On "inverted" scan lines, the vector angle will lead by 45° (from the ideal 241°), shifting the resulting color towards cyan. The average phase of the two errors (196° on "normal" scan lines and 286° on "inverted" scan lines) is 241°, which is the correct phase for green. For this reason, simple PAL decoders usually use a delay line (or line store) to facilitate averaging between two scan lines, as shown in Figure 6.33.

In the circuit of Figure 6.33, the delay is not a whole line (283.75 subcarrier periods), but rather a whole number of half subcarrier periods, typically 283.5 or 284. This small difference acts as a 90° phase shift at the subcarrier frequency, resulting in a simple subcarrier phase relationship between the input and output of the delay circuit. Since the subcarrier sidebands are not phase shifted exactly 90°, hue errors are present on vertical chrominance transitions.

Although the performance of the circuit in Figure 6.33 is usually adequate, the 284 T_{SC} delay may be replaced by a full line delay followed by a 90° phase shift or a PAL modifier, as shown in Figure 6.34. Using the

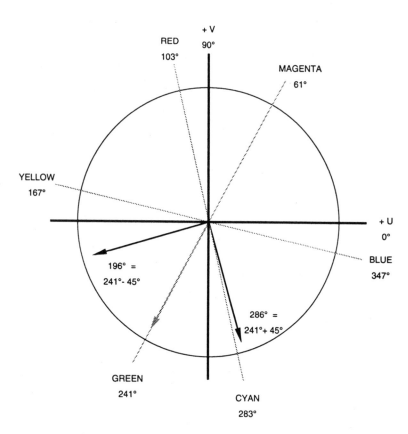

Figure 6.32. Phase Error "Correction" for PAL.

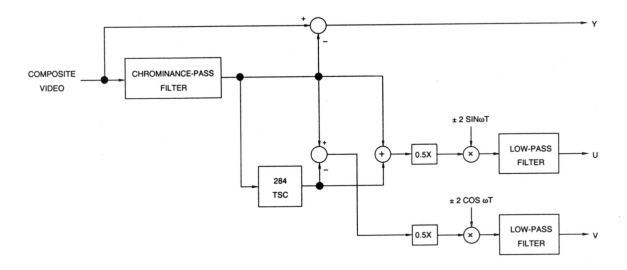

Figure 6.33. Typical Delay Line PAL Y/C Separator.

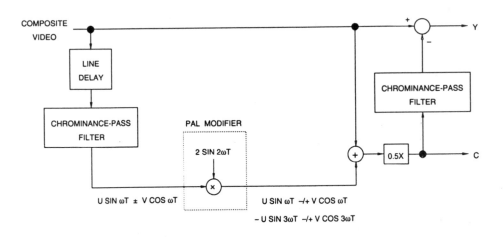

Figure 6.34. Typical Delay Line PAL Y/C Separator Using a PAL Modifier.

PAL modifier has the advantage of providing the 90° phase shift and inverting the V subcarrier, so the chrominance from the PAL modifier is in phase with the input chrominance.

Comb Filtering

Comb filters typically use two line stores for storing the previous, present, and next line of video information (there is a one-line delay in

decoding using this method). This information is used to attempt to more accurately separate the luminance and chrominance information at the expense of reduced vertical chrominance resolution. Averaging the signals across two line delays cancels most of the chrominance signals, leaving mainly luminance. The luminance is then subtracted from the composite signal at the center tap to obtain chrominance. Comb filters may actually use any number of line stores, trading off design complexity and cost versus performance.

The BBC has done research (Reference 4) on various comb filtering implementations, and has derived designs using two line stores optimized for general viewing (Figure 6.35 and Figure 6.37) and standards conversion (Figure 6.36 and Figure 6.38). The main difference between the circuits is the chrominance recovery. For standards conversion, the chrominance signal is derived from the full-bandwidth composite video signal. Standards conversion uses vertical interpolation which tends to reduce moving and high vertical fre-

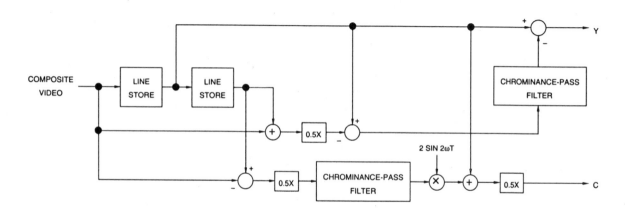

Figure 6.35. PAL Y/C Separator for General Viewing.

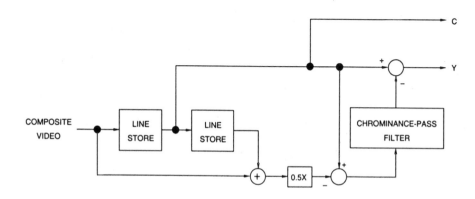

Figure 6.36. PAL Y/C Separator for Standards Conversion and Processing.

quency components, including cross-luminance and cross-color. Thus, vertical chrominance resolution after processing may be better than that obtained from the circuits for general viewing. On the other hand, the circuits for general viewing recover chrominance with an eye on reducing cross-effects within the decoder, at the expense of chrominance vertical resolution.

Adaptive Comb Filtering

Adaptive comb filtering is similar to the standard comb filtering, except that an attempt is made to maintain vertical chrominance resolution. An adaptive Y/C separator detects horizontal and vertical transitions and selects the optimum filtering algorithm to use. An example of an adaptive Y/C separator is shown in Figure 6.39. The coring function (detailed in

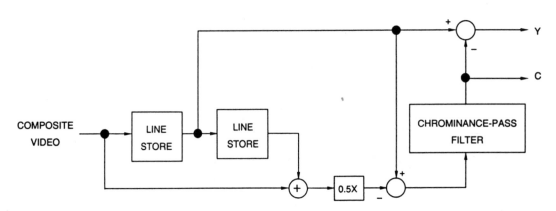

Figure 6.37. NTSC Y/C Separator for General Viewing.

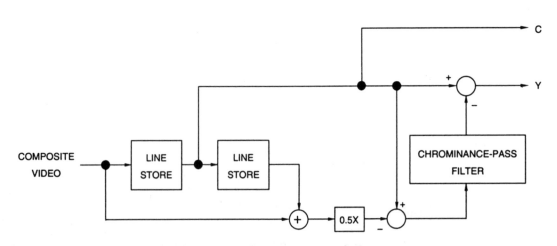

Figure 6.38. NTSC Y/C Separator for Standards Conversion and Processing.

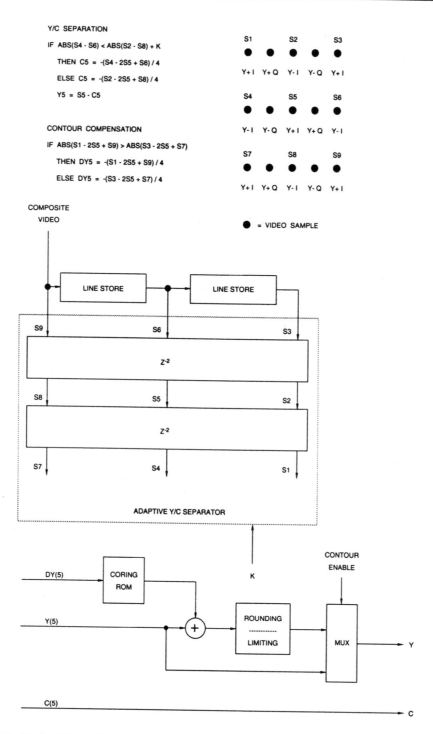

Figure 6.39. Typical Adaptive Y/C Separator Example for NTSC. Four times F$_{SC}$ operation with sampling along the ±I and ±Q axes.

Figure 6.40. Coring Function Detail.

Figure 6.40) removes low-level noise from the contouring data, reducing graininess. The contouring circuit enhances the horizontal and vertical edge transitions for more pleasing viewing. The circuit must be slightly modified for PAL operation.

For NTSC, most of these designs sample along the ±I and ±Q axes, or optionally along the ±U and ±V axes, at $4 \times F_{SC}$ to simplify chrominance demodulation. This results in 910 pixels per scan line (or 227.5 cycles of F_{SC}), with the chrominance phase alternating by 180° each scan line. Vertical up and down difference combs therefore yield twice the chrominance value with luminance generally cancelling. Vertical up and down summing combs yield twice the luminance value with the chrominance cancelling.

With many PAL systems, however, the line-to-line vertical changes of the subcarrier

phase are only 90° since there are 1135 samples per scan line at four times F_{SC} (283.75 cycles of F_{SC}). Single line vertical combs do not function correctly unless the sampling phase is changed to be the ±(V + U) and ±(V − U) components, which are 45° relative to the burst, rather than the ±U and ±V components. Figure 6.41 illustrates the vertical comb filtering for $4 \times F_{SC}$ NTSC and most PAL systems.

Field Processing

To perform Y/C separation, this technique adds the composite video data from the current field with the composite video data from two (for NTSC) or four (for PAL) fields ago (on a pixel-by-pixel basis). Since the chrominance is 180° out of phase, it cancels out, leaving luminance. Subtracting the luminance from the composite video recovers the chromi-

● = VIDEO SAMPLE

NTSC

PAL

CHROMINANCE COMBING DIRECTION

Figure 6.41. NTSC and PAL Vertical Chrominance Combing Example.
Four times F$_{SC}$ operation with sampling along the ±I and ±Q components
(NTSC) and along the ±(V + U) and ±(V − U) components (PAL).

nance. This technique is only useful for areas of the picture that have no movement. Areas of movement still require a Y/C separator based on simple filtering, comb filtering, or adaptive comb filtering, as previously discussed.

Closed Captioning Support

Closed captioning (discussed in Chapter 5) can be supported in several ways. If the video is displayed in a window large enough to read the caption information, the caption data may be contained within the video window. In this case, caption decoding may be able to be incorporated within the NTSC/PAL decoder, with the caption data placed over the digital video data before being output.

If the video window is too small to display the caption information, it may be desirable to optionally display the caption data at the bottom of the full-screen display. Again, caption decoding may be able to be incorporated within the NTSC/PAL decoder, with the caption data being output via the digital video outputs during the blanking intervals. Additional circuitry recovers and processes the caption data from the video stream, converts it to bit-mapped characters, and positions it on the display. Alternately, the bit-mapped caption data may be output from the NTSC/PAL decoder for loading directly into the frame buffer.

If compressing the video (using MPEG or JPEG, for example), the caption data may have to be recovered by the NTSC/PAL decoder, and passed on to the MPEG/JPEG encoder for special handling.

Copy Protection Support

If the decoder detects a video signal that is copy-protected, the video signal can still be decoded for viewing; however, storing the decoded copy should not be allowed. If the decoder has a status bit that indicates whether or not copy protection is present in the video signal, the operating system can use that information to enable or disable the MPEG/JPEG encoders from compressing and storing the video.

Timecode Support

If the decoder provides timecode support (discussed in Chapter 5), the ability to decode video only between two specified timecodes can be easily added, simplifying the editing process. During this time, audio capture can automatically be hardware-enabled. Timecode information, if present, should also be passed on to the MPEG/JPEG encoder. The decoder should be able to handle decoding timecode information from VTRs during fast forward and backward operation to aid finding specific video segments.

Alpha (Keying) Channel

By incorporating an additional A/D converter within the NTSC/PAL decoder, an analog alpha signal (also called a key) may be digitized, and pipelined with the video data to maintain synchronization. This allows the designer to change decoders (which may have different pipeline delays) to fit specific applications without worrying about the alpha channel pipeline delay. Alpha is usually linear, with an analog range of 0 to 100 IRE. There is no blanking pedestal or sync information present. In computer systems that support 32-bit pixels, 8 bits are typically available for alpha information. Alpha support is also discussed in Chapter 5 and Chapter 9.

Video Test Signals

Many industry-standard video test signals have been defined to help test the relative quality of NTSC/PAL decoders. By providing these test signals to the decoder, video test equipment may be used to evaluate the decoder's performance. Many of the same video test signals described in Chapter 5 for evaluating encoders are also useful for evaluating decoder performance.

Video Parameters

Many industry-standard video parameters have been defined to specify the relative quality of NTSC/PAL decoders. To measure these parameters, the output of the NTSC/PAL decoder (while decoding various video test signals such as those previously described) is monitored using video test equipment (see Appendix A for more information on video test-

ing). Along with a description of several of these parameters, typical AC parameter values for both consumer and studio-quality decoders are shown in Table 6.12.

Several AC parameters, such as short-time waveform distortion, group delay, and K factors, are dependent on the quality of the analog video filters, and are not discussed here. In addition to the AC parameters discussed in this section, there are several others that should be included in a decoder specification, such as burst frequency and tolerance, and the bandwidths of the YIQ or YUV baseband video signals.

There are also several DC parameters (such as white level and tolerance, blanking level and tolerance, sync height and tolerance, peak-to-peak burst amplitude and tolerance) that should be specified. as shown in Table 6.13. Although genlock capabilities are not usually specified, except for "clock jitter," we have attempted to generate a list of genlock parameters, shown in Table 6.14.

Parameter	consumer quality	studio quality	Units
differential phase	4	≤ 1	degrees
differential gain	4	≤ 1	%
luminance nonlinearity	2	≤ 1	%
hue accuracy	3	≤ 1	degrees
color saturation accuracy	3	≤ 1	%
SNR (per CCIR 410 or EIA RS-250-B)	48	> 60	dB
chrominance-to-luminance crosstalk	< − 40	< − 50	dB
luminance-to-chrominance crosstalk	< − 40	< − 50	dB
H tilt	< 1	< 1	%
V tilt	< 1	< 1	%
Y/C sampling skew	< 5	< 2	ns
demodulation quadrature	90 ±2	90 ±0.5	degrees

Table 6.12. Typical AC Video Parameters for NTSC and PAL Decoders.

Parameter	NTSC[1]	PAL[2]	Units
sync input amplitude	40 ±20	43 ±22	IRE
burst input amplitude	40 ±20	43 ±22	IRE
video input amplitude (0.7v nominal)	0.5 to 2.0	0.5 to 2.0	volts

Notes
1. (M) NTSC.
2. (B, D, G, H, I) PAL.

Table 6.13. Typical DC Video Parameters for NTSC and PAL Decoders.

Differential Phase

Differential phase distortion, commonly referred to as differential phase, specifies how much the chrominance phase is affected by the luminance level—in other words, how much hue shift occurs when the luminance level changes. Both positive and negative phase errors may be present, so differential phase is expressed as a peak-to-peak measurement, expressed in degrees of subcarrier phase. This parameter is measured using a test signal of uniform-phase and amplitude chrominance superimposed on different luminance levels, such as the modulated ramp test signal, or the modulated five-step portion of the composite test signal. The differential phase parameter for a studio-quality analog decoder may approach 1° or less.

Differential Gain

Differential gain distortion, commonly referred to as differential gain, specifies how much the chrominance gain is affected by the luminance level—in other words, how much color saturation shift occurs when the luminance level changes. Both attenuation and amplification may occur, so differential gain is expressed as the largest amplitude change between any two levels, expressed as a percent of the largest chrominance amplitude. This parameter is measured using a test signal of uniform phase and amplitude chrominance superimposed on different luminance levels, such as the modulated ramp test signal, or the modulated five-step portion of the composite test signal. The differential gain parameter for a studio-quality analog decoder may approach 1% or less.

Luminance Nonlinearity

Luminance nonlinearity, also referred to as differential luminance and luminance nonlinear distortion, specifies how much the luminance gain is affected by the luminance level. In other words, there is a nonlinear relationship between the decoded luminance level and the ideal luminance level. Using an unmodulated five-step or ten-step staircase test signal, or the modulated five-step portion of the composite test signal, the difference between the largest and smallest steps, expressed as a percentage of the largest step, is used to specify the luminance nonlinearity. Although this parameter is included within the differential gain and phase parameters, it is traditionally specified independently.

Chrominance Nonlinear Phase Distortion

Chrominance nonlinear phase distortion specifies how much the chrominance phase (hue) is

Parameter	Min	Max	Units
sync locking time[1]		2	fields
sync recovery time[2]		2	fields
short-term sync lock range[3]	±100		ns
long-term sync lock range[4]	±5		µs
number of consecutive missing horizontal sync pulses before any correction	5		sync pulses
vertical correlation[5]		±2	ns
short-term subcarrier locking range[6]	±200		Hz
long-term subcarrier locking range[7]	±500		Hz
subcarrier locking time[8]		10	lines
subcarrier accuracy		±2	degrees

Notes

1. Time from start of genlock process to vertical correlation specification is achieved.
2. Time from loss of genlock to vertical correlation specification is achieved.
3. Range over which vertical correlation specification is maintained. Short-term range assumes line time changes by amount indicated slowly between two consecutive lines.
4. Range over which vertical correlation specification is maintained. Long-term range assumes line time changes by amount indicated slowly over one field.
5. Indicates vertical pixel accuracy. For a genlock system that uses a VCO or VCXO, this specification is the same as clock jitter.
6. Range over which subcarrier locking time and accuracy specifications are maintained. Short-term time assumes subcarrier frequency changes by amount indicated slowly over 2 frames.
7. Range over which subcarrier locking time and accuracy specifications are maintained. Long-term time assumes subcarrier frequency changes by amount indicated slowly over 24 hours.
8. After instantaneous 180° phase shift of subcarrier, time to lock to within ±2°. Subcarrier frequency is nominal ±500 Hz.

Table 6.14. Typical Genlock Parameters for NTSC and PAL Decoders. Parameters assume a video signal with ≥ 30 dB SNR and over the range of DC parameters in Table 6.13.

affected by the chrominance amplitude (saturation)—in other words, how much hue shift occurs when the saturation changes. Using a modulated pedestal test signal, or the modulated pedestal portion of the combination test signal, the decoder output for each chrominance packet is measured. The difference between the largest and the smallest hue measurements is the peak-to-peak value. This parameter is not usually independently specified, but is included within the differential gain and phase parameters.

Chrominance Nonlinear Gain Distortion

Chrominance nonlinear gain distortion specifies how much the chrominance gain is affected by the chrominance amplitude (saturation). In other words, there is a nonlinear relationship between the decoded chrominance amplitude levels and the ideal chrominance amplitude levels—this is usually seen as an attenuation of highly saturated chrominance signals. Using a modulated pedestal test signal, or the modulated pedestal portion of the combination test signal, the decoder is adjusted so that the middle chrominance packet (40 IRE) is properly decoded. The largest difference between the measured and nominal values of the amplitudes of the other two decoded chrominance packets specifies the chrominance nonlinear gain distortion, expressed in IRE or as a percentage of the nominal amplitude of the worst-case packet. This parameter is not usually independently specified, but is included within the differential gain and phase parameters.

Chrominance-to-Luminance Crosstalk

Chrominance-to-luminance intermodulation, commonly referred to as cross-modulation, specifies how much the luminance level is affected by the chrominance. This may be the result of clipping highly saturated chrominance levels or quadrature distortion, and show up as irregular brightness variations due to changes in color saturation. Using a modulated pedestal test signal, or the modulated pedestal portion of the combination test signal, the largest difference between the decoded 50 IRE luminance level and the decoded luminance levels from the modulated pedestals specifies the chrominance-to-luminance intermodulation, expressed in IRE or as a percentage. This parameter is not usually inde-

pendently specified, but is included within the differential gain and phase parameters.

Hue Accuracy

Hue accuracy specifies how closely the decoded hue is to the ideal hue value. Both positive and negative phase errors may be present, so hue accuracy is the difference between the worst-case positive and worst-case negative measurements from nominal, expressed in degrees of subcarrier phase. This parameter is measured using EIA or EBU color bars as a test signal.

Color Saturation Accuracy

Color saturation accuracy specifies how closely the decoded saturation is to the ideal saturation value, using EIA or EBU color bars as a test signal. Both gain and attenuation may be present, so color saturation accuracy is the difference between the worst-case gain and worst-case attenuation measurements from nominal, expressed as a percentage of nominal.

H Tilt

H tilt, also known as line tilt and line time distortion, causes a tilt in line-rate signals, predominantly white bars. This type of distortion causes variations in brightness between the left and right edges of an image. For a digital decoder, such as that described in this chapter, H tilt is primarily an artifact of the analog input filters and the transmission medium. H tilt is measured using a line bar (such as the one in the NTC NTSC composite test signal) and measuring the peak-to-peak deviation of the tilt (in IRE or percent of white bar amplitude), ignoring the first and last microsecond of the white bar.

V Tilt

V tilt, also known as field tilt and field time distortion, causes a tilt in field-rate signals, predominantly white bars. This type of distortion causes variations in brightness between the top and bottom edges of an image. For a digital decoder, such as that described in this chapter, V tilt is primarily an artifact of the analog input filters and the transmission medium. V tilt is measured using an 18-μs, 100-IRE white bar in the center of 130 lines in the center of the field or using a field square wave. The peak-to-peak deviation of the tilt is measured (in IRE or percent of white bar amplitude), ignoring the first and last three lines.

VLSI Solutions

This section is an overview of commercially available VLSI solutions that use digital techniques for decoding NTSC and PAL video signals.

The Bt812 from Brooktree Corporation is a digital NTSC/PAL decoder. It decodes baseband composite NTSC or PAL video, and includes two on-chip 8-bit A/D converters to support digitizing both composite and Y/C video signals.

Features of the Bt812 include:

- NTSC and PAL Operation
- Two On-Chip A/D Converters
- 16-bit 4:2:2 YCrCb or 24-bit RGB Output Formats
- Standard MPU Interface
- +5 V CMOS Monolithic Construction
- 160-pin Plastic Quad Flatpack Package

The SAA7151 from Philips Semiconductors is a digital NTSC/PAL decoder. It decodes baseband composite NTSC, PAL, or SECAM video, and requires the SAA7197 clock generator chip and the TDA8708 A/D converter. By using an additional external A/D converter (TDA8709), decoding of Y/C video signals is supported. The SAA7192 color space converter provides YCrCb to RGB conversion, and provides programmable lookup table RAMs on the RGB outputs.

Features of the SAA7151 include:

- 13.5-MHz NTSC, PAL, and SECAM Operation
- 16-bit 4:2:2 and 12-bit 4:1:1 Digital YCrCb Output Formats
- I^2C Interface
- SCART Support
- +5 V CMOS Monolithic Construction
- 68-pin PLCC Package

The SAA7191 from Philips Semiconductors is a digital NTSC/PAL decoder. It decodes baseband composite NTSC or PAL video, and requires the SAA7197 clock generator chip and the TDA8708 A/D converter. By using an additional external A/D converter (TDA8709), decoding of Y/C video signals is supported. The SAA7192 color space converter provides YCrCb-to-RGB conversion, and provides programmable lookup table RAMs on the RGB outputs.

Features of the SAA7191 include:

- Square Pixel NTSC and PAL Operation
- 16-bit 4:2:2 and 12-bit 4:1:1 Digital YCrCb Output Formats
- I^2C Interface
- +5 V CMOS Monolithic Construction
- 68-pin PLCC Package

References

1. Benson, K. Blair, 1986, *Television Engineering Handbook*, McGraw-Hill, Inc.

2. CCIR Recommendation 624-4, 1990, *Characteristics of Television Systems*.

3. Clarke, C.K.P., 1986, "Colour encoding and decoding techniques for line-locked sampled PAL and NTSC television signals," BBC Research Department Report BBC RD1986/2.

4. Clarke, C.K.P., 1982, *Digital Standards Conversion: comparison of colour decoding methods*, BBC Research Department Report BBC RD1982/6.

5. Clarke, C.K.P., 1982, "High quality decoding for PAL inputs to digital YUV studios," BBC Research Department Report BBC RD1982/12.

6. Clarke, C.K.P., 1988, "PAL Decoding: Multi-dimensional filter design for chrominance-luminance separation," BBC Research Department Report BBC RD1988/11.

7. Perlman, Sturat S, Schweer, Rainer, "An Adaptive Lume-Chroma Separator Circuit for PAL and NTSC TV Signals," International Conference on Consumer Electronics, Digest of Technical Papers, June 6–8, 1990.

8. Philips Semiconductors, *Video Data Handbook*, 1991.

9. Sandbank, C. P., *Digital Television*, John Wiley & Sons, Ltd., 1990.

10. *Specification of Television Standards for 625-Line System-I Transmissions*, 1971, Independent Television Authority (ITA) and British Broadcasting Corporation (BBC).

11. Trundle, Eugene, *Newnes Guide to TV & Video Technology*, Heinemann Professional Publishing Ltd., 1988.

12. Watkinson, John, *The Art of Digital Video*, Focal Press, 1990.

14. Yoshimoto, Masahiko, et.al., 1986, "A Digital Processor for Decoding of Composite TV Signals using Adaptive Filtering," IEEE International Solid-State Circuits Conference Digest of Technical Papers, 1986.

Digital Composite Video

The digital composite video format was developed as a way of easing into the digital video world. It was developed after the digital component video standards (discussed in the next chapter), to act as a stepping stone between analog video and digital component video.

Although the video signal is in composite format, 20 or more editing operations are common before visual artifacts appear. Remaining in the composite format is therefore not as much of a disadvantage as it might seem at first, especially since many editing operations can be done directly on the composite video, avoiding the encoding and decoding processes.

This chapter discusses digital composite video encoder and decoder architectures, transmission of digital composite video, and ancillary data capabilities such as digital audio. Audio is transmitted digitally either over a separate digital channel (using the AES/EBU digital audio protocol) or during the digital video sync intervals (as ancillary data).

Digital Encoding

The generation of digital composite (M) NTSC and (B, D, G, H, I) PAL video signals from digital RGB or YCrCb data is similar to that used for the NTSC and PAL encoder discussed in Chapter 5. The major differences are: (a) only digital composite video data is generated, and (b) the pixel clock rate is four times F_{SC}: 14.32 MHz for (M) NTSC, 17.72 MHz for (B, D, G, H, I) PAL. Where ranges of values are mentioned, it is assumed 8-bit (plus sign) data val-

ues are used; 10-bit (plus sign) data values will result in more accurate computations at the expense of more circuitry.

Table 7.1 contains digital composite video encoding parameter values for both M(NTSC) and (B, D, G, H, I) PAL.

NTSC Considerations

Gamma-corrected RGB or YCrCb data is converted to YIQ data using the same equations as those used for the NTSC encoder discussed in

Parameters	(M) NTSC	(B, D, G, H, I) PAL
Number of samples	910 total per line	709,379 total per frame
Sampling frequency	4x F_{SC}	
Sampling phase	±I and ±Q axes	±U and ±V axes
Form of coding	Uniformly quantized PCM, 8 or 10 bits per sample	
Number of samples per digital active line	768	948
Correspondence between video signal levels and the quantization levels: 8-bit system white level blanking level sync level 10-bit system white level blanking level sync level	 200 60 4 800 240 16	 211 64 1 844 256 4
Code word usage	Code words used exclusively for synchronization and not available for video or ancillary information: 8-bit system: 00_H, FF_H 10-bit system: 000_H, 001_H, 002_H, 003_H, $3FC_H$, $3FD_H$, $3FE_H$, $3FF_H$	

Table 7.1. Encoding Parameter Values for Digital Composite Video.

Chapter 5 and the same considerations apply. Y has a range of 0 to 130, I a range of 0 to ±78, and Q a range of 0 to ±68. Since computers commonly use linear RGB data, linear RGB may be converted to gamma-corrected RGB as follows (values are normalized to have a value of 0 to 1):

for R, G, B < 0.018

$$R' = 4.5\,R$$
$$G' = 4.5\,G$$
$$B' = 4.5\,B$$

for R, G, B ≥ 0.018

$$R' = 1.099\,R^{0.45} - 0.099$$
$$G' = 1.099\,G^{0.45} - 0.099$$
$$B' = 1.099\,B^{0.45} - 0.099$$

A value of 10 is added to the digital luminance data during active video to incorporate the 7.5 IRE blanking pedestal. Digital composite sync information is added to the luminance data; digital values of 4 (sync present) or 60 (no sync) are assigned. For digital composite video, the sync edge values, and the horizontal counts at which they occur, are defined as shown in Figure 7.1. Horizontal count 0 corresponds to the start of active video, and a horizontal count of 768 corresponds to the start of horizontal blanking, as shown in Figure 7.2. The horizontal counter increments from 0 to 909 every scan line. To maintain zero SCH phase, horizontal count 784 occurs 25.6 ns (33° of the subcarrier phase) before the 50% point of the falling edge of horizontal sync, and horizontal count 785 occurs 44.2 ns (57° of the subcarrier phase) after the 50% point of the falling edge of horizontal sync. This is due to the clock phase being along the ±I and ±Q axes (33°, 123°, 213°, and 303°). The sampling phase at horizontal count 0 of line 10 (line 7 as defined in Figure 5.21), field one is on the +I axis (123°).

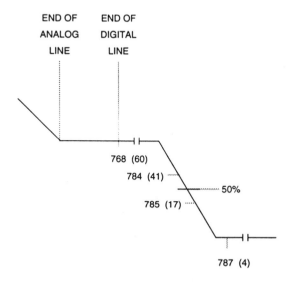

END OF
ANALOG
LINE

END OF
DIGITAL
LINE

768 (60)
784 (41)
785 (17)
50%
787 (4)

Figure 7.1. Digital Composite (M) NTSC Sync Timing. The horizontal counts with the corresponding 8-bit sample values in parentheses.

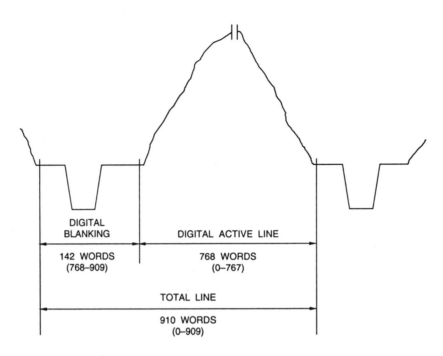

DIGITAL
BLANKING

DIGITAL ACTIVE LINE

142 WORDS
(768–909)

768 WORDS
(0–767)

TOTAL LINE

910 WORDS
(0–909)

Figure 7.2. Digital Composite (M) NTSC Analog and Digital Timing Relationship.

At this point, we have luminance with sync and blanking information, as shown in Table 7.2.

The I and Q color difference signals are lowpass filtered, with the same considerations as those used for the NTSC encoder discussed in Chapter 5. Note, however, that the lowpass filters should be optimized for 14.32 MHz in this instance. As there may be many cascaded conversions, the filters should be designed to very tight tolerances to avoid a buildup of visual artifacts; departure from flat amplitude and group delay response due to filtering is amplified through successive stages. For example, if filters exhibiting –1 dB at 1 MHz and –3 dB at 1.3 MHz were employed, the overall response would be –8 dB (at 1 MHz) and –24 dB (at 1.3 MHz) after four stages (assuming two filters per stage). The passband flatness and group-delay characteristics are therefore very important.

Since the pixel clock rate is four times the subcarrier frequency, F_{SC}, and aligned along the $\pm I$ and $\pm Q$ axes, the subcarrier sin and cos values are 0 and ± 1. There is no need for the sin and cos subcarrier ROMs and the associated p:q ratio counters used on the NTSC encoder discussed in Chapter 5. The 33° phase shift of the subcarrier during active video is automatically accommodated by aligning the pixel clock along the $\pm I$ and $\pm Q$ axes. At four times F_{SC}, a 90° subcarrier phase shift is a single clock cycle; therefore, a one clock cycle delay implements a 90° phase shift. After the modulated I and Q signals are added together, the result is rounded to the desired accuracy; the modulated chrominance has an 8-bit range of 0 to ± 82. Burst information is multiplexed

Video Level	8-bit digital value	10-bit digital value
white	200	800
black	70	280
blank	60	240
sync	4	16

Table 7.2. Sync, Blanking, Black, and White Video Levels for Digital Composite (M) NTSC Video Signals.

with the digital chrominance information. During the color burst time, the modulated chrominance data should be ignored, and the burst information inserted. Burst values for one subcarrier cycle (requiring four clock cycles) are 46, 83, 74, and 37. The burst starts (using the value of 46) at horizontal count 884, and lasts for 36 pixel clock cycles (9 subcarrier cycles). Note that the peak amplitudes of the burst are not sampled. At this point, we have modulated chrominance and burst information, as shown in Table 7.3.

The digital composite luminance data and the digital chrominance data are added together, generating digital composite video with the levels shown in Table 7.4. The digital composite video data is gated with the blanking control signal (BLANK*), forcing the blanking level outside of active digital video.

The horizontal and vertical timing is implemented the same as for the analog NTSC encoder, with the exception of the horizontal count positions. The NTSC encoder in Chapter 5 used a horizontal count starting at 1, rather than 0; in addition, the horizontal count started at 50% of the falling edge of horizontal sync rather than at the beginning of active video.

PAL Considerations

Gamma-corrected RGB or YCrCb data is converted to YUV data using different equations

Video Level	8-bit digital value	10-bit digital value
peak chroma	82	328
peak burst	28	112
blank	0	0
peak burst	−28	−112
peak chroma	−82	−328

Table 7.3. Chrominance Levels for Digital Composite (M) NTSC Video Signals.

Video Level	8-bit digital value	10-bit digital value
peak chroma	243	972
white	200	800
peak burst	88	352
black	70	280
blank	60	240
peak burst	32	128
peak chroma	26	104
sync	4	16

Table 7.4. Video Levels for Digital Composite (M) NTSC Video Signals.

from those used for the PAL encoder discussed in Chapter 5, although the same considerations apply. Y has a range of 0 to 147, U a range of 0 to ±64, and V a range of 0 to ±91. Since computers commonly use linear RGB data, linear RGB can be converted to gamma-corrected RGB as follows (values are normalized to have a value of 0 to 1):

for R, G, B < 0.018

$$R' = 4.5 R$$
$$G' = 4.5 G$$
$$B' = 4.5 B$$

for R, G, B ≥ 0.018

$$R' = 1.099 R^{0.36} - 0.099$$
$$G' = 1.099 G^{0.36} - 0.099$$
$$B' = 1.099 B^{0.36} - 0.099$$

RGB to YUV

$$Y = 0.172R' + 0.338G' + 0.066B'$$
$$U = -0.084R' - 0.167G' + 0.251B'$$
$$V = 0.355R' - 0.297G' - 0.058B'$$

YCrCb to YUV

$$Y = 0.671(Y - 16)$$

$$U = 0.572(Cb - 128)$$
$$V = 0.809(Cr - 128)$$

Professional video systems may use the gamma-corrected RGB color space, with RGB having a nominal range of 16 to 235. Occasional values less than 16 and greater than 235 are allowed, resulting in YUV values outside their nominal ranges. In this instance, RGB can be converted to YUV by scaling the RGB-to-YUV equations by 255/219:

$$Y = 0.200(R' - 16) + 0.394(G' - 16)$$
$$+ 0.077(B' - 16)$$
$$U = -0.098(R' - 16) - 0.194(G' - 16)$$
$$+ 0.292(B' - 16)$$
$$V = 0.413(R' - 16) - 0.346(G' - 16)$$
$$- 0.067(B' - 16)$$

Digital composite sync information is added to the luminance data; digital values of 1 (sync present) or 64 (no sync) are assigned. Horizontal count 0 corresponds to the start of active video, and a horizontal count of 948 corresponds to the start of horizontal blanking, as shown in Figure 7.3. The horizontal counter increments from 0 to 1134 (or 1136) every

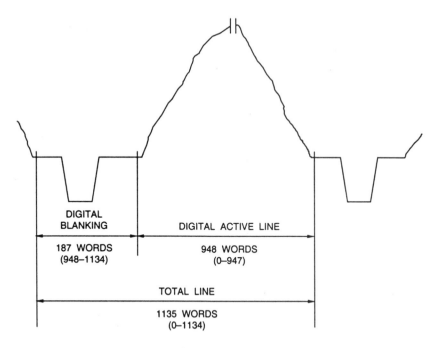

Figure 7.3. (B, D, G, H, I) PAL Analog and Digital Timing Relationship.

scan line. There are 1135 samples per line, except for lines 313 and 625 which have 1137 samples per line, making a total of 709,379 samples per frame. Sampling is therefore not H-coherent as with (M) NTSC, and the position of the sync pulses change from line to line. Zero SCH phase is now defined when alternate burst samples have a value of 64. For a digital encoder, the 50% point of the leading edge of sync pulses are typically designed to occur equidistant between two consecutive samples (typically at horizontal counts 957 and 958). The clock phase is along the ±U and ±V axes (0°, 90°, 180°, and 270°), with the sampling phase at horizontal count 0 of line 1, field one on the +V axis (90°).

At this point, we have luminance with sync and blanking information as shown in Table 7.5.

The U and V color difference signals are lowpass filtered, with the same considerations as those used for the analog PAL encoder. Note, however, that the lowpass filters should be optimized for 17.72 MHz in this instance. As there may be many cascaded conversions, the filters should be designed to very tight tolerances to avoid a buildup of visual artifacts; departure from flat amplitude and group delay response due to filtering is amplified through successive stages. For example, if filters exhibiting –1 dB at 1 MHz and –3 dB at 1.3 MHz were employed, the overall response would be –8 dB (at 1 MHz) and –24 dB (at 1.3 MHz) after four stages (assuming 2 filters per stage). The passband flatness and group-delay characteristics are very important. There is usually temptation to relax passband accuracy, but a better approach is to reduce

Video Level	8-bit digital value	10-bit digital value
white	211	844
black	64	256
blank	64	256
sync	1	4

Table 7.5. Sync, Blanking, Black, and White Video Levels for Digital Composite (B, D, G, H, I) PAL Video Signals.

the rate of cut-off and keep the passband as flat as possible.

Since the pixel clock rate is four times the subcarrier frequency, F_{SC}, and aligned along the ±U and ±V axes, the subcarrier sin and cos values are 0 and ±1. There is no need for the sin and cos subcarrier ROMs and the associated p:q ratio counters used on the PAL encoder. At four times F_{SC}, a 90° subcarrier phase shift is a single clock cycle; therefore, a one clock cycle delay implements a 90° phase shift. Note that the PAL SWITCH, used to alternate the sign of V from one line to the next, must also be incorporated.

After the modulated U and V signals are added together, the result is rounded to the desired accuracy; the modulated chrominance has an 8-bit range of 0 to ± 93. Burst information is multiplexed with the digital chrominance information. During the color burst time, the modulated chrominance data should be ignored, and the burst information inserted. Burst values are 95, 64, 32, and 64, continuously repeated. The swinging burst causes the peak burst (32 and 95) and zero burst (64) samples to change places.

Note that burst starts at horizontal count 1058, and lasts for 40 pixel clock cycles (10 subcarrier cycles). At this point, we have mod-

ulated chrominance and burst information as shown in Table 7.6.

The digital composite luminance data and the digital chrominance data are added together, generating digital composite video with the levels shown in Table 7.7. The digital composite video data is gated with the blanking control signal (BLANK*), forcing the blanking level outside of active digital video.

The horizontal and vertical timing is implemented the same as for the analog PAL encoder, with the exception of the horizontal count positions. The PAL encoder in Chapter 5 used a horizontal count starting at 1, rather than 0; in addition, the horizontal count started at the 50% of the falling edge of horizontal sync rather than at the beginning of active video.

Transmission Timing

8-bit/10-bit Parallel Transmission Interface

Due to many additional timing constraints not discussed here, the reader should obtain any relevant specifications before attempting an actual design. The parallel interface is based upon that used for 4:2:2 digital component

Video Level	8-bit digital value	10-bit digital value
peak chroma	93	372
peak burst	31	128
blank	0	0
peak burst	−32	−128
peak chroma	−93	−372

Table 7.6. Chrominance Levels for Digital Composite (B, D, G, H, I) PAL Video Signals.

Video Level	8-bit digital value	10-bit digital value
peak chroma	260 (limited to 255)	1040 (limited to 1023)
white	211	844
peak burst	95	376
black	64	256
blank	64	256
peak burst	32	128
peak chroma	32	128
sync	1	4

Table 7.7. Video Levels for Digital Composite (B, D, G, H, I) PAL Video Signals. Note that not all 100% saturation, 100% amplitude signals are possible.

video (discussed in the next chapter), except for the timing differences.

Eight-bit or 10-bit data and a four times F_{SC} clock signal are transmitted using 9 pairs (8-bit data) or 11 pairs (10-bit data) of cables. The individual bits are labeled Data 0–Data 9, with Data 9 being the most significant bit. The pin allocations for the signals are shown in Table 7.8. Equipment inputs and outputs both use 25-pin D-type subminiature female sockets so that interconnect cables can be used in either direction. Signal levels are compatible with ECL-compatible balanced drivers and receivers (although use of ECL technology is not specified). With the NRZ data format, transmission distances up to 50 m (unequalized) or 200 m (equalized) may be used.

The generator must have a balanced output with a maximum source impedance of 110 Ω; the signal must be between 0.8 V peak-to-

Pin	Signal	Pin	Signal
1	clock	14	clock return
2	system ground	15	system ground
3	data 9 (MSB)	16	data 9 return
4	data 8	17	data 8 return
5	data 7	18	data 7 return
6	data 6	19	data 6 return
7	data 5	20	data 5 return
8	data 4	21	data 4 return
9	data 3	22	data 3 return
10	data 2	23	data 2 return
11	data 1	24	data 1 return
12	data 0	25	data 0 return
13	cable shield		

Table 7.8. Parallel Connector Contact Assignments. For 8-bit interfaces, data 9–data 2 are used.

peak and 2.0 V peak-to-peak measured across a 110-Ω resistor connected to the output terminals without any transmission line. The transmitted clock signal is a 14.32 MHz or 17.72 MHz (four times F_{SC}) square wave, with a clock pulse width of 34.92 ±3 ns for (M) NTSC or 28.19 ±3 ns for (B, D, G, H, I) PAL. The positive transition of the clock signal occurs midway between data transitions with a tolerance of ±3 ns (as shown in Figure 7.4)—a difficult problem to solve without using adjustable delay lines and performing periodic tweaking. At the receiver, the transmission line must be terminated by 110 ±10 Ω.

To permit reliable operation at the longer interconnect lengths, the line receiver may incorporate equalization, which should conform to the nominal characteristics shown in Figure 7.5. This characteristic enables operation with a range of cable lengths down to zero.

10-bit Serial Transmission Interface

To support both the 8-bit and 10-bit environment, a 143 or 177 Mbit-per-second serial protocol was developed (Figure 7.6). This protocol makes use of 10 bits of parallel data latched at four times F_{SC}. A ten-times PLL generates a 40-times F_{SC} clock from the four-times F_{SC} clock signal. The 10 bits of data are serialized (LSB first) and processed using a scrambled NRZI format as follows:

$$G(x) = (x^9 + x^4 + 1)(x + 1)$$

The input signal to the scrambler (Figure 7.7) must use positive logic (the highest voltage represents a logical one; lowest voltage represents a logical zero). The formatted serial data is output at a 40-times F_{SC} bit-per-second rate. At the receiver, phase-lock synchronization is achieved by detecting the TRS-ID

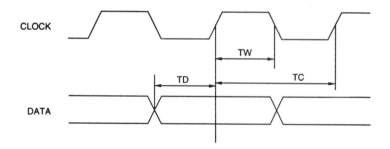

CLOCK

TW

TD TC

DATA

TW = 34.92 ± 3 NS (M) NTSC; 28.19 ± 3 NS (B, D, G, H, I) PAL

TC = 69.84 NS (M) NTSC; 56.39 NS (B, D, G, H, I) PAL

TD = 34.92 ± 3 NS (M) NTSC; 28.19 ± 3 NS (B, D, G, H, I) PAL

Figure 7.4. Parallel Transmitted Waveforms.

RELATIVE GAIN (DB)

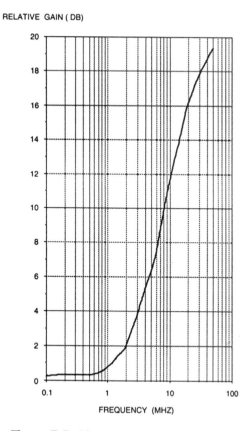

FREQUENCY (MHZ)

**Figure 7.5. Line Receiver Equalization
Characteristics for Small Signals.**

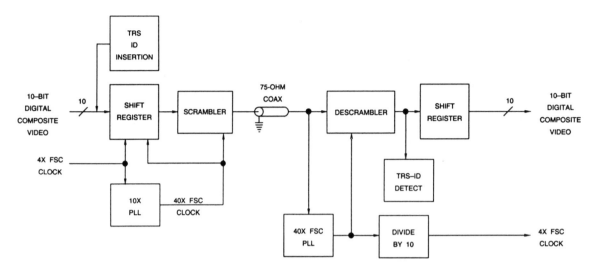

Figure 7.6. 143 or 177 Mbit-per-second Serial Interface Circuitry.

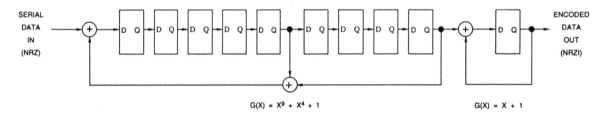

Figure 7.7. Typical Scrambler Circuit.

sequences (described later). The 40-times F_{SC} PLL is continuously adjusted slightly each scan line to ensure that these patterns are detected and to avoid bit slippage. The 40-times Fsc clock is divided by ten to generate the four-times F_{SC} output clock for the 10-bit parallel data. The serial data is low- and high-frequency equalized, the inverse scrambling performed (Figure 7.8), and deserialized.

The generator has an unbalanced output with a source impedance of 75 Ω; the signal must be 0.8 V ±10% peak-to-peak measured across a 75-Ω resistor connected to the output

terminals. The receiver has an input impedance of 75 Ω.

TRS-ID

When using the serial interface, a special four-word sequence (known as the TRS-ID) must be inserted into the digital video stream during the horizontal sync time. The TRS-ID is only present following sync leading edges which identify a horizontal transition, and occupies horizontal counts 790–794, inclusive (NTSC) or 967–971, inclusive (PAL). Table 7.9 shows the TRS-ID format; Figures 7.9 through 7.14

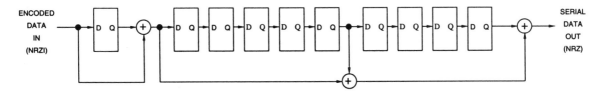

Figure 7.8. Typical Descrambler Circuit.

show the TRS-ID locations for digital composite (M) NTSC and (B, D, G, H, I) PAL video signals, respectively.

The line number ID word at horizontal count 794 (NTSC) or 971 (PAL) is defined as shown in Table 7.10.

	D9 (MSB)	D8	D7	D6	D5	D4	D3	D2	D1	D0
TRS ID word 0	1	1	1	1	1	1	1	1	1	1
TRS ID word 1	0	0	0	0	0	0	0	0	0	0
TRS ID word 2	0	0	0	0	0	0	0	0	0	0
TRS ID word 3	0	0	0	0	0	0	0	0	0	0
line number ID	D8*	ep	line number ID							

D8* = inverted value of the D8 bit.
ep = even parity for D0–D7

Table 7.9. TRS-ID format.

D2	D1	D0	NTSC	PAL
0	0	0	line 1–263 field 1	line 1–313 field 1
0	0	1	line 264–525 field 2	line 314–625 field 2
0	1	0	line 1–263 field 3	line 1–313 field 3
0	1	1	line 264–525 field 4	line 314–625 field 4
1	0	0	not used	line 1–313 field 5
1	0	1	not used	line 314–625 field 6
1	1	0	not used	line 1–313 field 7
1	1	1	not used	line 314–625 field 8

D7–D3	NTSC	PAL
$1 \leq x \leq 30$	line number 1–30 [264–293]	line number 1–30 [314–343]
$x = 31$	line number ≥ 31 [294]	line number ≥ 31 [344]
$x = 0$	not used	not used

Table 7.10. Line Number ID Word at Horizontal Count 794 (NTSC) or 971 (PAL).

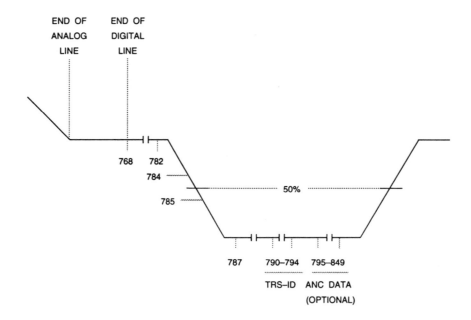

Figure 7.9. (M) NTSC TRS-ID and Ancillary Data Locations During Horizontal Sync Intervals (not to scale).

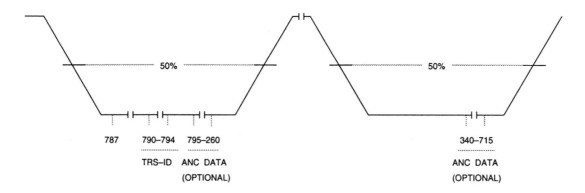

Figure 7.10. (M) NTSC TRS-ID and Ancillary Data Locations During Vertical Sync Intervals (not to scale).

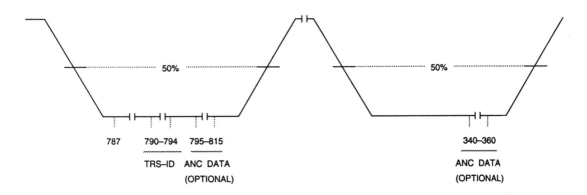

Figure 7.11. (M) NTSC TRS-ID and Ancillary Data Locations During Equalizing Pulse Intervals (not to scale).

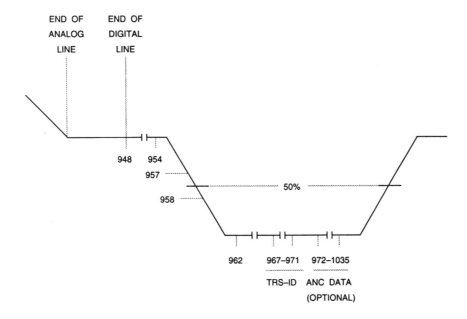

Figure 7.12. (B, D, G, H, I) PAL TRS-ID and Ancillary Data Locations During Horizontal Sync Intervals (not to scale).

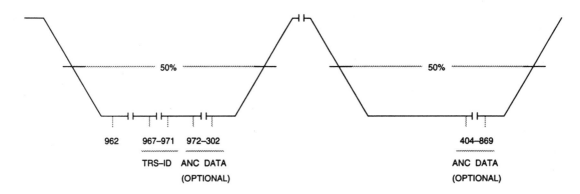

Figure 7.13. (B, D, G, H, I) PAL TRS-ID and Ancillary Data Locations During Vertical Sync Intervals (not to scale).

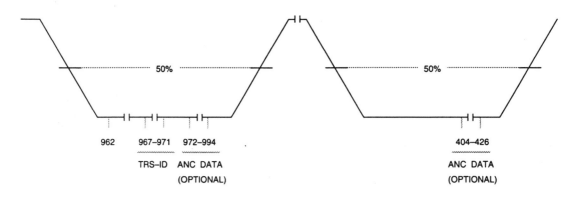

Figure 7.14. (B, D, G, H, I) PAL TRS-ID and Ancillary Data Locations During Equalizing Pulse Intervals (not to scale).

PAL requires the reset of the TRS-ID position relative to horizontal sync on lines 1 and 314 due to the 25-Hz offset. All lines have 1135 samples except lines 313 and 625, which have 1137 samples. The two additional samples on lines 313 and 625 are numbered 1135 and 1136, and occur just prior to the first active picture sample (sample 0).

Due to the 25-Hz offset, the samples occur slightly earlier each line. Initial determination of the TRS-ID position should be done on line 1, field 1, or a nearby line. The TRS-ID location always starts at sample 967, but the distance from the leading edge of sync varies due to the 25-Hz offset.

Ancillary Data

Ancillary data enables the transmission of various control data (such as digital audio, scan line numbers, error checking, field number-

ing, etc.) during the sync intervals. Design of the digital video encoder must ensure that ancillary information is generated only when appropriate. Currently, ancillary data is only defined to be used with the serial transmission protocol.

Audio Note

Although digital audio may be transmitted as ancillary information, most current digital composite VTRs accept digital audio using the AES/EBU audio protocol (AES3 or ANSI S4.40) with a sample rate of 48 kHz. The 48-kHz samples of the audio data are locked to the video as follows:

525–line systems: $48 \text{ kHz} = (1144/375) \, F_H$

625–line systems: $48 \text{ kHz} = (384/125) \, F_H$

Ancillary Data

Ancillary data may be present within the following word number boundaries (see Figures 7.9 through 7.14).

NTSC	PAL	
795–849	972–1035	horizontal sync period
795–815	972–994	equalizing pulse periods
340–360	404–426	
795–260	972–302	vertical sync periods
340–715	404–869	

The general ancillary data structure is shown below (Table 7.11).

	D9 (MSB)	D8	D7	D6	D5	D4	D3	D2	D1	D0
ancillary data flag	1	1	1	1	1	1	1	1	0	0
data ID	D8*	ep	\multicolumn value of 0 to 255							
data block number	D8*	ep	value of 0 to 255							
data count	D8*	ep	value of 0 to 255							
8-bit word format										
user data n	D8*	ep	user data word n							
user data n + 1	D8*	ep	user data word n + 1							
:	:	:	:							
9-bit word format										
user data n	D8*	user data word n								
user data n + 1	D8*	user data word n + 1								
:	:	:								
check sum	D8*	Sum of D0–D8 of data ID through last user data word. Preset to all zeros; carry is ignored.								

D8* = inverted value of the D8 bit
ep = even parity for D0–D7

Table 7.11. Ancillary data structure.

The ancillary data flag must be present if ancillary data is to be recognized (the value is $3FC_H$). There may be multiple ancillary data flags following the TRS-ID. Each flag identifies the beginning of another data block.

The data block number, if active, increments by one (according to modulo 255) for consecutive blocks of data with a common data ID, or when data blocks with a common data ID are to be linked. If D0–D7 are set to zero, the data block number is inactive and is not to be used by the receiver to indicate continuity of the data.

The data ID word identifies the type of user data; a value of FF_H for D0–D7 indicates audio data.

The data count word represents the number of user data words that follow, up to a maximum of 255.

The user data words are used to convey information as identified by the data ID word. The maximum number of user data words is 255, excluding the check sum. Note that user data words may consist of either 8-bit words plus even parity or 9-bit words positioned at D0–D8. The location of the LSB/MSB of user data is defined by a lookup table assigned to the individual data ID.

Digital Audio Ancillary Format

If digital audio is to be transmitted as ancillary information, it should follow the format shown in Table 7.12.

Digital Decoding

The decoding of digital composite NTSC and PAL video signals to digital RGB or YCrCb data is similar to that used for the NTSC and PAL decoder discussed in Chapter 6. The major differences are: (a) only digital composite video data is input, (b) the pixel clock rate is 4x F_{SC} (14.32 MHz for NTSC, 17.72 MHz for PAL), and (c) sync genlocking is not required since the video clock is transmitted with the video data and the active video samples are aligned along the IQ (NTSC) or UV (PAL) axes. During the loss of an input signal, the decoder should provide the option to either be transparent (so the input source can be monitored), to auto-freeze the output data (to compensate for short duration dropouts), or to autoblack the output data (to avoid potential problems driving a mixer or video tape recorder). Where ranges of values are mentioned, it is assumed 8-bit (plus sign) data values are used; 10-bit (plus sign) data values will result in more accurate computations at the expense of more circuitry.

NTSC Considerations

As with the analog NTSC decoder (discussed in Chapter 6), the composite video is processed by a Y/C separator. The output of the Y/C separator is separate luminance (Y) and chrominance (C) information. Y has 70 subtracted from it to remove the sync and blanking information; the resulting Y has a range of 0–130. Chrominance has a range of 0 to ±82.

Since the pixel clock rate is four times the subcarrier frequency F_{SC}, and aligned along the ±I and ±Q axes, the subcarrier sin and cos values are 0 and ±1. There is no need for the sin and cos subcarrier ROMs and the associated p:q ratio counters used on the NTSC decoder discussed in Chapter 6. The 33° phase shift of the subcarrier during active video is automatically accommodated by aligning the pixel clock along the ± I and ±Q axes. At four-times F_{SC}, a 90° subcarrier phase shift is a single clock cycle; therefore, a one clock cycle delay implements a 90° phase shift. Although sync genlocking is not required, the subcarrier

	D9 (MSB)	D8	D7	D6	D5	D4	D3	D2	D1	D0
ancillary data flag	1	1	1	1	1	1	1	1	0	0
data ID	D8*	ep	1	1	1	1	1	1	1	1
data block number	D8*	ep	value of 0 to 255							
data count	D8*	ep	Number of data words, maximum value of 255							
3 data words for audio sample 1	D8*	A5	A4	A3	A2	A1	A0	CH 1	CH 0	Z
	D8*	A14	A13	A12	A11	A10	A9	A8	A7	A6
	D8*	P	C	U	V	A19	A18	A17	A16	A15
					:					
3 data words for audio sample n	D8*	A5	A4	A3	A2	A1	A0	CH 1	CH 0	Z
	D8*	A14	A13	A12	A11	A10	A9	A8	A7	A6
	D8*	P	C	U	V	A19	A18	A17	A16	A15
check sum	D8*	Sum of D0–D8 of data ID through last data word. Preset to all zeros; carry is ignored.								

A0–A19: digital audio samples, A19 = MSB
V: AES/EBU Validity bit
U: AES/EBU User Data bit
C: AES/EBU Channel Status bit
Z: AES/EBU Z flag: specifies beginning of 192-sample channel status packet

P: even parity bit of the other 26 bits of the audio sample
ep: even parity bit for D0–D7
D8*: inverted value of D8 bit
CH 0 and CH 1 specify the audio channel number, CH 1 = MSB

Table 7.12. Digital Audio Ancillary Format.

generator must be genlocked to the incoming subcarrier by monitoring the burst phase. After demodulation, I has a range of 0 to ±78, and Q has a range of 0 to ±68. The digital composite sync information is separated into horizontal sync (HSYNC*) and vertical sync (VSYNC*) outputs.

The I and Q color difference signals are lowpass filtered, with the same considerations as those used for the NTSC decoder discussed in Chapter 6. Note, however, that the lowpass filters should be optimized for 14.32 MHz in this instance. As there may be many cascaded conversions, the filters should be designed to very tight tolerances to avoid a build-up of visual artifacts; departure from flat amplitude and group delay response due to filtering are amplified through successive stages. For example, if filters exhibiting –1 dB at 1 MHz and –3 dB at 1.3 MHz were employed, the overall response would be –8 dB (at 1 MHz) and –24 dB (at 1.3 MHz) after four stages (assuming two filters per stage). The passband flatness and group-delay characteristics are very important.

Processing for automatic flesh tone correction, saturation, hue, contrast, and brightness is the same as for the NTSC decoder. Finally, the YIQ data are converted to either RGB or YCrCb using the same equations as those for the analog NTSC decoder. For computer applications, the gamma-correction factor may be removed to generate linear RGB data (values are normalized to have a value of 0 to 1):

for R', G', B' < 0.0812

$$R = R'/4.5$$
$$G = G'/4.5$$
$$B = B'/4.5$$

for R', G', B' ≥ 0.0812

$$R = ((R' + 0.099)/1.099)^{2.2}$$
$$G = ((G' + 0.099)/1.099)^{2.2}$$
$$B = ((B' + 0.099)/1.099)^{2.2}$$

PAL Considerations

As with the analog PAL decoder discussed in Chapter 6, the composite video is processed by a Y/C separator. The output of the Y/C separator is separate luminance (Y) and chrominance (C) information. Y has 64 subtracted from it to remove the sync and blanking information; the resulting Y has a range of 0–147. Chrominance has a range of 0 to ±93.

Since the pixel clock rate is four times the subcarrier frequency, F_{SC}, and aligned along the ±U and ±V axes, the subcarrier sin and cos values are 0 and ±1. There is no need for the sin and cos subcarrier ROMs and the associated p:q ratio counters used on the PAL decoder discussed in Chapter 6. At four times F_{SC}, a 90° subcarrier phase shift is a single clock cycle; therefore, a one clock cycle delay implements a 90° phase shift. Although sync genlocking is not required, the subcarrier generator must be genlocked to the incoming subcarrier by monitoring the burst phase and the PAL SWITCH must be implemented. After demodulation, U has a range of 0 to ±64, and V has a range of 0 to ±91. The digital composite sync information is separated into horizontal sync (HSYNC*) and vertical sync (VSYNC*) outputs.

The U and V color difference signals are lowpass filtered, with the same considerations as those used for the analog PAL decoder. Note, however, that the lowpass filters should be optimized for 17.72 MHz in this instance. As

there may be many cascaded conversions, the filters should be designed to very tight tolerances to avoid a buildup of visual artifacts; departure from flat amplitude and group delay response due to filtering are amplified through successive stages. The passband flatness and group-delay characteristics are very important.

Processing for automatic flesh tone correction, saturation, hue, contrast, and brightness are the same as for the analog PAL decoder. Finally, the YUV data are converted to either RGB or YCrCb using the following equations:

YUV to RGB

$$R' = 1.736Y + 1.976V$$
$$G' = 1.736Y - 0.689U - 1.004V$$
$$B' = 1.736Y + 3.526U - 0.007V$$

YUV to YCrCb

$$Y = 1.489Y + 16$$
$$Cr = 1.236V + 128$$
$$Cb = 1.748U + 128$$

For computer applications, the gamma-correction factor may be removed to generate linear RGB data (values are normalized to have a value of 0 to 1):

for R', G', B' < 0.0812

$$R = R'/4.5$$
$$G = G'/4.5$$
$$B = B'/4.5$$

for R', G', B' ≥ 0.0812

$$R = ((R' + 0.099)/1.099)^{2.8}$$
$$G = ((G' + 0.099)/1.099)^{2.8}$$
$$B = ((B' + 0.099)/1.099)^{2.8}$$

Professional video systems may use the gamma-corrected RGB color space, with RGB having a nominal range of 16 to 235. Occasional values less than 16 and greater than 235 are allowed. In this instance, YUV

may be converted to RGB by scaling the YUV-to-RGB equations by 219/255 and adding an offset of 16:

$$R' = 1.491Y + 1.697V + 16$$
$$G' = 1.491Y - 0.592U - 0.862V + 16$$
$$B' = 1.491Y + 3.028U - 0.006V + 16$$

VLSI Solutions

For a standard to be readily accepted and used, appropriate VLSI solutions must be available so designers can implement the standard with minimal effort. An ideal VLSI solution allows the designer to tailor its use to his or her system-specific requirements. This section is an overview of commercially available VLSI solutions for implementing digital composite video.

Ancillary Data Coprocessors

The CXD-8110K and CXD-8129K from Sony Corporation are coprocessors for the transmission (CXD-8110K) and receiving (CXD-8129K) of digital composite video. The CXD-8110K (Figure 7.15) accepts digital composite video, adds the TRS-ID information, and any ancillary

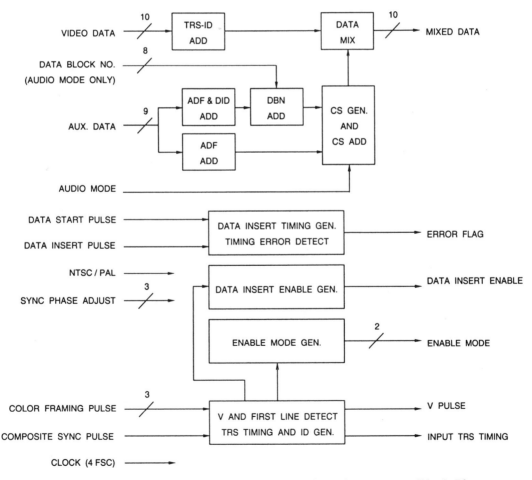

Figure 7.15. Sony Corporation CXD-8110K Transmitter Coprocessor Block Diagram.

information. Features of the CXD-8110K include:

- NTSC and PAL Compatible
- Adds TRS-ID Information
- Adds Ancillary Information and Formatting
- Adjustment of Sync Phase
- Adds Color Framing Information

- TTL Compatible Inputs and Outputs
- +5 V Power Supply
- 68-pin PLCC Package

The CXD-8129K (Figure 7.16) removes the ancillary and TRS-ID information from the digital video stream, and restores the sync tip areas with the proper digital values. The recovered ancillary, TRS-ID, and color framing information are available to the user. Features of the CXD-8129K include:

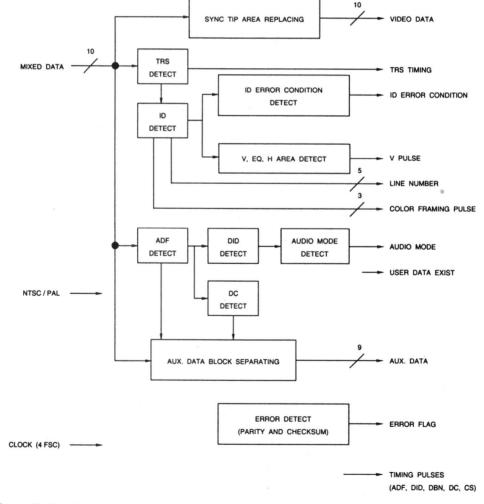

Figure 7.16. Sony Corporation CXD-8129K Receiver Coprocessor Block Diagram.

- NTSC and PAL Compatible

- Removes and Outputs TRS-ID Information

- Removes and Outputs Ancillary Information

- Removes and Outputs Color Framing Information

- TTL Compatible Inputs and Outputs

- +5 V Power Supply

- 68-pin PLCC Package

Parallel Line Drivers and Receivers

The VS620 and VS621 from VTC Incorporated are 11-bit TTL-to-ECL (VS621) and ECL-to-ECL (VS620) Line Drivers designed specifically for digital composite video applications. The VS621 (Figure 7.17) accepts up to 10 bits of TTL data and a four times F_{SC} TTL clock signal. The 10 bits of TTL data are latched and converted (along with the clock) to differential 10KH ECL levels. Having all of the TTL-to-ECL translators on a single chip also eliminates any device-to-device skew inherent in a multichip solution. Features of the VS621 include:

- Latched TTL Compatible Inputs

- 10KH ECL Compatible Differential Outputs

- ±5 V Power Supply

- 52-pin PLCC Package

The VS620 (Figure 7.18) accepts up to 10 bits of differential 10KH ECL data and a differential 10KH ECL clock signal. The data is latched and output (along with clock) onto the differential 10KH ECL outputs. Having all of the latches on a single chip eliminates device-to-device skew inherent in a multi-chip solution. Features of the VS620 include:

- Latched 10KH ECL Compatible Differential Inputs

- 10KH ECL Compatible Differential Outputs

- –5.2 V Power Supply

- 52-pin PLCC Package

Serial Line Drivers and Receivers

To support the 40-times F_{SC} serial protocol, Sony offers a 10-bit serial encoder (SBX-1601) and decoder (SBX-1602). Also available is a cable driver (CXA-1389) to ease interfacing the

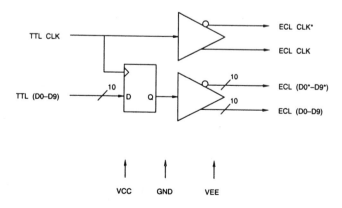

Figure 7.17. VTC Incorporated VS621 Line Driver (Parallel) Block Diagram.

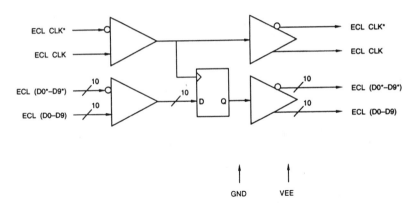

Figure 7.18. VTC Incorporated VS620 Line Driver (Parallel) Block Diagram.

SBX-1601 encoder to a coaxial cable. The serial encoder and decoder are hybrid ICs in which the fundamental processing is done on a monolithic chip, and the necessary support capacitors and resistors are mounted within the hybrid to obtain the best stability at such high frequencies.

These parts also second-sourced by SGS-Thomson Microelectronics (part numbers STV1601, STV1602, and STV1389).

The SBX-1601 serial encoder (Figure 7.19) accepts 8 or 10 bits of data and a four-times F_{SC} clock (either ECL or TTL data and clock signals are supported). If using 8-bit data, the two LSBs of the 10-bit inputs must be a logical zero. The input data is latched, serialized,

scrambled, and output onto the ECL differential outputs. An internal PLL multiplies the four-times F_{SC} input clock by ten times, generating the 40-times F_{SC} clock required to serialize the data. TTL input data may be used by supplying an external 1.4 V reference to the data return inputs (DN) and providing a +5 V supply to a special power pin. Features of the SBX-1601 include:

- 10-bit Latched Data plus Clock Inputs (ECL or TTL-Compatible)

- Parallel to Serial Encoding

- On-Chip PLL

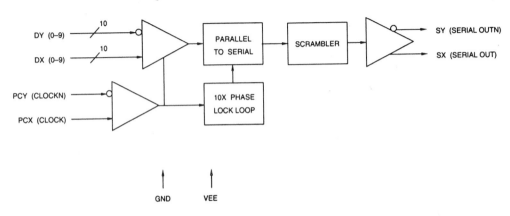

Figure 7.19. Sony Corporation SBX-1601 Serial Encoder Block Diagram.

- –5 V Power Supply (+5 V and +1.4 V required for TTL compatible operation)
- 37-pin PGA Package

The SBX-1602 serial decoder (Figure 7.20) accepts the serial data stream, performs various equalization on the data, and outputs 10 bits of parallel data and a four-times F_{SC} clock (both the parallel data and clock output signals are single-ended ECL levels). Two serial input ports are provided: differential analog with equalization (for use with coaxial cables up to 300 meters in length) and differential ECL with no equalization (for use with coaxial cables less than 1 m in length). A differential ECL serial output is provided, outputting a regenerated version of the selected serial input; this enables the SBX-1602 to also be used as a distribution amplifier. Features of the SBX-1602 include:

- 10-bit Data plus Clock Outputs (single-ended ECL compatible)

- Serial to Parallel Decoding
- On-Chip PLL
- –5 V Power Supply
- 37-pin PGA Package

References

1. Sony Corporation, SBX1601A Datasheet, 1991.
2. Sony Corporation, SBX1602A Datasheet, 1991.
3. Sony Corporation, CXD8110K Datasheet, 1991.
4. Sony Corporation, CXD8129K Datasheet, 1991.
5. VTC Incorporated, VS620 Datasheet, 1990.
6. VTC Incorporated, VS621 Datasheet, 1990.
7. Watkinson, John, *The Art of Digital Video*, Focal Press, 1990.

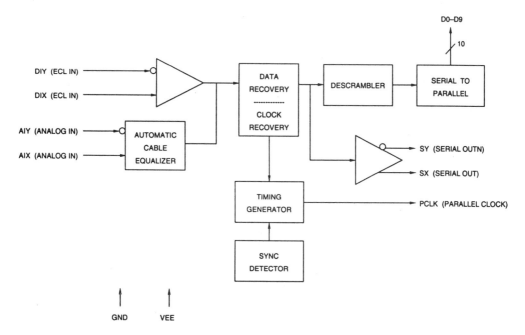

Figure 7.20. Sony Corporation SBX-1602 Serial Decoder Block Diagram.

4:2:2 Digital Component Video

In 4:2:2 digital component video, the video signals are in component (YCrCb) form, being encoded to composite form only when it is necessary for broadcasting or recording purposes. Advantages of using the 4:2:2 standard are several: a common color space (YCrCb), the same number of active pixels per scan line (720) regardless of the video standard (although the number of scan lines are still different), and a hierarchy of compatible coding standards. Although initially developed as a studio-level video interface, the 4:2:2 standard is now being used within video equipment to simplify the processing of video and the design of equipment for use worldwide.

The European Broadcasting Union (EBU) became interested in a standard for digital component video due to the difficulties of exchanging video material between the 625-line PAL and SECAM systems. The format held the promise that the digital video signals would be identical whether sourced in a PAL or SECAM country, allowing subsequent encoding to the appropriate digital composite form for broadcasting. Consultations with the Society of Motion Picture and Television Engi-

neers (SMPTE) resulted in the development of an approach to support international program exchange, including 525-line systems.

A series of demonstrations was carried out, using experimental equipment, to determine the quality and suitability for signal processing of various methods. From these investigations, the main parameters of the digital component coding and filtering standard were chosen (CCIR Recommendation 601). More detailed specifications, such as SMPTE RP-125, EBU 3267 (which replaces EBU 3246 and EBU 3247) and CCIR Recommendation 656, were then developed to define the actual transmission interfaces between equipment. CCIR Report 1212 describes test signals specifically designed for the 4:2:2 digital video environment.

This chapter discusses 4:2:2 encoder and decoder architectures, transmission of 4:2:2 digital component video, and ancillary data capabilities such as digital audio. Audio is transmitted digitally either over a separate digital channel (using the AES/EBU digital audio protocol) or during the digital video blanking intervals (as ancillary data).

Sampling Rate and Color Space Selection

Line-locked sampling of the analog component video signals is used to convert analog RGB or YUV video signals to 4:2:2 digital component. This technique produces a static orthogonal sampling grid in which samples on the current scan line fall directly beneath those on previous scan lines and fields (Figure 8.1). Another important feature is that the sampling is locked in phase so that one sample is coincident with the 50% amplitude point of the falling edge of analog horizontal sync (Figure 8.2). This ensures that different sources produce samples at nominally the same positions in the picture. Making this feature common to all members of the hierarchy simplifies conversion from one level to another. The component video signals chosen were luminance (Y) and two color difference signals (Cr and Cb), which are scaled and offset versions of the Y,

R'–Y, and B'–Y signals. This allows compatibility between various television signal standards and provides the ability to sample the Cr and Cb color difference signals at half the rate of the Y to reduce bandwidth and storage requirements.

Initially, several Y sampling frequencies were examined, including four times F_{sc}. However, the four times F_{sc} sampling rates did not support the requirement of simplifying international exchange of programs, so they were dropped in favor of a single common sampling rate. Since as low a sample rate as possible (while still supporting quality video) was a goal, a 12-MHz sample rate was preferred for a long time, but was eventually considered to be too close to the Nyquist limit, complicating the filtering requirements. When the frequencies between 12 MHz and 14.3 MHz were exam-

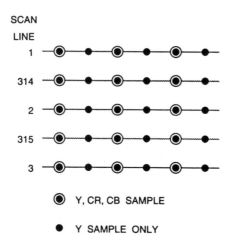

Figure 8.1. 4:2:2 Orthogonal Sampling. The position of sampling sites on the scan lines of an interlaced system.

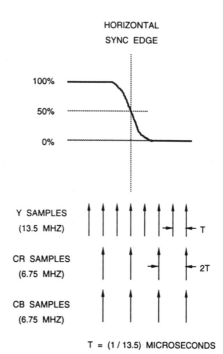

Figure 8.2. 4:2:2 YCrCb Samples Relative to the Analog Sync Position.

ined, it became evident that a 13.5-MHz sample rate for Y provided some commonality between 525- and 625-line systems. Cr and Cb, being color difference signals, do not require the same bandwidth as the luminance, so are sampled at half the luminance, or 6.75 MHz. The accepted notation for a digital component system with sampling frequencies of 13.5, 6.75, and 6.75 MHz for the luminance and color difference signals, respectively, is 4:2:2 (Y:Cb:Cr).

With 13.5-MHz sampling, each scan line contains 858 samples (525-line systems) or 864 samples (625-line systems), and consists of a digital blanking interval followed by an active line period. Both the 525- and 625-line systems have 720 samples during the active line period, with 138 samples (525-line systems) or 144 samples (625-line systems) present during digital blanking. Having a common number of samples for the active line period simplifies the design of multistandard equipment and standards conversion. With a sample rate of 6.75 MHz for Cr and Cb, each active line period contains 360 Cr samples and 360 Cb samples.

With analog systems, problems may arise with repeated processing, causing an extension of the blanking intervals and softening of the blanking edges. Using 720 digital samples for the active line period accommodates the range of analog blanking tolerances of both the 525- and 625-line systems. Therefore, repeated processing may be done without affecting the digital blanking interval. Blanking to define the analog picture width need only be done once, preferably at the monitor or conversion to composite video.

Standards Hierarchy

A unique feature of the CCIR 601 Recommendation is the coexistence of a hierarchy of compatible coding standards, provided that conversion to 4:2:2 sampling is straightforward. In practice, this restricts the choices to sampling frequencies with simple relationships to 4:2:2 frequencies, such as 4:4:4, 4:1:1, or 2:1:1. Using simple fixed ratios between the sampling rates allows conversions between them to be achieved using simple fixed-value interpolators. This hierarchy (shown in Table 8.1) allows the development of systems for which 4:2:2 would be unsuitable or unnecessary and still ensure compatibility.

Interest is growing in higher members of the 4:2:2 hierarchy, especially regarding high

Standard	Y Sample Rate	Cr Sample Rate	Cb Sample Rate	RGB Sample Rate
4:4:4 (see Table 8.2)	13.5 MHz	13.5 MHz	13.5 MHz	13.5 MHz
4:2:2 (see Table 8.3)	13.5 MHz	6.75 MHz	6.75 MHz	–
4:1:1	13.5 MHz	3.375 MHz	3.375 MHz	–
2:1:1	6.75 MHz	3.375 MHz	3.375 MHz	–

Table 8.1. Digital Component Video Hierarchy.

Parameters	525/60 systems	625/50 systems
Coded signals: Y, Cr, Cb or R, G, B	These signals are obtained from gamma precorrected signals, namely: Y, R' – Y, B' – Y or R', G', B'.	
Number of samples per total line: - luminance or R, G, B signal - each color difference signal	858 858	864 864
Sampling structure	Orthogonal, line, field and frame repetitive. The three sampling structures to be coincident and coincident also with the luminance sampling structure of the 4:2:2 family member.	
Sampling frequency: - luminance or R, G, B signal - each color difference signal	13.5 MHz 13.5 MHz The tolerance for the sampling frequencies should coincide with the tolerance for the line frequency of the relevant color television standard.	
Form of coding	Uniformly quantized PCM, 8 or 10 bits per sample, for the luminance and each color difference signal.	
Number of samples per digital active line: - luminance or R, G, B signal - each color difference signal	720 720	
Analog-to-digital horizontal timing relationship: - from end of digital active line to 0_H	16 luminance clock periods	12 luminance clock periods
Correspondence between video signal levels and quantization level for each sample: - scale - luminance or R, G, B signal - each color difference signal Code-word usage	0 to 255 (0 to 1023) 220 (877) quantization levels with the black level corresponding to level 16 (64) and the peak level corresponding to level 235 (940). The signal level may occasionally excurse beyond level 235 (940). 225 (897) quantization levels in the center part of the quantization scale with zero signal corresponding to level 128 (512). Code words corresponding to 8-bit quantization levels 0 and 255 are used exclusively for synchronization. 8-bit levels 1–254 are available for video.	

Table 8.2. Encoding Parameter Values for the 4:4:4 Member of the Family. 10-bit values are in parentheses and indicate 2 bits of fractional video data are used.

Parameters	525/60 systems	625/50 systems
Coded signals: Y, Cr, Cb	These signals are obtained from gamma precorrected signals, namely: Y, R′ – Y, B′ – Y or R′, G′, B′.	
Number of samples per total line: - luminance or R, G, B signal - each color difference signal	858 429	864 432
Sampling structure	Orthogonal, line, field and frame repetitive. Cr and Cb samples co-sited with odd (1st, 3rd, 5th, etc.) Y samples in each line.	
Sampling frequency: - luminance signal - each color difference signal	13.5 MHz 6.75 MHz The tolerance for the sampling frequencies should coincide with the tolerance for the line frequency of the relevant color television standard.	
Form of coding	Uniformly quantized PCM, 8 or 10 bits per sample, for the luminance and each color difference signal.	
Number of samples per digital active line: - luminance signal - each color difference signal	720 360	
Analog-to-digital horizontal timing relationship: - from end of digital active line to 0_H	16 luminance clock periods	12 luminance clock periods
Correspondence between video signal levels and quantization level for each sample: - scale - luminance signal - each color difference signal Code-word usage	 0 to 255 (0 to 1023) 220 (877) quantization levels with the black level corresponding to level 16 (64) and the peak level corresponding to level 235 (940). The signal level may occasionally excurse beyond level 235 (940). 225 (897) quantization levels in the center part of the quantization scale with zero signal corresponding to level 128 (512). Code words corresponding to 8-bit quantization levels 0 and 255 are used exclusively for synchronization. 8-bit levels 1–254 are available for video.	

Table 8.3. Encoding Parameter Values for the 4:2:2 Member of the Family. 10-bit values are in parentheses and indicate 2 bits of fractional video data are used.

definition television. In conversions involving higher scanning rates, a simple relationship between the positions of the picture sample points is as important as a simple relationship in clock frequencies.

A 4:4:4:4 hierarchy (commonly referred to as "4 × 4") is discussed later in this chapter. This implementation allows the transmission of four components of video data (either YCrCb or RGB and an additional component typically used for keying). Each component is sampled at 13.5 MHz with 10 bits of resolution.

YCrCb Coding Ranges

The selection of the coding ranges balances the requirements of adequate capacity for signals beyond the normal range and minimizing quantizing distortion. Although the black level of a video signal is reasonably well defined, the white level can be subject to variations due to video signal and equipment tolerances. Noise, gain variations, and transients produced by filtering can produce signal levels outside the nominal ranges.

The CCIR 601 Recommendation uses 8 bits per sample for each of the Y, Cr, and Cb components. Although 8-bit coding introduces some quantizing distortion, it was originally felt that most video sources contained suffi-

cient noise to mask most of the quantizing distortion. However, if the video source is virtually noise-free, the quantizing distortion is noticeable as contouring in areas where the signal brightness gradually changes. In addition, at least two additional bits of fractional YCrCb data were desirable to reduce rounding effects when transmitting between equipment in the studio editing environment. For these reasons, most studio equipment currently uses a 10-bit version of 4:2:2, allowing 2 bits of fractional YCrCb data to be maintained.

The 8-bit coding levels of CCIR Recommendation 601 correspond to a range of 256 levels (0 to 255 decimal or 00_H to FF_H). Levels 0 and 255 are reserved for timing information, leaving levels 1–254 for the actual signal values. Initial proposals had equal coding ranges for all three YCrCb components. However, this was changed so the luminance value had a greater margin for overloads at the white levels, as white level limiting is more visible than black. Thus, the nominal luminance (and RGB) levels are 16 to 235, while the nominal color difference levels are 16 to 240 (with 128 equal to zero). Occasional excursions into the other levels are permissible, but never at the 0 and 255 levels. The YCrCb levels to generate a 75% amplitude, 100% saturation color bar signal are shown in Table 8.4. Here, 4:4:4 RGB signals have the same nominal levels as

	Nominal Range	White	Yellow	Cyan	Green	Magenta	Red	Blue	Black
Y	16 to 235	180	162	131	112	84	65	35	16
Cr	16 to 240 (128 = zero)	128	142	44	58	198	212	114	128
Cb	16 to 240 (128 = zero)	128	44	156	72	184	100	212	128

Table 8.4. 75% Amplitude, 100% Saturation YCrCb Color Bars.

luminance to simplify the digital matrix conversions between RGB and YCrCb. To support checking of downstream equipment, it is convenient for the encoder to provide for the automatic generation of 75% amplitude, 100% saturation YCrCb color bars. Note that to achieve a true 8-bit result at the end of the processing chain, professional systems usually maintain 2 bits of fractional color data, resulting in 10-bit words being transferred between systems. Although various techniques may be used to round the result of a mathematical operation to 8 bits, each rounding operation introduces some noise into the signal. By maintaining two fractional data bits, the noise due to rounding is minimized.

Encoding (using 4:4:4 Sample Rates)

Digitizing analog RGB using 4:4:4 sample rates and converting to 4:2:2 YCrCb data digitally, as shown in Figure 8.3, have several advantages: support for digital RGB data (such as from a computer graphics frame buffer), stability of the RGB-to-YCrCb matrix (since it is digital rather than analog), and easier design of the analog circuitry (much more immune to temperature and power supply variations and tolerance drift). YCrCb and RGB ranges are assumed to be 0–255 (8-bit data).

The analog RGB video signals are lowpass filtered (to prevent aliasing) and the active video portions (black-to-white levels) of the RGB signals are digitized. The A/D converters are configured to generate a 16–235 output range. Any embedded sync information must also be stripped from the video signals and used to control the 27-MHz VCXO PLL (operating in a line-lock configuration) to generate the required timing signals.

Before the RGB-to-YCrCb matrix, ROM or RAM lookup tables may be used to implement any necessary gamma correction, since YCrCb must be derived from gamma-corrected RGB data. Having the ability to bypass or reconfigure the lookup tables is almost a necessity, since both linear and gamma-corrected RGB sources are common.

Gamma-corrected digital RGB signals with a 16–235 range may be converted to YCrCb using the following equations:

$$Y = (77/256)R' + (150/256)G' + (29/256)B'$$
$$Cr = (131/256)R' - (110/256)G' - (21/256)B' + 128$$
$$Cb = -(44/256)R' - (87/256)G' + (131/256)B' + 128$$

The RGB-to-YCrCb equations above ensure that the YCrCb data has the proper levels (16 to 235 for Y and 16 to 240 for Cr and Cb) for an RGB input range of 16 to 235. If the RGB data has a range of 0–255, as is commonly found in computer systems, or the A/D converters are configured to generate a 0–255 output range, the following equations may be more convenient to use:

$$Y = 0.257R' + 0.504G' + 0.098B' + 16$$
$$Cr = 0.439R' - 0.368G' - 0.071B' + 128$$
$$Cb = -0.148R' - 0.291G' + 0.439B' + 128$$

For both sets of equations, a minimum of 8 bits of fractional data should be maintained with the final results rounded to the desired accuracy. Since computers commonly use linear RGB data, linear RGB data may be converted to gamma-corrected RGB data as follows (values are normalized to have a value of 0 to 1):

for R, G, B < 0.018

$$R' = 4.5 R$$

$G' = 4.5\,G$

$B' = 4.5\,B$

for R, G, B ≥ 0.018

$R' = 1.099\,R^{0.45} - 0.099$

$G' = 1.099\,G^{0.45} - 0.099$

$B' = 1.099\,B^{0.45} - 0.099$

For 625/50 systems, a 0.36 exponent is used, rather than the 0.45 exponent.

The Y lowpass digital filter is required, as the image may have been computer-generated or modified, resulting in high-frequency luminance components. Cr and Cb are digitally lowpass filtered and decimated from a 13.5 to 6.75 MHz sample rate, generating the 4:2:2 YCrCb data. In a standard design, the Cr and Cb lowpass and decimation filters are combined into a single filter, and a single filter may be used for both Cr and Cb by multiplexing. Not shown are the digital delay adjustments between Y and CrCb data to ensure the video data are pipelined—aligned due to the differences in digital filter delays. Saturation logic should be included in the YCrCb data paths to limit the range to 1–254, ensuring that the 0 and 255 codes are not generated (as an option, further range limiting of 16 to 235 for Y and 16 to 240 for Cr and Cb may be supported).

RGB and Luminance Filtering

Digital sampling requires that the bandwidth of the analog RGB signals be defined by presampling lowpass filters, shown in Figure 8.3. The presampling filter prevents aliasing, generally from low-level components (noise) above the nominal video band. Also shown in Figure 8.3, if digital RGB data is used directly, the resulting luminance data should be processed by a digital lowpass filter in the event an image may have been computer-generated

or modified, resulting in high-frequency luminance components.

The CCIR 601 template for the analog RGB and digital luminance filters is shown in Figure 8.4. Both design limits and practical limits are specified in Table 8.5. The practical limits are included to demonstrate the difficulty in achieving the ideal design limits. As there may be many cascaded conversions (up to 10 were envisioned), the filters were designed to adhere to very tight tolerances to avoid a buildup of visual artifacts. Successive A/D and D/A stages do not degrade the signal beyond calculable quantizing noise. However, departure from flat amplitude and group delay response due to filtering is amplified through successive stages. For example, if filters exhibiting –1 dB at 1 MHz and –3 dB at 1.3 MHz were employed, the overall response would be –8 dB (at 1 MHz) and –24 dB (at 1.3 MHz) after four stages (assuming two filters per stage).

Although the sharp cut-off results in ringing on luminance edges, the visual effect should be minimal provided that group-delay performance is adequate. When cascading multiple filtering operations, the passband flatness and group-delay characteristics are very important. The passband tolerances, coupled with the sharp cut-off, make the template very difficult (some say impossible) to match. As a result, there is usually temptation to relax passband accuracy, but the best approach is to reduce the rate of cut-off and keep the passband as flat as possible.

CrCb Filtering

As with luminance filtering, the Cr and Cb filtering requires a sharp cut-off to prevent repeated conversions from producing a cumulative resolution loss. However, due to the low cut-off frequency, the sharp cut-off

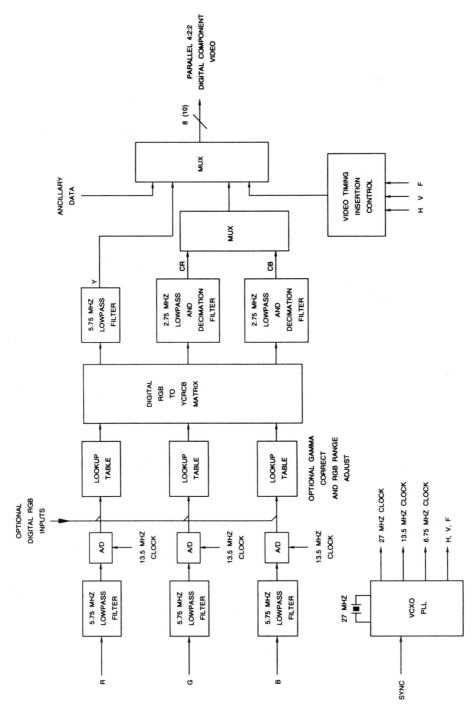

Figure 8.3. 4:2:2 Encoding Using 4:4:4 Sample Rates.

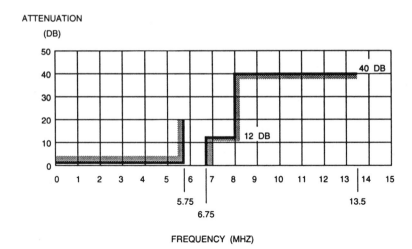

Figure 8.4. RGB and Luminance Filter Template When Sampling at 13.5 MHz.

Frequency Range	CCIR601 Spec	CCIR601 Practical Limits
Passband Ripple Tolerance		
1 kHz to 1 MHz	±0.005 dB	increasing from ±0.01 to ±0.025 dB
1 MHz to 5.5 MHz	±0.005 dB	±0.025 dB
5.5 MHz to 5.75 MHz	±0.005 dB	±0.05 dB
Passband Group Delay Tolerance		
1 kHz to 5.75 MHz	0 increasing to ±2 ns	±1 ns increasing to ±3 ns

Table 8.5. RGB and Luminance Filter Ripple and Group Delay Tolerances When Sampling at 13.5 MHz.

produces ringing that is more noticeable than for luminance.

The template for the Cr and Cb digital filters used in Figure 8.3 is shown in Figure 8.5. Both design limits and practical limits are specified in Table 8.6. The practical limits are included to demonstrate the difficulty in achieving the ideal design limits. Since aliasing is less noticeable in color difference signals,

the attenuation at half the sampling frequency is only 6 dB. There is an advantage in using a skew-symmetric response passing through the –6 dB point at half the sampling frequency— this makes alternate coefficients in the digital filter zero, almost halving the number of taps, and also allows using a single digital filter for both the Cr and Cb signals. Use of a transversal digital filter has the advantage of providing

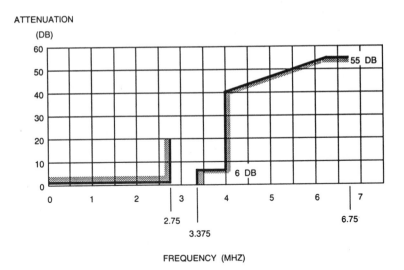

Figure 8.5. Color Difference Filter Template for Digital Filter for Sample Rate Conversion from 4:4:4 To 4:2:2 Color Difference Signals.

Frequency Range	CCIR601 Spec	CCIR601 Practical Limits
Passband Ripple Tolerance		
1 kHz to 1 MHz	0 dB	increasing from ±0.01 to ±0.05 dB
1 MHz to 2.75 MHz	0 dB	±0.05 dB
Passband Group Delay Tolerance		
1 kHz to 2.75 MHz	delay distortion is zero by design	
2.75 MHz to $F_{-3\,dB}$		

Table 8.6. Color Difference Filter Ripple and Group Delay Tolerances for Digital Filter for Sample Rate Conversion from 4:4:4 to 4:2:2 Color Difference Signals.

perfect linear phase response, eliminating the need for group-delay correction. As with the luminance filters, the passband flatness and group-delay characteristics are very important, and the best approach is once again to reduce the rate of cut-off and keep the passband as flat as possible.

Encoding (using 4:2:2 Sample Rates)

Analog RGB video may be converted to analog YUV and digitized at the 4:2:2 sample rates, as shown in Figure 8.6. This is probably less

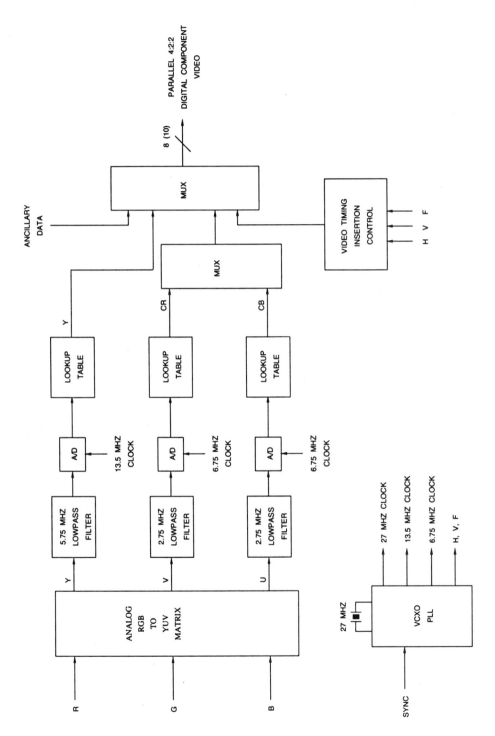

Figure 8.6. 4:2:2 Encoding using 4:2:2 Sample Rates.

expensive to implement than the design shown in Figure 8.3. However, digital RGB data (such as from a computer graphics frame buffer) is not supported, and more design effort is necessary to ensure that the analog circuitry is robust against temperature and power supply variations and tolerance drift. YCrCb and RGB ranges are assumed to be 0–255 (8-bit data).

The gamma-corrected analog RGB signals are converted to analog YUV using the following equations:

$$Y = 0.299R' + 0.587G' + 0.114B'$$
$$U = (0.5/0.886)(B' - Y) = 0.564(B' - Y)$$
$$= -0.169R' - 0.331G' + 0.500B'$$
$$V = (0.5/0.701)(R' - Y) = 0.713(R' - Y)$$
$$= 0.500R' - 0.419G' - 0.081B'$$

The YUV signals must be lowpass filtered and the active video portions of the YUV signals digitized. Not shown are the analog delay adjustments between the YUV data to ensure the video data are time-aligned due to the differences in analog filter delays. The A/D converters are configured to generate a 16–235 output range for Y and a 16–240 output range for Cr and Cb (with 128 equal to zero). As the analog color difference signals are bipolar (they have a normalized range of 0 to ±0.5), the A/D converters for the color difference signals must be configured to generate an output value of 128 when the input is 0. Any embedded sync information must also be stripped from the video signals, and used to control the 27-MHz VCXO PLL (operating in a line-lock configuration) to generate the required timing signals. Saturation logic should be included in the YCrCb data paths to limit the range to 1–254, ensuring that the 0 and 255 codes are not generated (as an option, further range limiting of 16 to 235 for Y and 16 to 240 for Cr and Cb may be supported).

Luminance Filtering

The luminance presampling lowpass analog filter has the same characteristics as the RGB presampling lowpass analog filters used in Figure 8.3, and all the same considerations apply. The characteristics are shown in Figure 8.4 and Table 8.5.

Color Difference Filtering

The color difference presampling lowpass analog filters define the color difference signal bandwidth. The template for the filters is shown in Figure 8.7 and Table 8.7. As with luminance filtering, the color difference filtering requires a sharp cut-off to prevent repeated codings from producing a cumulative resolution loss. However, due to the low cut-off frequency, the sharp cut-off produces ringing that is more noticeable than for luminance.

Since aliasing is less noticeable in color difference signals, the attenuation at half the sampling frequency is only 6 dB. As with the luminance filters, the passband flatness and group-delay characteristics are very important. Once again, the best approach is to reduce the rate of cut-off and keep the passband as flat as possible.

Transmission Timing

Rather than digitize and transmit the entire horizontal blanking interval, a special four-word sequence is inserted into the digital video stream to indicate the start of active video (SAV) and end of active video (EAV). These EAV and SAV sequences indicate when horizontal and vertical blanking are present and which field is being transmitted, enabling most of the horizontal blanking interval to be used to transmit ancillary data-line numbering,

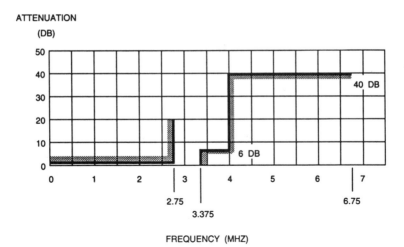

Figure 8.7. Color Difference Filter Template when Sampling at 6.75 MHz.

Frequency Range	CCIR601 Spec	CCIR601 Practical Limits
Passband Ripple Tolerance		
1 kHz to 1 MHz	±0.01 dB	increasing from ±0.01 to ±0.05 dB
1 MHz to 2.75 MHz	±0.01 dB	±0.05 dB
Passband Group Delay Tolerance		
1 kHz to 2.75 MHz	increasing from 0 to ±0.4 ns	increasing from ±2 to ±6 ns
2.75 MHz to $F_{-3\,dB}$	–	±12 ns

Table 8.7. Color Difference Filter Ripple and Group Delay Tolerances when Sampling at 6.75 MHz.

digital audio data, error-checking data, etc. (see Figures 8.8 through 8.15). Note that EAV and SAV sequences must have priority over active video data or ancillary data to ensure that correct video timing is always maintained at the receiver. The receiver decodes the EAV and SAV sequences to recover the video timing signals.

The video timing sequence at the encoder is controlled by three signals—H (horizontal blanking), V (vertical blanking), and F (even or odd field). A logical zero-to-one transition of the H control signal must trigger an EAV (end of active video) sequence while a logical one-to-zero transition must trigger an SAV (start of active video) sequence. The typical values of H, V, and F on different lines are shown in Figure 8.11 and Figure 8.15. F and V are only allowed to change at EAV sequences. Both 8-bit and 10-bit transmission interfaces are supported, with the 10-bit interface used to transmit 2 bits of fractional color data information to minimize cumulative processing errors and support 10-bit ancillary data.

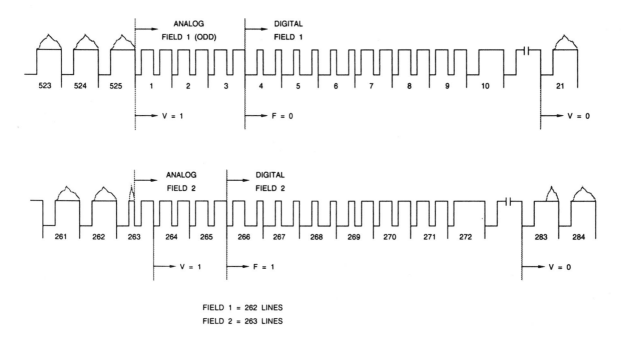

Figure 8.8. 525/60 V and F Timing. Note that the line numbering matches that used in standard practice for 525/60 video signals.

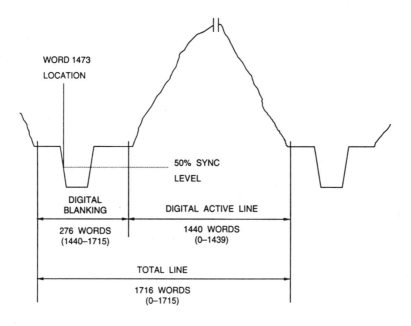

Figure 8.9. 525/60 Horizontal Sync Relationship.

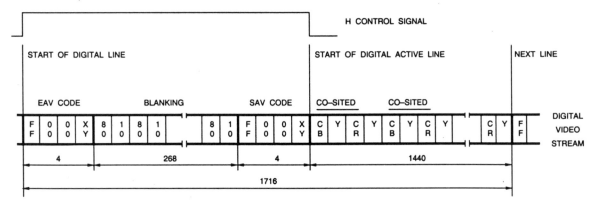

Figure 8.10. 525/60 Digital Horizontal Blanking (8-bit Transmission System).

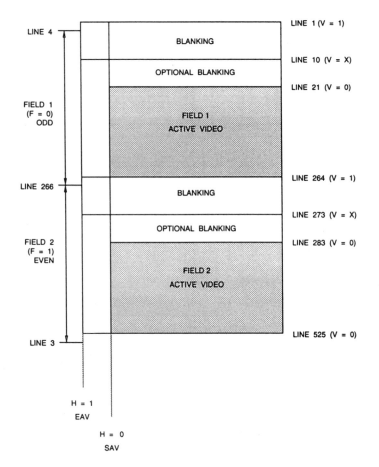

LINE NUMBER	F	V	H (EAV)	H (SAV)
1–3	1	1	1	0
4–20	0	1	1	0
21–263	0	0	1	0
264–265	0	1	1	0
266–282	1	1	1	0
283–525	1	0	1	0

Figure 8.11. 525/60 Digital Vertical Timing. F and V change state synchronously with the EAV sequence at the beginning of the digital line. Note that digital line number changes state prior to start of horizontal sync, as shown in Figure 8.9.

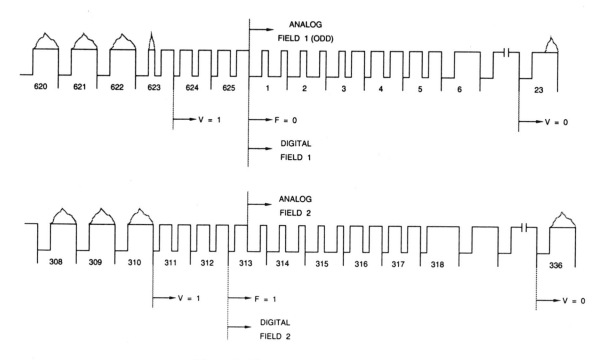

Figure 8.12. 625/50 V and F Timing.

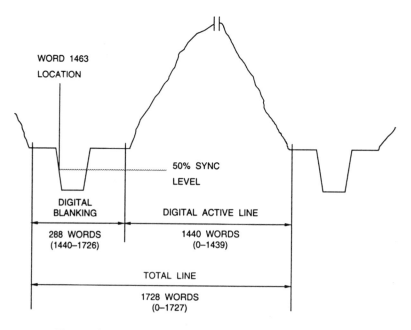

Figure 8.13. 625/50 Horizontal Sync Relationship.

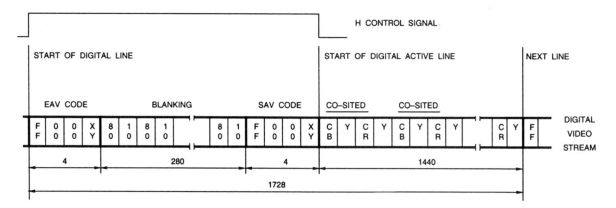

Figure 8.14. 625/50 Digital Horizontal Blanking (8-bit Transmission System).

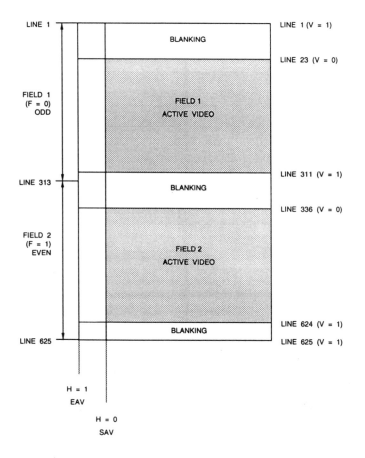

LINE NUMBER	F	V	H (EAV)	H (SAV)
1–22	0	1	1	0
23–310	0	0	1	0
311–312	0	1	1	0
313–335	1	1	1	0
336–623	1	0	1	0
624–625	1	1	1	0

Figure 8.15. 625/50 Digital Vertical Timing. F and V change state synchronously with the EAV sequence at the beginning of the digital line. Note that digital line number changes state prior to start of horizontal sync, as shown in Figure 8.13.

The EAV and SAV sequences are shown in Table 8.8.

The status word is defined as:

F = 0 for field 1; F = 1 for field 2
V = 1 during vertical blanking
H = 0 at SAV, H = 1 at EAV
P3–P0 = protection bits

$$P3 = V \oplus H$$
$$P2 = F \oplus H$$
$$P1 = F \oplus V$$
$$P0 = F \oplus V \oplus H$$

where \oplus represents the exclusive-OR function. These protection bits enable single-bit errors to be detected and corrected (and some multiple bit errors detected) at the receiver. Color and ancillary data may not use the 10-bit values 000_H–003_H and $3FC_H$–$3FF_H$ to avoid contention with 8-bit systems.

A potential timing problem at the encoder is the alignment of the H (horizontal blanking) control signal relative to the EAV and SAV sequences. The EAV and SAV sequences must occupy, respectively, the first four and last four words of the digital horizontal blanking interval. Although an EAV sequence is easily generated from a transition of H (the rising edge is shown in Figure 8.10 and Figure 8.14), the generation of the SAV sequence must start four words before the opposite transition of H (the falling edge is shown in Figure 8.10 and Figure 8.14). This requires that the pipeline delay of the H control signal relative to the pixel data be changed depending on whether an EAV or SAV sequence is being generated, or that an H control signal four words shorter than the digital blanking interval be used.

After each SAV sequence, the stream of active data words always begins with a Cb sample, as shown in Figure 8.10 and Figure 8.14. In the multiplexed sequence, the co-sited samples (those that correspond to the same point on the picture) are grouped as Cb, Y, Cr. During all blanking intervals, unless ancillary data is present, Y values must be set to 16 (64 if a 10-bit system) and CrCb values set to 128 (512 if a 10-bit system).

At the receiver (decoder) the EAV and SAV sequences must be detected (by looking for the 8-bit FF_H 00_H 00_H preamble). The status word (optionally error corrected at the receiver, see Table 8.9) is used to recover the H, V, and F bits to produce even/odd field, vertical blanking, and horizontal blanking signals directly. Although the proper timing for the transition of H (the falling edge is shown in Figure 8.10 and Figure 8.14) from the SAV sequence is easily accomplished, the generation of the opposite transition of H (the rising edge is shown in Figure 8.10 and Figure 8.14) must start four words before the end of the EAV sequence. This requires that the pipeline delay of the H signal (relative to the pixel data)

	8-bit data								10-bit data	
	D9 (MSB)	D8	D7	D6	D5	D4	D3	D2	D1	D0
	1	1	1	1	1	1	1	1	1	1
preamble	0	0	0	0	0	0	0	0	0	0
	0	0	0	0	0	0	0	0	0	0
status word	1	F	V	H	P3	P2	P1	P0	0	0

Table 8.8. EAV and SAV Sequence.

Received D5–D2	Received F, V, H (Bits D8–D6)							
	000	001	010	011	100	101	110	111
0000	000	000	000	*	000	*	*	111
0001	000	*	*	111	*	111	111	111
0010	000	*	*	011	*	101	*	*
0011	*	*	010	*	100	*	*	111
0100	000	*	*	011	*	*	110	*
0101	*	001	*	*	100	*	*	111
0110	*	011	011	011	100	*	*	011
0111	100	*	*	011	100	100	100	*
1000	000	*	*	*	*	101	110	*
1001	*	001	010	*	*	*	*	111
1010	*	101	010	*	101	101	*	101
1011	010	*	010	010	*	101	010	*
1100	*	001	110	*	110	*	110	110
1101	001	001	*	001	*	001	110	*
1110	*	*	*	011	*	101	110	*
1111	*	001	010	*	100	*	*	*

* = uncorrectable error

Table 8.9. SAV and EAV Error Correction at Decoder.

be changed depending on whether an EAV or SAV sequence is being received, or that an H control signal four words shorter than the digital blanking interval be generated. The number of clock cycles between EAV sequences may be used to automatically configure the receiver for 525/60 or 625/50 operation.

8-bit/10-bit Parallel Transmission Interface

In the parallel interface format (SMPTE RP-125, EBU 3267, and within CCIR Recommendation 656), 8-bit or 10-bit data and a 27-MHz clock signal are transmitted using nine pairs (8-bit data) or eleven pairs (10-bit data) of cables. The individual bits are labeled Data 0–Data 9, with Data 9 being the most significant bit. The pin allocations for the signals are shown in Table 8.10. Equipment inputs and outputs both use 25-pin D-type subminiature female sockets so that interconnect cables can be used in either direction. Signal levels are compatible with ECL-compatible balanced drivers and receivers (although use of ECL technology is not specified). Transmission distances up to 50 m may be used; transmission distances greater than 50 m may require equalization.

Pin	Signal	Pin	Signal
1	clock	14	clock return
2	system ground A	15	system ground B
3	data 9 (MSB)	16	data 9 return
4	data 8	17	data 8 return
5	data 7	18	data 7 return
6	data 6	19	data 6 return
7	data 5	20	data 5 return
8	data 4	21	data 4 return
9	data 3	22	data 3 return
10	data 2	23	data 2 return
11	data 1	24	data 1 return
12	data 0	25	data 0 return
13	cable shield		

Table 8.10. Parallel Connector Contact Assignments. For 8-bit interfaces, data 9 through data 2 are used.

The generator must have a balanced output with a maximum source impedance of 110 Ω; the signal must be between 0.8 V peak-to-peak and 2.0 V peak-to-peak measured across a 110-Ω resistor connected to the output terminals without any transmission line. The transmitted clock signal is a 27-MHz square wave, with a clock pulse width of 18.5 ±3 ns. The positive transition of the clock signal occurs midway between data transitions with a tolerance of ±3 ns (as shown in Figure 8.16)—a difficult problem to solve without using adjustable delay lines and performing periodic tweaking. At the receiver, the transmission line must be terminated by 110 ±10 Ω.

To permit reliable operation at interconnect lengths greater than 50 m, the line receiver may require equalization, which should conform to the nominal characteristics shown in Figure 8.17. This characteristic enables operation with a range of cable lengths down to zero.

Due to many additional timing constraints not discussed here, the reader should obtain the relevant specifications before attempting an actual design.

Serial Transmission Interfaces

Use of the serial interface allows the digital video data to be transmitted down a single transmission line, using either a standard 75-Ω video coaxial cable or optical fiber. The serial interface was developed because it was thought that the parallel interface was impractical outside of the studio environment due to the size of cabling, large connectors, and limited cabling length. Equipment inputs and out-

CLOCK

TW

TD

TC

DATA

TW = 18.5 ± 3 NS

TC = 37 NS

TD = 18.5 ± 3 NS

Figure 8.16. Parallel Transmitted Waveforms (at Transmitter).

RELATIVE GAIN (DB)

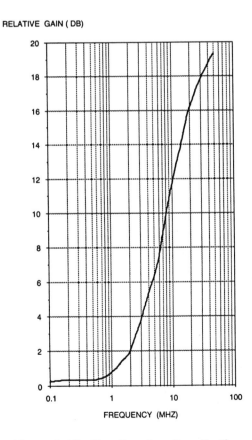

FREQUENCY (MHZ)

**Figure 8.17. Line Receiver Equalization
Characteristics for Small Signals.**

puts both use BNC-type sockets so that interconnect cables can be used in either direction.

Due to many additional timing constraints not discussed here, the reader should obtain any relevant specifications before attempting an actual design.

8-bit Serial Transmission Interface (243 Mbit per second)

Initially, an 8-bit serial protocol was developed (EBU 3247 and as a part of CCIR Recommendation 656). However, as these specifications do not support an upwardly compatible 10-bit environment, newer equipment has instead opted for the 270 Mbit per second serial interface (EBU 3267) described in the next section.

In the 243 Mbit-per-second serial protocol implementation (Figure 8.18), the 8-bit words are encoded to 9 bits as shown in Table 8.11 (to provide some measure of making the system polarity-free). For some 8-bit words, alternate 9-bit encoded words exist, as shown in columns 9B and 9B*, each 9-bit word being the complement of the other. In such cases, the 9-

bit word must be selected alternately from columns 9B and 9B* on each successive occasion that any such 8-bit word is conveyed (in the decoder, either 9-bit word must be converted back to the corresponding 8-bit word). The 9-bit parallel words are then serialized (the LSB is output first) using a 243-MHz clock (9 x 27 MHz) and transmitted in NRZ form. The 243-MHz clock is typically generated locally by using a PLL, multiplying the 27-MHz clock by nine. The voltage at the output terminal of the line driver shall increase on a transition from 0 to 1 (positive logic).

At the receiver, the 9 bits of data are deserialized, converted back to 8 bits, and output at a 27-MHz data rate. As clock information is not transmitted with the serial data, the receiver must generate a local 243-MHz clock that is phase-locked to the data stream. The use of 9-bit patterns simplifies this task by introducing more frequent transitions than would be present in the normal 8-bit data. Phase-lock synchronization is done by detecting the two all-zero words in the normal EAV and SAV sequences; encoded, each all-zero word contains a unique pattern—seven consecutive bits

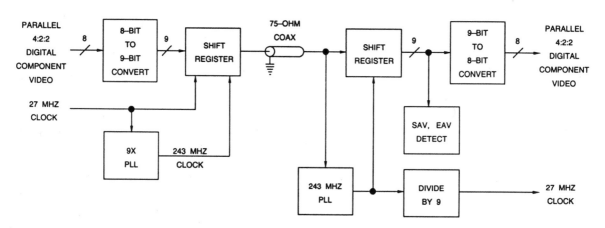

Figure 8.18. 243 Mbit-per-second Serial Interface Circuitry.

in	out	out	in	out	out	in	out	out	in	out	out	in	out	in	out	out
	9B	9B*		9B	9B*		9B	9B*		9B	9B*		9B		9B	9B*
00	0FE	101	2B	053		56	097		81	0AA		AC	12C	D7	0CC	
01	027		2C	1AC		57	168		82	055		AD	0D9	D8	139	
02	1D8		2D	057		58	099		83	1AA		AE	126	D9	0CE	
03	033		2E	1A8		59	166		84	0D5		AF	0E5	DA	133	
04	1CC		2F	059		5A	09B		85	12A		B0	11A	DB	0D8	
05	037		30	1A6		5B	164		86	095		B1	0E9	DC	131	
06	1C8		31	05B		5C	09D		87	16A		B2	116	DD	0DC	
07	039		32	05D		5D	162		88	0B5		B3	02E	DE	127	
08	1C5		33	1A4		5E	0A3		89	14A		B4	1D1	DF	0E2	
09	03B		34	065		5F	15C		8A	09A		B5	036	E0	123	
0A	1C4		35	19A		60	0A7		8B	165		B6	1C9	E1	0E4	
0B	03D		36	069		61	158		8C	0A6		B7	03A	E2	11D	
0C	1C2		37	196		62	025	1DA	8D	159		B8	1C5	E3	0E6	
0D	14D		38	026	1D9	63	0A1	15E	8E	0AC		B9	04E	E4	11B	
0E	0B4		39	08C	173	64	029	1D6	8F	153		BA	1B1	E5	0E8	
0F	14B		3A	02C	1D3	65	091	16E	90	0AE		BB	05C	E6	119	
10	1A2		3B	098	167	66	045	1BA	91	151		BC	1A3	E7	0EC	
11	0B6		3C	032	1CD	67	089	176	92	02A	1D5	BD	05E	E8	117	
12	149		3D	0BE	141	68	049	1B6	93	092	16D	BE	1A1	E9	0F2	
13	0BA		3E	034	1CB	69	085	17A	94	04A	1B5	BF	066	EA	113	
14	145		3F	0C2	13D	6A	051	1AE	95	094	16B	C0	199	EB	0F4	
15	0CA		40	046	1B9	6B	08A	175	96	0A8	157	C1	06C	EC	10D	
16	135		41	0C4	13B	6C	0A4	15B	97	0B7	148	C2	193	ED	076	
17	0D2		42	04C	1B3	6D	054	1AB	98	0F5	10A	C3	06E	EE	10B	
18	12D		43	0C8	137	6E	0A2	15D	99	0BB	144	C4	191	EF	0C7	
19	0D4		44	058	1A7	6F	052	1AD	9A	0ED	112	C5	072	F0	13C	
1A	129		45	0B1		70	056		9B	0BD	142	C6	18D	F1	047	
1B	0D6		46	14E		71	1A9		9C	0EB	114	C7	074	F2	1B8	
1C	125		47	0B3		72	05A		9D	0D7	128	C8	18B	F3	067	
1D	0DA		48	14C		73	1A5		9E	0DD	122	C9	07A	F4	19C	
1E	115		49	0B9		74	06A		9F	0DB	124	CA	189	F5	071	
1F	0EA		4A	06B		75	195		A0	146		CB	08E	F6	198	
20	0B2		4B	194		76	096		A1	0C5		CC	185	F7	073	
21	02B		4C	06D		77	169		A2	13A		CD	09C	F8	18E	
22	1D4		4D	192		78	0A9		A3	0C9		CE	171	F9	079	
23	02D		4E	075		79	156		A4	136		CF	09E	FA	18C	
24	1D2		4F	18A		7A	0AB		A5	0CB		D0	163	FB	087	
25	035		50	08B		7B	154		A6	134		D1	0B8	FC	186	
26	1CA		51	174		7C	0A5		A7	0CD		D2	161	FD	0C3	
27	04B		52	08D		7D	15A		A8	132		D3	0BC	FE	178	
28	1B4		53	172		7E	0AD		A9	0D1		D4	147	FF	062	19D
29	04D		54	093		7F	152		AA	12E		D5	0C6			
2A	1B2		55	16C		80	155		AB	0D3		D6	143			

Table 8.11. 8-bit to 9-bit Encoding Table.

of all zeros or all ones. The 243-MHz PLL is continuously adjusted slightly each scan line to ensure that these patterns are detected and to avoid bit slippage. The 243-MHz clock is divided by nine to generate the 27-MHz output clock for the 8-bit parallel data.

The generator has an unbalanced output with a source impedance of 75 Ω; the signal must be 0.4 V to 0.7 V peak-to-peak measured across a 75-Ω resistor connected to the output terminals. The receiver has an input impedance of 75 Ω.

10-bit Serial Transmission Interface (270 Mbit per second)

To support both the 8-bit and 10-bit environment, a 270 Mbit-per-second serial protocol, EBU 3267, was developed (Figure 8.19). This protocol makes use of 10 bits of parallel data latched at 27 MHz. A ten times PLL generates a 270-MHz clock from the 27-MHz clock signal. The 10 bits of data are serialized (LSB first) and processed using a scrambled NRZI format as follows:

$$G(x) = (x^9 + x^4 + 1)(x + 1)$$

The input signal to the scrambler (Figure 8.20) must use positive logic (the highest voltage represents a logical one; lowest voltage represents a logical zero). The formatted serial data is output at a 270 Mbit-per-second rate. At the receiver, phase-lock synchronization is done by detecting the EAV and SAV sequences. The 270-MHz PLL is continuously adjusted slightly each scan line to ensure that these patterns are detected and to avoid bit slippage. The 270-MHz clock is divided by ten to generate the 27-MHz output clock for the 10-bit parallel data. The serial data is low- and high-frequency equalized, inverse scrambling performed (Figure 8.21), and deserialized.

The generator has an unbalanced output with a source impedance of 75 Ω; the signal must be 0.8 V ±10% peak-to-peak measured across a 75-Ω resistor connected to the output terminals. The receiver has an input impedance of 75 Ω.

In an 8-bit environment, before serialization, 00_H and FF_H values must be expanded to 10-bit values of 000_H and $3FF_H$, respectively. All other 8-bit data is appended with two least significant "0" bits before serialization.

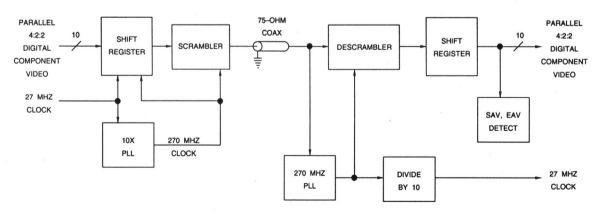

Figure 8.19. 270 Mbit-per-second Serial Interface Circuitry.

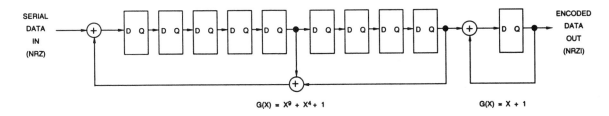

Figure 8.20. Typical Scrambler Circuit.

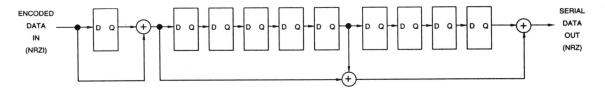

Figure 8.21. Typical Descrambler Circuit.

Decoding (using 4:4:4 Sample Rates)

In digital decoding (shown in Figure 8.22) the 4:2:2 data stream is input and the video timing signals (H, V, and F) are recovered from the EAV and SAV sequences. At this time, any ancillary information is also detected and output for further processing. The decoder design should be robust enough to ignore 0 and 255 code words, except during EAV, SAV, and ancillary preamble sequences. During the loss of an input signal, the decoder should provide the option to either be transparent (so the input source can be monitored), to auto-freeze the output data (to compensate for short duration dropouts), or to autoblack the output data (to avoid potential problems driving a mixer or video tape recorder). YCrCb and RGB ranges are assumed to be 0–255 (8-bit data).

The 4:2:2 YCrCb data is demultiplexed and converted to 4:4:4 YCrCb data by generating additional Cr and Cb samples (using interpolation filters) that are interleaved with the original Cr and Cb samples. Care must be taken that the original Cr and Cb samples pass through unchanged, and that the interpolated values replace the values that were decimated by the encoding process. Not shown are the digital delay adjustments between YCrCb data to ensure that the video data are pipelined-aligned due to the differences in digital filter delays.

Using the inverse of the encoding equations, the 4:4:4 YCrCb data is converted to gamma-corrected digital RGB:

$$R' = Y + 1.366(Cr - 128) - 0.002(Cb - 128)$$
$$G' = Y - 0.700(Cr - 128) - 0.334(Cb - 128)$$
$$B' = Y - 0.006(Cr - 128) + 1.732(Cb - 128)$$

The resulting gamma-corrected RGB values have a nominal range of 16–235, with occasional excursions into the 1–15 and 236–254 values (due to Y and CrCb occasionally going outside the 16–235 and 16–240 ranges, respectively).

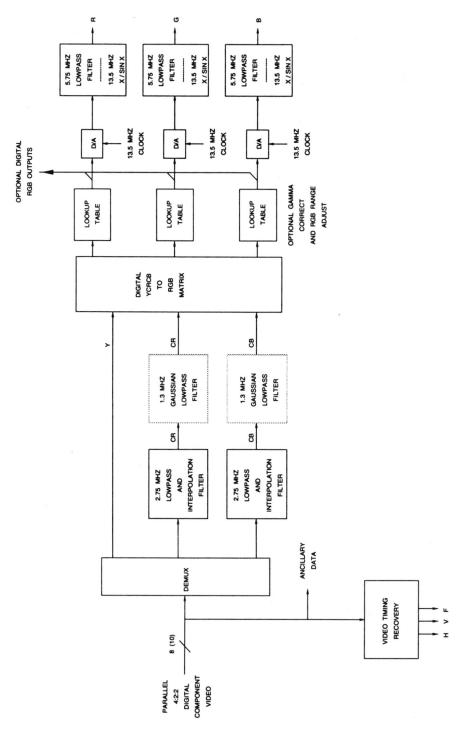

Figure 8.22. 4:2:2 Decoding using 4:4:4 Sample Rates.

If the desired RGB data range is 0–255, as is commonly found in computer systems, there are other alternatives. For example, the following equations may be used:

$$R' = 1.164(Y - 16) + 1.596(Cr - 128)$$
$$G' = 1.164(Y - 16) - 0.813(Cr - 128)$$
$$- 0.391(Cb - 128)$$
$$B' = 1.164(Y - 16) + 2.018(Cb - 128)$$

ROM lookup tables may be used to perform the multiplications and a minimum of 8 bits of fractional data should be maintained with the final results rounded to the desired accuracy. The gamma-corrected RGB data must be saturated at 255 (on overflow) and 0 (on underflow) to prevent any overflow and underflow errors from occurring due to Y and CrCb occasionally going outside the 16–235 and 16–240 ranges, respectively. After the YCrCb-to-RGB matrix, ROM or RAM lookup tables may be used to remove gamma correction.

For computer applications, the gamma-correction may be removed to generate linear RGB data (values are normalized to have a value of 0 to 1):

for R', G', B' < 0.0812

$$R = R'/4.5$$
$$G = G'/4.5$$
$$B = B'/4.5$$

for R', G', B' ≥ 0.0812

$$R = ((R' + 0.099)/1.099)^{2.2}$$
$$G = ((G' + 0.099)/1.099)^{2.2}$$
$$B = ((B' + 0.099)/1.099)^{2.2}$$

For 625/50 systems, the 2.2 exponent would be replaced with a value of 2.8. Having the ability to bypass or reconfigure the lookup tables is almost a necessity, since either linear or gamma-corrected RGB data may be needed

by the system. The digital RGB data may also be converted to analog RGB signals by D/A converters and lowpass filtered.

RGB Filtering

The RGB analog lowpass filters after the D/A converters have the same characteristics as the analog RGB filters on the input of the A/D converters shown in Figure 8.3, and all the same considerations apply. The characteristics are shown in Figure 8.4 and Table 8.5. The output filter removes the high-level repeated spectra produced by the sampling process. The sample-and-hold action of the D/A converter introduces a sin x/x characteristic, which must be compensated for in the analog output filter. The filter characteristics in Figure 8.4 ignore the sin x/x correction required when used for the analog output filter.

CrCb Filtering

Two types of CrCb lowpass and interpolation filters are required for the decoding. If subsequent digital processing is to be done, lowpass filters having the same characteristics as the CrCb digital lowpass filters shown in Figure 8.3 should be used, and the same discussion applies. The characteristics for these sharp roll-off filters are shown in Figure 8.5 and Table 8.6. The stopband attenuation is –55 dB, rather than –40 dB as in the analog filtering case, because there is no attenuation from sin x/x sample-and-hold loss. If the data is to be used for the generation of composite video, slow roll-off Gaussian lowpass filters (having an attenuation of about 6 dB at 2 MHz) should be used to minimize ringing.

Interpolation to 13.5 MHz introduces no sample-and-hold loss, so sin x/x correction is not required for the interpolation filters. The Gaussian characteristics, where needed, may be incorporated with the interpolation filtering

or implemented separately after the interpolation process.

Decoding (using 4:2:2 Sample Rates)

In digital decoding (shown in Figure 8.23) the 4:2:2 data stream is input and the video timing signals (H, V, and F) recovered from the EAV and SAV sequences. At this time, any ancillary information is also detected and output for further processing. The decoder design should be robust enough to ignore 0 and 255 code words, except during EAV, SAV, and ancillary preamble sequences. During the loss of an input signal, the decoder should have the option to either be transparent (so the input source can be monitored), auto-freeze the output data (to compensate for short duration dropouts), or autoblack the output data (to avoid potential problems driving a mixer or

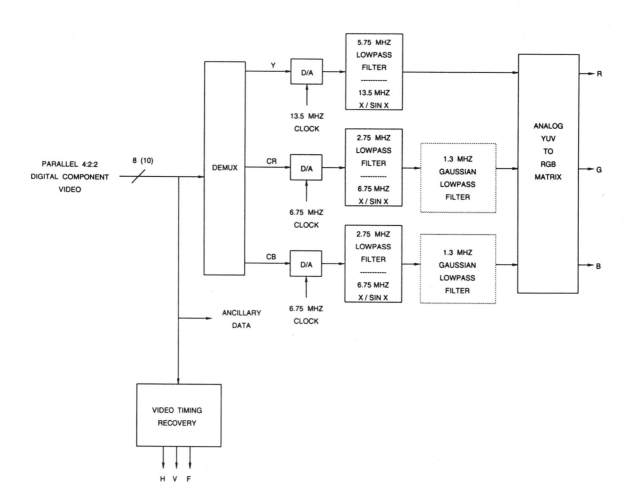

Figure 8.23. 4:2:2 Decoding using 4:2:2 Sample Rates.

video tape recorder). Note that YCrCb and RGB ranges are assumed to be 0–255 (8-bit data).

The 4:2:2 YCrCb data is demultiplexed into Y, Cr, and Cb, each driving a D/A converter to generate analog YUV data. The outputs of the D/A converters are lowpass filtered (and include sin x/x correction) as shown. The analog YUV data is converted to gamma-corrected analog RGB using the following equations:

$$R' = Y + 1.402V$$
$$G' = Y - 0.714V - 0.344U$$
$$B' = Y + 1.772U$$

Luminance Filtering

The luminance analog lowpass filter after the D/A converter has the same characteristics as the analog RGB filters on the input of the A/D converters shown in Figure 8.3, and all the same considerations apply. The characteristics are shown in Figure 8.4 and Table 8.5. The output filter removes the high-level repeated spectra produced by the sampling process. The sample-and-hold action of the D/A converter introduces a sin x/x characteristic, which must be compensated for in the analog output filter. The filter characteristics in Figure 8.4 ignore the sin x/x correction required when used for the analog output filter.

Color Difference Filtering

The color difference analog lowpass filter after the D/A converters have the same characteristics as the analog color difference filters on the input of the A/D converters shown in Figure 8.6, and all the same considerations apply. The characteristics are shown in Figure 8.7 and Table 8.7. The output filters remove the high-level repeated spectra produced by the sampling process. The sample-

and-hold action of the D/A converter introduces a sin x/x characteristic, which must be compensated for in the analog output filter. The filter characteristics in Figure 8.7 ignore the sin x/x correction required when used for the analog output filter.

If the analog YUV data is to be used for the generation of composite video, slow roll-off Gaussian lowpass filters (having an attenuation of about 6 dB at 2 MHz) should be used to minimize ringing.

Ancillary Data

Ancillary data enables the transmission of various control data (such as digital audio, scan line numbers, error checking, field numbering, etc.) during the blanking intervals. Design of the digital video encoder must ensure that ancillary information is not generated during active video or while the EAV and SAV sequences are present in the data stream. As the implementation of ancillary data formats is being continuously worked on and updated, a designer should obtain the latest specifications before starting a design.

Unless it is the intended function of a particular piece of equipment, ancillary data must not be modified by that equipment.

Audio Note

Although digital audio may be transmitted as ancillary information, most current 4:2:2 digital VTRs accept digital audio using the AES/EBU audio protocol (AES3 or ANSI S4.40) with an audio sample rate of 48 kHz. The 48 kHz samples of the audio data are locked to the video as follows:

525-line system: 48 kHz = (1144/375) F_H

625-line system: 48 kHz = (384/125) F_H

Ancillary Data (525-Line Systems)

During all horizontal blanking intervals, up to 268 words, including preamble(s), can be transmitted in the interval starting with the end of the EAV and terminating with the beginning of SAV. Multiple ancillary sequences may therefore be sent in a horizontal blanking interval. If a 10-bit transmission interface is used, either 8-bit or 10-bit horizontal ancillary (HANC) data may be transmitted. If an 8-bit transmission interface is used, only 8-bit HANC data may be transmitted.

During vertical blanking, up to 1440 words, including preamble(s), may be transmitted in the interval starting with the end of the SAV and terminating with the beginning of EAV. Thus, multiple ancillary sequences may be sent in a vertical blanking interval. Only 8-bit ancillary data may be transmitted, even if a 10-bit transmission interface is used. Vertical ancillary (VANC) data is allowed only in the active portion of lines 1–19 and 264–282, inclusive, and only if active video is not being transmitted.

Ancillary sequences consist of a preamble, followed by a data ID word (to indicate the type of data), the data word count, and finally, the actual data, as shown in Table 8.12.

Lines 14 and 277 may be reserved for digital vertical interval timecode (DVITC) and video index. The DVITC is proposed to be carried by the luminance (Y) data in the active portion of lines 14 and 277. Note that these correspond to line numbers 11 and 273 in Figure 5.21, for the NTSC encoder discussed in Chapter 5. The video index, which would specify things about the video signal such as format, filtering, etc., is proposed to be carried by the color difference (CrCb) data in the active portion of lines 14 and 277.

The data ID specifies the ID number of the ancillary sequence, indicating the type of data being sent. It may not use the 8-bit values 00_H or FF_H (10-bit values 000_H–003_H and $3FC_H$–$3FF_H$).

	8-bit data								10-bit data	
	D9 (MSB)	D8	D7	D6	D5	D4	D3	D2	D1	D0
preamble	0	0	0	0	0	0	0	0	0	0
	1	1	1	1	1	1	1	1	1	1
	1	1	1	1	1	1	1	1	1	1
data ID	x	x	x	x	x	x	x	x	x	x
data word count	0	L11	L10	L9	L8	L7	L6	op	0	0
	0	L5	L4	L3	L2	L1	L0	op	0	0
data word(s)	x	x	x	x	x	x	x	x	x	x
					:					
	x	x	x	x	x	x	x	x	x	x

Table 8.12. Ancillary Data Sequence.

The data word count indicates the data word count or video line number (the range is 1–1434), and is specified as a 12-bit binary value (L0–L11, L11 is the MSB); the "op" value is an odd parity bit for D3–D9. When used to transmit the video line number, the line number is transmitted by the data word count value and no data words follow.

Data words may not use the 8-bit values 00_H or FF_H (10-bit values $000_H–003_H$ and $3FC_H–3FF_H$).

Ancillary Data (625-Line Systems)

During horizontal blanking, up to 280 words, including preamble(s), can be transmitted in the interval starting with the end of the EAV and terminating with the beginning of SAV. Multiple ancillary sequences may therefore be sent in a horizontal blanking interval. If a 10-bit transmission interface is used, either 8-bit or 10-bit horizontal ancillary (HANC) data may be transmitted. If an 8-bit transmission interface is used, only 8-bit HANC data may be transmitted.

During vertical blanking, up to 1440 words, including preamble(s), may be transmitted in the interval starting with the end of the SAV and terminating with the beginning of EAV. Multiple ancillary sequences may be sent in a vertical blanking interval. Only 8-bit ancillary data may be transmitted, even if a 10-bit transmission interface is used. Lines 20 and 333 are reserved for equipment self-checking purposes.

Ancillary sequences consist of a preamble, followed by a data ID word (to indicate the type of data), the data word count, and finally, the actual data, as shown in Table 8.12.

The data ID specifies the ID number of the ancillary sequence, indicating the type of data being sent. It may not use the 8-bit values 00_H or FF_H (10-bit values $000_H–003_H$ and $3FC_H–3FF_H$). An ancillary preamble followed by an 8-bit data ID value of 15_H indicates that there is no further ancillary data on that scan line. Insertion of additional ancillary data on the scan line requires the replacement of the 15_H data ID with the desired data ID, inserting the data word count and data words, followed immediately by a preamble with a data ID of 15_H to indicate that there is no further ancillary data.

The data word count indicates the data word count or video line number (the range is 1–1434), and is specified as a 12-bit binary value (L0–L11, L11 is the MSB); the "op" value is an odd parity bit for D3–D9. When used to transmit the video line number, the line number is transmitted by the data word count value and no data words follow.

Data words may not use the 8-bit values 00_H or FF_H (10-bit values $000_H–003_H$ and $3FC_H–3FF_H$). Note that the original 8-bit specifications called for the LSB (D2) to be an odd parity bit; this has been deleted from the 10-bit specifications.

4:4:4:4 (4 x 4) Format

After the 4:2:2 digital component standards were developed, a need developed within the studio environment for a higher bandwidth transmission link to support full-bandwidth CCIR601 resolution video and graphics. In addition, support for an additional channel (of the same bandwidth as luminance) to support such functions as keying was required. Work has therefore begun on a 4:4:4:4 (also referred to as 4 x 4) superset to the 4:2:2 hierarchy.

Note that 4 x 4 digital component video is similar to 4:2:2 digital component video. However, there are four fundamental differences.

First, either YCrCb or RGB data may be transmitted. Second, an additional channel of data (such as keying) is also transmitted. Third, 10-bit data is transmitted to support the higher-quality requirements of the broadcast and graphics industry. Fourth, all four channels of data have the same bandwidth (5.75 MHz) and are sampled at 13.5 MHz. Table 8.13 describes the 4 × 4 parameters.

Parameters	525/60 systems	625/50 systems
Coded signals: YCrCb or RGB	These signals are obtained from gamma precorrected signals, namely: Y, R′ – Y, B′ – Y or R′, G′, B′.	
Number of samples per total line: - each of 3 video components - auxiliary channel	858 858	864 864
Sampling structure	Orthogonal, line, field and frame repetitive. The three sampling structures to be coincident and coincident also with the luminance sampling structure of the 4:2:2 family member.	
Sampling frequency: - each of 3 video components - auxiliary channel	13.5 MHz 13.5 MHz The tolerance for the sampling frequencies should coincide with the tolerance for the line frequency of the relevant color television standard.	
Form of coding	Uniformly quantized PCM, 10 bits per sample	
Number of samples per digital active line: - each of 3 video components - auxiliary channel	720 720	
Analog-to-digital horizontal timing relationship: - from end of digital active line to 0_H	16 luminance clock periods	12 luminance clock periods
Correspondence between video signal levels and the quantization level for each sample: - scale - luminance or R, G, B signal and A signal - each color difference signal	0 to 1023 877 quantization levels with the black level corresponding to level 64 and the peak level corresponding to level 940. The signal level may occasionally excurse beyond level 940. 897 quantization levels in the center part of the quantization scale with zero signal corresponding to level 512.	

Table 8.13. Encoding Parameter Values for 4:4:4:4 Digital Component Video.

Two quasi–4:2:2–type transmission links are used. Link A contains all the luminance samples plus those Cr and Cb samples that are located at even-numbered sample points. Link B contains samples from the keying channel and the Cr and Cb samples from the odd-numbered sampled points. While it may be common to refer to Link A as 4:2:2 and Link B as 2:2:4, Link A is not a true 4:2:2 signal since the color difference data was sampled at 13.5 MHz, rather than 6.75 MHz.

Coding Ranges

The 10-bit coding levels correspond to a range of 1023 levels (0 to 1023 decimal or 000_H to $3FF_H$). Levels 0–3 and 1020–1023 are reserved for timing information, leaving levels 4–1019 for the actual signal values. The nominal luminance (or RGB) levels are 64 to 940, while the nominal color difference levels are 64 to 960 (with 512 equal to zero). Occasional excursions into the other levels are permissible, but never at the 0–3 or 1020–1023 levels. The 10-bit YCrCb levels to generate a 75% amplitude, 100% saturation color bar signal are shown in Table 8.14.

Gamma-corrected digital RGB signals with a 64–940 range are converted to YCrCb using the following equations:

$$Y = (306/1024) R' + (601/1024)G' + (117/1024) B'$$
$$Cr = (730/1024) (R' - Y) + 512$$
$$Cb = (578/1024) (B' - Y) + 512$$

YCrCb data is converted to digital gamma-corrected RGB as follows:

$$R' = Y + (1436/1024) (Cr - 512)$$
$$G' = Y - (731/1024) (Cr - 512) - (352/1024) (Cb - 512)$$
$$B' = Y + (1815/1024) (Cb - 512)$$

525-Line System Timing

As there are 858 samples per scan line (numbered 0–857) and four video channels are used, a total of 3432 words per scan line are available. 2880 words per scan line are used for active video, consisting of 720 words for the active period of the YCrCb (or RGB) and Auxiliary (A) video data. The remaining words con-

	Nominal Range	White	Yellow	Cyan	Green	Magenta	Red	Blue	Black
Y	64 to 940	720	644	524	448	336	260	140	64
Cr	64 to 960 (512 = zero)	512	568	176	232	792	848	456	512
Cb	64 to 960 (512 = zero)	512	176	624	288	736	100	848	512

Table 8.14. 75% Amplitude, 100% Saturation 10-bit YCrCb Color Bars.

tain EAV (end of active video), SAV (start of active video), and ancillary information.

The 3432 total words per scan line are separated into two data streams (link A and link B) each consisting of 1716 words (numbered 0–1715), 1440 of which represent active video. Link A contains all the Y data plus even-numbered Cr and Cb data (0, 2, 4,...718). Link B contains all the auxiliary (A) data plus odd-numbered Cr and Cb data (1, 3, 5,...719).

For both Link A and Link B, words 0–1439, inclusive, contain active video. Words 1440–1443 are reserved for EAV sequences; words 1712–1715 are reserved for the SAV sequence. The remaining 268 words may be used for ancillary information. The half-amplitude point of the leading edge of the analog horizontal sync signal corresponds to word number 1473.

Figure 8.24 illustrates the horizontal timing relationship. The vertical timing is the same as that described for 4:2:2 digital component video.

625-Line System Timing

As there are 864 samples per scan line (numbered 0–863) and four video channels are used, a total of 3456 words per scan line are available. 2880 words per scan line are used for active video, consisting of 720 words for the active period of the YCrCb (or RGB) and Auxiliary (A) video data. The remaining words contain EAV (end of active video), SAV (start of active video), and ancillary information.

The 3456 total words per scan line are separated into two data streams (link A and link

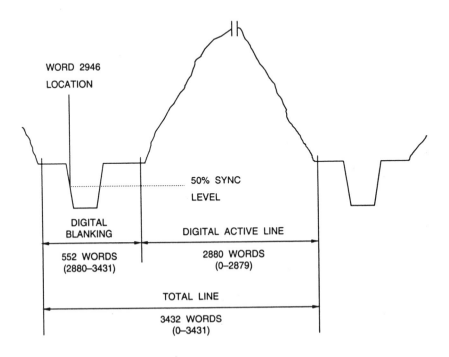

WORD 2946
LOCATION

50% SYNC
LEVEL

DIGITAL
BLANKING

DIGITAL ACTIVE LINE

552 WORDS
(2880–3431)

2880 WORDS
(0–2879)

TOTAL LINE

3432 WORDS
(0–3431)

Figure 8.24. 525/60 Horizontal Sync Relationship.

B) each consisting of 1728 words (numbered 0–1727), 1440 of which represent active video. Link A contains all the Y data plus even-numbered Cr and Cb data (0, 2, 4, ...718). Link B contains all the auxiliary (A) data plus odd-numbered Cr and Cb data (1, 3, 5, ...719).

For both link A and link B, words 0–1439, inclusive, contain active video. Words 1440–1443 are reserved for EAV sequences; words 1724–1727 are reserved for the SAV sequence. The remaining 280 words may be used for ancillary information. The half-amplitude point of the leading edge of the analog horizontal sync signal corresponds to word number 1465.

Figure 8.25 illustrates the horizontal timing relationship. The vertical timing is the same as that described for 4:2:2 digital component video.

Multiplexing Structure

Figure 8.26 shows contents of link A and link B when transmitting YCrCbA video data. Figure 8.27 illustrates the structure when transmitting RGBA video data. If the auxiliary signal (A) is not present, the A sample values have a 10-bit value of 940.

The YCrCbA video data words are multiplexed in the order shown in Figure 8.28 and Figure 8.29. When RGBA video signals are transmitted, the G samples are sent in the Y locations, the R samples are sent in the Cr locations, and the B samples are sent in the Cb locations.

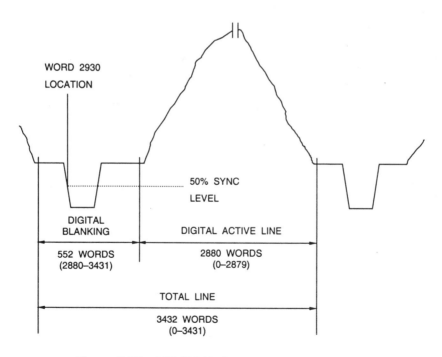

Figure 8.25. 625/50 Horizontal Sync Relationship.

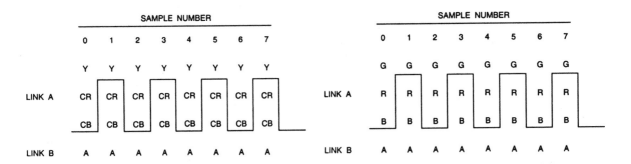

Figure 8.26. Link Content Representation for YCrCbA Video Signals.

Figure 8.27. Link Content Representation for RGBA Video Signals.

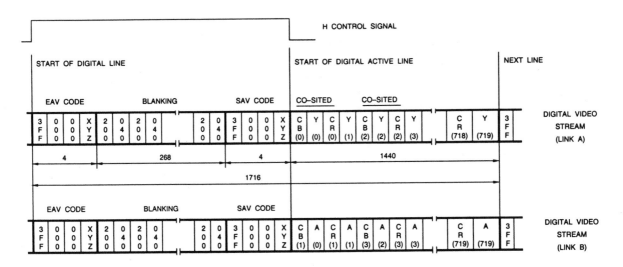

NOTE: IF "A" INFORMATION IS NOT PRESENT, THEN THE "A" SAMPLES MUST BE SET TO VALUE 940 (10-BIT VALUE).

Figure 8.28. 525/60 Digital Horizontal Blanking.

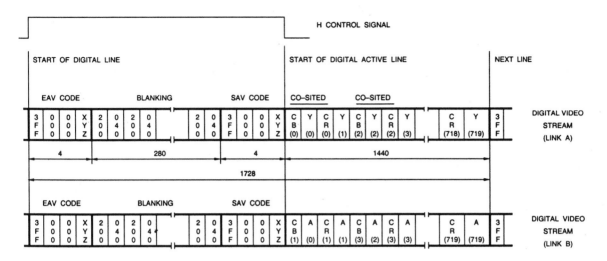

NOTE: IF "A" INFORMATION IS NOT PRESENT, THEN THE "A" SAMPLES MUST BE SET TO VALUE 940 (10-BIT VALUE).

Figure 8.29. 625/50 Digital Horizontal Blanking.

Video Test Signals

Several industry-standard video test signals are being developed for the 4:2:2 environment to help test the relative quality of the encoders and decoders, and perform calibration. Most of the test signals reviewed here are discussed in CCIR Report 1212. Although the YCrCb sample numbering starts with (1) in CCIR Report 1212, our YCrCb samples start with (0) for consistency with the rest of the chapter. For test signals that calculate a YCrCb value based on the sample number, we have modified the equations for calculating the value so as to achieve the same result.

100/0/75/0 Color Bars

This color bar test signal assumes a rise and fall time of 150 ns for Y and 300 ns for Cr and Cb (measured between the 10% and 90% points). The Y values are given in Table 8.15 and the Cr and Cb values are listed in Table 8.16. This test is valid for both 525/60 and 625/50 systems.

100/0/100/0 Color Bars

This color bar test signal assumes a rise and fall time of 150 ns for Y and 300 ns for Cr and Cb (measured between the 10% and 90% points). The Y values are given in Table 8.17 and the Cr and Cb values are listed in Table 8.18. This test is valid for both 525/60 and 625/50 systems.

White End-of-Line Porches

This test signal has no shaping of the Y at the ends of the digital active line and may be used to monitor the analog shaping of the line blanking by 4:2:2 decoders. Two pulses with a rise and fall time of 300 ns are placed 3 μs from the leading and trailing edges of 625/

i	0–14	15	16	17	18–100	101	102	103	104–185
Y (i)	16	39	126	212	235	227	198	169	162
i	186	187	188	189	190–272	273	274	275	276–358
Y (i)	161	158	146	134	131	129	122	114	112
i	359	360	361	362–444	445	446	447	448–530	531
Y (i)	109	98	87	84	82	74	67	65	62
i	532	533	534–616	617	618	619	620–719		
Y (i)	50	38	35	33	25	18	16		

Table 8.15. Y Values for 100/0/75/0 Color Bars.

i	0–49	50	51	52	53–91	92	93	94	95
Cr (i)	128	129	135	140	142	141	132	93	54
Cb (i)	128	119	86	53	44	44	56	100	145
(i)	96–135	136	137	138	139	140–177	178	179	180
Cr (i)	44	45	51	56	58	58	58	72	128
Cb (i)	156	148	114	81	73	72	73	84	128
i	181	182	183–220	221	222	223	224	225–264	265
Cr (i)	184	198	198	198	200	205	211	212	202
Cb (i)	172	183	184	183	175	142	108	100	111
i	266	267	268	269–307	308	309	310	311–359	
Cr (i)	163	124	115	114	116	121	127	128	
Cb (i)	156	200	212	212	203	170	137	128	

Table 8.16. CrCb Values for 100/0/75/0 Color Bars.

i	0–14	15	16	17	18–100	101	102	103	104–186
Y (i)	16	39	126	212	235	232	223	213	210
i	187	188	189	190–271	272	273	274	275	276–357
Y (i)	206	190	174	170	169	167	157	147	145
i	358	359	360	361	362	363–444	445	446	447
Y (i)	144	141	126	110	107	106	104	94	84
i	448	449–530	531	532	533	534–616	617	618	619
Y (i)	82	81	77	61	45	41	38	28	19
i	620–719								
Y (i)	16								

Table 8.17. Y Values for 100/0/100/0 Color Bars.

i	0–49	50	51	52	53–92	93	94	95	96–135
Cr (i)	128	130	137	144	146	133	81	29	16
Cb (i)	128	116	72	28	16	31	91	150	166
(i)	136	137	138	139–177	178	179	180	181	182
Cr (i)	18	25	32	34	35	54	128	202	221
Cb (i)	154	110	65	54	54	69	128	187	202
i	183–221	222	223	224	225–264	265	266	267	268–307
Cr (i)	222	224	231	238	240	227	175	123	110
Cb (i)	202	191	146	102	90	106	165	225	240
i	308	309	310	311–359					
Cr (i)	112	119	126	128					
Cb (i)	228	184	140	128					

Table 8.18. CrCb Values for 100/0/100/0 Color Bars.

50 analog line blanking, allowing monitoring of the transitions. For this test, Cr and Cb both have values of 128. The Y values are given in Table 8.19.

Blue End-of-Line Porches

This test signal is a variation of the white end-of-line porches, and may be used to monitor what happens for high transitions of Cb. For

this test, Cr has a value of 110 and Y has a value of 41. The Cb values are given in Table 8.20. This test is valid for both 525/60 and 625/50 systems.

Red End-of-Line Porches

This test signal is a variation of the white end-of-line porches, and may be used to monitor what happens for high transitions of Cr. For

i	0–46	47	48	49	50	51	52	53	54
Y (i)	235	232	218	187	139	86	46	24	17
i	55–667	668	669	670	671	672	673	674	675
Y (i)	16	19	33	64	112	165	205	227	234
i	676–719								
Y (i)	235								

Table 8.19. Y Values for White End-of-Line Porches.

i	0–23	24	25	26	27–333	334	335	336	337
Cb (i)	240	232	191	143	128	130	152	204	236
i	338–359								
Cb (i)	240								

Table 8.20. Cb Values for Blue End-of-Line Porches.

this test, Cb has a value of 90 and Y has a value of 81. The Cr values are given in Table 8.21. This test is valid for both 525/60 and 625/50 systems.

Yellow End-of-Line Porches

This test signal is a variation of the white end-of-line porches, and may be used to monitor what happens for low transitions of Cb. For this test, Cr has a value of 146 and Y has a value of 210. The Cb values are given in Table

8.22. This test is valid for both 525/60 and 625/50 systems.

Cyan End-of-Line Porches

This test signal is a variation of the white end-of-line porches, and may be used to monitor what happens for low transitions of Cr. For this test, Cb has a value of 166 and Y has a value of 170. The Cr values are given in Table 8.23. This test is valid for both 525/60 and 625/50 systems.

i	0–23	24	25	26	27–333	334	335	336	337
Cr (i)	240	232	191	143	128	130	152	204	236
i	338–359								
Cr (i)	240								

Table 8.21. Cr Values for Red End-of-Line Porches.

i	0–23	24	25	26	27–333	334	335	336	337
Cb (i)	16	24	65	113	128	126	104	52	20
i	338–359								
Cb (i)	16								

Table 8.22. Cb values for Yellow End-of-Line Porches.

i	0–23	24	25	26	27–333	334	335	336	337
Cr (i)	16	24	65	113	128	126	104	52	20
i	338–359								
Cr (i)	16								

Table 8.23. Cr Values for Cyan End-of-Line Porches.

End-of-Line Pulses

This test signal may be used to check the position of the digital active line relative to the analog line. The outside edges of the two internal pulses coincide with the ends of the line displayed on 625/50 systems. For this test, both Cr and Cb have a value of 128. The Y values are given in Table 8.24.

Black/White Ramp

This test signal may be used to check the existence and position of quantization levels 1–254

of the luminance signal. For this test, both Cr and Cb have a value of 128. The Y values are given in Table 8.25. In instances where a calculation has a remainder, it is dropped and only the integer is used. This test is valid for both 525/60 and 625/50 systems.

YCrCb Ramp

This test signal enables checking any demultiplexing and remultiplexing operations. The Y, Cr, and Cb values are given in Table 8.26 for the 1440 samples of the multiplexed digital

i	0	1	2	3	4	5	6–9	10	11
Y (i)	16	44	154	235	154	44	16	17	64
i	12	13	14	15	16–705	706	707	708	709
Y (i)	185	229	121	31	16	17	64	185	229
i	710	711	712–713	714	715	716	717	718	719
Y (i)	121	31	16	44	154	235	154	44	16

Table 8.24. Y Values for End-of-Line Pulses.

i	0–20	21	22	23	24–59	60–87	88–99	100–535	536–549
Y (i)	16	14	9	3	1	(i – 56)/2	16	(i – 66)/2	235
i	550–585	586–559	600	601	602	603	604	605–719	
Y (i)	(i – 78)/2	254	250	217	135	53	20	16	

Table 8.25. Y Values for Black/White Ramp.

i	0–253	254–507	508–761	762–1015	1016–1269	1270–1439
F (i)	1	508 –i	i – 507	1016 – i	i – 1015	1524 – i

Table 8.26. YCrCb Values for YCrCb Ramp.

active line. This test is valid for both 525/60 and 625/50 systems.

Red Field

The Red Field signal consists of a 75% amplitude, 100% saturation red signal (Y = 65, Cr = 212, Cb = 100). This is useful as the human eye is sensitive to static noise intermixed in a red field. Distortions that cause small errors in picture quality can be visually examined for the effect on the picture. This test is valid for both 525/60 and 625/50 systems.

VLSI Solutions

This section is an overview of commercially available VLSI solutions for implementing 4:2:2 digital component video.

Encoders and Decoders

The STV3300 from SGS-Thomson Microelectronics (Figure 8.30) is a 4:2:2 decoder, accepting 8 bits of Y and 8 bits of multiplexed Cr and Cb, and generating 24 bits of digital RGB. Y input data is two times oversampled and filtered using a 19-order luminance filter that includes sin x/x attenuation compensation of external D/A conversion. Cr and Cb input data are oversampled by four times, with four different cut-off frequencies user-selectable. Only a 27-MHz RGB output rate is supported (Y and CrCb data is input every other clock cycle as controlled by the SYNC input). The MAC control input configures the chrominance signals to be compatible with MAC (multiplexed analog components) levels by dividing the Cr and Cb samples by 1.3 (approximated by multiplying by 0.75). Features of the STV3300 include:

- 8-bit Y and 8-bit Multiplexed CrCb Inputs
- Four Selectable CrCb Filters
- Lowpass Y Filter
- YCrCb to RGB Conversion
- TTL Compatible Inputs and Outputs
- +5 V Monolithic CMOS
- 52-pin PLCC Package

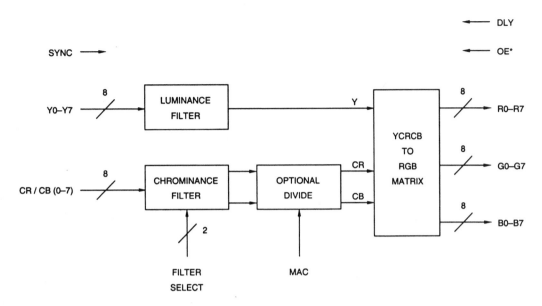

Figure 8.30. SGS-Thomson Microelectronics STV3300 4:2:2 Decoder Block Diagram.

Line Drivers/Receivers—Parallel

The VS620 and VS621 from VTC Incorporated are 11-bit TTL-to-ECL (VS621) and ECL-to-ECL (VS620) Line Drivers designed specifically for 4:2:2 applications. The VS621 (Figure 8.31) accepts up to 10 bits of TTL data and a 27-MHz TTL clock signal. The 10 bits of TTL data are latched and converted (along with the clock) to differential 10KH ECL levels. Having all of the TTL-to-ECL translators on a single chip also eliminates any device-to-device skew

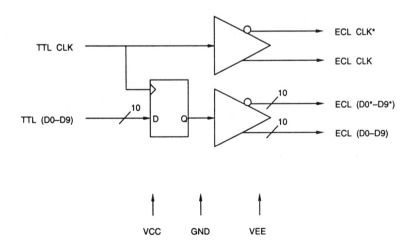

Figure 8.31. VTC Incorporated VS621 Line Driver (Parallel) Block Diagram.

inherent in a multichip solution. Features of the VS621 include:

- Latched TTL Compatible Inputs
- 10KH ECL Compatible Differential Outputs
- ±5 V Power Supply
- 52-pin PLCC Package

The VS620 (Figure 8.32) accepts up to 10 bits of differential 10KH ECL data and a 27-MHz differential 10KH ECL clock signal. The data is latched and output (along with clock) onto the differential 10KH ECL outputs. Having all of the latches on a single chip eliminates device-to-device skew inherent in a multichip solution. Features of the VS620 include:

- Latched 10KH ECL Compatible Differential Inputs
- 10KH ECL Compatible Differential Outputs

- –5.2 V Power Supply
- 52-pin PLCC Package

Line Drivers/Receivers-Serial

To support the 270 Mbit-per-second serial protocol, Sony offers a 10-bit serial encoder (SBX-1601) and decoder (SBX-1602). Also available is a cable driver (CXA-1389) to ease interfacing the SBX-1601 encoder to a coaxial cable. The serial encoder and decoder are hybrid ICs in which the fundamental processing is done on a monolithic chip, and the necessary support capacitors and resistors are mounted within the hybrid to obtain the best stability at such high frequencies.

These parts also second-sourced by SGS-Thomson Microelectronics (part numbers STV1601, STV1602, and STV1389).

The SBX-1601 serial encoder (Figure 8.33) accepts 8 or 10 bits of data and a 27-MHz clock (either ECL or TTL data and clock signals are supported). If using 8-bit data, the two LSBs of

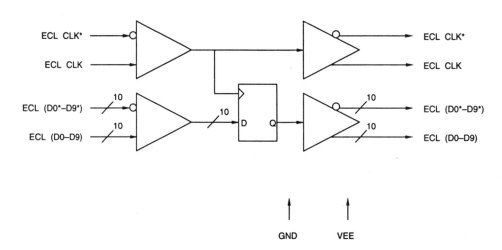

Figure 8.32. VTC Incorporated VS620 Line Driver (Parallel) Block Diagram.

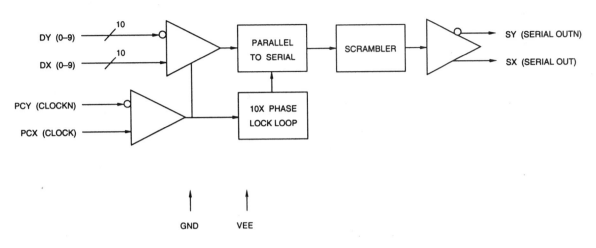

Figure 8.33. Sony Corporation SBX-1601 Serial Encoder Block Diagram.

the 10-bit inputs must be a logical zero. The input data is latched, serialized, scrambled, and output onto the ECL differential outputs. An internal PLL multiplies the 27-MHz input clock by ten, generating the 270-MHz clock required to serialize the data. TTL input data may be used by supplying an external 1.4 V reference to the data return inputs (DN) and providing a +5 V supply to a special power pin. Features of the SBX-1601 include:

- 10-bit Latched Data plus Clock Inputs (ECL or TTL-Compatible)
- Parallel to Serial Encoding
- On-Chip PLL
- –5 V Power Supply (+5 V and +1.4 V required for TTL compatible operation)
- 37-pin PGA Package

The SBX-1602 serial decoder (Figure 8.34) accepts the 270-Mbit-per-second serial data stream, performs various equalization on the data, and outputs 10 bits of parallel data and a 27-MHz clock (both the parallel data and clock output signals are single-ended ECL levels). Two serial input ports are provided: differential analog with equalization (for use with coaxial cables up to 300 m in length) and differential ECL with no equalization (for use with coaxial cables less than 1 m in length). A differential ECL serial output is provided, outputting a regenerated version of the selected serial input; this enables the SBX-1602 to also be used as a distribution amplifier. Features of the SBX-1602 include:

- 10-bit Data plus Clock Outputs (single-ended ECL compatible)
- Serial to Parallel Decoding
- On-Chip PLL
- –5 V Power Supply
- 37-pin PGA Package

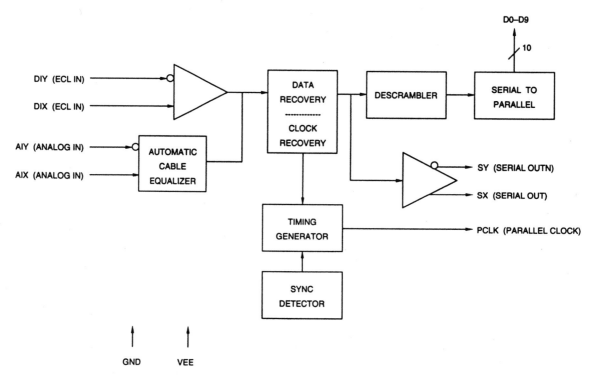

Figure 8.34. Sony Corporation SBX-1602 Serial Decoder Block Diagram.

References

1. Benson, K, Blair, 1986. *Television Engineering Handbook*, McGraw-Hill, Inc.
2. CCIR Recommendation 601-2, 1990, *Encoding Parameters of Digital Television for Studios.*
3. CCIR Recommendation 656, 1986, *Interfaces for Digital Component Video Signals in 525-Line and 625-Line Television Systems.*
4. CCIR Report 1212, 1990, *Measurements and Test Signals for Digitally Encoded Colour Television Signals.*
5. Clarke, C. K. P., 1989, *Digital Video: Studio Signal Processing*, BBC Research Department Report BBC RD1989/14.
6. Devereux, V. G., 1984, *Filtering of the Colour-Difference Signals in 4:2:2 YUV Digital Video Coding Systems*, BBC Research Department Report BBC RD1984/4.
7. Devereux, V. G., 1987, *Limiting of YUV Digital Video Signals*, BBC Research Department Report BBC RD1987/22.
8. EBU Tech. 3246-E, 1983, *EBU Parallel Interface for 625-Line Digital Video Signals*, European Broadcasting Union, August, 1983.
9. EBU Tech. 3267-E, 1991, *EBU Interfaces for 625-Line Digital Video Signals at the 4:2:2 Level of CCIR Recommendation 601*, European Broadcasting Union, June, 1991.

10. SMPTE Proposed Recommended Practice T14.22x24D, *Digital Interface for 4 × 4 Component Video Signals*, August, 1990.

11. SMPTE Recommended Practice RP125-1984, *Bit-Parallel Digital Interface for Component Video Signals*.

12. Sony Corporation, SBX1601A Datasheet, 1991.

13. Sony Corporation, SBX1602A Datasheet, 1991.

14. VTC Incorporated, VS620 Datasheet, 1990.

15. VTC Incorporated, VS621 Datasheet, 1990.

Video Processing

Encoding and decoding analog and digital video may actually be the easiest tasks when it comes to getting video into or out of a computer system. Since most computer systems use noninterlaced video for their displays, the interlaced video from NTSC or PAL decoders (for example) must be converted to noninterlaced before being merged with other graphics or video information. Many applications need to use the noninterlaced video being displayed as an output to a VCR or other video storage device. Noninterlaced-to-interlaced conversion may therefore need to be performed before generating NTSC/PAL video. In addition, many computer displays have a vertical refresh rate of 70–80 Hz, while video has a vertical refresh rate of 25 or 30 Hz. Some form of frame rate matching may be required to minimize video movement artifacts.

Another not-so-subtle problem includes scaling the video to fit into a window. Many computer systems today use a graphical user interface (GUI) that allows multiple windows (of arbitrary sizes) to be displayed. Naturally, users expect video to behave like any other data source and expect it to fit into any size window as defined by the user.

Alpha mixing and chroma keying are used to mix multiple video signals or video and graphics information. Alpha mixing ensures a smooth crossover between sources, allows subpixel positioning of text, and limits source transition bandwidths to simplify eventual encoding to NTSC, PAL, or SECAM video signals.

This chapter discusses various techniques for deinterlacing video signals, scaling real-time video, alpha mixing, and several other considerations necessary to incorporate and process video within the computer environment.

Rounding Considerations

When two 8-bit values are multiplied together, a 16-bit result is generated. At some point, a result must be rounded to some lower precision (for example, 16 bits to 8 bits or 32 bits to 16 bits) in order to realize a cost-effective hardware implementation. If the lower resolution bits are simply discarded, contours may become visible in areas of solid colors. There are several rounding techniques: truncation, conventional rounding, error feedback rounding, and dynamic rounding.

Truncation

Truncation simply drops any fractional data during each rounding operation. As a result, after only a few rounding (truncation) operations, a significant error may be introduced.

Conventional Rounding

Conventional rounding means using the fractional data bits to determine whether to round up or round down. If the fractional data is greater than 0.5, rounding up should be performed—positive numbers should be made more positive and negative numbers should be made more negative. If the fractional data is less than 0.5, rounding down should be performed—positive numbers should be made less positive and negative numbers should be made less negative.

Error Feedback Rounding

Error feedback rounding follows the principle of "never throw anything away." This is accomplished by storing the residue of a truncation and adding it to the next video sample. This approach substitutes less visible noise-like quantizing errors in place of contouring effects caused by simple truncation. An example of an error feedback rounding implementation is shown in Figure 9.1. In this example, 16 bits are reduced to 8 bits using error feedback.

Dynamic Rounding

This technique dithers the LSB according to the weighting of the discarded fractional bits. The original data word is divided into two parts, one representing the resolution of the final output word and one dealing with the remaining fractional data. The fractional data is compared to the output of a random sequence generator equal in resolution to the fractional data. The output of the comparator is a 1-bit random pattern weighted by the value of the

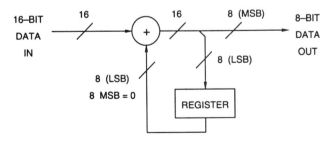

Figure 9.1. Error Feedback Rounding.

fractional data, and serves as a carry-in to the adder. In all instances, only one LSB of the output word is changed, in a random fashion. An example of a dynamic rounding implementation is shown in Figure 9.2.

Interlaced-to-Noninterlaced Conversion (Deinterlacing)

Once a video signal has been input to a system, the user may want to display it at some point. A problem arises in that computers commonly use noninterlaced displays, while video is typically interlaced. Some form of interlaced-to-noninterlaced conversion (commonly called deinterlacing or progressive scan conversion) is desirable. There are essentially three ways of performing deinterlacing: scan line duplication, scan line interpolation, and field processing. Note that deinterlacing must be performed on component (i.e., RGB, YUV, YIQ, YCrCb, etc.) video signals. Composite color video signals cannot be deinterlaced directly, due to the presence of subcarrier phase information (which would be meaningless after processing); these signals must be decoded into component color signals, such as RGB or YCrCb, prior to deinterlacing.

Scan Line Duplication

Scan line duplication (Figure 9.3) simply duplicates the previous real scan line. Although the number of vertical scan lines is doubled, there is no increase in the vertical resolution. This method is usually acceptable for the color difference signals (such as CrCb, IQ, UV, etc.), as they have a lower resolution than the luminance (Y).

For each video component (for example, Y, Cr, and Cb), two line stores are required. While writing into line store number 1, line store number 2 is read out twice (the reading rate is twice the writing rate). Once line store number 2 is read out twice (at the same time line store number 1 is filled with new data), the role of the line stores switch—while writing into line store number 2, line store number 1 is read out twice.

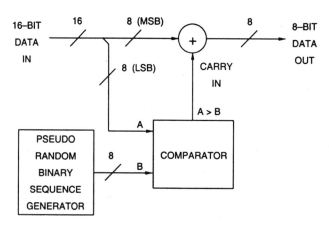

Figure 9.2. Dynamic Rounding.

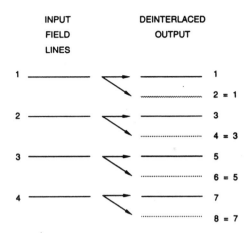

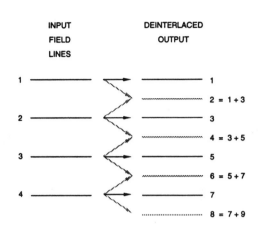

Figure 9.3. Deinterlacing using Scan Line (Field-based) Duplication. Shaded scan lines are generated by duplicating the real scan line above it.

Figure 9.4. Deinterlacing using Scan Line (Field-based) Interpolation. Shaded scan lines are generated by interpolating between the real scan lines above and below it.

Scan Line Interpolation

Scan line interpolation (Figure 9.4) positions interpolated scan lines between two original scan lines. Although the number of vertical scan lines is doubled, the vertical resolution is not.

For each video component, two line stores are required. While writing into line store number 1, line store number 2 is read out twice (the reading rate is twice the writing rate). One read cycle is used to generate a new scan line directly. During the next read cycle, the data is interpolated with the data in line store number 1 (being updated with the next original scan line). Once line store number 2 is read out twice (at the same time line store number 1 should be filled with new data), the role of the line stores switch—while writing into line store number 2, line store number 1 is read out twice.

Field Merging

This technique simply merges two consecutive fields together to produce a frame of video (Figure 9.5). At each field time, the scan lines of that field are merged with the scan lines of the previous field. The result is that for each field time, a new pair of fields combine to generate a frame (see Figure 9.6). Although simple to implement conceptually, and the vertical resolution is doubled to the full frame resolution, there will be artifacts in regions of movement. This is due to the time difference between two fields—a moving object may be located in a different position from one field to the next.

When the two fields are merged together, there may be a "double image" of the moving object (see Figure 9.7). An ideal solution is to use field merging for still areas of the picture and scan line interpolation for

INPUT INPUT DEINTERLACED
FIELD FIELD OUTPUT
 A B

1 —————————————— ————▶ ——————————— 1
 2 —————————— ————▶ 2
3 —————————————— ————▶ ——————————— 3
 4 —————————— ————▶ 4
5 —————————————— ————▶ ——————————— 5
 6 —————————— ————▶ 6
7 —————————————— ————▶ ——————————— 7
 8 —————————— ————▶ 8

Figure 9.5. Deinterlacing using Field Merging. Shaded scan lines are generated by using the real scan line from the next or previous field.

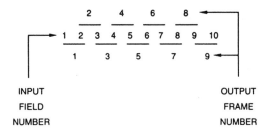

INPUT OUTPUT
FIELD FRAME
NUMBER NUMBER

Figure 9.6. Producing Deinterlaced Frames at Field Rates.

areas of movement. To accomplish this, motion, on a pixel-by-pixel basis, must be detected over the entire picture in real time. Motion can be detected by comparing the luminance value of a pixel with the value two fields earlier. Since we are combining two fields, and either or both may contain areas of motion, motion detection must be done between two odd fields and two even fields. Four field stores are therefore required.

As two fields are combined, full vertical resolution is maintained in still areas of the picture, where the eye is most sensitive to detail. The pixel differences may have any value, from 0 (no movement and noise-free) to maximum (for example, a change from full intensity to black). A choice must be made when to use a pixel from the previous field (which is in the wrong location due to motion) or to interpolate a new pixel from

OBJECT POSITION
IN FIELD ONE

OBJECT POSITION
IN FIELD TWO

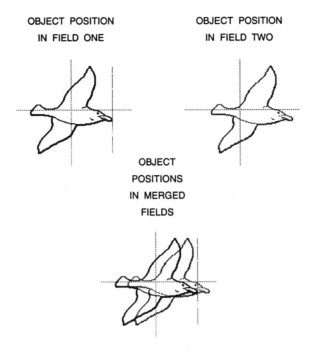

OBJECT
POSITIONS
IN MERGED
FIELDS

Figure 9.7. Movement Artifacts When Field Merging Is Used.

adjacent scan lines in the current field. Sudden switching between methods is visible, so crossfading is used. At some magnitude of pixel difference, the loss of resolution due to a double image is equal to the loss of resolution due to interpolation. That amount of motion should result in the crossfader being at the 50/50 point. Any less motion will result in a fade towards field merging and any more motion in a fade towards the interpolated values.

Frequency Response Considerations

Various two-times vertical upsampling schemes for deinterlacing may be implemented by stuffing zero values between two valid lines and filtering, as shown in Figure 9.8.

Line A shows the frequency response for line duplication, in which the lowpass filter coefficients for the filter shown are 1, 1, and 0. Interpolation, using lowpass filter coefficients of 0.5, 1.0, and 0.5, results in the frequency response curve of Line B; note that line duplication results in a better high-frequency response. Vertical filters with a better frequency response than the one for line duplication are possible, at the cost of more line stores and processing.

The best vertical frequency response is obtained when field merging is implemented. The spatial position of the lines are already correct and no vertical processing is required, resulting in a flat curve (Line C). Once again, this applies only for stationary areas of the image.

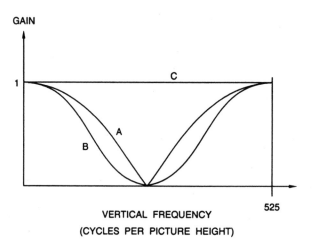

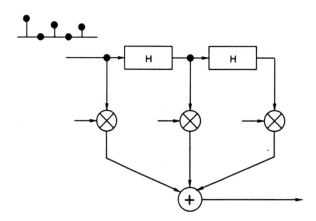

Figure 9.8. Frequency Response of Various Deinterlacing Filters. (A) line duplication. (B) line interpolation. (C) field merging.

Noninterlaced-to-Interlaced Conversion

Since the computer typically uses a noninterlaced display, the data must usually be converted to an interlaced format if NTSC, PAL, or SECAM, digital composite, or digital component video is to be generated. The easiest approach is to simply throw every other scan line in each noninterlaced frame away, as shown in Figure 9.9. Although the cost is minimal, there are problems with this approach, especially when horizontal lines that are one or two noninterlaced scan lines wide are converted. Lines that are one noninterlaced scan line wide will flicker at the frame refresh rate (30 Hz for NTSC, 25 Hz for PAL and SECAM) when converted to interlaced. The reason is that they are only displayed every other field as a result of the simple conversion. This effect may also occur on the top and bottom edges of

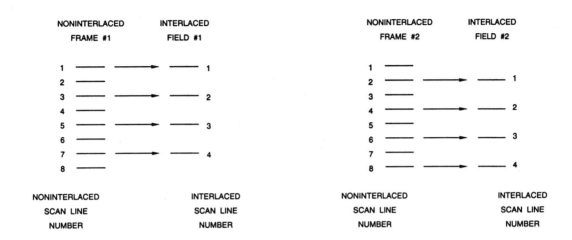

Figure 9.9. Basic Noninterlaced-to-Interlaced Conversion.

objects. Lines that are two noninterlaced scan lines wide will oscillate up and down between two interlaced scan lines at the frame refresh rate (30 Hz for NTSC, 25 Hz for PAL and SECAM) when converted to interlaced.

A more elegant solution to the problem is to use two, or preferably three, scan lines of noninterlaced data to generate one scan line of interlaced data, as shown in Figure 9.10. In this way, hard vertical edge transitions are smoothed out over several interlaced scan lines. This implementation does require line stores (for each video component) to store the video data until needed, as well as digital filters. Note that care must be taken at the beginning and end of each frame in the event that a fewer number of scan lines are available for filtering. However, the improvement in flicker

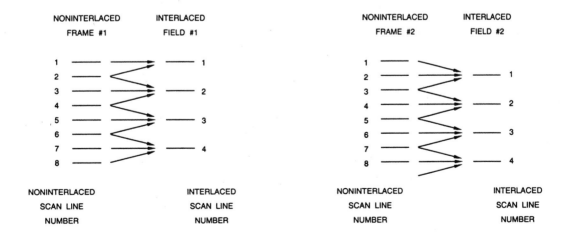

Figure 9.10. Noninterlaced-to-Interlaced Conversion using Filtering.

reduction makes this the preferred implementation in almost all cases.

Noninterlaced-to-interlaced conversion must be performed on component (i.e., RGB, YUV, YIQ, YCrCb, etc.) video signals. Composite color video signals cannot be converted directly due to the subcarrier phase information present (which would be meaningless after processing).

Video Mixing

Mixing two video sources may be as common as simply switching between the sources (using a multiplexer) or implementing full alpha mixing (also known as soft keying). If the resulting video is to be displayed on a computer display (CRT), simple switching between the sources is adequate. If it is to be used for eventual encoding to NTSC, PAL, SECAM, digital composite, or digital component video, a more sophisticated mixing arrangement must be used to limit the video bandwidth at the switching times.

In addition to mixing between two or more video sources, alpha mixing may be used to fade to or from a specific color (such as black). Alpha mixing may also be used to overlay text or graphics on a video signal.

Mathematically, alpha mixing is implemented as (alpha is normalized to have values of 0–1):

$$out = (alpha_0)(in_0) + (alpha_1)(in_1) + ...$$

In this instance, each video source has its own alpha information. The normalized alpha information may or may not total to one (unity gain). Figure 9.11 shows mixing of two YCrCb video signals, each with its own alpha information. As YCrCb uses an offset binary notation, the offset (16 for Y and 128 for Cr and Cb) is removed prior to mixing the video signals. After mixing, the offset is added back in.

When only two video sources are mixed (implementing a crossfader), and alpha_0 + alpha_1 = 1, a single alpha value may be used, mathematically shown as:

$$out = (alpha)(in_0) + (1 - alpha)(in_1)$$

When alpha = 0, the output is equal to the in_1 video signal; when alpha = 1, the output is equal to the in_0 video signal. When alpha is between 0 and 1, the two video signals are proportionally multiplied, and added together. Expanding and rearranging the above equation shows how a two-channel mixer (also called a crossfader) may be implemented using a single multiplier:

$$out = (alpha)(in_0 - in_1) + in_1$$

If using 8-bit values for YCrCb or RGB and alpha, this implementation requires an 8×9 multiplier, since the subtraction of two 8-bit numbers requires 9 bits. For either implementation, it may be desirable to bypass the appropriate multiplier when alpha = FF_H (assuming an 8-bit alpha value) to achieve precise unity gain. Figure 9.12 illustrates mixing two YCrCb sources using a single multiplier. Note that additional circuitry to compensate for the offsets (16 for Y and 128 for Cr and Cb) is not required. Fading to and from a specific color is easily done using the two-channel alpha mixer, by setting one of the sources to a constant desired color (such as black).

Figure 9.13 and Figure 9.14 illustrate mixing two RGB video sources (RGB has a range of 0–255). Figure 9.15 and Figure 9.16 show mixing two digital composite video signals.

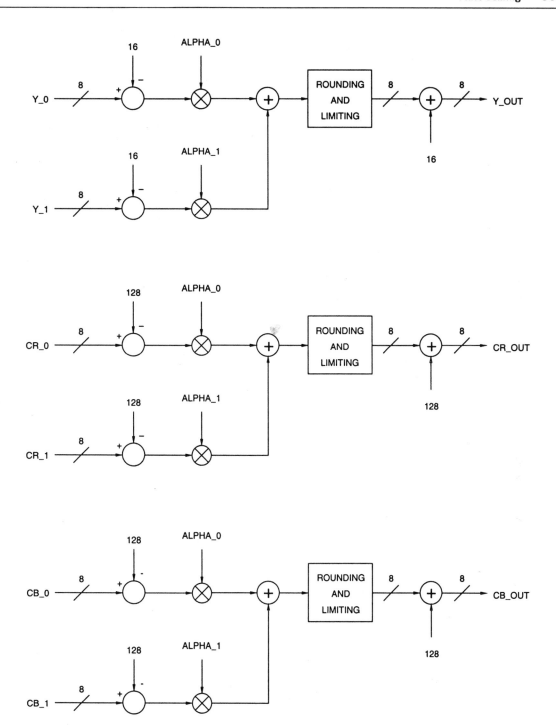

Figure 9.11. Mixing Two YCrCb Video Signals, Each with Its Own Alpha Channel.

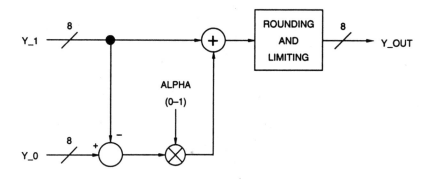

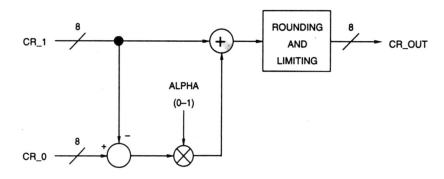

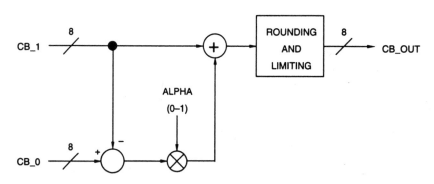

Figure 9.12. Simplified Mixing (Crossfading) of Two YCrCb Video Signals using A Single Alpha Channel.

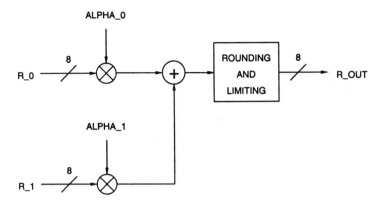

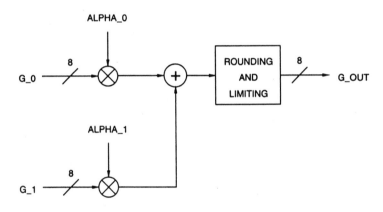

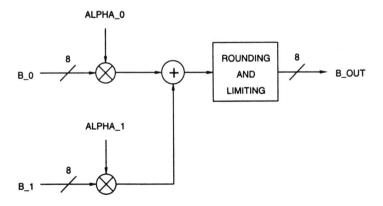

Figure 9.13. Mixing Two RGB Video Signals (RGB has a Range of 0–255), Each with Its Own Alpha Channel.

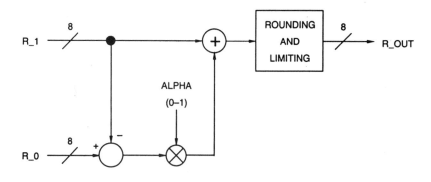

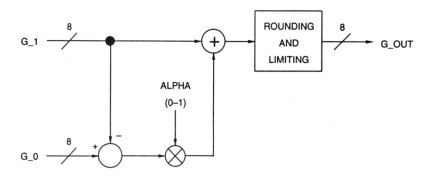

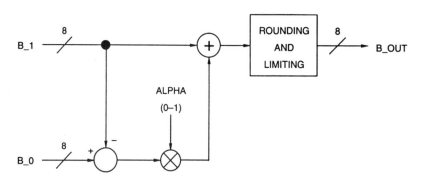

Figure 9.14. Simplified Mixing (Crossfading) of Two RGB Video Signals (RGB has a Range of 0–255), using a Single Alpha Channel.

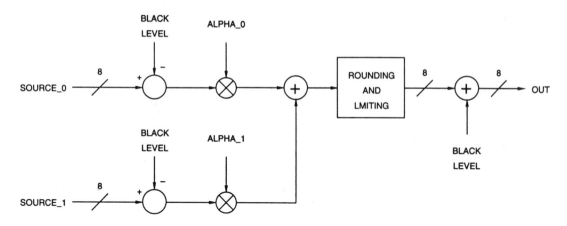

Figure 9.15. Mixing Two Digital Composite Video Signals, Each with Its Own Alpha Channel.

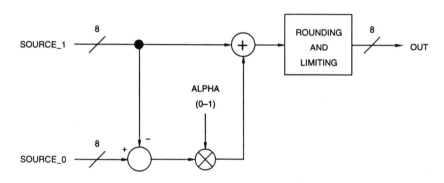

Figure 9.16. Simplified Mixing (Crossfading) of Two Digital Composite Video Signals, using a Single Alpha Channel.

A common problem in computer graphics systems that use alpha is that the frame buffer may or may not contain pre-processed RGB or YCrCb data; that is, the RGB or YCrCb data in the frame buffer has already been multiplied by alpha. Assuming an alpha value of 128 (50%), nonprocessed RGBA values for white are (255, 255, 255, 128); pre-processed RGBA values for white are (128, 128, 128, 128). Therefore, any mixing circuit that accepts RGB or YCrCB data from a frame buffer should be able to handle either format.

By adjusting the alpha values, slow to fast crossfades are possible, as shown in Figure 9.17. Large differences in alpha during each clock cycle result in a fast crossfade; smaller differences in alpha result in a slow crossfade. If using alpha mixing for special effects, such as wipes, the switching point (where 50% of each video source is used) must be able to be adjusted to an accuracy of less than one pixel to ensure smooth movement. By controlling the alpha values, the switching point can be effectively positioned anywhere, as shown in Figure 9.17a.

Text can be overlaid onto video by having the character generator control the alpha inputs. By setting one of the sources to the

(a)

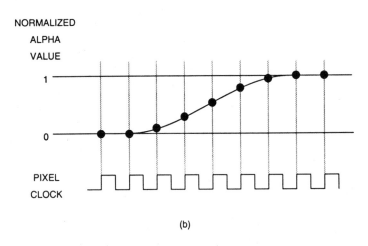

(b)

Figure 9.17. Controlling Alpha Values to Implement Fast (a) or Slow (b) Keying. Subpixel positioning of the switching point is also shown in (a).

mixer to a constant color, the text will assume that color.

Keying

Simply, keying involves specifying a desired foreground color; areas containing this color are replaced with a background image. Alternately, an area of any size or shape may be specified; foreground areas inside (or option-

ally outside) this area are replaced with a background image.

Luminance Keying

Luminance keying involves specifying a desired foreground luminance (or brightness) level; foreground areas containing luminance levels above (or optionally below) the keying level are replaced with the background image. Alternately, this hard keying implementation

may be replaced with soft keying by specifying two luminance values of the foreground video signal: Y_H and Y_L ($Y_L < Y_H$). For keying the background into "white" foreground areas, foreground luminance values (Y_{FG}) above Y_H contain the background video signal; Y_{FG} values below Y_L contain the foreground video signal. For Y_{FG} values between Y_L and Y_H, linear mixing is done between the foreground and background video signals. This operation, using values normalized to 0–1, may be expressed as:

if $Y_{FG} > Y_H$ (background only)
$K = 1$

if $Y_{FG} < Y_L$ (foreground only)
$K = 0$

if $Y_H \geq Y_{FG} \geq Y_L$ (mix)
$K = (Y_{FG} - Y_L)/(Y_H - Y_L)$

For keying the background into "black" foreground areas, values above Y_H contain the foreground video signal; values below Y_L contain the background video signal. For values between Y_L and Y_H, linear mixing is done between the foreground and background video signals. By subtracting K from 1, the new luminance keying signal for keying into "black" foreground areas can be generated.

Figure 9.18 illustrates luminance keying for two YCrCb digital component video sources. Although chroma keying typically uses a suppression technique to remove information from the foreground image, this is not done when luminance keying as the magnitude of Cr and Cb are usually not related to the luminance level. Figure 9.19 illustrates luminance keying for RGB sources, which is more applicable for computer graphics. Y_{FG} may be obtained by the equation:

$$Y_{FG} = 0.299R' + 0.587G' + 0.114B'$$

In some applications, the red and blue data is ignored, resulting in Y_{FG} being equal to only the green data. Figure 9.20 illustrates one technique of luminance keying between two digital composite video sources.

Chroma Keying

Chroma keying involves specifying a desired foreground key color; foreground areas containing the key color are replaced with the background image. The color difference components (CrCb, UV, etc.) are used to specify the key color; luminance information may be used to increase the realism of the chroma keying function. The actual mixing of the two video sources may be done in the component or composite domain, although component mixing provides many additional benefits.

Early chroma keying circuits simply performed a hard or soft switch between the foreground and background sources. In addition to limiting the amount of fine detail maintained in the foreground image, the background is not visible through transparent or translucent foreground objects, and shadows from the foreground are not present in areas containing the background image.

Linear keyers were developed which combine the foreground and background images in a proportion determined by the key level, resulting in the foreground image being attenuated in areas containing the background image. Although allowing foreground objects to appear transparent, there is a limit on the fineness of detail maintained in the foreground. Shadows from the foreground are not present in areas containing the background image unless additional processing is done—the luminance levels of specific areas of the background image must be reduced to create the effect of shadows cast by foreground objects. If the blue backing used with the foreground scene is evenly lit except for shadows

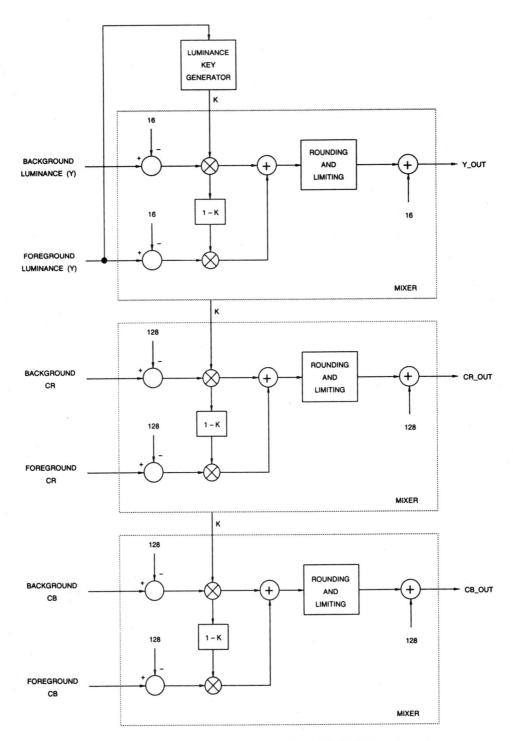

Figure 9.18. Luminance Keying of Two YCrCb Video Signals.

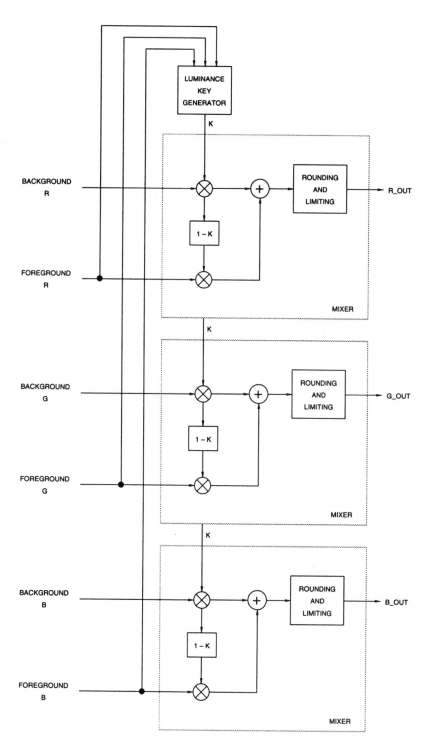

Figure 9.19. Luminance Keying of Two RGB Video Signals. RGB range is 0–255.

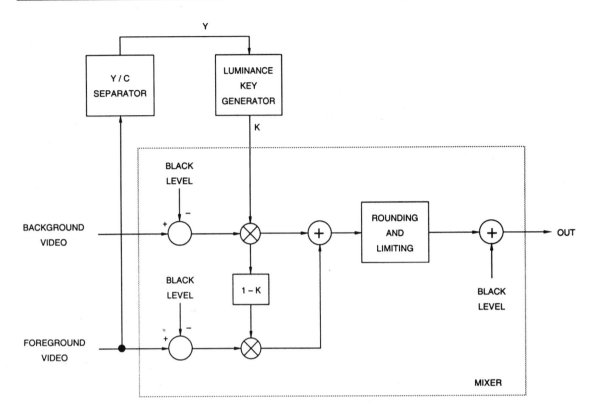

Figure 9.20. Luminance Keying of Two Digital Composite Video Signals.

cast by the foreground objects, the effect on the background will be that of shadows cast by the foreground objects. This process, referred to as shadow chroma keying, or luminance modulation, enables the background luminance levels to be adjusted in proportion to the brightness of the blue backing in the foreground scene. This results in more realistic keying of transparent or translucent foreground objects by preserving the spectral highlights. Chroma keyers are also limited in their ability to handle foreground colors that are close to the key color without switching to the background image. Another problem may be a bluish tint to the foreground objects as a result of blue light reflecting off the blue backing or being diffused in the camera lens.

Chroma spill is difficult to remove since the spill color is not the original key color; some mixing occurs, changing the original key color slightly.

The best solution currently available to solve most of the chroma keying problems is to process the foreground and background images individually before adding them together, as shown in Figure 9.21. Rather than choosing between the foreground and background, each is individually processed and then added together. The foreground key (K_{FG}) and background key (K_{BG}) signals have a range of 0 to 1. The garbage matte key signal (the term matte comes from the film industry) forces the mixer to output the foreground source in one of two ways. The first method is

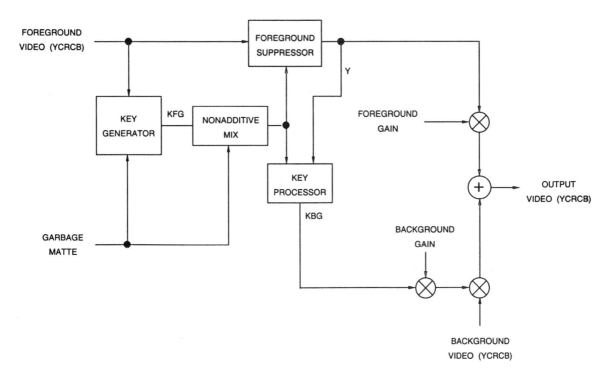

Figure 9.21. Typical Component Chroma Key Circuit.

to reduce K_{BG} in proportion to increasing K_{FG}. This provides the advantage of minimizing black edges around the inserted foreground. The second method is to force the background to black for all nonzero values of the matte key, and insert the foreground into the background "hole." This requires a cleanup function to remove noise around the black level, as this noise affects the background picture due to the straight addition process. The garbage matte is added to the foreground key signal (K_{FG}) using a non-additive mixer (NAM). A nonadditive mixer takes the brighter of the two pictures, on a pixel-by-pixel basis, to generate the key signal. Matting is ideal for any source that generates its own keying signal, such as character generators, etc.

Not shown in Figure 9.21 is the circuitry to initially subtract 16 (Y) or 128 (Cr and Cb)

from the foreground and background video signals, and the addition of 16 (Y) or 128 (Cr and Cb) after the final output adder. Any DC offset not removed will be amplified or attenuated by the foreground and background gain factors, shifting the black level. Figure 9.22 illustrates the major processing steps for both the foreground and background images during the chroma key process.

The key generator monitors the foreground Cr and Cb data, generating a foreground keying signal, K_{FG}. A desired key color is selected, as shown in Figure 9.23. The foreground Cr and Cb data are normalized (generating Cr' and Cb') and rotated θ degrees to generate the X and Z data, such that the positive X axis passes as close as possible to the desired key color. Typically, θ may be varied in 1° increments, and optimum chroma keying

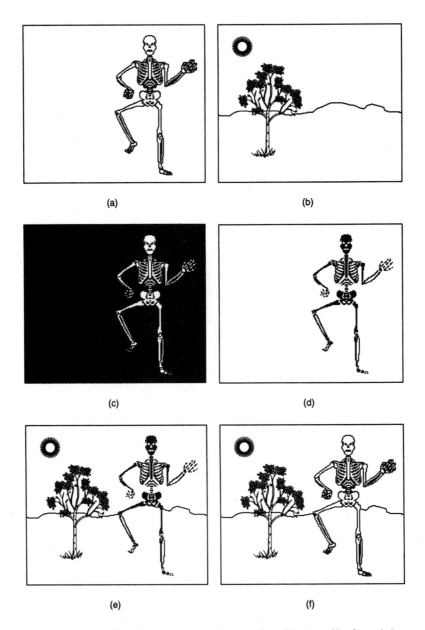

(a)

(b)

(c)

(d)

(e)

(f)

Figure 9.22. Major Processing Steps during Chroma Keying: (a) Original Foreground Scene; (b) Original Background Scene; (c) Suppressed Foreground Scene; (d) Background Keying Signal; (e) Background Scene after Multiplication by Background Key; (f) Composite Scene Generated by Adding (c) and (e).

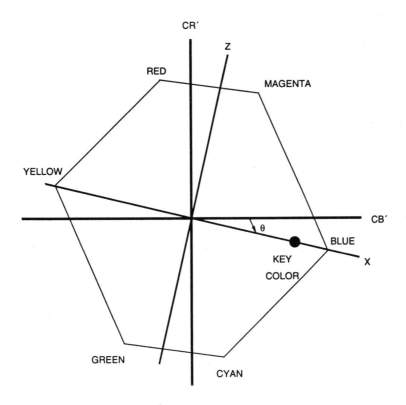

Figure 9.23. Rotating the Normalized Cr and Cb (Cr′ and Cb′) Axes by θ to Obtain the X and Z Axes, such that the X Axis Passes through the Desired Key Color (Blue in this Example).

occurs when the X axis passes through the key color. X and Z are derived from the Cr and Cb using the equations:

$$X = Cb' \cos \theta + Cr' \sin \theta$$
$$Z = Cr' \cos \theta - Cb' \sin \theta$$

Since Cr′ and Cb′ are normalized to have a range of ±1, X and Z have a range of ±1. The foreground keying signal (K_{FG}) is generated from X and Z and has a range of 0–1:

$$K_{FG} = X - (|Z| / (\tan (\alpha/2)))$$
$$K_{FG} = 0 \text{ if } X < (|Z| / (\tan (\alpha/2)))$$

where α is the acceptance angle, symmetrically centered about the positive X axis, as shown in Figure 9.24. Outside the acceptance angle, K_{FG} is always set to zero. Inside the acceptance angle, the magnitude of K_{FG} linearly increases the closer the foreground color approaches the key color and as its saturation increases. Colors inside the acceptance angle are further processed by the foreground suppressor.

The foreground suppressor reduces foreground chrominance information by implementing $X = X - K_{FG}$, with the key color being clamped to the black level. To avoid processing Cr and Cb when $K_{FG} = 0$, the foreground suppressor performs the operations:

$$Cb_{FG} = Cb - K_{FG} \cos \theta$$
$$Cr_{FG} = Cr - K_{FG} \sin \theta$$

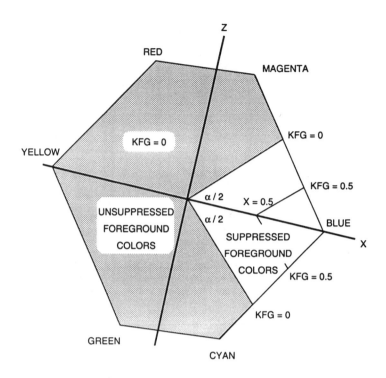

Figure 9.24. Foreground Key Values and Acceptance Angle.

where Cr_{FG} and Cb_{FG} are the foreground Cr and Cb values after key color suppression. Prior implementations suppressed foreground information by multiplying Cr and Cb by a clipped version of the K_{FG} signal. This, however, generated in-band alias components due to the multiplication and clipping process and produced a harder edge at key color boundaries.

Unless additional processing is done, the Cr_{FG} and Cr_{FG} components are set to zero only if they are exactly on the X axis. Hue variations due to noise or lighting will result in areas of the foreground not being entirely suppressed. Therefore, a suppression angle is set, symmetrically centered about the positive X axis. The suppression angle (β) is typically configurable from a minimum of zero degrees, to a maximum of about one third the acceptance angle

(α). Any CrCb components that fall within this suppression angle are set to zero. Figure 9.25 illustrates the use of the suppression angle.

Foreground luminance, after being normalized to have a range of 0–1, is suppressed by:

$$Y_{FG} = Y' - y_S K_{FG}$$
$$Y_{FG} = 0 \text{ if } y_S K_{FG} > Y'$$

y_S is an programmable value and used to adjust Y_{FG}, which has a range of 0–1, so that it is clipped at the black level in the key color areas.

The foreground suppressor also removes key-color fringes on wanted foreground areas caused by chroma spill, the overspill of the key color, by removing discolorations of the wanted foreground objects. Ultimatte® improves on this process by measuring the dif-

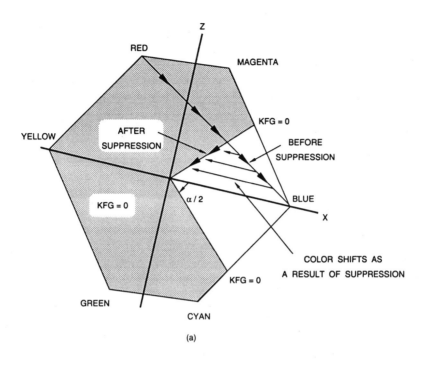

(a)

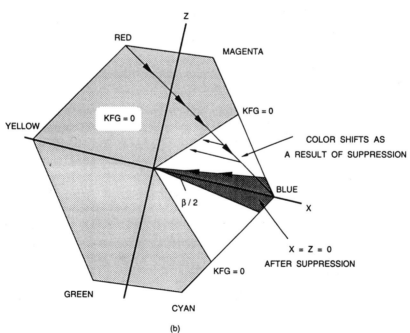

(b)

Figure 9.25. Suppression Angle Operation for a Gradual Change from a Red Foreground Object to the Blue Key Color: (a) Simple Suppression; (b) Improved Suppression using a Suppression Angle.

ference between the blue and green colors since the blue backing is never pure blue and there may be high levels of blue in the wanted foreground objects. Pure blue is rarely found in nature and most natural blues have a higher content of green than red. For this reason, the red, green, and blue levels are monitored to differentiate between the blue backing and blue in wanted foreground objects. If the difference between blue and green is great enough, all three colors are set to zero to produce black; this is what happens in areas of the foreground containing the blue backing. If the difference between blue and green is not large, the blue is set to the green level unless the green exceeds red. This technique allows the removable of the bluish tint caused by the blue backing while being able to reproduce natural blues in the foreground. There is a price to pay, however. Magenta in the foreground is changed to red. A green backing can be used, but in this case, yellow in the foreground is modified. Usually, the clamping is gradually released to increase the blue content of magenta areas. As an example, a white foreground area would normally consist of equal levels of red, green, and blue. If the white area is affected by the key color (blue in this instance), it will have a bluish tint—the blue levels will be greater than the red or green levels. Since the green does not exceed the red, the blue level is made equal to the green, removing the bluish tint. Note that, in this instance, RGB data is used for processing the foreground image.

The key processor generates the initial background key signal (K'_{BG}), used to remove areas of the background image where the foreground is to be visible. K'_{BG} is adjusted to be zero in desired foreground areas and unity in background areas with no attentuation. It is generated from the foreground key signal K_{FG} by applying lift (k_L) and gain (k_G) adjustments followed by clipping at zero and unity values:

$$K'_{BG} = (K_{FG} - k_L)k_G$$

Figure 9.26 illustrates the operation of the background key signal generation. The transition band between $K'_{BG} = 0$ and $K'_{BG} = 1$ should be made as wide as possible to minimize discontinuities in the transitions between foreground and background areas.

For foreground areas containing the same CrCb values, but different luminance (Y) values, as the key color, the key processor may also reduce the background key value as the foreground luminance level increases, allowing turning off the background in foreground areas containing a "lighter" key color, such as light blue. This is done by:

$$K_{BG} = K'_{BG} - y_c Y_{FG}$$
$$K_{BG} = 0 \text{ if } y_c Y_{FG} > K_{FG}$$

To handle shadows cast by the foreground objects, and opaque or translucent foreground objects, the luminance levels of the blue backing of the foreground image is monitored. Where the luminance of the blue backing is reduced, the luminance of the background image is also reduced. The amount of background luminance reduction must be controlled so that defects in the blue backing (such as seams or footprints) are not interpreted as foreground shadows. Additional controls may be implemented to enable the foreground and background signals to be independently controlled. Examples are adjusting the contrast of the foreground so it matches the background or fading the foreground in various ways (such as fading to the background to make a foreground object vanish or fading to black to generate a silhouette).

In the computer graphics environment, there may be relatively slow, smooth edges—especially edges involving smooth shading. As smooth edges are quickly distorted during the chroma keying process, a wide keying process

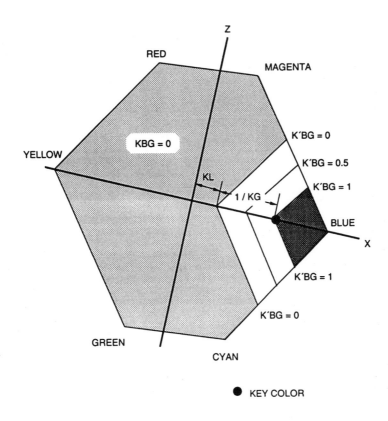

Figure 9.26. Background Key Generation.

is usually used in these circumstances. During wide keying, the keying signal starts before the edge of the graphic object.

Composite Chroma Keying

In some instances, the component video signals (such as YCrCb) are not directly available. For these situations, composite chroma keying may be implemented, as shown in Figure 9.27. To detect the chroma key color, the foreground video source must be decoded to produce the Cr and Cb (or U and V) color difference signals. The keying signal, K_{FG}, is then used to mix between the two composite video sources. The garbage matte key signal forces the mixer to output the background source by reducing K_{FG}. Chroma keying directly using composite video signals usually results in unrealistic keying, since there is inadequate color bandwidth. As a result, there is a lack of fine detail and halos are present on edges.

High-end video editing systems may also make use of superblack keying. In this application, areas of the foreground composite video signal that have a level of 0 to –5 IRE are replaced with the background video information.

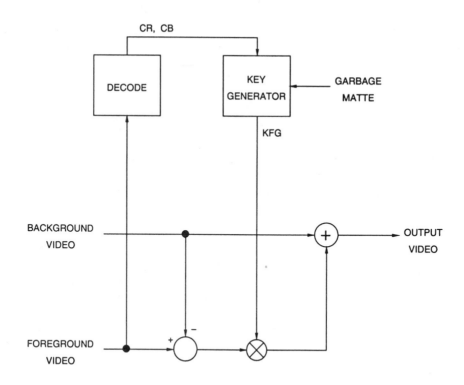

Figure 9.27. Typical Composite Chroma Key Circuit.

Video Scaling

With today's graphical user interfaces (GUIs), users expect to be able to display live video in an arbitrary-sized window. Of course, there is the problem of how the system will respond if the user defines a window that does not maintain the proper aspect ratio, distorting the image. Note that scaling must be performed on component (i.e., RGB, YUV, YIQ, YCrCb, etc.) video signals. Composite color video signals cannot be processed directly due to the subcarrier phase information present (which would be meaningless after processing). If possible, scaling should be done on noninterlaced video.

If it is desired to convert the computer display to NTSC, PAL, or SECAM formats, the display image may also require scaling. Table

9.1 illustrates the scale factors for scaling common computer display resolutions to square pixel NTSC, PAL, and SECAM resolutions. Table 9.2 illustrates the scale factors for scaling square pixel NTSC, PAL, and SECAM resolutions to common computer display resolutions. NTSC square pixel resolution is 640 × 480, and PAL and SECAM square pixel resolution is 768 × 576. Use of the square pixel formats avoids the problem of circles on the computer display monitor becoming ellipses when stored on video tape.

When scaling 1280 × 1024 to NTSC, PAL, or SECAM square pixel formats, some of the noninterlaced scan lines are ignored. Scaling 800 × 600 to square pixel PAL and SECAM may be simplified by ignoring 32 pixels on each scan line and 24 scan lines so as to process 768 × 576 pixels.

Noninterlaced Display Resolution	640 x 480 Scale Factor	768 x 576 Scale Factor
640×480	1	1.2
800×600	0.8	0.96
1024×768	0.625	0.75
1280×1024	0.5	0.6

Table 9.1. Various Scaling Factors for Computer Display Resolutions to NTSC/PAL/SECAM Square Pixel Resolutions.

NTSC/PAL/SECAM Resolution	640 × 480 Scale Factor	800 × 600 Scale Factor	1024 × 768 Scale Factor	1280 × 1024 Scale Factor
640×480	1	1.25	1.6	2.0
768×576	1/1.2	1/0.96	1/0.75	1/0.6

Table 9.2. Various Scaling Factors for NTSC/PAL/SECAM Square Pixel Resolutions to Computer Display Resolutions.

As a side note, the user or software application must be concerned with such things as character sizes, line thicknesses, and so forth if attempting to scale down a high-resolution image to standard NTSC/PAL/SECAM resolutions. For example, 9-point text on a 1280 × 1024 display will not be readable on a standard NTSC/PAL/SECAM display due to the large amount of scaling involved. Thin horizontal lines, easily visible on a 1280 × 1024 display, either disappear completely or oscillate up and down one pixel at a 30- or 25-Hz rate when converted to NTSC/PAL SECAM resolutions.

Scaling By Decimation

The simplest form of scaling down is simple decimation, where every (m) out of (n) pixels are thrown away horizontally and vertically. For example, as shown in Figure 9.28, if a scaling factor of 1/3 is required (resulting in an image that is 1/9 as large as the original), two out of every three pixels are thrown away in both the horizontal and vertical directions. A modified version of the Bresenham line-drawing algorithm is typically used to determine which pixels not to discard.

Scaling up can be accomplished by pixel duplication. Again, a modified version of the Bresenham line-drawing algorithm can be used to determine which pixels to duplicate.

Note that decimation may be used only when scaling down (reducing the size of the image). Some low-end video scaler ICs on the market decimate horizontally and vertically; others decimate vertically but perform filtering for horizontal scaling. Scaling down by more than a factor of 2 or 3 using decimation is not recommended due to the amount of information lost. Scaling by decimation is also not recommended if the resulting image is to be further processed due to aliasing and the introduction of high-frequency components.

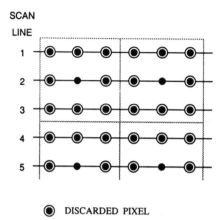

SCAN
LINE

ⓞ DISCARDED PIXEL

Figure 9.28. Example of 1/3 Scaling by Decimation.

Scaling by Convolution

A more sophisticated approach, and therefore more expensive to implement, is to digitally filter the image both horizontally and vertically. The filter size varies by the amount of scaling required; for example, scaling a picture by 1/3 (resulting in an image that is 1/9 as large as the original) requires a 3 × 3 filter; scaling by 1/5 requires a 5 × 5 filter. One advantage of this implementation is that scaling up may be incorporated into the design. This is useful for applications that require scaling a picture to fill a large portion of a high-resolution (for example, 1280 × 1024) display screen. If the scaling image is to be further processed (for example, encoding into a composite video signal or compressed), scaling by convolution should be used to minimize aliasing and the introduction of high-frequency components.

If large scale-down factors are required for display purposes, a combination of decimation and convolution may be used. Below a specific scaling factor (determined by the number of line stores), convolution is used for scaling. Above this scaling factor, decimation is used to specify which pixels to ignore—convolution is

then used in the region of maximum interest. For example, as shown in Figure 9.29, by using four line stores, scaling by convolution is done for scaling factors up to 1/4. For larger scaling factors—for example, 1/6—convolution is performed on the center group of 4 × 4 pixels; the remaining pixels of the 6 × 6 pixel block are ignored.

Field and Frame Rate Conversion

Personal computers and workstations usually operate the display in a noninterlaced fashion, with a refresh rate of 60–80 frames per second—obviously incompatible with consumer video refresh rates, which are interlaced with a refresh rate of 25 or 30 frames per second. To perform ideal frame rate conversion requires the interpolation of video fields or frames, which is currently very costly to implement. As a result, when displaying live video on the computer monitor, most systems currently do not compensate for the frame-rate differences other than attempting to ensure "tearing" does

SCAN
LINE

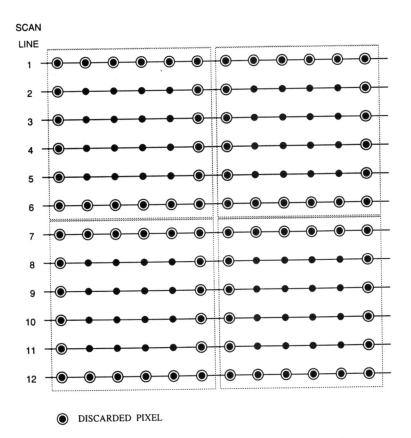

⊚ DISCARDED PIXEL

Figure 9.29. Example of 1/6 Scaling by Combination Decimation and Convolution.

not frequently occur (see Chapter 2 for additional system-level discussions on frame-rate conversion). To ensure "tearing" does not occur, some high-end systems use multiple video frame stores. Note that processing must be performed on component (i.e., RGB, YUV, YIQ, YCrCb, etc.) video signals. Composite color video signals cannot be processed directly due to the subcarrier phase information present (which would be meaningless after processing).

When generating live video, the problem becomes more complex. Although the video timing subsystem will usually support 60- or

50-Hz interlaced video timing, many of the newer computer display monitors do not support interlaced operation; even if they do, the flicker of large areas of white or highly saturated colors makes the computer display unpleasant to use. Therefore, the best solution is to configure the video timing subsystem for 60- or 50-Hz noninterlaced operation, and perform noninterlaced-to-interlaced conversion prior to encoding. If the noninterlaced-to-interlaced conversion is implemented by vertical filtering, flicker of the interlaced image is also reduced.

For computer-generated images that have little or no movement between fields, field dropping or duplicating may be used to change the field rate. Simple field-rate conversion may be done by dropping or duplicating one out of every N fields, as done by some consumer multistandard VTRs. For example, the conversion of 60-Hz interlaced to 50-Hz interlaced may drop one out of every six fields, as shown in Figure 9.30, requiring a single field store. However, in areas where the original source has smooth or large amounts of movement, the resulting image will have jerky movement. The only solution to avoiding the resulting jerky movement during field or frame-rate conversion is to interpolate temporally.

Conversion of 50-Hz interlaced to 60-Hz interlaced using temporal interpolation is illustrated in Figure 9.31. For every five fields of 50-Hz interlaced video, there are six fields of 60-Hz interlaced video. After both sources are aligned, two adjacent 50-Hz fields are mixed together to generate a new 60-Hz field. This technique is used in some inexpensive stan-

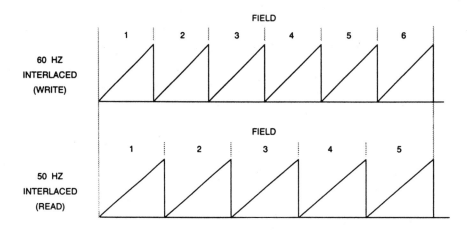

Figure 9.30. 60-Hz Interlaced to 50-Hz Interlaced Conversion using a Single Field Store by Dropping One Out of Every Six Fields.

Figure 9.31. 50-Hz Interlaced to 60-Hz Interlaced Conversion using Temporal Interpolation with no Motion Compensation.

dards converters to convert between 625/50 and 525/60 standards. Note that no motion analysis is done. Therefore, for example, if the camera operating at 625/50 pans horizontally past a narrow vertical object, you will see one object once every six 525/60 fields, and for the five fields in between, you will see two objects, one fading in while the other fades out. Prior to the temporal interpolation shown in Figure 9.31, vertical filtering was used to convert from 625 to 525 scan lines per frame.

When building dedicated converters, such as to go between 625/50 and 525/60, the temporal interpolation and vertical scaling are usually implemented together, as shown in Figure 9.32. This example uses vertical, followed by temporal, interpolation. If temporal, followed by vertical, interpolation were implemented, the field stores would be half the size. However, the number of line stores would increase from four to eight. In either case, the first interpolation process must produce an intermediate, higher-resolution sequential format to avoid interlace components that would interfere with the second interpolation process. It is insufficient to interpolate, either vertically or temporally, using a mixture of lines from even and odd fields, due to the one-dimensional interpolation process not being able to compensate for the temporal offset of interlaced lines.

Figure 9.33 illustrates the spectral representation of the circuit in Figure 9.32. More modern designs combine the vertical and temporal interpolation into a single, integrated design, as shown in Figure 9.34, with the corresponding spectral representation shown in Figure 9.35.

Newer, more expensive standards converters perform motion estimation on small blocks of pixels (typically 8×8 pixels) from one field to the next. The motion estimator generates a motion vector for each block of pixels, indicating the direction and amount of movement of each moving object between fields. When generating a new, interpolated field, the motion vectors are interpolated linearly based on the position of the new field. For example, looking at Figure 9.31, the motion vectors from 525/50 field 1 would be scaled by 5/6ths to indicate the position of moving objects in 525/60 field 2. Stationary objects would retain their position as indicated in 525/50 field 1. Further information may be needed from the field before and after 525/50 field 1 to properly fill in behind moved objects. Really fast motion may create artifacts; also, after a fast cut to a new scene, garbage may be generated for several fields.

The transfer of film to video is covered, just for completeness. Film is usually recorded at 24 frames per second. When transferring to PAL or SECAM, the film is simply played back slightly faster, at 25 frames per second, matching the PAL/SECAM refresh rate. When transferring to NTSC, the 3-2 pulldown technique is used, as shown in Figure 9.36, where two film frames generate five video fields, resulting in 60 fields per second. In scenes of high-speed motion of objects, manual adjustment of which film frame to use for a specific video field is usually done to minimize motion artifacts.

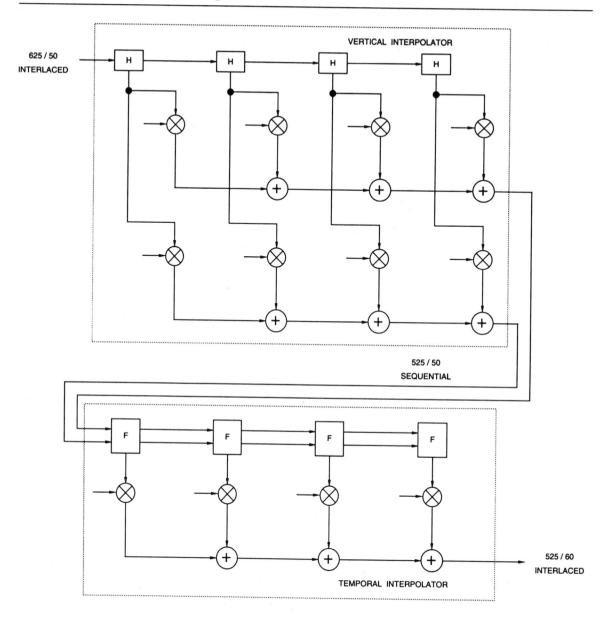

Figure 9.32. Typical 625/50 to 525/60 Conversion using Vertical, Followed by Temporal, Interpolation.

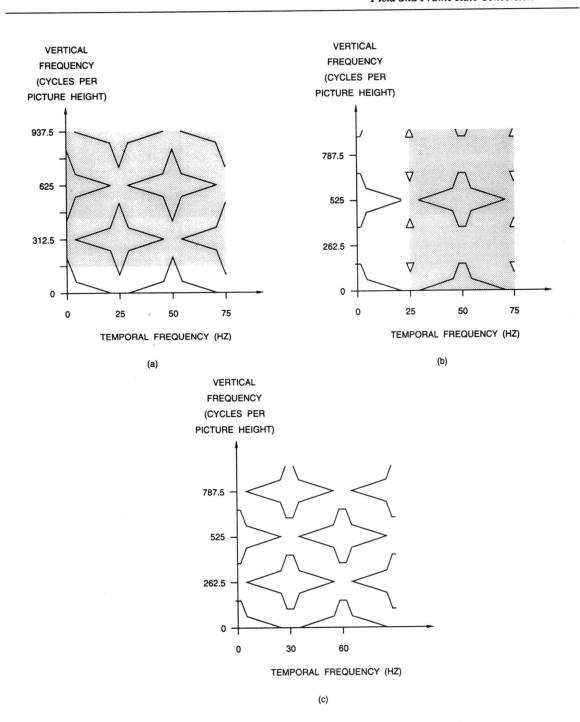

Figure 9.33. Spectral Representation of Vertical, Followed by Temporal, Interpolation: (a) Vertical Lowpass Filtering; (b) Resampling to Intermediate Sequential Format and Temporal Lowpass Filtering; (c) Resampling to Final Standard.

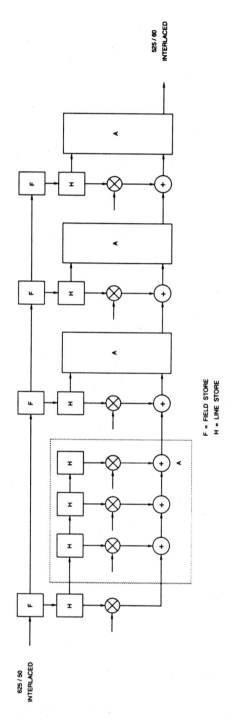

Figure 9.34. Typical 625/50 to 525/60 Conversion using Combined Vertical and Temporal Interpolation.

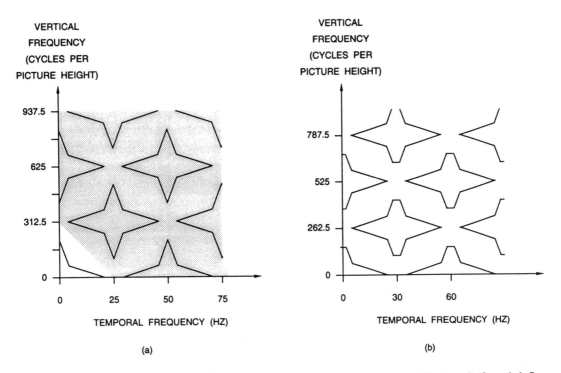

Figure 9.35. Spectral Representation of Combined Vertical and Temporal Interpolation: (a) 2-Dimensional Lowpass Filtering; (b) Resampling to Final Standard.

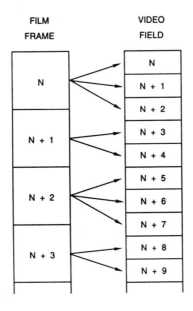

Figure 9.36. 3-2 Pulldown for Transferring Film to NTSC Video.

VLSI Solutions

The Brooktree Bt885 Video CacheDAC™, shown in Figure 9.37, provides support for video-in-a-window applications. The 64-bit pixel input port may be configured for various graphics and video input formats. The video window may be positioned anywhere on the display screen, and be any size, with horizontal scaling being performed by the Bt885. The video source may be scaled up any amount to fit the video window.

Features of the Bt885 include:

- 135-MHz Pipelined Operation
- 32-bit Graphics and 32-bit Video Input Port
- Mixed Video and Graphics Support
- YCrCb-to-RGB Conversion
- Horizontal Up-Scaling
- 800-byte FIFO For Asynchronous Video Operation

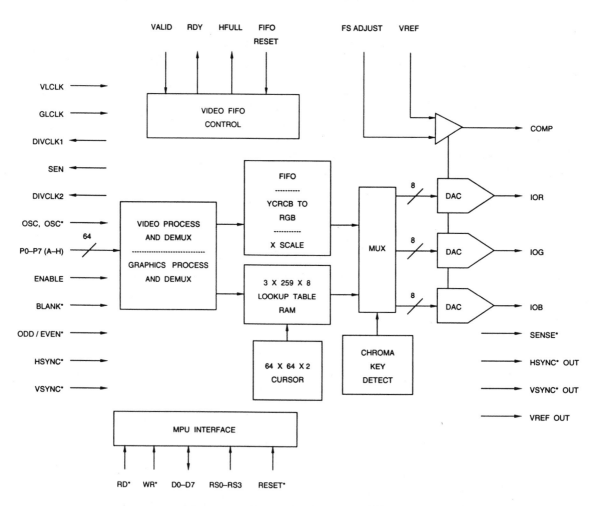

Figure 9.37. Brooktree Bt885 Video CacheDAC™ Block Diagram.

- 64 × 64 × 2 Cursor

- Pipelined Horizontal and Vertical Sync Outputs

- Programmable Chroma Key Value and Mask

- Three 256 × 8 Lookup Table RAMs

- 3 × 24 Cursor Palette

- Standard MPU Interface

- Power-Down Mode

- 160-pin Plastic Quad Flatpack Package

The Chips and Technologies 82C9001 PC Video™ Video Windowing Controller, whose application is shown in Figure 9.38, is designed to add "video-in-a-window" capabilities to a standard VGA graphics environment. The 89C9001 requires 4–8 Mbits of memory, using 256k × 4 VRAMs.

Features of the 82C9001 include:

- (x, y) Coordinates or Color Keying for Window Positioning

- Supports 12-bit (2:1:1 or 4:1:1) and 16-bit (4:2:2) YCrCb

- Supports 16-bit RGB

- Independent X and Y scaling of Video Image to 1/64 Original Size

- Interlaced or Noninterlaced Input Video

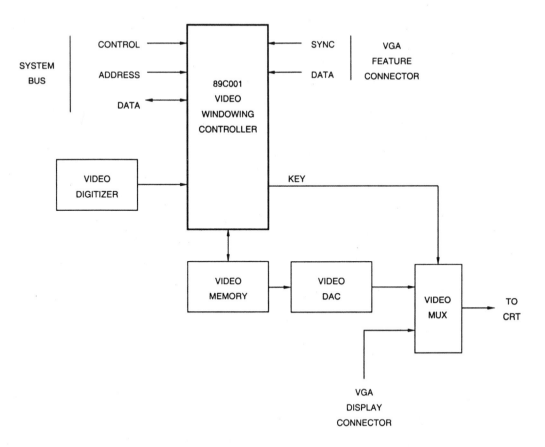

Figure 9.38. Chips and Technologies 82C9001 Application Diagram.

- Interlaced or Noninterlaced Output Support

- Output Zoom of 2×, 4×, and 8×

- Output Resolutions up to 800 × 600

The Chips and Technologies 69003 Windowing Controller and the 69004 Data Path chip comprise the PC Video™ Pro CHIPSet Video Windowing Controller, whose application is shown in Figure 9.39, and is designed to add "video-in-a-window" capabilities to a standard VGA graphics environment. The chip set requires 4–16 Mbits of memory, using 256K × 4 VRAMs.

Features of the 69003/69004 chip set include:

- Software Compatible with 82C9001

- (x, y) Coordinates or Color Keying for Window Positioning

- Supports 12-bit (2:1:1 or 4:1:1) and 16-bit (4:2:2) YCrCb

- Supports 16-bit, 24-bit, and 32-bit RGB

- Independent X and Y scaling of Video Image to 1/64 Original Size

- Interlaced or Noninterlaced Input Video

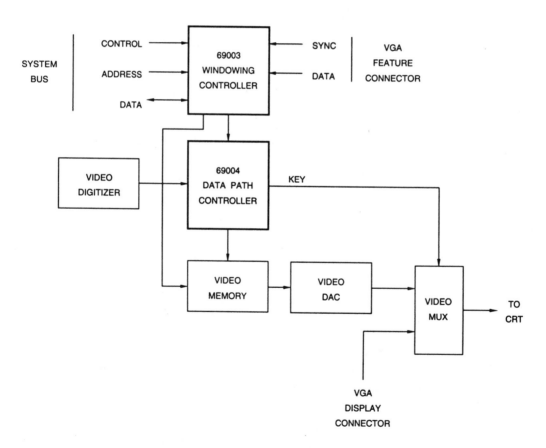

Figure 9.39. Chips and Technologies 69003/69004 Application Diagram.

- Interlaced or Noninterlaced Output Support

- Output Zoom of 2×, 4×, and 8×

- Output Resolutions up to 1024 × 768

The Philips Semiconductors SAA7186 Digital Video Scaler, whose block diagram is shown in Figure 9.40, performs real-time down-scaling of video to support video-in-a-window applications. Down-scaling of video windows with 768 pixels or fewer per line and 576 lines or fewer per frame are supported. Down-scaling from 1023 × 1023 is possible without vertical processing.

Features of the SAA7186 include:

- Two On-Chip 768 × 16 Line Memories

- 2-D Processing (Horizontal and Vertical)

- 15-bit RGB, 24-bit RGB, or 16-bit YCrCB output

- Optional 1-bit Alpha Key Output

- 16-, 24-, and 32-bit VDRAM Output Interface

- Optional Gamma Removal from RGB Data

- I²C Control Interface

- 100-pin Plastic Quad Flatpack Package

The Pixel Semiconductor CL-PX2080 MediaDAC™ (whose block diagram is shown in Figure 9.41) is a multiple-source video D/A converter that manages and mixes two different pixel data streams, one for video and one for graphics. Features of the CL-PX2080 include:

- Video Inputs:

- (8, 8, 8) RGB at 40 MHz

- (5, 5, 5) and (5, 6, 5) RGB at 85 MHz

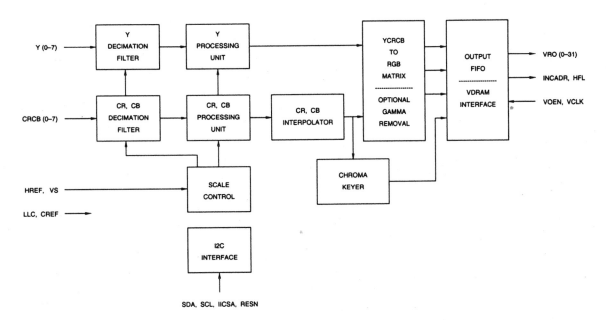

Figure 9.40. Philips Semiconductors SAA7186 Digital Video Scaler Block Diagram.

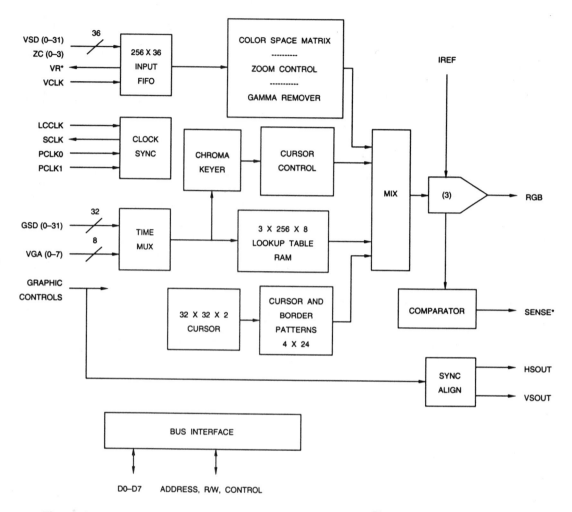

Figure 9.41. Pixel Semiconductor CL-PX2080 MediaDAC™ Simplified Block Diagram.

- 4:2:2 YCrCb at 85 MHz
- 36-bit Data Path
- 256 × 36 Input FIFOs
- X Zoom Control
- Graphics Inputs:
- 4-bit and 8-bit Pseudo-Color at 85 MHz
- (5, 6, 5) and (5, 5, 5) RGB at 85 MHz
- (8, 8, 8, 8) RGBalpha at 40 MHz

- 8-bit VGA and 32-bit VRAM Interface
- 32 × 32 × 2 Hardware Cursor
- Overlay Control
- Tagged Chroma Color Key
- Graphics Overlay Color Key
- X/Y Window
- ISA and MCA Bus Interface

The Pixel Semiconductor CL-PX2070 Video Processor (Figure 9.42 shows the block diagram) supports up to three simultaneous video/graphics streams by using two dedicated video ports and the host interface. The video processing unit (VPU) prepares input data streams for processing and/or storage in the frame buffer, and outputs the data to the frame buffer. VPU processing features include color space conversion, data tagging, lookup table operations, window clipping, horizontal and vertical scaling, and output stream format conversion. The reference frame unit (RFU) allows simultaneous access to eight object buffers and four display windows. RFU processing features include window size and location, X and Y BLT directions, FIFO association, chrominance and luminance channel masking, and output decimation.

Features of the CL-PX2070 include:

- Complete Frame Buffer Control

- Supports 0.5–8.0 Mbytes of Frame Buffer Memory

- Color Space Conversion, Prescaling, Zooming, Windowing

- Programmable, Triple Channel Lookup Table RAMs

- Two Video Input/Output Ports, Each Configurable as Input Only, Output Only, or Pixel- or Field-Duplexed Input/Output

- Programmable Sync Polarity

- 16-bit YCrCb, 12-bit YCrCb, 16-bit RGB (Input)

- 16-bit YCrCb, 16-bit RGB (Output)

When Used with the CL-PX2080, Provides:

- Simultaneous Video and RGB Display

- 4 Overlapping (Occluded) Windows

- $1\times$ to $256\times$ Zoom

- 1024×768 Display at 85 MHz

- Integrated ISA, MCA, and Host Bus Interface

The Trident Microsystems T1 and T2 chips comprise a video processing chipset, combining 8-bit VGA/XGA graphics/text with 24-bit live video data from a video decoder. Supported features include scalable full-motion video windowing, multiple frame capture, VGA/XGA graphics and text overlay, digital special effects processing, and chroma keying. The chroma keying options include keying on a color range or fixed color, or on the blue component of the live video input. Shadows may be preserved during chroma keying. Digital special effects include selectable border colors, scaling, negative video, color filtering, mosaic, panning, transparency, solarization, linear blending, and crossfading. A minimum of four $256k \times 4$ or two $256k \times 8$ VRAMs are required.

Features of the T1/T2 chip set include:

- 8, 16, 24, and 32 Bits per Pixel

- Video Scaling and Video Window Clipping

- VGA/XGA graphics and text overlay

- Chroma Keying

- Special Effects

- Software-controlled Hue, Contrast, Brightness, and Saturation

- 160-pin (T1) and 184-pin (T2) Plastic Quad Flatpack Packages

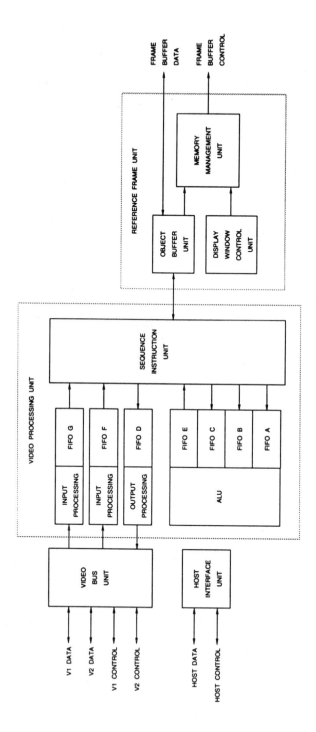

Figure 9.42. Pixel Semiconductor CL-PX2070 Video Processor Simplified Block Diagram.

References

1. Brooktree Corporation, Bt885 Datasheet, November, 1992.
2. Chips and Technologies 69003/69004 Data-sheet, January 1992.
3. Chips and Technologies 82C9001 Data-sheet, April 1992.
4. Croll, M.G. et. al., 1987, *Accommodating the Residue of Processed or Computed Digital Video Signals Within the 8-bit CCIR Recommendation 601*, BBC Research Department Report BBC RD1987/12.
5. Philips Semiconductor, SAA7186 Data-sheet, March 1992.
6. Pixel Semiconductor, CL-PX2070 Data-sheet, May, 1992.
7. Pixel Semiconductor, CL-PX2080 Data-sheet, May, 1992.
8. Sandbank, C. P., *Digital Television*, John Wiley & Sons, Ltd., 1990.
9. Trident Microsystems, VideoView™ Video Processing Chipset, February 1992.
10. Ultimatte®, Technical Bulletin No. 5, Ultimatte Corporation.
11. Watkinson, John, *The Art of Digital Video*, Focal Press, 1990.

Video Compression/ Decompression

Advances in audio/video compression and decompression algorithms and VLSI technology are opening up new capabilities, such as transmitting digital audio/video via satellite or cable directly into the home, storing digital audio/video within the computer environment, and the development of digital video tape and video CD recorders. Also, new applications are being developed, such as CD-Interactive (CD-I).

Three of the most common algorithms in use are JPEG (Joint Photographic Expert Group), MPEG (Moving Pictures Expert Group), and CCITT H.261. Although each algorithm is tailored for a specific application, they have much in common, such as using the discrete cosine transform (DCT), quantization, and run-level coding.

Since JPEG is designed for still images, the encoding and decoding are relatively easy to implement since no motion estimation processing is required. Note that JPEG images may be of any resolution and color space, and both lossy (baseline JPEG, DCT based) and lossless (using differential pulse code modulation [DPCM] techniques) algorithms are available. Compression ratios for lossy operation are about 1 bit per pixel. Note that there is nothing preventing JPEG from being used for motion video, with each field or frame of video being individually processed.

H.261 (also known as Px64) is designed for video teleconferencing and uses motion estimation from the previous frame. Picture resolution is restricted to CIF (352 × 288) and QCIF (176 × 144) resolutions, using the 4:1:1 YCrCb format shown in Figure 10.1. Temporal rates are 30, 15, 10, or 7.5 frames per second and can vary dynamically. Compression ratios of about 0.1 bits per pixel are typical. Cost is minimized since the decoder requires only a single frame store. Note that H.261 is designed for very low data rates with little emphasis on quality and was targeted to work with channel bandwidths of 64k to 2 Mbits per second.

MPEG, designed for motion video and audio, also uses motion estimation, with emphasis placed on video quality. Its features include random access, fast-forward, reverse play, and so forth. The original channel bandwidth and picture resolution were set by available media (one hour of play time on a CD-ROM at 1.5 Mbits per second), with a minimal decoder cost. Initial MPEG resolutions are typ-

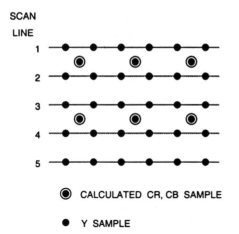

Figure 10.1. 4:1:1 Coded Picture Sampling for H.261 and MPEG, showing the position of sampling sites on the scan lines of a noninterlaced system.

ically CIF (352 × 288), using the 4:1:1 YCrCb format shown in Figure 10.1. Although good compression ratios are available (about 0.3–0.5 bits per pixel), this is done at the expense of increased encoder and decoder complexity. Since MPEG contains most of the functions required by H.261 and JPEG, multistandard encoders and decoders will be commonplace. Many designs are extending the basic MPEG specification and using higher channel bandwidths to allow full CCIR 601 resolution (720 × 576 using the 4:2:2 YCrCb format), fewer motion artifacts, and support for 24-bit true-color RGB graphics.

Work is also progressing on MPEG II that assumes channel bandwidths of 5–10 Mbits per second, allowing higher resolutions, higher quality video, and interlaced video to be supported. Table 10.1 lists some of the common video formats used for H.261 and MPEG.

Still Image Compression and Decompression

Figure 10.2 illustrates the basic encoding and decoding processes for still-image compression and decompression, on which baseline JPEG and MPEG are based. For color images, the same process is used for each color component, be it RGB, YCrCb, or CMYK. The decoder recovers each color component individually, merging them together to regenerate the image.

format	refresh rate (Hz)	field resolution	YCrCb sampling	notes
QCIF	10–25 (30)	176 × 144 (120)	4:1:1	video teleconferencing
CIF	15–25 (30)	352 × 288 (240)	4:1:1	
square pixel NTSC	60	640 × 240	4:1:1	S-VHS quality
square pixel PAL	50	768 × 288	4:1:1	
CCIR 601	50 (60)	720 × 288(240)	4:1:1	
square pixel NTSC	60	640 × 240	4:2:2	broadcast quality
square pixel PAL	50	768 × 288	4:2:2	
CCIR 601	50 (60)	720 × 288(240)	4:2:2	

Table 10.1. Common Video Formats.

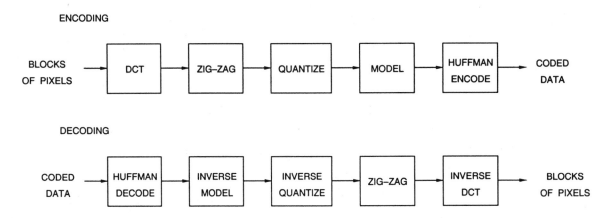

Figure 10.2. Still Picture Encoding and Decoding Operations. For color images, each color component is individually processed.

A more detailed look of the encoding process is revealed by Figures 10.3 through 10.7. The image is divided into 8 × 8 blocks, as shown in Figure 10.3. Each 8 × 8 block is processed by the DCT, resulting in an 8 × 8 block of frequency-dependent transform coeffi-

cients, as shown in Figure 10.4. The 8 × 8 block of transform coefficients are zig-zag scanned, starting with the DC component, generating a linear stream of transform coefficients arranged in order of increasing frequency, as shown in Figure 10.5. These are

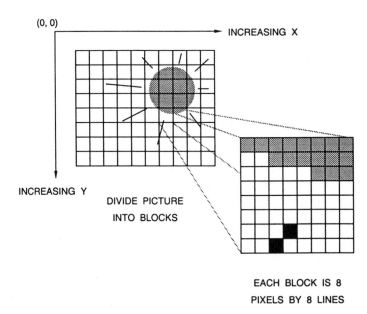

Figure 10.3. The Image is Divided Up into 8 × 8 blocks for DCT Processing.

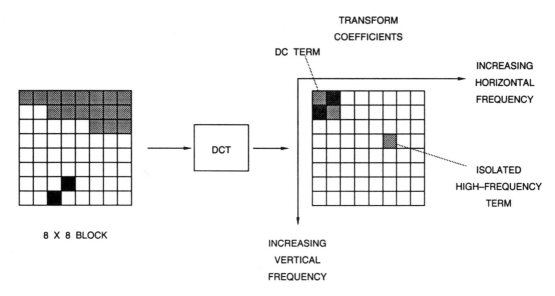

Figure 10.4. The DCT Processes the Actual Pixel Data to Generate Transform Coefficients.

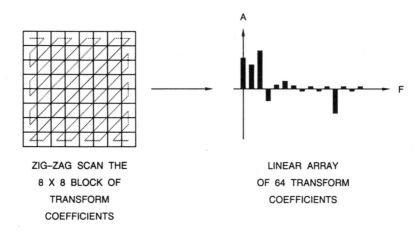

ZIG–ZAG SCAN THE
8 X 8 BLOCK OF
TRANSFORM
COEFFICIENTS

LINEAR ARRAY
OF 64 TRANSFORM
COEFFICIENTS

Figure 10.5. The 8 × 8 Array of Transform Coefficients from the DCT Are Zig-zag Scanned to Arrange in Order of Increasing Frequency.

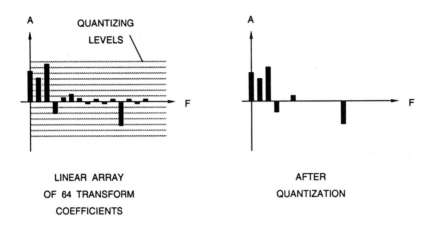

(a) FLAT QUANTIZATION

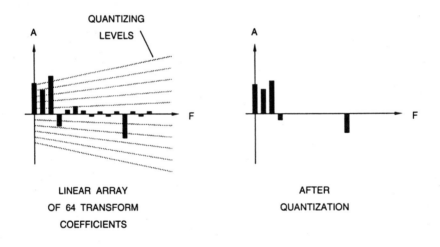

(b) TABLE QUANTIZATION

Figure 10.6. After Zig-zag Scanning, the Coefficients are Quantized: (a) Using a Flat Quantizer, Such as Used With H.261 (b) Using a Table-based Quantizer, Such as Used With JPEG and MPEG.

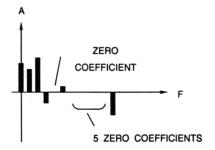

RUN LEVEL

0	+5
0	+4
0	+6
0	-2
1	+1
5	-4

EOB

Figure 10.7. Modeling, Where Run-level Values are Set. Each run-level combination is called an event; EOB (end of block) is a special event.

then quantized as shown in Figure 10.6. Either flat quantizing (H.261) or table-based quantizing (MPEG and JPEG) can be used. The quantizing levels used during the encoding process are passed on to the decoder. The quantized levels are converted to run-level codes as shown in Figure 10.7. Huffman encoding is used to transfer data concerning motion vectors, prediction modes, and so forth.

Motion Prediction and Compensation

To further increase the compression ratio, MPEG also uses motion prediction and compensation, resulting in three types of frames.

Intra frames (I frames) are encoded using still-image JPEG coding. Predicted frames (P frames) are encoded using motion prediction from an earlier I frame. To predict, the encoder makes a guess at the current frame using information from the previous I frame. The prediction is subtracted from the current frame to form an error signal, which is encoded. The decoder decodes the error signal and adds it to its prediction (which is the same as the encoder) to reconstruct the desired picture for that frame. The MPEG decoder also generates bidirectional frames (B frames), which are interpolated from earlier and later I and P frames, as shown in Figure 10.8. Two numbers (M and N) describe the prediction scheme used. M specifies the distance between P frames or a P frame and an I frame; N specifies the distance between I frames, as shown in Figure 10.9. The value of N affects the usefulness of the random access and special modes. The value of M affects the implementation cost and video quality. Using larger values for M may cause motion estimation problems and requires more memory. For MPEG using CIF resolution, experiments have determined that a value of three or four for M achieves the best compression.

Since the coding between frames is dependent on the frame position and its contents, MPEG is difficult to use for video editing. JPEG, which processes each frame individually, is better suited for video editing. Once the editing process is complete, a MPEG-encoded file can be generated for distribution.

H.261 also uses simple motion prediction to further increase the compression ratio. Again, the prediction is subtracted from the current frame to form an error signal, which is encoded. The decoder decodes the error signal and adds it to its prediction (which is the same as the encoder) to reconstruct the desired picture for that frame. In MPEG terms,

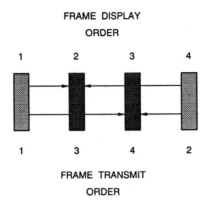

Figure 10.8. MPEG Bidirectional Interpolative Coding. Some frames can be transmitted out of sequence, complicating the interpolation process, and requiring frame reordering at the output of the MPEG decoder.

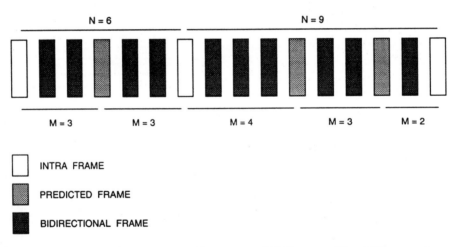

Figure 10.9. MPEG I Frames, P Frames, and B Frames. M and N are not constants and can vary dynamically.

H.261 uses M = 1 and N = ∞. In general, there are no intra frames, but some macroblocks (a 2 × 2 block of 8 × 8 pixels) are sent as "intra" each frame, as shown in Figure 10.10.

As shown in Figure 10.11, simple motion prediction can be done by subtracting corre-sponding pixels between two frames to gener-ate an error signal. Motion prediction can be improved by filtering the pictures to reduce the effects of block edges and quantization noise. For example, H.261 uses a simple low-pass filter that operates within the 8 × 8 block.

INTRA

PREDICTED

Figure 10.10. H.261 Frames. Note that some frames can be dropped.

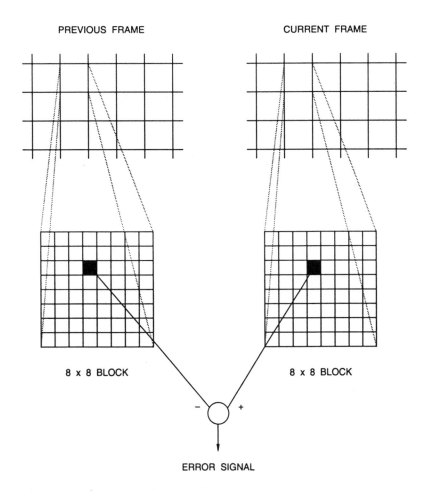

Figure 10.11. Simple Prediction. Corresponding pixels in the two frames are subtracted to form an error signal.

The filter is applied over the six center pixels horizontally, then vertically. The first and last pixels of a row and column are not filtered. Further improvements in motion prediction, at the expense of more calculations, can be achieved by using half-pixel accuracy; interpolation is done using the surrounding pixels.

MPEG also uses motion compensation, as shown in Figure 10.12, allowing displaced pixels between two frames (due to moving objects) to be easily subtracted to generate an error signal. Motion vectors specify where a block of pixels came from in the previous frame; motion vectors do not say where a block of pixels will be in the next frame; that must be calculated by the decoder using the motion vectors and the contents of the previous frame. As with H.261, further improvements in motion prediction can be achieved at the expense of more calculations by using half-pixel accuracy.

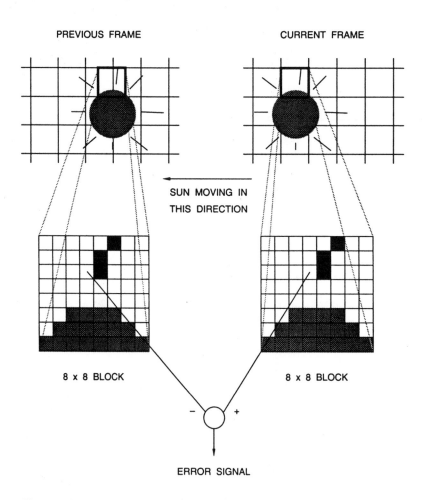

Figure 10.12. Motion Compensated Prediction. Motion compensation allows displaced pixels in the two frames to be subtracted to form an error signal.

Motion vectors are also used by the decoder in determining where moving objects will be when generating B frames. In this instance, the motion vectors are interpolated so as to position moving objects at the correct locations within the corresponding B frames. Note that MPEG does not specify how to do the motion prediction and compensation, allowing a trade-off between complexity, new algorithms, and video quality to be made. Various types of motion vector processing are possible, such as frame walking using constant positioning or constant velocity, log search, hierarchical estimation, and phase correlation. The goal of each of these techniques is to improve motion estimation while decreasing the amount of processing required.

Handling Interlaced Video

Originally, MPEG was primarily designed to handle CIF resolution video. If the original video source was per CCIR 601 (720 × 288, 2:1 interlaced), only the even or the odd fields would be used for encoding. The fields would be scaled down to CIF resolution (352 × 288) and encoded. During decoding, the fields would be scaled up to the original 720 × 288 resolution and repeated, as shown in Figure 10.13.

Alternately, the even and odd fields can be combined into a single frame of 720 × 576 resolution at 25 Hz and encoded. During decoding, the fields would again be separated, as shown in Figure 10.14. This technique has the disadvantage of requiring a much higher data rate to avoid motion artifacts and maintain the resolution, as well as the additional memory costs of the encoder and decoder to handle the higher resolution video.

A third approach, shown in Figure 10.15, is to treat each field as an individual picture, encoding each field individually. Again, this technique has the disadvantage of requiring a much higher data rate to avoid motion artifacts and maintain the resolution, and the additional memory costs of the encoder and decoder to handle the higher resolution video.

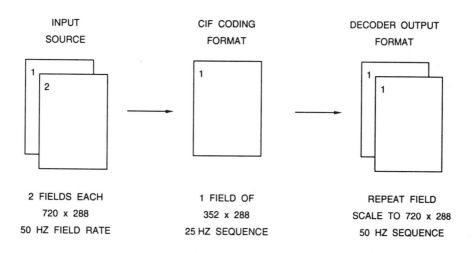

INPUT SOURCE	CIF CODING FORMAT	DECODER OUTPUT FORMAT
2 FIELDS EACH	1 FIELD OF	REPEAT FIELD
720 x 288	352 x 288	SCALE TO 720 x 288
50 HZ FIELD RATE	25 HZ SEQUENCE	50 HZ SEQUENCE

Figure 10.13. Encoding and Decoding of CIF Pictures Assuming CCIR 601 Input and Output.

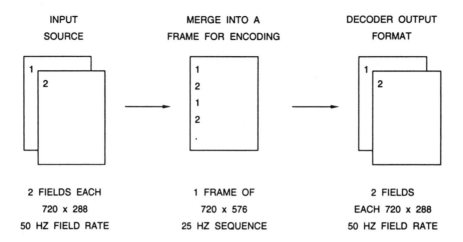

Figure 10.14. Encoding and Decoding of CCIR 601 Pictures as Frames.

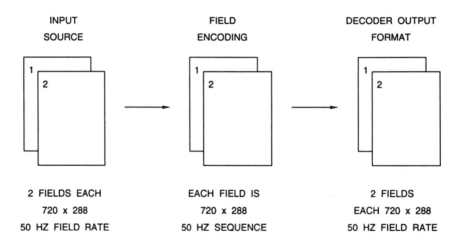

Figure 10.15. Encoding and Decoding of CCIR 601 Pictures as Fields.

MPEG Video Quality Issues

Several factors affect the quality of MPEG-compressed video:

- the resolution of the original video source

- the frame rate of the original video source

- the data rate (channel bandwidth) allowed after compression

- where random access points are built into the video

- motion estimator effectiveness

- the quality of the data rate regulation algorithm.

The ultimate limitation of the quality of the compressed video is determined by the resolution and frame rate of the original video source. If the original resolution was too low, there will be a general lack of detail and visible artifacts on 8 × 8 block boundaries. If the original frame rate was too low, fast-moving objects can have movement artifacts, such as judder (uneven movement).

The higher the data rate (channel bandwidth), the more information that can be transmitted, allowing fewer motion artifacts to be present or a higher resolution image to be displayed. If the data rate is too low, there will be a general degradation in video quality, with the 8 × 8 blocks becoming clearly visible.

Motion estimator effectiveness determines motion artifacts, such as a reduction in video quality when movement starts or the amount of movement is above a certain threshold. Poor motion estimation will contribute to a general degradation of video quality, with the 8 × 8 blocks being visible. In addition, fast-moving areas can have reduced detail, turning into "fuzzy blobs."

The data rate regulation algorithm throttles the compressed data being presented to the decompressor. This is required since the decompressor generates so much output data. Poor regulation can show up as some areas of the picture being worse than others, or the quality of the entire picture varying over time.

Appendix
Video Test and
Measurement Methods

This appendix describes standard NTSC/PAL test and measurement methods used for quantifying signal distortions and rating the performance of video devices. It does not provide detailed instructions on how to use particular measurement instruments. It is assumed that you know the basics of waveform monitor and vectorscope operation. For specific equipment operating instructions, consult your instrument manuals.

Equipment Requirements

Two instruments, a vectorscope and a waveform monitor, are the most commonly used for testing video signals. A vectorscope demodulates the signal and displays R–Y versus B–Y, allowing you to accurately evaluate the chrominance portion of the signal. A waveform monitor provides video triggering capabilities and filters that allow you to separately evaluate the chrominance and luminance portion of the signal. In describing the test procedures, it is assumed that all users have access to at least a vectorscope and either a waveform monitor or an oscilloscope equipped with TV trigger capabilities. All of the measurements discussed may also be made automatically using a Tektronix VM700 Video Measurement Set, a sophisticated test and measurement instrument that digitizes the video signal and automatically analyzes it in the digital domain, or other automated video measurement instruments.

Measurement Techniques

There is no one standard that completely defines NTSC or PAL signals. A number of organizations publish documents that provide recommended limits on distortion levels, that can serve as guidelines. For (M) NTSC, EIA RS-170A and FCC 73.699 are frequently used specifications. CCIR Report 624 is the most commonly used PAL standard, although governments of the various countries that use PAL

also issue their own standards documents. Definitions for expressing the magnitude of distortions can vary from standard to standard. Make sure that you are clear about the definitions in whatever standards you use, to avoid misunderstandings about one or more of the measurements taken and how the amount of distortion is to be expressed. It is recommended that you record this information along with the measurements taken.

Although most instruments are stable over time, you should verify the calibration of your waveform monitor and vectorscope before each measurement session. Many instruments have internally generated calibration signals to facilitate this process. Refer to your instrument's manual for detailed procedures. Many instruments specify a warm-up time of 20 or 30 minutes before calibration is undertaken. The more sophisticated instruments, such as the VM700, do not require operator calibration, but still need a warm-up time.

Color Bars

NTSC

Two types of NTSC color bars are in common use, 75% and 100% bars. The names refer to the maximum amplitudes of the red, green, and blue signals when they form the six primary and secondary colors that make up the color bars. For 75% bars, the max amplitude of the RGB signals is 75% of the peak white level; the signals can extend to 100% of peak white for 100% bars. The 75% bars are most commonly used.

In the RGB format, colors are saturated if at least one of the primaries is at zero. Both 75% and 100% color bars are 100% saturated. A parameter completely independent of the 75%/100% amplitude distinction is the white bar

level. It also is typically specified as 75% or 100%, but either white level can be associated with either of the two bar types.

Both chrominance and luminance amplitudes in the composite signal vary according to the 75%/100% definition. The ratio between chrominance and luminance, however, stays constant in order to maintain 100% saturation.

The maximum available signal level is 100 − 7.5, or 92.5 IRE. 75% of 92.5 is 69.4 IRE; when this is added to the 7.5 IRE pedestal, it gives 77 IRE, which is the 75% signal level.

Figure A.1 shows a typical vectorscope color bar display for full-screen EIA color bars. The accuracy and consistency of dot placement within the targets is the primary indicator of signal quality. Fine dots positioned exactly in the signal crosshairs and clean vector edges are indicative of superior signals. Figure A.2 shows typical (M) NTSC measurements (luminance level, chrominance level, and chrominance phase) for a NTSC encoder generating full-screen EIA color bars.

Another commonly used test signal is the split-field SMPTE signal, composed of standard color bars for the top 2/3 of the field, reverse blue bars for the next 1/12 of the field, and the IYQB signal for the remainder of the field.

PAL

Three types of PAL color bars are commonly used: 100%, 95%, and 75% EBU bars. The maximum amplitudes of the R, G, and B signals are sometimes used to distinguish the different bars. It is extremely important to know which type of bars are being used and to select the correct setting on your vectorscope or other measurement instrument.

Since there is much room for confusion concerning which parameters are being specified, it is best to use the following four

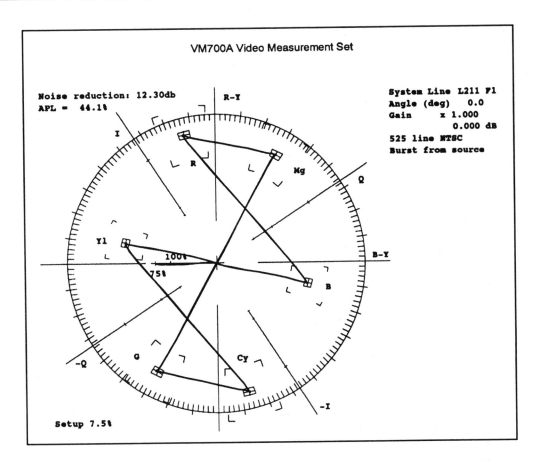

Figure A.1. Typical (M) NTSC Vectorscope Display for Full-screen EIA Color Bars.

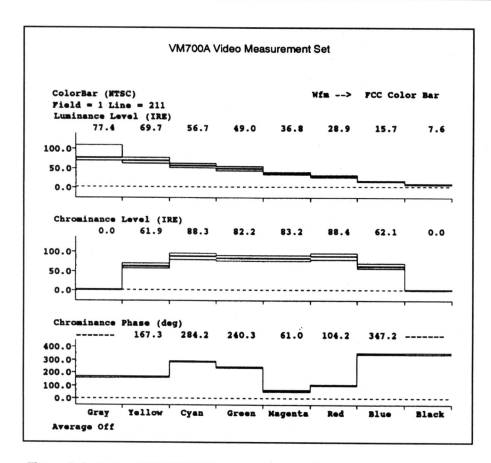

Figure A.2. Typical (M) NTSC Measurements for Encoder Generating Full-screen EIA Color Bars.

parameters to define PAL color bar signals, where E_R', E_G' and E_B' are the three color signals:

- maximum value of E_R', E_G' or E_B' for an uncolored bar

- minimum value of E_R', E_G', or E_B' for an uncolored bar

- maximum value of E_R', E_G' or E_B' for a colored bar

- minimum value of E_R', E_G', or E_B' for a colored bar.

Each parameter is expressed as a percentage of the maximum voltage excursion allowable, or 700 mV.

Figure A.3 shows a typical (B, D, G, H, I) PAL vectorscope display for full-screen EBU color bars.

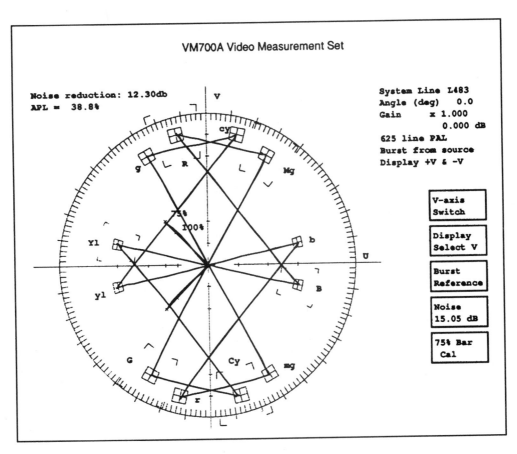

Figure A.3. Typical (B, D, G, H, I) PAL Vectorscope Display for Full-screen EBU Color Bars.

Timing Measurements

For (M) NTSC, recommended limits for video timing parameters are specified by the FCC and by RS-170A; however, the standards define the various time intervals differently. Be sure that you know which standard applies to the test you are performing. The RS-170A specifications are generally more stringent. CCIR Report 624 is the most commonly accepted standard for PAL timing specifications. Important timing parameters include horizontal and vertical synchronization pulse widths, rise times, fall times, and the position and number of cycles in the burst.

Numerous problems can result from inaccurate timing. Although small errors in pulse widths won't affect the quality of the video image, if the errors become large, picture breakup can occur. If signals rise or fall too sharply or too slowly, problems can occur with equipment attempting to lock to the signals. Edges that are too sharp also can cause ringing problems. While TV is relatively forgiving of many timing errors, studio equipment and many other video applications demand a signal that adheres closely to specifications.

A waveform monitor can be used to measure pulse widths, by comparing the waveform to the marks along the horizontal baseline of the graticule. For sufficient resolution, you should magnify the waveform display horizontally. For NTSC measurements between the 90% points of the transition, use the waveform monitor's variable gain control to normalize the sync height to 100 IRE. Then position the blanking level at +10 IRE and read the measurement from the baseline marks. For measurements to be taken at the 50% points, place the top of the pulse at +20 IRE and the bottom at –20 IRE and read the pulse width from the horizontal scale. Most PAL pulse width mea-

surements are made between the 50% points of the transition, and can usually be made with the vertical gain in the calibrated position. Some waveform monitors have cursors to assist with measuring time intervals. Automated measurement instruments, such as the VM700, have settings for automatically making and displaying standard interval timing measurements.

Many standards specify rise and fall times of the sync pulse, measurements that are indicators of how fast the transitions occur. These measurements are typically made between the 10% and 90% points of the transition. The same methods described for measuring pulse widths can be generally applied to rise and fall time measurements. Figure A.4 shows horizontal sync and burst interval detail for (M) NTSC, and Figure A.5 shows the same information for (B, D, G, H, I) PAL.

SCH Phase

SCH phase, which stands for SubCarrier-to-Horizontal phase, defines the timing relationship between the 50% point of the leading edge of sync and the zero crossings of the reference subcarrier. Errors in SCH phase are expressed in degrees of subcarrier phase. As specified by RS-170A, SCH phase should be within ±40 degrees, but much tighter tolerances are usually found, often within a few degrees, in both NTSC and PAL systems. In actuality, consistency is more important for SCH phase than the actual percentage, as long as the percentage falls within the specification.

This relationship is important when signals from two or more sources are combined or switched sequentially. To prevent color shifts or horizontal jumps, correct timing of the sync edges and matching of the burst

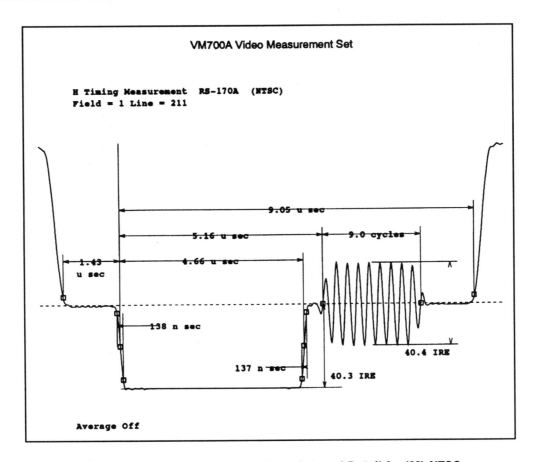

Figure A.4. Horizontal Sync and Burst Interval Detail for (M) NTSC.

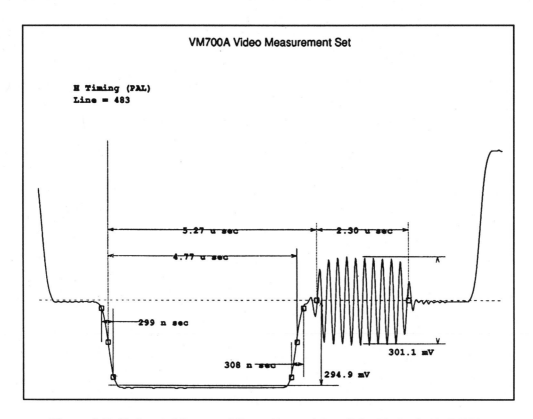

Figure A.5. Horizontal Sync and Burst Interval Detail for (B, D, G, H, I) PAL.

phases is essential. These conditions can only be met simultaneously if the SCH phase relationship of the signals is the same.

For (M) NTSC signals, the exact SCH phase relationship for a given line only repeats itself once every four fields (two frames). The four-field sequences of the signals must be properly aligned—a condition termed "color framed." Proper color framing and SCH phase relationship are essential for correct sync timing and burst phase matching conditions to be met. For (B, D, G, H, I) PAL signals, an eight-field sequence exists because of the relationships between the line, field, and subcarrier frequencies; the exact SCH phase relationship for a given line repeats itself once every eight fields (four frames).

Some measurement instruments have a polar SCH display consisting of the burst vector and a dot that represents horizontal sync. The phase relationship can be read directly from the graticule. Automated instruments like the VM700 allow you to display SCH phase directly.

Frequency Response

These measurements, also called gain/frequency distortion or amplitude vs. frequency response, allow you to evaluate a system's amplitude response over the entire video spectrum. They measure the ability of a system to transfer components of different frequencies without affecting their amplitudes. Variation in amplitude can be given in dB or percent (or IRE for NTSC systems). The reference is normally white (0 dB or 100%). Frequency response measurements must contain three components—amplitude, frequency at which the measurement was taken, and reference frequency. Problems in frequency response can cause a number of unwanted picture effects,

such as flicker, brightness inaccuracies, horizontal streaking and smearing, or fuzzy vertical edges.

Various test signals can be used to measure frequency response; this appendix, however, only treats the Multiburst signal. Multiburst measurements of frequency response can be made with a waveform monitor, by measuring the peak-to-peak amplitudes of the packets. Multiburst usually includes six packets of discrete frequencies falling within the video passband. The signal allows a fast approximation of a system's frequency response. It is essential to select one standard reference level and use it consistently throughout the testing, as there is little agreement among the various measurement standards on what reference level to use.

Either the white bar or the first packet can be used as the reference with full-amplitude Multiburst. With reduced-amplitude Multiburst, some standards recommend normalizing the white bar to 100 IRE. The difference between peak-to-peak amplitude of each packet and the nominal level is the distortion at that frequency. The VM700 provides amplitude versus frequency response information for Multiburst automatically.

Noise Measurements

Noise is usually expressed as signal-to-noise ratio (SNR), given in dB, since it is the amount of noise in relation to the signal amplitude that causes problems, rather than the absolute amount of noise. Noisy pictures can be snowy or grainy, or sparkles of color may appear.

Since noise does not lend itself well to straightforward amplitude measurements, a number of special techniques have been developed to measure it. Specialized equipment, such as the VM700, is required to completely

characterize the noise performance of a video system.

Nonlinear Distortion Measurements

All of the following tests measure *nonlinear distortion*, a term given to amplitude-dependent waveform distortions. Since amplifiers and other electronic circuits maintain linearity only over a certain range, they tend to clip or compress large signals, resulting in nonlinear distortion of various types. These distortions may also show up as crosstalk and intermodulation effects between the luminance and chrominance portions of the signal. The three most familiar and frequently measured nonlinear distortions are differential phase, differential gain, and luminance nonlinearity. Also discussed here are chrominance nonlinear phase, chrominance nonlinear gain, and chrominance-to-luminance intermodulation.

Luminance Nonlinearity

Also called differential luminance, *luminance nonlinearity* appears when luminance gain is affected by luminance level—a nonlinear relationship exists between the input and output signals in the luminance channel. This results when the system is not able to process luminance uniformly over the complete range of amplitude. Luminance nonlinearity is expressed as a percentage.

Luminance nonlinearity is particularly noticeable in color images since color saturation, to which the eye is fairly sensitive, is affected. (Color saturation is always affected when the ratio between chrominance amplitude and luminance amplitude is incorrectly transferred.) This distortion is less noticeable in black-and-white pictures. However, if large amounts of distortion are present, a loss of detail in highlights and shadows might become noticeable.

For this measurement, a differentiated step (usually called a "diff step") filter is required; it is found on many waveform monitors. A diff step filter creates a spike corresponding to each luminance step transition. The amplitude of each spike is directly related to the step height of each transition. Luminance nonlinearity can be measured by determining the difference in amplitude between the largest and smallest spike, and expressing this as a percentage of the largest spike. For example, a waveform with a maximum spike of 300 mV and a minimum spike of 295 mV would have a luminance nonlinearity of:

$$(300 - 295)/300 = .0167, \text{ or } 1.67\%.$$

Differential Phase and Gain

Differential phase distortion (often called "diff phase" or "dP") occurs when a system cannot uniformly process the high-frequency chrominance information at all luminance levels. Differential phase is characterized by distortion in the hue phase angle, and is expressed in degrees of subcarrier phase, peak to peak. (It is important to be clear that the peak-to-peak phase error is being specified, which is the most common usage, and not maximum deviation from zero.)

This type of distortion causes changes in hue to occur with changes in the picture brightness. In high-luminance parts of the picture, colors may not reproduce correctly. (Most PAL systems use some type of delay-line decoders, so reasonable amounts of differential phase distortion cannot be detected in the picture.)

When differential phase is present, the chrominance phase will be different on the different luminance levels. A simple measure-

ment of differential phase can be made on any vectorscope. Simply increase the gain of the vectorscope until the signal vector is brought out to the graticule circle. The distortion in the hue phase angle can then be read directly off the graticule circle. Some vectorscopes provide a separate region on the vectorscope display to facilitate differential phase and gain measurements. In this case, the vectorscope display should be rotated until the signal vector is in the appropriate region.

Differential gain ("diff gain" or "dG") occurs if chrominance gain is affected by luminance level, and is a result of the system not being able to process the high-frequency chrominance signal uniformly at all luminance levels. It is characterized by distortion in the saturation level, and is expressed in percent. When differential gain is present, color saturation depends too heavily on luminance level. At the higher luminance levels, saturation is not reproduced properly.

The measurement of differential gain can be made at the same time as differential phase. Differential gain is displayed on a vectorscope as elongation of the vector in the radial direction. The percentage can be read directly off the vectorscope display, as most vectorscopes have special marks on the graticule for this purpose.

While these procedures will yield a crude value for differential phase and gain, equipment such as a VM700, or a vectorscope with special differential phase and gain modes, is required for accurate measurement.

Figure A.6 shows typical differential phase and gain plots for an NTSC encoder, generating full-screen EIA color bars.

Chrominance Nonlinear Phase and Gain

Chrominance nonlinear phase distortion occurs when a signal's chrominance phase is affected by the chrominance amplitude. It is a result of the system's inability to process all amplitudes of high-frequency chrominance information uniformly. This distortion is expressed in degrees of subcarrier phase. To measure these values, a signal with three chrominance packets with the same phase but different amplitudes on a 50 IRE pedestal is used.

This distortion can cause hue shift as color saturation increases. It is most commonly seen in high-amplitude chrominance signals. For PAL systems, the effects of chrominance nonlinear phase are averaged out in delay-line decoders, as with diff phase, and hue shifts are not detectable in the picture.

Chrominance nonlinear phase distortion can be measured using a standard vectorscope. The three chrominance packets will produce three dots on the vectorscope display. Change the gain of the vectorscope to bring the largest vector out to the graticule circle. The largest difference, in degrees, between any two signal vectors is the chrominance nonlinear phase distortion. As with differential phase, the vectorscope display may be rotated to facilitate this reading.

Chrominance nonlinear gain distortion is characterized by a change in a signal's chrominance gain due to changes in chrominance amplitude. That is, the relationship between input and output chrominance amplitudes does not remain constant when the input amplitude is changed. It is expressed in IRE or percent. This distortion shows up in the picture as incorrect color saturation.

Chrominance nonlinear gain distortion can be measured using either a waveform monitor or an oscilloscope. It is measured by determining the difference in amplitude between a packet and its ideal value.

The three chrominance packets in the modulated pedestal test signal should have amplitudes of 20, 40, and 80 IRE units (NTSC systems). When using an oscilloscope, the amplitude of the 40 IRE packet can be mea-

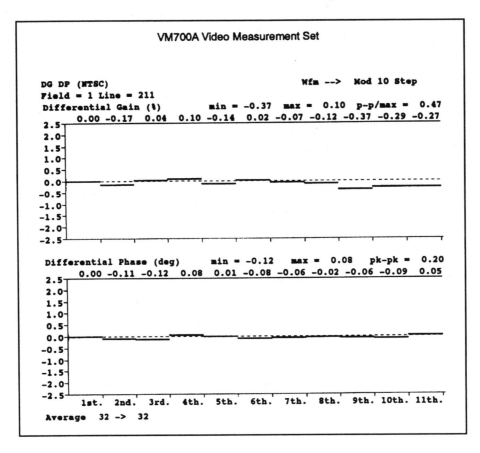

Figure A.6. Typical Differential Gain and Phase Plot for NTSC Encoder Generating Full-screen EIA Color Bars.

sured and recorded. With a waveform monitor, the gain of the monitor should be varied until the center packet is displayed as 40 IRE units. With the value of the center packet determined, the errors in the two other packets can then be determined. On an oscilloscope, the amplitudes of these two packets should be measured in the same manner as the 40 IRE packet. The waveform monitor graticule can be directly read to determine the amplitude of these two packets. The chrominance nonlinear gain distortion is the largest deviation from nominal value of the other two

packets. It is expressed as a percentage of the nominal value of the packet exhibiting the largest error, or in IRE.

Chrominance-to-Luminance Intermodulation

Chrominance-to-luminance intermodulation, also called cross-modulation, occurs when a signal's luminance value is affected by superimposed chrominance. It can be caused by clipping of high-amplitude chrominance peaks or by quadrature distortion. Video image

effects of this distortion can include variations in brightness caused by color saturation inaccuracies.

The test is run using the same signal as that used for chrominance nonlinear phase and gain distortion. The distortion can be measured by passing the video signal through a chrominance filter and examining the output. If you are using an oscilloscope, measure the largest deviation from the 50 IRE pedestal. This voltage, expressed as a percentage of the 50 IRE voltage, is the chrominance-to-luminance intermodulation value. If a waveform monitor is used, expand the signal until the pedestal is at 100 IRE units. The largest difference in the pedestal level is the error. It may be expressed as a percentage or in IRE units.

Glossary

To assist the beginner, this glossary offers many of the video terms commonly used. Definitions are simplified, so you don't have to be a video wizard to understand them. The material in this glossary is copyrighted by Brooktree Corporation, and is used with their permission.

AC Coupled

AC coupling is a method of connecting a video signal to any circuit in a way that removes the DC offset, or the overall voltage level that the video signal "rides" on.

BEFORE AC COUPLING

AFTER AC COUPLING
AND DC RESTORATION

You can see in the figure that not knowing the DC offset means that we don't know exactly where the video signal is. One way to find the signal is to remove the DC offset by AC coupling, and then do DC restoration to add a known DC offset (one that we selected). Another reason AC coupling is important is that it can remove harmful DC offsets.

Active Video

The part of the video waveform that is actually visible on the display screen.

A/D, ADC

These are short for analog-to-digital converter. This device is what most digital systems currently use to get video and audio into a computer. An ADC for digitizing video must be very fast, capable of sampling at 10 to 150 million samples per second (MSPS). There are two main types of ADCs: flash and sigma delta.

Alpha	See Alpha Channel and Alpha Mix.
Alpha Channel	The alpha channel is used to specify an alpha value for each color pixel. The alpha value is used to control the blending, on a pixel-by-pixel basis, of two images.

new pixel = (alpha)(pixel A color) + (1 – alpha)(pixel B color)

Alpha typically has a normalized value of 0 to 1. In a computer environment, the alpha values can be stored in additional bit planes of frame-buffer memory. When you hear about 32-bit frame buffers, what this really means is that there are 24 bits of color, 8 each for red, green, and blue, along with an 8-bit alpha channel. Also see Alpha Mix.

Alpha Mix	This is a way of combining two images. How the mixing is performed is provided by the alpha channel. The little box that appears over the left-hand shoulder of a news anchor is put there by an alpha mixer. Wherever the pixels of the little box appear in the frame buffer, an alpha number of "1" is put in the alpha channel. Wherever they don't appear, an alpha number of "0" is placed. When the alpha mixer sees a "1" coming from the alpha channel, it displays the little box. Whenever it sees a "0," it displays the news anchor. Of course, it doesn't matter if a "1" or a "0" is used, but you get the point.
Aperture Delay	Aperture delay is the time from an edge of the input clock of the ADC until the time the part actually takes the sample. The smaller this number, the better.
Aperture Jitter	The uncertainty in the aperture delay. This means the aperture delay time changes a little bit over time, and that little bit of change is the aperture jitter.
Artifacts	In the video domain, artifacts are blemishes, noise, snow, spots, whatever. When you have an image artifact, something is wrong with the picture from a visual standpoint. Don't confuse this term with not having the display properly adjusted. For example, if the hue control is set wrong, the picture will look bad, but this is not an artifact. An artifact is some physical disruption of the image.
Aspect Ratio	The ratio of the width of the display screen to the height. For most current TV sets, this ratio is 4:3. For HDTV, the ratio will be 16:9. The aspect ratio, along with the number of vertical scan lines that make up the image, determines what sample rate should be used to digitize the video signal.
Authoring Platform	A computer that has been outfitted with the right hardware for creating material to be viewed in a multimedia box. The video quality of the authoring platform has to be high enough that the playback equipment is the limiting factor.

Back Porch The area of the video waveform between the rising edge of the horizontal sync and right before the active video.

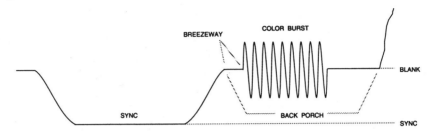

Bit-Blt Pronounced "bit blit," this is short for Bit-Boundary Block Transfer. This is an operation in which one area of the frame buffer is copied to another area of the frame buffer. Generally the areas are rectangular and the pixels are copied from their original locations to corresponding locations in the new area.

Black Burst Black burst is the video waveform without the active video part. Black burst is used to sync video equipment together so that video output is aligned. Black burst tells the video equipment the vertical sync, horizontal sync, and the chroma burst information.

Black Level This level represents the darkest an image can get. This defines what black is for the particular image system. If for some reason the video dips below this level, it is referred to as blacker-than-black. You could say that sync is blacker-than-black.

Blanking On the screen, the scan line moves from the left edge to the right edge, jumps back to the left edge, and starts out all over again, on down the screen. When the scan line hits the right-hand limit and is about to be brought back to the left-hand edge, the video signal is blanked so that you can't "see" the return path of the scan beam from the right to the left-hand edge. To blank the video signal, the video level is brought down to the blanking level, which may or may not be the black level if a pedestal is used.

Blanking Level That level of the video waveform defined by the system to be where blanking occurs. This could be the black level if a pedestal is not used or below the black level if a pedestal is used.

Blit This is short for bit-blit, which is short for bit-boundary block transfer.

Blitter A blitter is a circuit or device that does blitting. See Bit-Blit.

Blooming This is an effect, sometimes caused when video becomes whiter-than-white, in which a line that is supposed to be nice and thin becomes fat and fuzzy on the screen.

Breezeway That portion of the video waveform between the rising edge of the horizontal sync and the start of color burst.

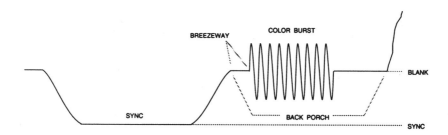

Brightness This is the intensity of the video level and refers to how much light is emitted by the display.

Burst See color burst.

Burst Gate This is a signal that tells the system where the color burst is located within the scan line.

CCIR 601 This is a recommendation developed by the International Radio Consultative Committee for the digitization of color video signals. The CCIR 601 recommendation deals with color space conversion from RGB to YCrCb, the digital filters used for limiting the bandwidth, the sample rate (defined as 13.5 MHz), and the horizontal resolution (720 active pixels).

Chroma A shortened version of chrominance.

Chroma Bandpass In an NTSC or PAL video source the luminance (black and white) and the chrominance (color) information are combined together. If you want to decode an NTSC or PAL video signal, the luminance and chrominance must be separated. The chroma bandpass filter removes the luminance from the video signal, leaving the chrominance relatively intact. This works reasonably well except in certain images where the luminance information and chrominance information overlap, meaning that we have luminance and chrominance stuff at the same frequency. The filter can't tell the difference between the two and passes everything within a certain area. If there is luminance in that area, it's let through too. This can make for a funny-looking picture. Next time you're watching TV and someone is wearing a herringbone jacket or a shirt with thin, closely spaced stripes, take a good look. You'll see a rainbow color effect moving through that area. What's happening is that the chroma demodulator thinks the luminance is chrominance. Since the luminance isn't chrominance, the TV can't figure out what color it is and it shows up as a rainbow pattern. This problem can be overcome by using a comb filter.

Chroma Burst See Color Burst.

Chroma Demodulator

After the NTSC or PAL video source makes its way through the Y/C separator, by either the chroma bandpass, chroma trap, or comb filter method, the colors must be decoded. That's what a chroma demodulator does. It takes the chrominance output of the Y/C separator and recovers two color difference signals (typically I and Q or U and V). To do this, the chroma demodulator uses the color subcarrier. Now, with the luminance information and color difference signals, the video system can figure out what colors to put on the screen.

Chroma Key

This is a method of combining two video images. An example of chroma keying in action is the nightly news weatherman standing in front of a giant weather map. In actuality, the weatherman is standing in front of a solid, bright-blue background and his (or her) image is projected on top of the computer-generated map. This is how it works: a TV camera is pointed at the person or object that you want to project on top of the artificial background (e.g., the weather map). The background doesn't actually have to be artificial. It can be another real image—it doesn't really matter. As mentioned, our imaginary weatherman is standing in front of a bright-blue background. This person and bright-blue background image is fed along with the image of the artificial background into a box. Inside the box, a decision is made. Wherever it sees the bright-blue background, it displays the artificial background. Wherever it does not see bright blue, it shows the original image. So, whenever the weatherman moves around, he's moving around in front of the bright-blue background. The box figures out where he is and where he isn't, and displays the appropriate image.

Chroma Trap

In an NTSC or PAL video source the luminance (black and white) and the chrominance (color) information are combined together. If you want to decode the video signal, the luminance and chrominance must be separated. The chroma trap is a method for separating the chrominance from the luminance, leaving the luminance relatively intact. How does this work? The NTSC or PAL signal is fed to a bandstop filter. For all practical purposes, a bandstop filter allows some types of information (actually certain frequencies) to pass through but not others. The bandstop filter is designed with a response, or stop, to remove the chrominance so that the output of the filter only contains the luminance. Another name for a bandstop filter is a trap. Since this trap stops chrominance, it's called a chroma trap. The sad part about all of this is that not only does the filter remove chrominance, it removes luminance as well if it exists within the region where the stop exists. The filter only knows ranges and, depending on the image, the luminance information may overlap the chrominance information. The filter can't tell the difference between the luminance and chrominance, so it stops both when they are in the same range. What's the big deal? Well, you lose luminance and this means that the picture is degraded somewhat. Using a comb filter for a Y/C separator is better than a chroma trap or chroma bandpass. See the chroma bandpass and the Y/C separator definitions.

Chrominance The NTSC or PAL video signal contains two pieces that make up what you see on the screen: the black and white (luminance) part, and the color part. Chrominance is the color part—a.k.a. chroma.

CIF CIF is short for Common Interchange Format. It was developed so that computerized video images could be shared from one computer to another without too much of a problem. An image that is digitized to CIF format has a resolution of 352×288 or 352×240, , which is essentially one-half of CCIR 601.

Clamp This is basically another name for the DC-restoration circuit. It can also refer to a switch used within the DC-restoration circuit. When it means DC restoration, then it's usually used as "clamping." When it's the switch, then it's just "clamp."

Clipping Logic A circuit used to prevent illegal conversion. Some colors can exist in one color space but not in another. Right after the conversion from one color space to another, a color space converter might check for illegal colors. If any appear, the clipping logic is used to chop off, or clip, part of the information until a legal color can be represented. Since this circuit clips off some information and is built using logic, it's not too hard to see how the name "clipping logic" was developed.

CMYK This is a color space primarily used in printing. CMYK is an acronym for Cyan, Magenta, Yellow, and blacK. The CMYK color space is subtractive, meaning that cyan, magenta, yellow and black pigments or inks are applied to a white surface to remove color information from the white surface to create the final color. Remember, white light contains all of the colors of the spectrum; that's why it's used in printing. They deal with a white surface, or almost white. The reason black is used is because even if a printer could put down hues of cyan, magenta, and yellow inks perfectly enough to make black (which it can't for large areas), it would be too expensive since colored inks cost more than black inks. So, when black has to be made, instead of putting down a lot of CMY, they just use black. So, what is a printing term doing here? The reason is that a lot of color systems are being hooked up to color printers. The display screen uses RGB but the printer uses CMYK. A color space conversion needs to be performed for true WYSIWYG ("wizzy-wig"—What You See Is What You Get) performance in a color system that has a printer.

Color Bars This is a test pattern used to check whether a video system is calibrated correctly. A video system is calibrated correctly if the colors are the correct brightness, hue, and saturation. This can be checked with a vectorscope, or by looking at the RGB levels.

Color Burst That portion of the video waveform that sits between the breezeway and the start of active video. The color burst tells the color decoder how to decode the color information contained in that line of active video. By looking at the color burst, the decoder can determine what's blue, orange, or magenta. Essentially, the decoder figures out what the correct color is. If you've ever seen a TV picture in which the

colors were just not right, a reason might be that the TV can't find the color burst and doesn't know how to make the correct color.

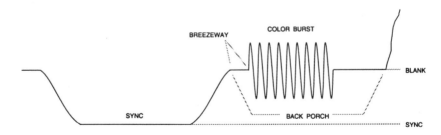

Color Decoder

This is the circuit in the video system that uses the chrominance portion of NTSC/ PAL to derive the two color difference signals. The color decoder sits right after the Y/C separator and before the color space converter. The color decoder needs a 3.58-MHz (NTSC) or 4.43-MHz (PAL) signal that is accurately phase-locked to the color burst. If it isn't locked well enough, then the color decoder can't figure out the right colors. Also called a Chroma Demodulator.

Color Demodulator

See Color Decoder and Chroma Demodulator.

Color Difference

All of the color spaces used in color video require three components. These might be RGB, YIQ, YUV or $Y(R-Y)(B-Y)$. In the $Y(R-Y)(B-Y)$ color space, the $R-Y$ and $B-Y$ components are often referred to as color difference signals for obvious reasons. They are made by subtracting the luminance (Y) from the red and blue components. I and Q and U and V are also color difference signals since they are scaled versions of $R-Y$ and $B-Y$. All the Ys in each of the YIQ, YUV and $Y(R-Y)(B-Y)$ are basically the same.

Color Encoder

The color encoder does the exact opposite of the color decoder. It takes the two color difference signals, such as I and Q or U and V, and combines them into the chrominance signal. The color encoder, or what may be referred to as the color modulator, uses the color subcarrier to do the encoding.

Color Modulator

Take a look at the Color Encoder definition.

Color Key

This is essentially the same thing as Chroma Key.

Color Killer

A color killer is a circuit that shuts off the color decoder in a video system if the incoming video does not contain color information. How does this work? The color killer looks for the color burst and if it can't find it, it shuts off the color decoder. For example, let's say that a color TV is going to receive material recorded in black and white. Since the black and white signal does not contain a color burst, the color

decoder is shut off. Why is a color killer used? Well, in the old days, the color decoder would still generate a tiny little bit of color if a black and white transmission was received, due to small errors in the color decoder, causing a black and white program to have faint color spots throughout the picture.

Color Purity

This term is used to describe how close a color is to the theoretical. For example, in the YUV color space, color purity is specified as a percentage of saturation and $\pm\theta$, where θ is an angle in degrees, and both quantities are referenced to the color of interest. The smaller the numbers, the closer the actual color is to the color that it's really supposed to be. For a studio-grade device, the saturation is $\pm2\%$ and the hue is $\pm2°$. On a vectorscope, if you're in that range, you're studio grade.

Color Space

A color space is a mathematical representation for a color. No matter what color space is used—RGB, YIQ, YUV, etc.—orange is still orange. What changes is how you represent orange in an imaging system. For example, the RGB color space is based on a Cartesian coordinate system and the HSI color space is based on a polar coordinate system.

Color Subcarrier

The color subcarrier is a clock signal used to run the color encoder or color decoder. For NTSC the frequency of the color subcarrier is 3.58 MHz and for PAL it's 4.43 MHz. In the color encoder, a portion of the color subcarrier is used to create the color burst, while in the color decoder, the color burst is used to reconstruct the color subcarrier.

Comb Filter

This is another method of performing a Y/C separator. A comb filter is used in place of a chroma bandpass or chroma trap. The comb filter provides better video quality since it does a better job of separating the luminance from chrominance. It reduces the amount of creepy-crawlies or zipper artifacts. It's called a comb filter because the frequency response looks like a comb. The important thing to remember is that the comb filter is a better method for Y/C separation than chroma bandpass or chroma trap.

Compact Disk Interactive (CD-I)

This is Philips' answer to the multimedia question. Instead of a PC with special hardware, CD-I is a dedicated box that you buy just like any other piece of consumer audio or video gear. CD-I currently uses a proprietary image and audio compression scheme, with JPEG and MPEG being supported in the future.

Comparator

This is a circuit or functional block that is a basic component of flash ADCs. A comparator has two inputs, X and Y, along with one output, which we will call Z. The comparator implements the following mathematical function:

If $A - B > 0$, then $Z = 1$
If $A - B < 0$, then $Z = 0$

What does this mean? A comparator "compares" *A* to *B*. If *A* is larger than *B*, the output of the comparator is a "1." If *A* is smaller than *B*, then the output is a "0." If *A* = *B*, the output *Z* may be undefined and oscillate between 1 and 0 wildly until that condition is removed, it may be a "1," or it may be a "0." It depends on how the comparator was designed.

Composite Video

If a video system is to receive video correctly, it must have several pieces of the puzzle in place. It must have the picture that is to be displayed on the screen, and it must be displayed with the correct colors. This piece is called the active video. The video system also needs information that tells it where to put each pixel. This is called sync. The display needs to know when to shut off the electron beam so the viewer can't see the spot retrace across the display. This piece of the video puzzle is called blanking. Now, each piece could be sent in parallel over three separate connections, and it would still be called video and would still look good on the screen. This is a waste, though, because all three pieces can be combined together so that only one connection is needed. Composite video is a video stream that combines all of the pieces required for displaying an image into one signal, thus requiring only one connection. NTSC and PAL are examples of composite video. Both are made up of: active video, horizontal sync, horizontal blanking, vertical sync, vertical blanking, and color burst. RGB is not an example of composite video, even though each red, green, and blue signals may each contain sync and blank information, because all three signals are required to display the picture with the right colors.

Compression Ratio

Compression ratio is a number used to tell how much information is squeezed out of an image when it has been compressed. For example, suppose we start with a 1-Mbyte image and compress it down to 128 kbytes. The compression ratio would be:

$$\frac{1,048,576}{131,072} = \frac{8}{1}$$

This represents a compression ratio of 8:1; 1/8 of the original amount of storage is now required. For a given compression technique—MPEG, for example—the higher the compression ratio, the worse the image looks. This has nothing to do with which compression method is better, for example JPEG vs. MPEG. Rather, it depends on the application. A video stream that is compressed using MPEG at 100:1 may look better than the same video stream compressed to 100:1 using JPEG.

Contouring

This is an image artifact caused by not having enough bits to represent the image. The reason the effect is called "contouring" is because the image develops lines that look like a geographical contour map. In a black-and-white imaging system, contouring may be noticed at 6 bits per pixel or less, while in a color system it may be 18 bits per pixel or less.

Contrast	A video term referring to how far the whitest whites are from the blackest blacks in a video waveform. If the peak white is far away from the peak black, the image is said to have high contrast. With high contrast, the image is very stark and very "contrasty," like a black-and-white tile floor. If the two are very close to each other, the image is said to have poor, or low, contrast. With poor contrast, an image may be referred to as being "washed out"—you can't tell the difference between white and black, and the image looks gray.
Creepy-crawlies	Yes, this is a real video term! Creepy-crawlies refers to a specific image artifact that is a result of the NTSC system. When the nightly news is on, and a little box containing a picture appears over the anchorperson's shoulder, or when some computer-generated text shows up on top of the video clip being shown, get up close to the TV and check it out. Along the edges of the box, or along the edges of the text, you'll notice some jaggies "rolling" up (could be down) the picture. That's the creepy-crawlies. Some people refer to this as zipper because it looks like one.
D1	This is a storage and tape format standard for very high-end digital video tape decks, although commonly used to refer to the CCIR 601 digital video format. D1 video tape decks use digital component video (CCIR 601) for getting digital video into and out of the tape deck.
D2, D3	These are storage and tape format standards for medium- to high-end digital video tape decks, although commonly used to refer to the digital composite video format. D2 and D3 video tape decks use digital composite video for getting digital video into and out of the tape deck.
D/A, DAC	These are short for digital-to-analog converter.
DC Restoration	DC restoration is what you have to do to a video waveform after it has been AC coupled and has to be digitized. Since the video waveform has been AC coupled, we no longer know absolutely where it is. For example, is the bottom of the sync tip at –5 V or at 100 V? Is the back porch at 3.56 V or at 0 V? In fact, not only don't we know where it is, it also changes over time, since the voltage level of the active video changes over time. Since the resistor ladder on the flash ADC is tied to a pair of voltage references, such as REF– to 0 volts and REF+ to 1.3 volts, the video waveform needs to be referenced to some known DC level; otherwise, we couldn't digitize it correctly. DC restoration is essentially putting back a DC component that was removed to make an AC-coupled signal. We don't have to put back the original DC value—it could be a different one. In decoding NTSC or PAL video, the DC level for DC restoration is such that the sync tip is set to the ADCs REF– level. Therefore, when sync tip is digitized it will be assigned the number 0 and when peak white is digitized, it will be assigned the number 196. (This assumes that the gains are correct, but that's another problem.)

DCT
This is short for Discrete Cosine Transform, used in the JPEG and MPEG image compression algorithms.

Decimation
When a video waveform is digitized so that 100 pixels are produced, but only every other one is stored or used, the video waveform is decimated by a factor of 2:1. The image is now 1/4 of its original size, since 3/4 of the data is missing. If only one out of five pixels were used, then the image would be decimated by a factor of 5:1, and the image would be 1/25 its original size. Decimation, then, is a quick-and-easy method for image scaling and is in fact the method used by low-cost systems that scale video into a window.

Decimation can be performed in several ways. One way is the method just described, where data is literally thrown away. Even though this technique is easy to implement and cheap to build, it generally introduces image artifacts unacceptable to medium- to high-end customers. Another method is to use a decimation filter. This reduces the image artifacts to an acceptable level by smoothing them out, but is more costly to implement than the method of just throwing data away.

Decimation Filter
Since you probably read the preceding definition of decimation, this one should be easy. A decimation filter is a filter designed to provide decimation without the artifacts associated with throwing data away (the method of throwing data away is the example described in the decimation definition).

Demodulator
In video, demodulation is the technique used to recover the color difference signals in NTSC or PAL systems. See the definitions for Chroma Demodulator and Color Decoder; those are two other names for a demodulator used in a video application.

Differential Gain
Differential gain is how much the color saturation changes when the luminance level changes (it isn't supposed to). The result on the screen will be incorrect color saturation. For a video system, the better the differential gain—that is, the smaller the number specified—the better the system is at figuring out the correct color.

Differential Phase
Differential phase is how much the hue changes when the luminance level changes (it isn't supposed to). The result on the screen will be incorrect colors. For a video system, the better the differential phase—that is, the smaller the number specified—the better the system is at figuring out the correct color.

Digital Component Video
Digital video using separate color components, such as YCrCb or RGB. See CCIR 601. Sometimes incorrectly referred to as D1.

Digital Composite Video
Digital video that is essentially the digitized waveform of composite NTSC or PAL video signals, with specific digital values assigned to the sync, blank, and white levels. Sometimes incorrectly referred to as D2 or D3.

Digital Video Interactive (DVI)

DVI is a multimedia system being marketed by Intel. It is not just an image-compression scheme, but includes everything that is necessary to implement a multimedia playback station. Intel's DVI offering is represented by chips, boards, and software. DVI currently uses a proprietary image and audio compression scheme, with JPEG and MPEG being supported in the future.

Discrete Cosine Transform (DCT)

A DCT is just another way to represent an image. Instead of looking at it in the time domain—which, by the way, is how we normally do it—it is viewed in the frequency domain. It's analogous to color spaces, where the color is still the color but is represented differently. Same thing applies here—the image is still the image, but it is represented in a different way.

Why do JPEG and MPEG base part of their compression schemes on the DCT? Because it is more efficient to represent an image that way. In the same way that the YCrCb color space is more efficient than RGB in representing an image, the DCT is more efficient at image representation.

Discrete Time Oscillator (DTO)

A discrete time oscillator is a digital version of the voltage-controlled oscillator.

Double Buffering

As the name implies, you need two buffers—for video, this means two frame buffers. While one of the buffers is being displayed, the other buffer is operated on by a filter, for example. When the filter is finished, the buffer that was just operated on is displayed while the first buffer is now operated on. This goes back and forth, back and forth. Since the buffer that contains the correct image (already operated on) is always displayed, the viewer does not see the operation being performed and just sees a perfect image all the time.

Equalization Pulses

These are two groups of pulses, one that occurs before the serrated vertical sync and another group that occurs after. These pulses happen at twice the normal horizontal scan rate. They exist to ensure correct 2:1 interlacing in early televisions.

Fade

Fading is a method of switching from one video source to another. Next time you watch a TV program (or a movie), pay extra attention when the scene is about to end and go on to another. The scene fades to black, then a fade from black to another scene occurs. Fading between scenes without going to black is called a dissolve. One way to do a fade is to use an alpha mixer.

Field

A TV screen is made using two fields, each one containing half of the scan lines needed to make up one frame of video. One field contains the even-numbered scan lines while the other field is made up of the odd-numbered scan lines. Each field is displayed in its entirety—therefore, all of the odd-numbered scan lines are displayed, then the even, then the odd, and so on. Fields only exist for interlaced scanning systems. So for NTSC, which has 525 lines per frame, a field has 262.5 lines, and two fields make up a 525-line frame.

Filter

In general, a filter is a used to remove unwanted material from a signal. If you have some high frequencies, such as noise, in with the signal that you really want, then a lowpass filter is used. A lowpass filter "passes" frequencies below a certain point and stops frequencies above that same point. A highpass filter does just the opposite—it stops low frequencies and passes the high frequencies. A bandpass filter lets through frequencies within a certain range or "band," but stops frequencies outside of the band.

Finite Impulse Response (FIR) Filter

This definition won't teach you how to design one of these, but will at least get you the basic information. A FIR filter is a type of digital filter. FIRs can be any type, such as lowpass, highpass or bandpass. Digital filters in general are much better than analog filters. Sometimes the only way to design a very high-quality filter is with an FIR—it would be impossible to design using analog components. A FIR filter is very, very good, it's digital, and it's somewhat expensive to build.

Flash A/D

A really fast method for digitizing something. The signal to be digitized is provided as the source for one input of a whole bank of comparators. The other input is tied to a tap of a resistor ladder, with each comparator tied to its own tap. This way, when the input voltage is somewhere between the top and bottom voltages connected to the ladder, the comparators output a thermometer code. This means that all the comparators output a "yes" up to the input voltage and a "no" above that. The ADC then takes this string of Yes's and No's and converts them into a binary number which tells where the Yes's turned into No's. See the definition of resistor ladder for more details, if you're interested.

Flicker

Flicker occurs when the refresh rate of the video is too low. It's the same effect produced by an old fluorescent light fixture. In order for flicker to disappear, the update rate, or the video frame rate, must be at least 24 scene changes (frames) per second. This is fast enough so that the eyeball can't keep up with the individual frames. The two problems with flicker are that it's distracting and tiring to the eyes.

Frame

A frame of video is essentially one picture or "still" out of a video stream. In NTSC, a frame of video is made up of 525 individual scan lines. For PAL and SECAM, it's 625 scan lines. If you get up close to your TV screen, you'll be able to see the individual lines that make up the picture. After 525 lines are painted on the screen, the next frame appears; then after that one, the next; and so on, and so on. By playing these individual frames fast enough, it looks like people are "moving" on the screen. It's the same principle as flip cards, cartoons, and movies.

Frame Buffer

A frame buffer is a big bunch of memory, used to hold the image for the display. How much memory are we talking about? Well, let's assume a horizontal resolution of 640 pixels and 480 scan lines, and we'll use the RGB color space. This works out to be:

$640 \times 480 \times 3 = 921,600$ bytes or 900 kbytes

So, 900 kbytes are needed to store one frame of video at that resolution.

Frame Rate

The frame rate of a video source is how fast the source repaints the screen with a new frame. For example, with the NTSC system, the screen is repainted once every 30th of a second for a frame rate of 30 frames per second. For PAL, the frame rate is 25 frames per second. For some computer and workstation displays, the frame rate can reach 70 to 75 frames per second.

Frame Rate Conversion

Frame rate conversion is the act of converting one frame rate to another. One real example that poses a difficult problem is that the frame rate of NTSC, 30 frames per second, is different from a typical computer's display, which may be anywhere from 70 to 75 frames per second (or Hz if you prefer). Therefore, some frame-rate conversion process must be performed before NTSC video can be shown correctly on a computer display. Without frame rate conversion, the screen might look as if it "stalls" every now and then. If there is motion within the video, the objects that are moving might appear cut in half.

Front Porch

This is the area of the video waveform that sits between the start of horizontal blank and the falling edge (start of) horizontal sync.

Gamma

The characteristics of the displays using phosphors (as well as some cameras) are nonlinear. A small change in voltage when the voltage level is low produces a change in the output display brightness level, but this same small change in voltage at a high voltage level will not produce the same magnitude of change in the brightness output. This effect, or actually the difference between what you should have and what you actually measured, is known as gamma.

Gamma Correction

Computers like to number crunch on linear RGB data. Before being displayed, this linear RGB data must be processed (gamma corrected) to compensate for the gamma of the display.

Genlock

A video signal provides all of the information necessary for a decoder to reconstruct the picture. This includes brightness, color, and timing information. To properly decode the video signal, the decoder must be "genlocked" to the video signal. The decoder looks at the color burst of the video signal and reconstructs the original color subcarrier that was used by the encoder. This is needed to properly decode the color information. The decoder also generates a pixel clock (done by looking at the sync information within the video signal) that was the same as the pixel clock used by the encoder. The pixel clock is used to clock pixel data out of the decoder into a memory for display or into another circuit for processing. The circuitry within the decoder that does all of this work is called the genlock circuit. Although it sounds simple, the genlock circuit must be able to handle very bad video sources, such as the output of VCRs. In reality, the genlock circuit is the most complex section of a video decoder.

Gray Scale

The term gray scale has several meanings. It some instances it means the luminance component of the NTSC, PAL, or SECAM signals. In other cases it means a black-and-white video signal.

H.261 This is a video compression standard developed for video teleconferencing systems. It is DCT-based and resembles MPEG to some degree. It is hoped that this will be the standard that allows a videophone from one manufacturer to "talk" to a videophone from another manufacturer, just as two different FAX machines can "talk" to each other.

Hi-8 Hi-8 is a videotape format that uses an 8-mm wide tape. It provides better image quality than VHS.

High-Definition Television (HDTV) This term describes several advanced standards proposals to allow high-resolution TV to be received in the home.

Horizontal Scan Rate This is how fast the scanning beam in a display or a camera is swept from side to side. In the NTSC system this rate is 63.556 ms, or 15.734 kHz. That means the scanning beam in your home TV moves from side to side 15,734 times a second.

Horizontal Sync This is the portion of the composite video signal that tells the receiver where to place the image in the left-to-right dimension. The horizontal sync pulse tells the receiving system where the beginning of the new scan line is. Check to see if your TV at home has a horizontal hold control. If it does, give it a twist and observe what happens. When the picture rolls around like that, it's demonstrating what the picture would look like if there weren't any horizontal sync, or if the receiver couldn't find it.

HSI HSI stands for Hue, Saturation and Intensity. It is a color space used to represent images. HSI is based on polar coordinates, while the RGB color space is based on a three-dimensional Cartesian coordinate system. The intensity, analogous to luminance, is the vertical axis of the polar system. The hue is the angle and the saturation is the distance out from the axis. HSI is more intuitive to manipulate colors as opposed to the RGB space. For example, in the HSI space, if you want to change red to pink, you decrease the saturation. In the RGB space, what would you do? My point exactly. In the HSI space, if you wanted to change the color from purple to green, you would adjust the hue. Take a guess what you would have to do in the RGB space. However, the key thing to remember, as with all color spaces, is that it's just a way to represent a color—nothing more, nothing less.

HSL This is similar to HSI, except that HSL stands for Hue, Saturation and Lightness.

HSYNC Check out the Horizontal Sync definition.

HSV This is similar to HSI, except that HSV stands for Hue, Saturation and Value.

Hue

In technical terms, hue refers to the wavelength of the color. That means that hue is the term used for the base color—red, green, yellow, etc. Hue is completely separate from the intensity or the saturation of the color. For example, a red hue could look brown at low saturation, bright red at a higher level of saturation, or pink at a high brightness level. All three "colors" have the same hue.

Huffman Coding

Huffman coding is a method of data compression. It doesn't matter what the data is—it could be image data, audio data, or whatever. It just so happens that Huffman coding is one of the techniques used in JPEG and MPEG to help with the compression. This is how it works. First, take a look at the data that needs to be compressed and create a table that lists how many times each piece of unique data occurs. Now assign a very small code word to the piece of data that occurs most frequently. The next largest code word is assigned to the piece of data that occurs next most frequently. This continues until all of the unique pieces of data are assigned unique code words of varying lengths. The idea is that data that occurs most frequently is assigned a small code word, and data that rarely occurs is assigned a long code word, resulting in space savings.

Hypermedia

Since the term multimedia is slightly overused, some people use the term hypermedia instead. Essentially, hypermedia is just another name for multimedia and will soon be overused, to be replaced with something else.

Illegal Video

Some colors that exist in the RGB color space can't be represented in the video domain. For example, 100% saturated red in the RGB space (which is the red color on full strength and the blue and green colors turned off) can't exist in the NTSC video signal, due to color bandwidth limitations. The NTSC encoder must be able to determine that an illegal color is being generated and stop that from occurring, since it may cause over-saturation and blooming.

Image Buffer

For all practical purposes, an image buffer is the same as a frame buffer. An image is acquired by the computer and stored in the image buffer. Once it is in the image buffer, it can typically be annotated with text or graphics or manipulated in some way, just like anything else in a frame buffer.

Image Compression

Image compression is used to reduce the amount of memory required to store an image. For example, an image that has a resolution of 640×480 and is in the RGB color space at 8 bits per color, requiring 900 kbytes of storage. If this image can be compressed at a compression ratio of 20:1, then the amount of storage required is only 45 kbytes. There are several methods of image compression, but the most popular will be JPEG and MPEG as they become the accepted standards. H.261 is the image compression standard to be used by video telephones.

Improved Definition Television (IDTV)

IDTV (also called enhanced definition television or EDTV) is different from HDTV. IDTV is a system that improves the display of NTSC or PAL systems by adding processing in the receiver; standard NTSC or PAL signals are transmitted. HDTV is a radical departure from NTSC or PAL. Some people think IDTV is just a stepping stone to HDTV, while others think that if IDTV is good enough, HDTV will not be required.

Input Level

For flash ADCs, the input level is the voltage range required of the input video for proper operation of the part. For example, if the required input level for an 8-bit ADC is 0 to 10 V, then an input voltage level of 0 V is assigned the code 0 and an input voltage of 10 V is assigned the code 255. It is important that the voltage range of the input signal matches that of the ADC. Let's take a case where the voltage range of the signal is 0 V to 5 V and the ADC's input range is 0 V to 10 V. When the input level is 0 V, the output of the ADC will be the number 0, and when the input signal is at its maximum of 5 V, the output of the ADC will be 127. In this example, one-half of the ADC is wasted because the numbers 128 through 255 can't be generated since the input level of the source never gets high enough. The problem exists in the other direction also. Let's take an example where the input voltage level has the range of 0 V to 10 V, but the input range of the ADC is only 0 V to 5 V. When the input level is 0 V, the output of the ADC will be the number 0, but when the input signal is in the range of 5 V to 10 V, the output of the ADC will be stuck at 255, since the input is outside of the range for the ADC.

Intensity

This is the same thing as brightness.

Interlaced

An interlaced raster system is one where two (in general—it could be more, but we'll stick with two) interleaved fields are used to scan out one video frame. Therefore, the number of lines in a field are one-half of the number of lines in a frame. In NTSC, there are 262.5 lines per field (525 lines per frame) while there are 312.5 lines per field in PAL. The two fields are interlaced, which means that all of the odd-numbered lines are contained in one field, while the other field is made up of all the even-numbered lines. In NTSC, PAL and SECAM, every other scan line belongs to the same field. Each field is drawn on the screen consecutively—first one field, then the other.

Why did the founding fathers (oops, persons) of video decide to go with an interlaced system? It has to do with frame rate. A large TV screen that was updated at 30 frames per second would flicker, meaning that the image would begin to fade away before the next one was drawn on the screen. By using two fields, each containing one-half of the information that makes up the frame and each field being drawn on the screen consecutively, the field update rate is 60 fields per second. At

this update rate, the eye blends everything together into a smooth, continuous motion.

Interlace: field 1 (lines 1, 3, 5, 7) is scanned, then field 2 (lines 0, 2, 4, 6).

Interpolation

Interpolation is a mathematical way of regenerating missing or needed information. Let's say that an image needs to be scaled up by a factor of two, from 100 pixels to 200 pixels. We can do this by interpolation. The missing pixels are generated by interpolating between the two pixels that are on either side of the pixel that needs to be generated. After all of the "missing" pixels have been interpolated—presto!—200 pixels exist where only 100 existed before, and the image is twice as big as it used to be. There are many methods of interpolation; the method described here is an example of simple averaging.

JPEG

JPEG stands for Joint Picture Experts Group. However, what people usually mean when they use the term "JPEG" is the image compression standard developed by an international body. JPEG was developed to compress still images, such as photographs, a single video frame, something scanned into the computer, and so forth. You can run JPEG at any speed that the application requires. For a still picture database such as mugshots, the algorithm doesn't have to be too fast. If you run JPEG fast enough, though, you can compress motion video—which means that JPEG would have to run at 30 frames per second. You might want to do this if you were designing a video editing or authoring platform. Now, JPEG running at 30 frames per second is not as efficient as MPEG running at 30 frames per second because MPEG was designed to take advantage of certain aspects of motion video. So in a video editing platform, you would have to trade off the lower bit rate (high compression) of MPEG with the ability to do frame-by-frame edits in JPEG (but not in MPEG). Both standards have their place in an image compression strategy and both standards will probably exist in a box simultaneously.

Line Store

A line store is a memory buffer used to hold one line of video. If the horizontal resolution of the screen is 640 pixels and RGB is used as the color space, the line store would have to be 640 locations long by 3 bytes wide. This amounts to one location for each pixel and each color plane. Line stores are typically used in filtering algorithms. For example, a comb filter is made up of two or more line stores. The DCT used in the JPEG and MPEG compression algorithms could use eight line stores since processing is done on blocks of 8 x 8 pixels.

Linearity

Linearity is a basic measurement of how well an ADC or DAC is performing. Linearity is typically measured by making the ADC or DAC represent a diagonal line. The actual output of the device is compared to what is the ideal the output. The difference between the actual diagonal line and the ideal line is a measure of the linearity. The smaller the number, the better. Linearity is typically specified as a range or percentage of LSBs (Least Significant Bits).

Locked

When a PLL is accurately producing horizontal syncs that are precisely lined up with the horizontal syncs of the incoming video source, the PLL is said to be "locked." When a PLL is locked, the PLL is stable and there is minimum jitter in the generated pixel clock.

Loop Filter

A loop filter is used in a PLL design to smooth out tiny bumps in the output of the phase comparator that might drive the loop out of lock. The loop filter helps to determine how well the loop locks, how long it takes to lock and how easy it is to knock the loop out of lock.

Lossless

Lossless is a term used with image compression. Lossless image compression is when the decompressed image is exactly the same as the original image. It's lossless because you haven't lost anything.

Lossy

Lossy image compression is the exact opposite of lossless. The regenerated image is different from the original image. The differences may or may not be noticeable, but if the two images are not identical, the compression was lossy.

Luma

This is short for luminance.

Luminance

As mentioned in the definition of chrominance, the NTSC and PAL video systems use a signal that has two pieces: the black and white part, and the color part. The black and white part is the luminance. It was the luminance component that allowed color TV broadcasts to be received by black and white TVs and still remain viewable.

Media Engine

This is the CPU or DSP processor that coordinates all of the video and audio activities in a multimedia platform. The media engine is used to coordinate the audio with the video, control multiple video inputs, and control the compression and decompression hardware. The media engine is most likely not the host CPU—e.g., not the 80486 processor on the PC motherboard.

Modulator

A modulator is basically a circuit that combines two different signals in such a way that they can be pulled apart later. What does this have to do with video? Let's take the NTSC system as an example, although the example applies equally as well to PAL. The NTSC system uses the YIQ color space, with the I and Q signals containing all of the color information for the picture. Two 3.58-MHz color subcarriers (90° out of phase) are modulated by the I and Q components and added together to create the chrominance part of the NTSC video.

Moiré	This is a type of image artifact. A moiré effect occurs when a pattern is created on the screen where there really shouldn't be one. A moiré pattern is typically generated when two different frequencies beat together to create a new, unwanted frequency.
Monochrome	A monochrome signal is a video source having only one component. Although usually meant to be the luminance (or black-and-white) video signal, the red video signal coming into the back of a computer display is monochrome because it only has one component.
Monotonic	This is a term that is used to describe ADCs and DACs. An ADC or DAC is said to be monotonic if for every increase in input signal, the output increases also. The output should not decrease. Any ADC or DAC that is nonmonotonic—meaning that the output does decrease for an increase in input—is bad! Nobody wants a nonmonotonic ADC or DAC.
Motion Estimation	Motion estimation is trying to figure out where an object has moved to from one video frame to the other. Why would you want to do that? Well, let's take an example of a video source showing a ball flying through the air. The background is a solid color that is different from the color of the ball. In one video frame the ball is at one location and in the next video frame the ball has moved up and to the right by some amount. Now let's assume that the video camera has just sent the first video frame of the series. Now, instead of sending the second frame, wouldn't it be more efficient to send only the position of the ball? Nothing else moves, so only two little numbers would have to be sent instead of 900 kbytes (the amount of storage required for a whole frame of video). This is the essence of motion estimation. By the way, motion estimation is an integral part of MPEG.
MPEG	MPEG stands for Moving Picture Experts Group. This is an ISO (International Standards Organization) body that is developing compression algorithms for motion video. MPEG differs from JPEG in that MPEG takes advantage of the redundancy on a frame-to-frame basis of a motion video sequence, where JPEG does not.
Multimedia	Where does one start? This term has been so overused, mistreated, and so hyped up that it's lost all of its meaning. Multimedia was originally meant to describe a system that uses text, graphics, still pictures, video, and audio in an interactive way to provide information. With this definition, a video game is not multimedia because it does not provide information, even though it is highly interactive. Video editing, even though it is interactive and deals with audio and video, is not multimedia because video editing is creating information, not supplying it. A good example of multimedia is an electronic encyclopedia. A student sits down at a computer, browses through a list of entries, and selects the one that is needed. A text passage is displayed on the screen along with a picture (the picture could be graphic based or a still or moving image). After reading for a while, the student clicks on the head-

phone icon to listen to an audio segment, which may contain a speech delivered by the person who is being researched. A click on a different icon produces a video clip showing this political leader in action at the last rally. All of the aspects described in the example are required for true multimedia. Accept no substitutes.

Noise

Any random fleck that shows up in the display. The noise may also be referred to as snow, flecks, blips, hash.

Noninterlaced

This is a method of scanning out a video display that is the total opposite of interlaced. All of the lines in the frame are scanned out sequentially, one right after the other. The term "field" does not apply in a noninterlaced system. Another term for a noninterlaced system is progressive scan.

NTSC

Never Twice the Same Color, Never The Same Color, or National Television Standards Committee, depending on who you're talking to. To make it simple, NTSC is the video standard used in North America and some other parts of world to get video into your home and to record onto video tape.

One of the requirements for the color television broadcast standard that the NTSC (National Television Standards Committee) created in the 1950s was that it had to be capable of being received on a black-and-white set. When it came down to selecting what color space to use for this new color TV standard, RGB couldn't be used since all three colors, or planes, are independent. This means that each plane—red, green, or blue—has the same chance, or probability, of representing the picture as any other, so all three are needed. How could a black-and-white set, that receives only one plane, receive three? The answer was, it couldn't.

The NTSC decided to make a new color space based on a black and white component and two color difference signals. Since, in the RGB space, each color has as good a chance of representing the image as any other color (equal bandwidth), the black-and-white component is made up of portions of all three colors. This black and white component is often referred to as the luminance. The two color difference signals were developed by taking the red signal and subtracting out the luminance, and taking the blue signal and also subtracting out the luminance. Thus, the color space for NTSC is a luminance component (Y) with red minus luminance (R–Y) and blue minus luminance (B–Y).

After a little bit of mathematics, the R–Y component turns into an I component while the B–Y component turns into a Q component. I and Q are modulated and added together to create the chrominance, which contains all of the color information for the picture. The color information is then added to the black-and-white information. Therefore, the NTSC system is just like a black-and-white sketch with a water color wash painted over it for color.

The NTSC system uses 525 lines per frame, a 30 frame per second update rate, and the YIQ color space. Modern NTSC encoders and decoders may also use the YUV color space.

PAL

PAL stands for Phase Alternation Line. PAL is to Europe as NTSC is to North America. In other words, PAL is the video standard used in Europe and a few other countries. There are a few differences. PAL uses 625 lines per frame while NTSC has 525 lines. Therefore, PAL has higher vertical resolution. The frame rate of NTSC is 30 frames per second while for PAL it is 25. This means the update rate for NTSC is higher and therefore there is more flicker with PAL. PAL uses the YUV color space while NTSC uses YIQ or YUV. That's no big deal, just a little mathematical difference. It is becoming increasingly important for imaging systems suppliers to produce equipment that can be sold worldwide without many manufacturing difficulties. This implies that the equipment must be designed from the start to accommodate both standards.

Pedestal

Pedestal is an offset used to separate the active video from the blanking level. When a video system uses a pedestal, the black level is above the blanking level by a small amount. When a video system doesn't use a pedestal, the black and blanking levels are the same. NTSC uses a pedestal, PAL and SECAM do not.

Phase Adjust

This is a term used to describe a method of adjusting the color in a NTSC video signal. The phase of the color subcarrier is moved, or adjusted, relative to the color burst. This adjustment affects the hue of the picture.

Phase Comparator

This is a circuit used in a PLL to tell how well two signals line up with each other. For example, let's say we have two signals, A and B, with signal A connected to the positive (+) input of the phase comparator and signal B connected to the minus (−) input. If both signals are exactly the same, the output of the phase comparator is 0; they are perfectly aligned. Now, if signal A is just a little bit faster than signal B, then the output of the phase comparator is a 1, showing that A is faster than B. If signal A is slower than B, then the output of the phase comparator is a −1, designating that B is faster. Read the Phase-Locked Loop definition to see how a phase comparator is used in a circuit.

Phase-Locked Loop

A phase-locked loop (PLL) is the heart of any genlocked system. Very simply, a PLL is a means of providing a very stable pixel clock that is based or referenced to some other signal. Let's say that we want to design a video system with a horizontal resolution of 100 pixels. Let's assume that, in order to get the 100 pixels across the display, if the horizontal sync rate were perfect, we would need a pixel clock of 5 MHz. If we didn't have a PLL and the horizontal rate were to shrink a little (the horizontal width gets smaller), we would get less than 100 pixels because we didn't adjust the pixel clock. Or, conversely, if the horizontal rate were to become a little longer (the image widens just a little), we would get more than 100 pixels. This is definitely bad news, because the time between horizontal syncs usually does vary just a tiny little bit, small enough that you may not notice it on your TV, but a computer would notice. So, from line to line, the number of pixels would change. A PLL guarantees that the same number of pixels appears on every line by changing the pixel clock frequency to match the horizontal sync rate.

First, a voltage controlled oscillator (VCO) or voltage controlled crystal oscillator (VCXO) is used and the free-running frequency is set to the pixel clock rate needed if the horizontal rate was always to be perfect. The output of the VCO or VCXO is then used as the system pixel clock. This pixel clock is also used as the input to a circuit that takes the pixel clock frequency and divides it down to the horizontal sync frequency. So, at this point, we have a new signal whose frequency is the same as the frequency of horoizntal sync. This newly generated signal, along with horizontal sync, are inputs to a phase comparator. The output of the phase comparator tells how well the output of the clock divider lines up with the incoming horizontal sync. The output of the phase comparator is fed to a loop filter to remove tiny little bumps that might throw the system out of whack. The output of the loop filter then becomes the control voltage for the VCO or VCXO.

With this arrangement, if the incoming horizontal rate is just a little too fast, the phase comparator generates a signal that is then filtered and tells the VCO/VCXO to speed up a little bit. The VCO/VCXO does, which then speeds up the pixel clock just enough to ensure that the horizontal resolution is 100 pixels. This pixel clock is divided down to the horizontal sync rate and is then phase compared again.

Pixel

A pixel, which is short for picture element, is the smallest division that makes up the raster scan line for computers. For example, when the horizontal resolution is defined as 640, that means that there are 640 individual locations, or spots, that make up the horizontal scan line. A pixel is also referred to as a pel. A "square" pixel is one that has an aspect ratio of 1:1, or the width is equal to the height. Square pixels are needed in computers so that when the software draws a square in the frame buffer, it looks like a square on the screen. If the pixels weren't square, the box would look like a rectangle. NTSC, PAL, and SECAM television systems use pixels that have a 4:3 aspect ratio.

Pixel Clock

The pixel clock is used to divide the incoming horizontal line of video into pixels. This pixel clock has to be stable (a very small amount of jitter) relative to the incoming video or the picture will not be stored correctly. The higher the frequency of the pixel clock, the more pixels that will appear across the screen.

Pixel Drop Out

This can be a real troublemaker, since it can cause image artifacts. In some instances, a pixel drop out looks like black spots on the screen, either stationary or moving around. Several things can cause pixel drop out, such as the ADC not digitizing the video correctly. Also, the timing between the ADC and the frame buffer might not be correct, causing the wrong number to be stored in the buffer. For that matter, the timing anywhere in the video stream might cause a pixel drop out.

PLL

See Phase-Locked Loop.

Pseudo Color Pseudo color is a term used to describe a technique that applies color, or shows color, where it does not really exist. We are all familiar with the satellite photos that show temperature differences across a continent or the multicolored cloud motion sequences on the nightly weather report. These are real-world examples of pseudo color. The color does not really exist. The computer adds the color so the information, such as temperature or cloud height, is viewable.

Px64 This is basically the same as H.261.

Quad Chroma Quad chroma refers to a technique where the pixel clock is four times the frequency of the chroma burst. For NTSC this means that the pixel clock is 14.31818 MHz (4 × 3.57955 MHz), while for PAL the pixel clock is 17.73444 MHz (4 × 4.43361 MHz). The reason these are popular pixel clock frequencies is that, depending on the method chosen, they make the chrominance (color) decoding easier.

Raster Essentially, a raster is the series of scan lines that make up a TV picture or a computer's display. You may from time to time hear the term raster line—it's the same as scan line. All of the scan lines that make up a frame of video form a raster.

Real Time If a system incorporating a computer operates fast enough that it seems like there isn't a computer in the loop, then that computer system is operating in real time. How fast "real time" really is changes depending on who or what is using the system. For example, a fighter pilot flying the latest computer-controlled jet moves the stick to perform a roll maneuver. The stick then tells a computer its position, the computer makes some decisions, and then it tells the flaps and rudder what adjustments to make to perform the move. Since all of this happens fast enough so that the pilot thinks the stick is connected directly to the flaps and rudder, the plane is a real-time system.

What's the definition of real time for video? Well, for NTSC that's 30 frames per second, with each frame made up of 525 individual scan lines. That's roughly equivalent to 30 Mbytes of data per second that must be processed.

Residual Subcarrier This is the amount of color subcarrier information in the color data after decoding a NTSC or PAL video signal. The number usually appears as –n dB. The larger "n" is, the better.

Resistor Ladder A resistor ladder is a string of resistors used for defining voltage references. In the case of 8-bit flash ADCs, the resistor ladder is made up of 256 individual resistors, each having the same resistance. If a voltage representing the number 1 is attached to one end of the ladder and the other end is attached to 0, each junction between resistors is different from the other by 1/256. So, if we start at the top of the ladder, the value is 1. If we move down one rung, the value is 0.99609, the next rung's value is 0.99219, the next rung's is 0.98828 and so on down the ladder until we reach 0 (the other end of the ladder). A resistor ladder is an important part of a flash ADC

because each rung of the ladder, or tap, is connected to one side of a comparator, in effect providing 256 references. The definition of flash ADCs helps out here.

Resolution

This is a basic measurement of how much information is on the screen. It is usually described as "some number" by "some number." The first "some number" is the horizontal (across the screen) resolution and the second "some number" is the vertical resolution (down the screen). The higher the number, the better, since that means there's more detail to see. Some typical examples of resolutions are:

VHS:	330 by 220
S-VHS:	400 by 300
Studio Quality:	720 by 480
Personal Computer Screen:	1024 by 768
Workstation Computer Screen:	1280 by 1024

Retrace

Retrace is what the electron beam does when it gets to the right-hand edge of the display to get back to the left-hand edge. Retrace happens during the blanking time.

RS-170, RS-170A

RS-170 is the United States standard that was used for black-and-white TV, and defines voltage levels, blanking times, the width of the sync pulses, and so forth. The specification spells out everything required for a receiver to display a monochrome picture. The output of those little black-and-white security cameras hanging from ceilings conforms to the RS-170 specification. Now, RS-170A is essentially the same specification, modified for color TV by adding the color components. When the NTSC decided on the color broadcast standard, they modified RS-170 just a tiny little bit so that color could be added, with the result being called RS-170A. This tiny little change was so small that the existing black-and-white TVs didn't even notice it.

RS-343

RS-343 does the same thing as RS-170, defining a specification for video, but the difference is that RS-343 is for higher-resolution video (computers) while RS-170 is for lower-resolution video (TV).

Run Length Coding

Run length coding is a type of data compression. Let's say that this page is wide enough to hold a line of 80 characters. Now, imagine a line that is almost blank except for a few words. It's 80 characters long, but it's just about all blanks—let's say 50 blanks between the words "coding" and "medium." These 50 blanks could be stored as 50 individual codes, but that would take up 50 bytes of storage. An alternative would be to define a special code that said a string of blanks is coming and the next number is the amount of blanks in the string. So, using our example, we would need only 2 bytes to store the string of 50 blanks, the first special code byte followed by the number 50. We compressed the data; 50 bytes down to 2. This is a compression ration of 25:1. Not bad, except that we only compressed one line out of this entire document, so we should expect that the total compression ratio would be much less.

Run length coding all by itself as applied to images is not as efficient as using a DCT for compression, since long runs of the same "number" or series rarely exist in real-world images. The only advantage of run length coding over the DCT is that it is easier to implement. Even though run length coding by itself is not efficient for compressing images, it is used as part of the JPEG and MPEG compression schemes.

S-VHS

S-VHS is an enhancement to regular VHS video tape decks. S-VHS provides better resolution and less noise than VHS. S-VHS video tape decks support separate luminance (Y) and chrominance (C) video inputs and outputs, although this is not required. It does, however, improve the quality by not having to continuously merge and then separate the luminance and chrominance signals.

S-Video

Separate Video, also called Y/C.

Sample Rate

Sample rate is how often the ADC will take a sample of the video. The sample rate is determined by the pixel clock.

Saturation

Saturation is the amount of color present. For example, a lightly saturated red looks pink, while a fully saturated red looks like the color of a red crayon. Saturation does not mean the brightness of the color, just how much "pigment" is used to make the color. The less "pigment," the less saturated the color is, effectively adding white to the pure color.

Scaling

Scaling is the act of changing the effective resolution of the image. For example, let's take a TV size resolution of 640 × 480 and display that image as a smaller picture on the same screen, so that multiple pictures can be shown simultaneously. We could scale the original image down to a resolution of 320 × 240, which is 1/4 of the original size. Now, four pictures can be shown at the same time. That was an example of "scaling down." Scaling up is what occurs when a snapshot is enlarged into an 8" × 10" glossy. There are many different methods for image scaling, and some "look" better than others. In general, though, the better the algorithm "looks," the harder or more expensive it is to implement.

Scan Line

A scan line is an individual sweep across the face of the display by the electron beam that makes the picture. An example of a scan line is what happens in a copier. When you press the copy button, a mirror "scans" the document by moving across the length of the page. Same concept with television—an electron beam "scans" the screen to produce the image on the display. It takes 525 of these scan lines to make up a NTSC TV picture.

SECAM

This is another TV format similar to PAL. The major difference between the two is that in SECAM the chrominance is FM modulated.

Serration Pulses	These are pulses that occur during the vertical sync interval, at twice the normal horizontal scan rate. The reason these exist was to ensure correct 2:1 interlacing in early televisions.
Setup	Setup is the same thing as Pedestal.
Signal-to-Noise Ratio (SNR)	Signal-to-noise ratio is the magnitude of the signal divided by the amount of unwanted stuff that is interfering with the signal (the noise). SNR is usually described in decibels, or "dB," for short; the bigger the number, the better looking the picture.
Subsampled	Subsampled means that a signal has been sampled at a lower rate than some other signal in the system. A prime example of this is the YCrCb color space used in CCIR 601. For every two luminance (Y) samples, only one Cr and Cb sample is taken. This means that the Cr and Cb signals are subsampled.
Sync	Sync is a fundamental, you gotta have it, piece of information for displaying any type of video. This goes for TVs, workstations, or PCs. Essentially, the sync signal tells the display where to put the picture. The horizontal sync, or HSYNC for short, tells the display where to put the picture in the left-to-right dimension, while the vertical sync (VSYNC) tells the display where to put the picture from top-to-bottom.
Sync Generator	A sync generator is a circuit that provides sync signals. A sync generator may have genlock capability, or it may not.
Sync Noise Gate	A sync noise gate is used to define an area within the video waveform where the sync stripper is to look for the sync pulse. Anything outside of this defined window will be rejected by the sync noise gate and won't be passed on to the sync stripper. The main purpose of the sync noise gate is to make sure that the output of the sync stripper is nice, clean, and correct.
Sync Stripper	A composite video signal contains video information, which is the picture to be displayed, and timing (sync) information that tells the receiver where to put this video information on the display. A sync stripper pulls out the sync information from the composite video signal and throws the rest away.
Tessellated Sync	This is what the Europeans call serrated sync. See the definitions of Serration Pulses and Composite Sync.
Timebase Corrector	Certain video sources have their sync signals screwed up. The most common of these sources is the VCR. A timebase corrector "heals" a video signal that has bad sync. (I guess you could call a timebase corrector a "sync doctor.") This term is included because more and more companies making video capture cards are providing this function.

True Color	True color means that an image is represented using at least three color components, such as RGB or YCrCb.
Vector Scope	A vector scope is used to determine the color purity of a NTSC or PAL video system. If you've read the YIQ or YUV definitions, then you know that the I and Q (or U and V) components are the axis of a Cartesian coordinate system. The vector scope is essentially a Cartesian coordinate display scope. The vector scope looks at the I and Q signals and puts a point of light where the two signals say the color is. On a vector scope, six little boxes correspond to the six colors in the standard color bar pattern: yellow, cyan, magenta, green, red, and blue. If the input to the video system is a color bar pattern from a test generator and the output is displayed on a vector scope, then the accuracy of the color system can be checked. Each point of light that represents the corresponding color should be within the little box—certainly, the closer the better. If the spot makes it within the little box, that represents an error of less than ±2°. That means you can't notice the error with your eyeball.
Vertical Scan Rate	This is the same as the Frame Rate.
Vertical Sync	This is the portion of the composite video signal that tells the receiver where the top of the picture is.
Video Mixing	Video mixing is taking two independent video sources and merging them together.
Video Quality	Video quality is a phrase that means "how good does the picture look?". A video image that has a high signal-to-noise ratio and is free of any image artifacts has high image quality. The typical VCR has marginal image quality.
Video Waveform	The video waveform is what the signal "looks" like to the receiver or TV. The video waveform is made up of several parts (sync, blanking, video, etc.) that are all required to make up a TV picture that can be accurately displayed.
Voltage Controlled Crystal Oscillator (VCXO)	A VCXO is just like a voltage-controlled oscillator except that a VCXO uses a crystal to set the free-running frequency. This means that a VCXO is more stable than a VCO but it's also more expensive to implement.
Voltage Controlled Oscillator (VCO)	A VCO is a special type of oscillator that changes its frequency depending on what the voltage is on a control pin. A VCO has what's called a free-running frequency which is the frequency that the oscillator runs at when the control voltage is at midrange, normal operating condition. If the control voltage rises above midrange, the VCO increases the frequency of the output clock, and if the control voltage falls below midrange, then the VCO lowers the frequency of the output clock. See the definition of a Phase-Locked Loop.
White Level	This level defines what white is for the particular video system.

Y/C	The Y/C designation is shorthand for luminance (Y) and chrominance (C). You will also see this term used in the description of the S-VHS video tape format.

Y/C Separator A Y/C separator is what's used in a decoder to pull the luminance and chrominance apart in an NTSC or PAL system. This is the first thing that any NTSC or PAL receiver must do. The composite video signal is first fed to the Y/C separator so that the chrominance can then be decoded further.

YCrCb YCrCb is the color space used in the CCIR601 specification. Y is the luminance component and the Cr and Cb components are color difference signals. Cr and Cb are scaled versions of U and V in the YUV color space.

4:2:2 YCrCb means that Y has been sampled at 13.5 MHz, while Cr and Cb were each sampled at 6.75 MHz. Thus, for every two samples of Y, there is one sample each of Cr and Cb. 4:1:1 YCrCb means that Y has been sampled at 13.5 MHz, while Cr and Cb were each sampled at 3.375 MHz. Thus, for every four samples of Y, there is one sample each of Cr and Cb. 2:1:1 YCrCb means that Y has been sampled at 6.75 MHz, while Cr and Cb were each sampled at 3.375 MHz. Thus, for every two samples of Y, there is one sample each of Cr and Cb. This notation may also be used with YUV, YIQ, HSI, and HSV color spaces, where required.

YIQ YIQ is the color space used in the NTSC color system. The Y component is the black-and-white portion of the image. The I and Q parts are the color components; these are effectively nothing more than a "watercolor wash" placed over the black and white, or luminance, component.

YUV YUV is the color space used by the PAL color system (it may also be used in the NTSC system). As with the YIQ color space, the Y is the luminance component while the U and V are the color components.

Zeroing Zeroing is what's done to the bank of comparators in a CMOS flash ADC to keep them honest. Without zeroing, the comparators would build up enough of an error that the output of the flash ADC would not be correct any more. To solve the problem, the comparators are "zeroed," or the accumulated error is removed.

Zipper See the definition for creepy-crawlies.

Zoom Zoom is a type of image scaling. Zooming is making the picture larger so that you can see more detail. In a way, it's sort of like a "video microscope," since a microscope makes things larger so that they are easier to see. A microscope does this optically, with lenses, while video zooming does it mathematically. The examples described in the definition of scaling are also examples that could be used here.

Index